CASTLES FROM THE AIR

castles
from the air

FRANCES LINCOLN

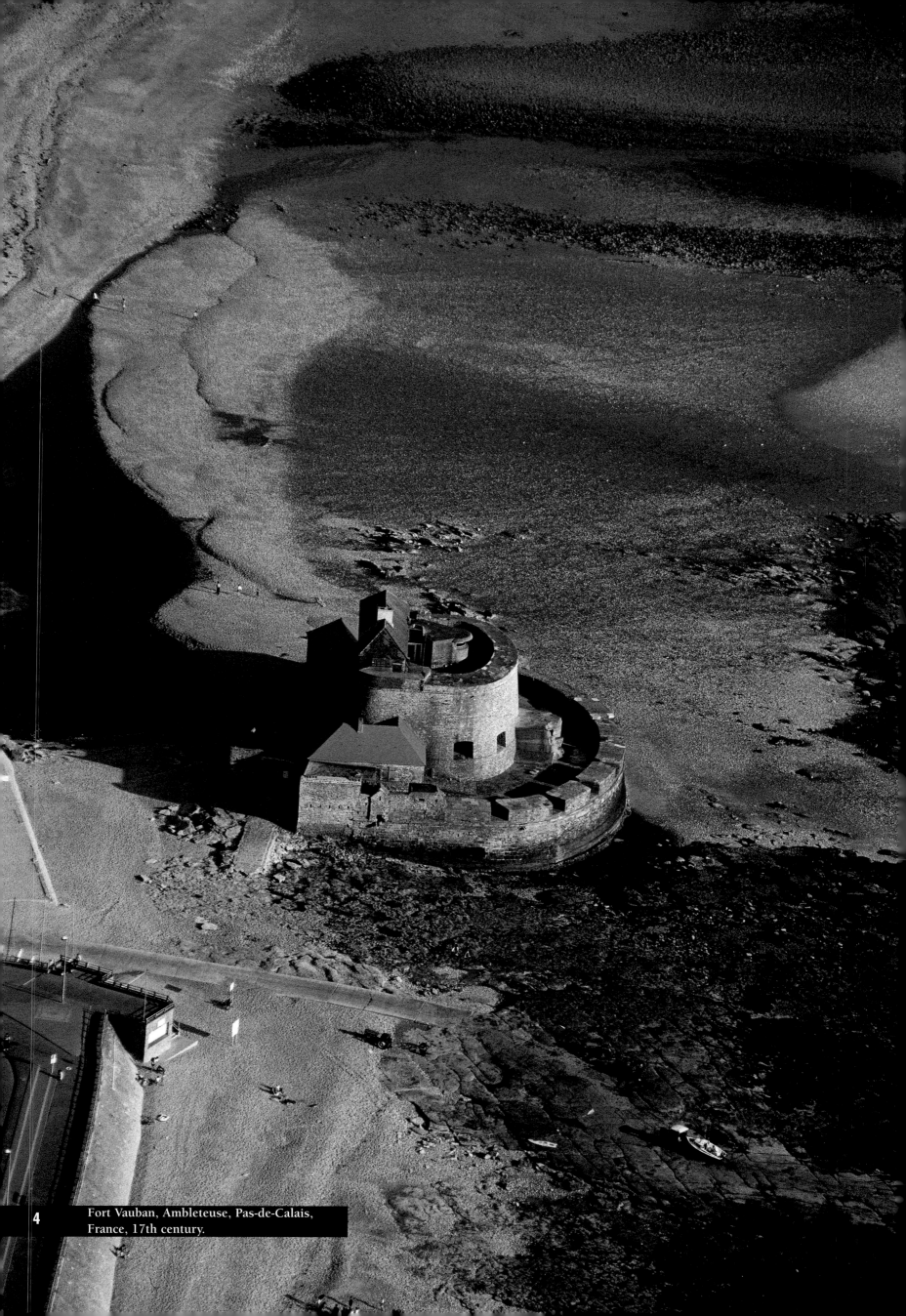

Fort Vauban, Ambleteuse, Pas-de-Calais,
France, 17th century.

Contents

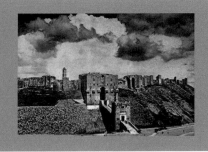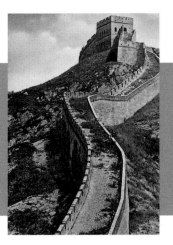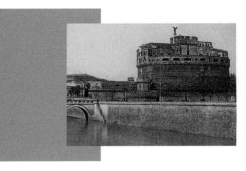

Above:
The fortifications of Aleppo (Syria). Castello Eurialo in Syracuse (Italy). The Great Wall of China. Castel Sant'Angelo, Rome (Italy).

The word "castle" is derived from the Latin word *castellum*, a diminutive of *castrum*; it therefore means "small fortified encampment". We use the word much more generally today, and it does not necessarily have the same military flavour. A castle nowadays is a building characterised by its isolated position and the presence of turreted walls. In some cases, in fact, a building is defined as a "castle" simply because it is an aristocratic residence; a defensive establishment for military use is generally called a "fort" or a "fortress", words derived respectively from the Latin adjective *fortis*, meaning strong, and from *fortitia*, a mediaeval Latin word meaning strength. Today the meaning of the word "castle", when used to describe or inform, is so general as to be fairly imprecise. In order to clarify our understanding of the castle, let us look at its history.

In Neolithic times elevated mounds were walled with large boulders to protect the inhabitants from attacks by wild animals or enemies; archaeologists call these mounds hill forts. Their defensive function would be limited to the immediate neighbourhood, and they also allowed their inhabitants to watch over the surrounding countryside with its sprinkling of houses, pastures and fields. These fortified mounds began to develop – locally and according to no particular chronology – and various types of construction began to appear upon them: the fortress to protect the countryside, isolated or surrounded by a village, like the *nuraghi* of Sardinia; the fortified residence of warrior princes, for example at Tiryns in Greece, and the village protected by a wall, like Mycenae, also in Greece; or Zimbabwe. In addition to these, throughout the history of ancient civilisations, we meet genuine defensive fortresses built specifically for military purposes: these include the imposing structure called the *Fortaleza* in Paramonga, Peru, built at the time of the Incas; the Phoenician fortress of Kelibia (Tunisia) which protects the port; Castello Eurialo (which means "nail head") in Syracuse, Sicily, which looked down on the Hellenic city-state from above, and the Palace of Diocletian in Split, in Croatia. Architecturally, the latter echoes the type of grand, monumental fortified residence of the late Roman Empire. Many ancient city walls remain with well-fortified gateways: from the Etruscan walls around Volterra in Italy to the *Porta Nigra* in Trier, Germany.

Although plenty of documentary evidence exists for agricultural and residential buildings built for defence by this time, the type of "castle" we are familiar with today had not yet made its appearance.

The story of the castle really begins in the Middle Ages, during the last couple of centuries of the first millennium. Although grand royal residences still imitated Roman models, for example the palace of Charlemagne in Aix-la-Chapelle, villages and farms were also beginning to be enclosed inside defensive walls. At this period of political, religious and social upheaval, in the central core of Europe (France, Germany, the southern part of Great Britain and the Baltic states, Catalonia, Northern and Central Italy) a complex situation was arising: communities and centres of power would gather together in the shadow of the two great competing yet complementary institutions, the Holy Roman Empire and the Church, both in a state of rapid evolution. These two institutions were the product of the meeting of Germanic tradition with the remains of the prestigious administrative machine that had been the Roman Empire closely influenced by the all-embracing organisation of the Christian church. In the ever-changing panorama which emerged from this clash, when recognition of the superior authority of a local princeling was often a mere formality (as for example in Burgundy or in the Lombard duchies), even village communities and smallholders had to ensure their own safety.

The Provençal word *maner* (*manor* in English, *maniero* in Italian), derived from the Latin *manere* (to stay), indicates a fortified residence from which a landowner controls and administers a large agricultural estate. This was the earliest form of the feudal castle, with characteristics that varied from region to region. The fragmentary information we possess on the birth of the manor house is gleaned from documents and local traditions rather than from archaeological remains. In many cases they were nothing more than farm buildings, each with a different function, grouped around a courtyard and presenting a continuous wall with few openings to the outside world; the wall would be fortified with a protected entrance door. This primitive form survived in the so-called "fortified Manor house", still to be seen in agricultural country, with vegetable gardens and threshing

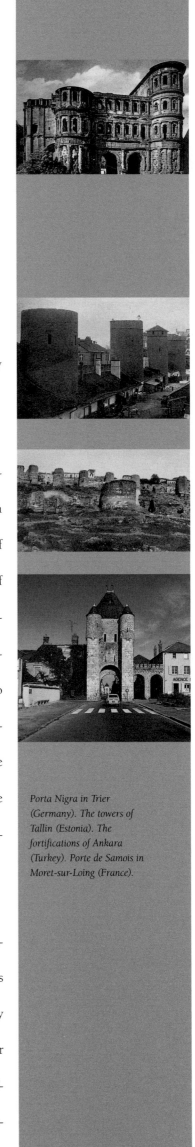

Porta Nigra in Trier (Germany). The towers of Tallin (Estonia). The fortifications of Ankara (Turkey). Porte de Samois in Moret-sur-Loing (France).

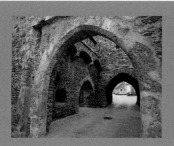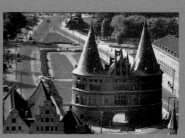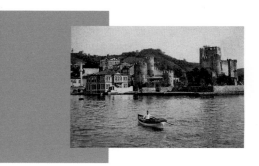

Fortified gateway in Oberwölz (Austria). The Holstentor in Lübeck (Germany). Crac des Chevaliers (Syria). The Asian castle in Istanbul (Turkey).

floors enclosed inside a curtain wall; these can also be found in mountainous locations, such as for example La Salle in the Aosta Valley or on the English/Welsh borders. Some villages were probably protected in the same way: these were settlements with more or less the same requirements, but with the difference that no overlord lived in them.

Historical events in general have little respect for traces of the past, particularly when requirements have changed and the old buildings no longer fulfil their original purpose. This is why most castles, even grand ones, dating from the years around 1000 AD, have come down to us in a state of ruin, or else have been so radically altered that their original shape has been distorted. At this period institutions were based more on strength than on legitimacy, and battles for domination or emancipation, even in small places, were frequent and bloody. The control of land, beyond the boundaries of the burgeoning urban communities and, to some extent, the monasteries, was in the hands of the landed nobility and was based on vassalage; this complex hierarchical organisation imposed reciprocal ties of loyalty and protection. At local level, rivalries and brigandage, plus territorial claims and bids for freedom, with the repression that such claims were met with, made life for the village and its overlord very insecure. The result was frequently no more than a skirmish involving a few dozen people, but this nevertheless made it essential to defend one's dwelling and one's fields.

The castle buildings and ruins that remain from this period can be divided into four basic types: the fortified dwelling, the fortified enclosure, the isolated tower and the fortress or stronghold. The fortified dwelling, as has already been said, was nothing more than a farm built around a closed courtyard. The fortified enclosure was a more complex structure, and by far the most common at the time. It was usually built in an elevated position, like the ancient fortified mound or hill fort, and consisted of a circular wall with towers, to protect the entrance. Inside the wall there could be dwellings, stables, stores, the oven and the workshop as well as vegetable gardens and orchards. One particular type of fortified enclosure was characterised by the presence of

a huge structure in the centre, a massive tower called the "donjon" or keep, built to defend the inhabitants in extreme circumstances, for example if the assailants managed to scale the outer wall. Variations on this type of castle included the insertion of the keep into the curtain wall, or the building of a double defensive wall. A particularly complex example consisted of two tangential walls built at different heights and linked by internal passageways: the higher of the two walls had regular defensive towers along its length and was probably used to house the owner and his family, or for defence when circumstances required.

The isolated tower was built as a lookout along the coastline, or along roads leading into valleys, on mountain passes or on the brow of a mountain ridge. Although built for military purposes, this did not preclude residential use. Such buildings were generally built on a quadrilateral base and were on three levels, access being gained to the third floor via a retractable ladder. The ground floor had massive walls with a few small arrow slits for windows and was used as a store or warehouse. On the second level (which could be reached from outside) was one large living room with windows splayed towards the inside to facilitate defence. The third floor was divided by curtains or wooden panels and contained the bedrooms. The roof of the tower was flat with crenellated walls to help the inhabitants withstand attack. Matilda of Canossa (in Northern Italy) ordered a series of such towers to be built on the boundaries of her estates, and from these her vassals administered the villages and protected the countryside.

Finally, the fortress was generally a fairly complex fortified structure, often built in an elevated position and designed for an armed garrison. At the period under discussion, the fortress was undoubtedly the most secure solution and could control areas greater than a few fields or groups of smallholdings. The nobles who lived there would have had additional administrative responsibilities and were also in charge of tax collection and the raising of armies for themselves or for other, higher authorities. The fortress is a complex structure, and was by this time arranged as a genuine castle. In the oldest of them, those built during the centuries around the first

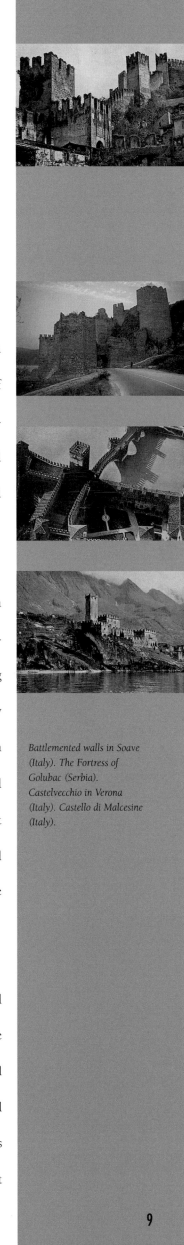

Battlemented walls in Soave (Italy). The Fortress of Golubac (Serbia). Castelvecchio in Verona (Italy). Castello di Malcesine (Italy).

9

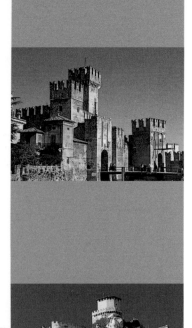

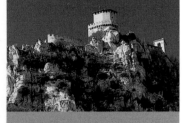

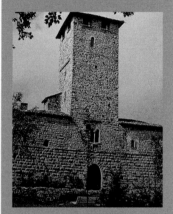

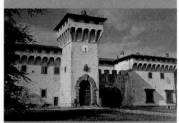

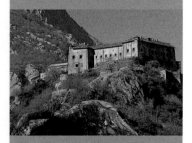

Castello di Sirmione (Italy).
Rocca di San Marino
(Republic of San Marino).
Castello Suardo, now Faglia,
in Bianzano (Italy).
Medici Castle in Cafaggiolo.
(Italy).
Fort di Bard (Italy).

millennium, the exterior appearance is of a curtain wall with turrets, not unlike those of the fortified enclosure but more closely grouped around the internal space and rendered inaccessible by their position and by the strength of the walls. From the mid eleventh century to the mid twelfth century, as institutions grew stronger and longer lived, the feudal castle adopted a more compact form. The walls, towers and farm buildings designed to be lived in were all joined together, and the internal courtyards around which they were grouped became increasingly regular in shape and increasingly less influenced by the nature of the location. Increased wealth, due to improved methods of exploiting the countryside with the introduction of new agricultural techniques and new tools, plus craft and commercial activities in towns and villages and, in an ascending spiral, the consequent increase in population provided the basis for real economic progress. More sophisticated building techniques and more highly skilled workers also made a contribution to the development of the classic type of castle, on a rectangular plan with towers at the corners, often surrounded by a moat, and equipped with an advanced defensive structure – the guard tower – protecting access, then later the drawbridge. This new type of castle was also suitable for siting on flat ground and was to enjoy huge success in later centuries.

By the time the organisation of Europe had become more clearly defined in the twelfth century, the network of institutions was already very complex. The Holy Roman Empire interpreted and guaranteed the legitimacy of the feudal system at the institutional level. Grouped together within it, however, were the signs of an organisation based on smaller territorial units, governed by powerful princes who were also the Emperor's great electors. Norman expansion during the eleventh century began to integrate other countries into the system, first England, then Portugal, Southern Italy and Sicily, expelling the Arabs and the Byzantines. At local level, the landed gentleman still ruled the estates around his own castle. On the other hand, the Church, although solidly united by ideological ties, had not yet developed a well-organised structure. Forms of integration with the feudal system can be detected in the church (count-bishops, for example), and administrative divisions which were late Roman in origin (the diocese often occupied the same area as the territorial unit of the Roman admin-

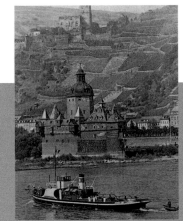
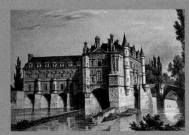
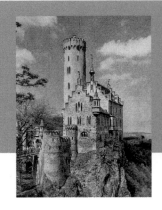

istration), and ways of taking part in the management of villages and cities, often from a dominant position.

Alongside this evolving political framework, the spread of monastic orders such as the Benedictines and the

Cluniac friars was already taking place; the orders aimed to establish forms of land management guided by reli-

gious communities, with the intention of living communally in a Christian manner. Papal authority, which

would have kept all these religious institutions together, was still uncertain, however, and was strongly influ-

enced by intervention from the imperial and princely authorities, which aimed to make use of the church for

their own political ends. The two great institutions, Church and Empire, tended to find an equilibrium based

on reciprocal legitimation. It was now that villages, cities, ports and frontier posts began to be equipped with

fortresses and walls to guarantee security whilst also guaranteeing the submission of the populace.

Schloss Kaub (Germany). Château de Chenonceaux (France). Princes' Castle (Liechtenstein).

The twelfth century was the period during which free communes developed and marine republics came to

prominence. These adopted a form of self-government in order to encourage production and commercial activ-

ities and to organise security for the local villages, towns and dependent territories. Walls and fortresses rose

up to defend this hard-won independence and to protect it from the onslaughts of armies and armed bands.

When from amongst the warring factions the personal and familial power of the "seigniories" emerged, in the

thirteenth and fourteenth centuries, the castle was to become a secure home where the new masters were pro-

tected from the attacks of rivals.

The structural revolution embodied in Gothic architecture, which began in France in about the mid twelfth

century and spread throughout Europe in the thirteenth, was the most visible sign of the burgeoning of Euro-

pean civilisation in the fields of art and technology. It was the result of an ability to plan and organise, which

by now had become the expression of an articulate and complex body of knowledge and of a flourishing and

brilliantly inventive economy. The society which underpinned it was experimenting with different ways of

organising life and work. It succeeded in integrating these into institutions and associations which co-existed

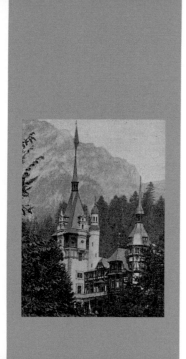

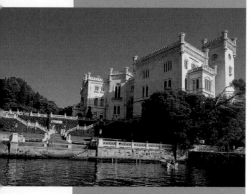

on the basis of the separation of administrative and political powers, and on mutual respect for the prerogatives peculiar to each. The legality of the respective spheres of influence of the Empire, the Church, the regional principalities, and the autonomy of the middle-class corporations in the cities, were all recognised. The competition and conflict which developed were still tightly controlled by the hierarchy of powers, but they were also the driving force behind the rapid transformation of lifestyles which laid the foundations of the modern world. At the beginning of the thirteenth century, Emperor Frederick of Hohenstaufen attempted to reinforce his control over feudal lands by constructing a system of fortresses, some of them in towns. But the castle still remained the place where the nobility resided and wielded power until the beginning of the fifteenth century.

The classic type of castle, as we have seen, took shape in this period. To its original defensive function was now added the requirement for a comfortable and luxurious residence. The first effect of this was an increase in size: the structure was built to a much larger plan. In addition, without abandoning the need to guarantee security, some adaptations appeared which aimed at adding elegance and harmony, and also at providing light and ventilation to the residential quarters by means of balconies and windows. These sometimes even open outwards to provide a view. Some typical innovations can be identified. The enclosure survived and was augmented by tall battlemented walls without windows, usually built to a quadrilateral plan with towers at the corners and a fortified entrance. Inside the residential buildings could either be arranged around the walls or in the central area, and they often now adopted forms that made no concessions to defensive requirements. There was frequently a "keep", the ultimate bulwark in case of attack. The quadrilateral plan with inner courtyard and rectangular or cylindrical towers at each corner is undoubtedly the most widespread. It usually consisted of four conjoined buildings, combining residential areas and a protective curtain wall. Towers and walkways, jutting out above the walls on supports called corbels, were covered by sloping roofs which added refinement to the castle's appearance. Sometimes a high tower (always quadrilateral) was built at the entrance. Many more complex structures derive from this basic plan; some have a series of courtyards obtained either by subdividing the

interior space into several parts, or by juxtaposing a succession of quadrilateral structures. One variant of the latter solution is the castle with a "refuge", in which the main courtyard is the residence, whilst another one (the refuge), through which it is necessary to pass to gain access to the castle itself, is surrounded by peasants' dwellings. The U-shaped plan, consisting of only three sides, was less common at this time but was to enjoy great success in later centuries. Another type of castle consists of a compact building without an interior courtyard; this is either designed in the shape of a rectangle or parallelepiped, with or without towers at the corners, or is the result of the combination of various buildings, often constructed at different times. The latter type is particularly common in the Alpine region and in Central Europe.

The architectural language of the Gothic period is characterised by the search for formal elegance, the outcome no doubt of the demands of clients interested in quality. This search found expression in the creation of single buildings which were symmetrical and well-proportioned, with new features to modify the solidity of the walls and the courtyard spaces – monumental doorways, double mullioned windows, loggias and porticoes, and also in the use of regular series of corbels, buttresses and battlements. Gradually builders became able to integrate the various innovations into a homogeneous style, in which structural, functional, formal and decorative elements would blend harmoniously. To this was added, from the fourteenth century onwards, the embellishment of the interior space with wooden ceilings, monumental fireplaces, niches with windows and, above all, opulent painted wall decorations. We have to thank this castle architecture for preserving and handing down to us much of the secular art produced in the late Middle Ages. Subjects taken from tales of chivalry, pictures of aristocratic life and hunting, and stories from Boccaccio and others provided the material for sophisticated paintings, inventive and imaginative of composition, often richly coloured and filled with decorative details.

From this time onwards, the transformation of the castle into a luxurious residence was inevitable. Changed political conditions meant that the administration and government began to be concentrated in the hands of

national monarchs, with the consequent shift of anxieties about defence to the central administration, its army and defensive buildings. The castle began to acquire sophistication, becoming a place for feasting and hunting; the thick, closed curtain walls were replaced with elegant successions of windows and loggias. Inner courtyards opened out to parks and gardens, and antique forms like towers and battlements were used with inexhaustible fantasy in the pursuit of elegance. The castle as a type was well established by now, and would remain as a constant reference for prestigious architecture right up to the present day; it provided models for innumerable noble residences which make but fleeting allusion to defence: from Renaissance villas such as the Medicean Cafaggiolo, to the fabulously romantic nineteenth-century castle of Neuschwanstein in Bavaria. At the same time the implements of war became more technically advanced, and any serious military defensive structures had to develop in parallel to withstand the onslaught of the new artillery with curved walls and round towers to withstand projectiles.

Finally, we need to remind ourselves that castle architecture developed just as impressively beyond the confines of Europe. Firstly on the shores of the Eastern Mediterranean in response to the need to protect the territory of the Byzantine Empire; then as the expression of Islamic military expansion, or in garrisons built to protect the commercial activities of the European seafaring powers such as Venice, or as strongholds for crusader orders and kingdoms. Nor should the architecture of the East be forgotten, though it is not discussed or illustrated in this book.

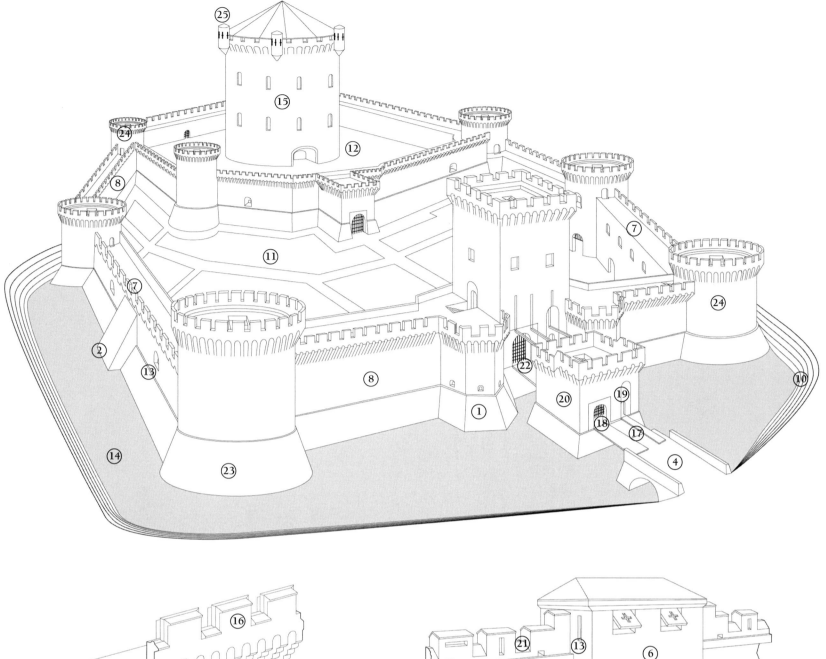

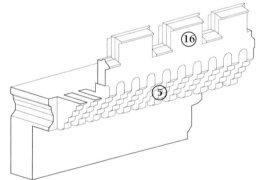

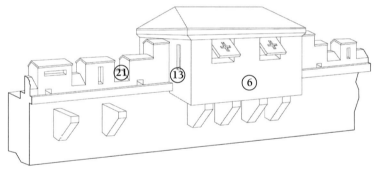

BASIC TERMINOLOGY

1. bulwark
2. barbican
3. bastion
4. access bridge
5. corbel
6. lookout
7. battlemented parapet
8. curtain wall
9. counterguard
10. counterscarp
11. outer ward, lists
12. inner ward
13. arrow slit, embrasure
14. moat
15. keep, donjon
16. crenellation
17. drawbridge
18. carriage gateway
19. pedestrian gate
20. guard tower
21. crenel, hence
 crenellation
22. portcullis
23. escarpment
24. angle tower
25. turret

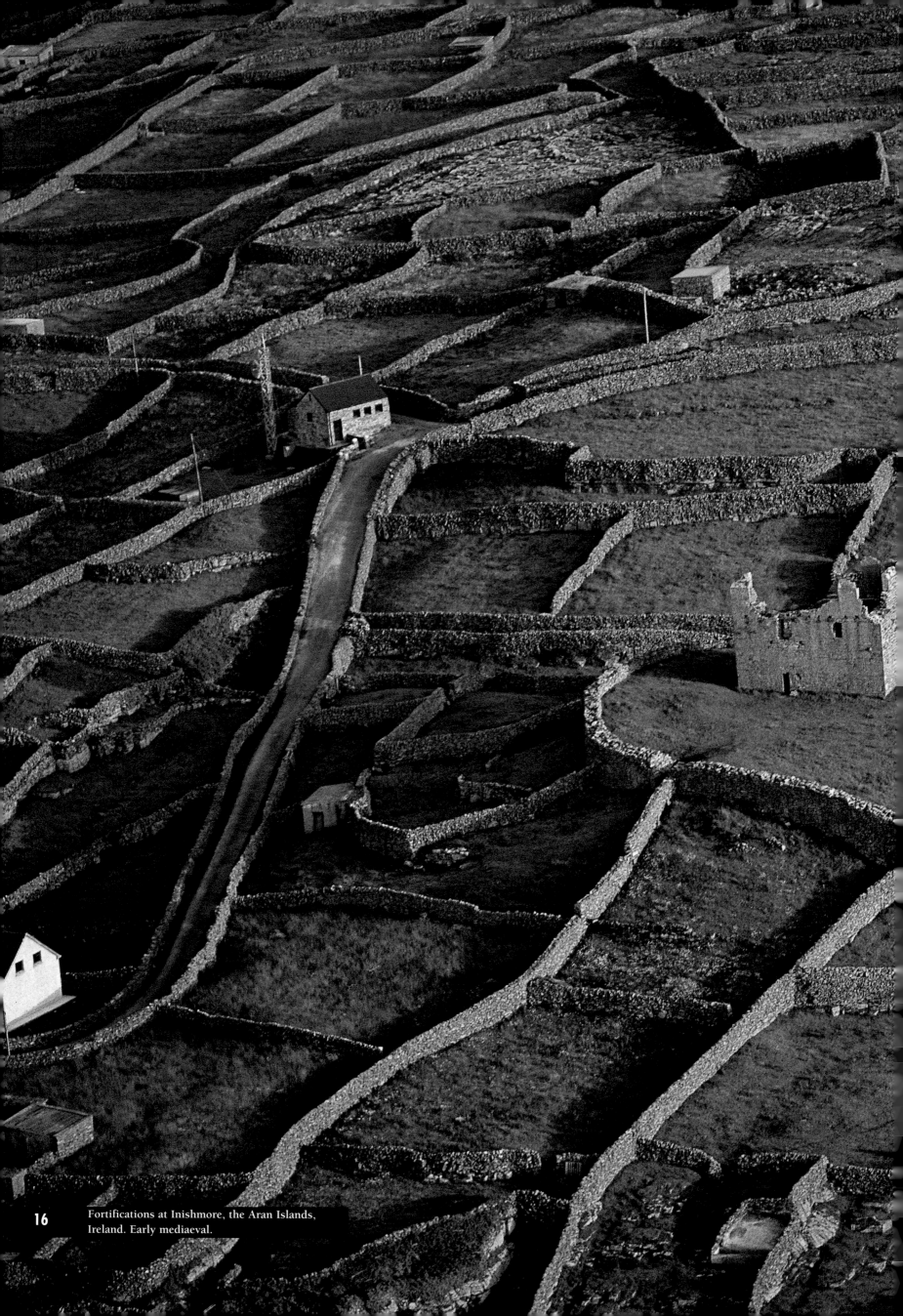

Fortifications at Inishmore, the Aran Islands,
Ireland. Early mediaeval.

Mediaeval castles

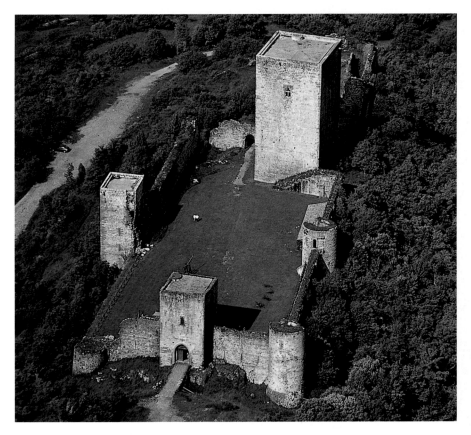

Ruins of the Château de Puivert, France, 10th-11th century.

Early times

Almost all the oldest castle sites have suffered the ravages of time. They have been destroyed by wars, completely rebuilt over the centuries or have sometimes been simply abandoned and fallen into ruin. Many factors have contributed to their transformation and abandonment.

First and foremost, the changing nature of war: stronger and more powerful armies and more sophisticated weaponry wrought profound changes on the means of defence and armed response. In addition, whilst such changes were coming about, Europe saw (amongst other things) important demographic and economic changes which increased the wealth of the nobility and other institutions, and encouraged alterations to the size and structure of castles and fortresses; larger garrisons had to be housed, and interiors were altered in order to provide a more comfortable way of life.

Of the oldest forms of castle, for example the three-storey tower or the English manor house with three buildings arranged around a courtyard, only archaeological traces or much later copies remain; the later copies possessed little of the functional and administrative importance of their predecessors. There remain many more fortified farms, and above all fortified enclosures, although these also are often now reduced to ruins.

Some sites of enormous historical and archaeological interest, for example the early mediaeval castle at Inishmore in the Aran Islands (Ireland), offer little to the visitor except an evocation of early times and a profound sense of mystery. Some of these architectural sites, however, retain vestiges of a size and complexity which remind us of the power and authority of some mediaeval rulers. Look at the solid strength of the wall and square tower at Puivert (France), the complex structure of the fortified farm at Châtellerault (France) or the same type of dwelling at Ciano d'Enza (Italy).

Castello di Rossena, Ciano d'Enza, Italy.
10th-13th century.

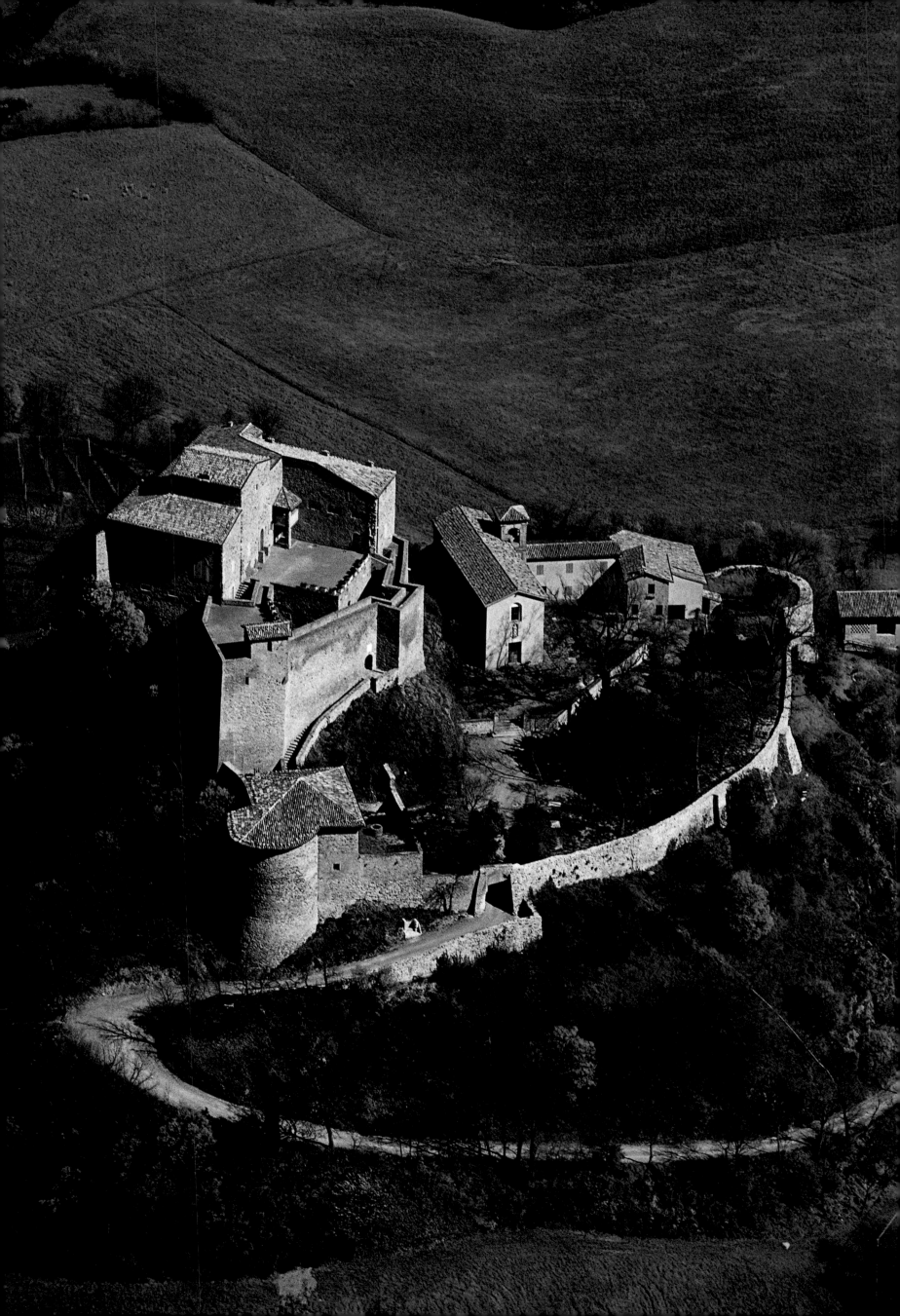

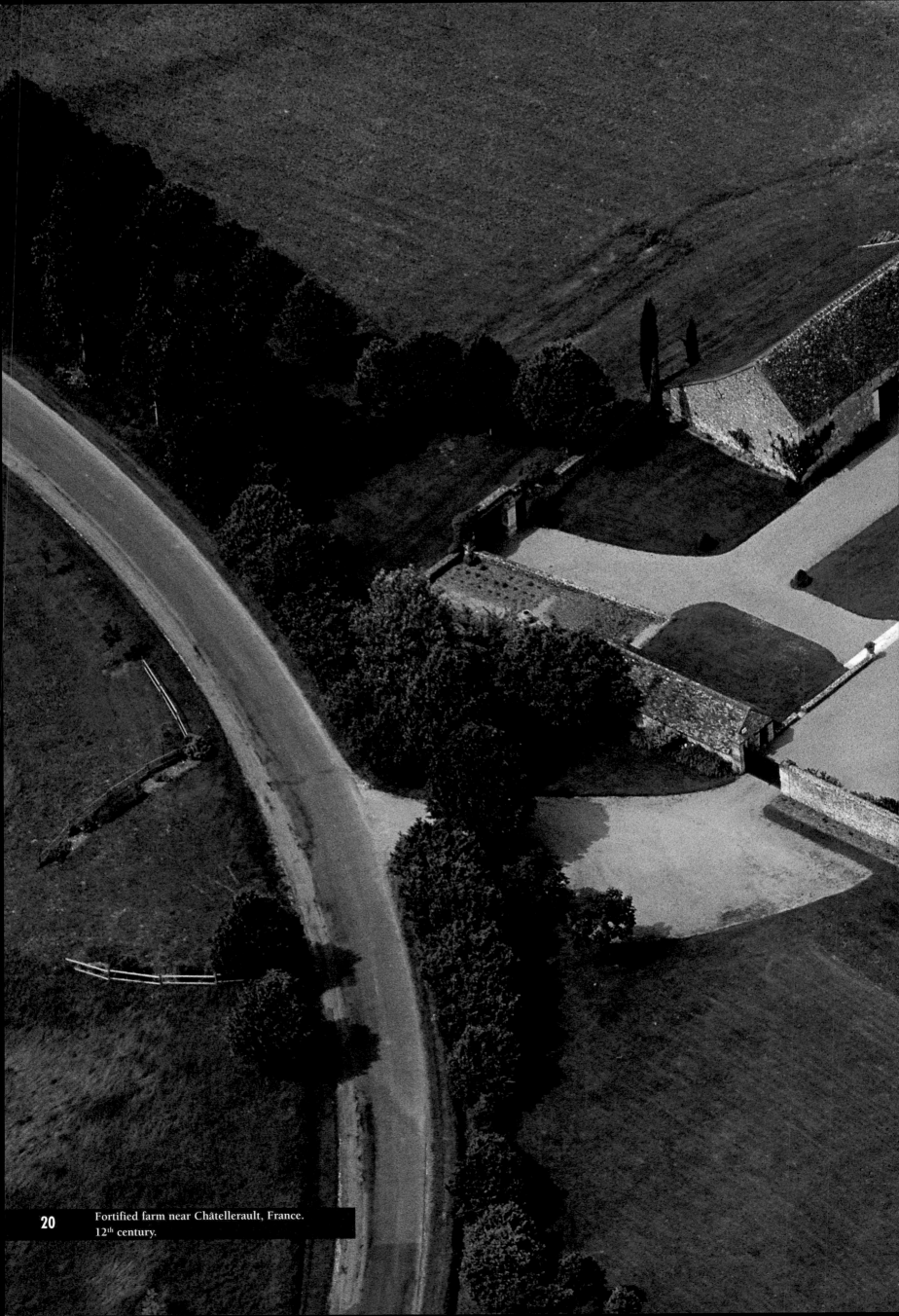

Fortified farm near Châtellerault, France.
12th century.

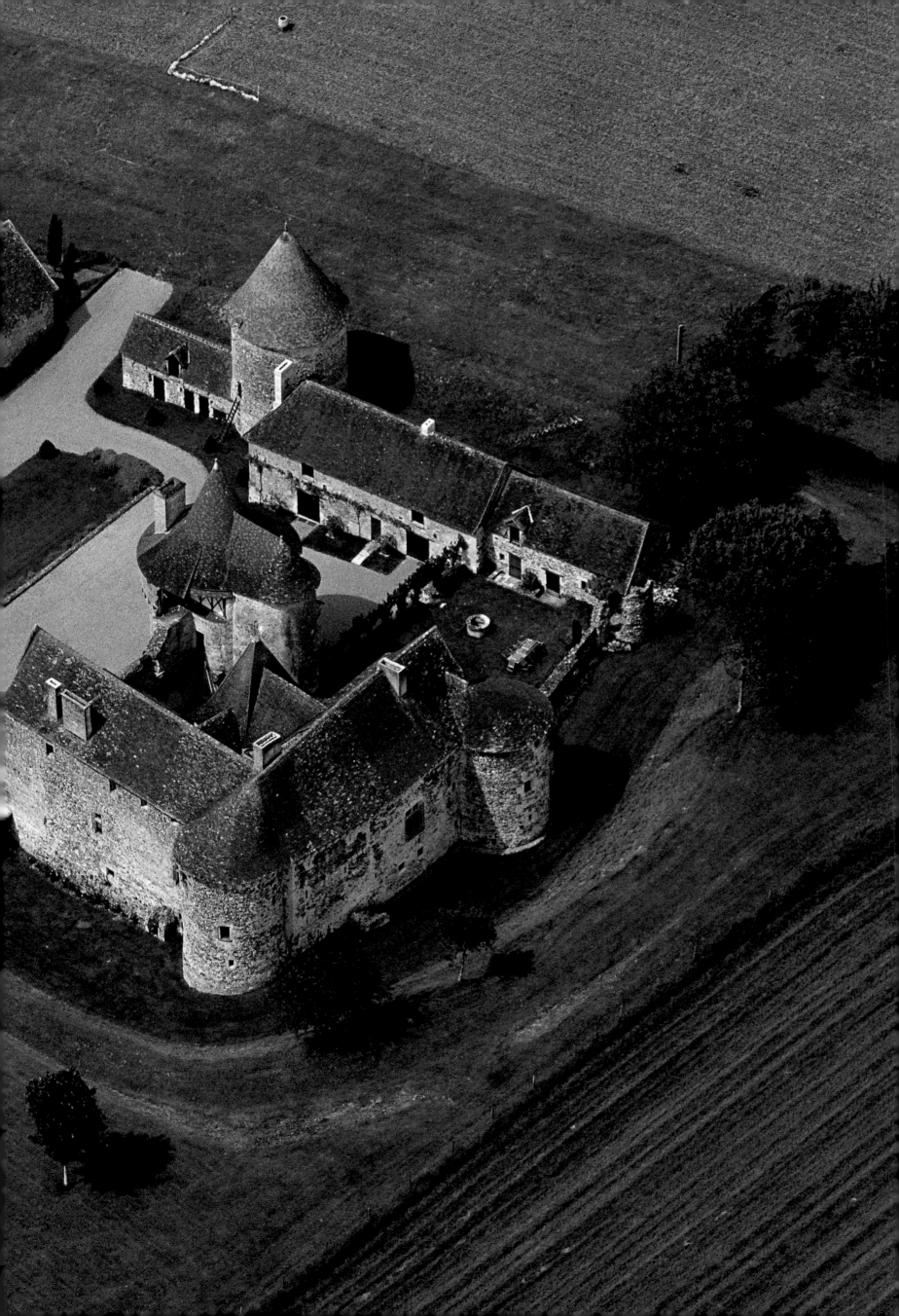

Imposing ruins

Some of the oldest castle architecture in Europe was built by the Arabs, whose contribution to the continuity and transmission of the knowledge and technical skills of the ancient world to mediaeval Europe is enormous. More than one of the buildings featured in this book has its origins in Islamic fortifications in Spain and Southern Italy; these sometimes date from as far back as the eighth or ninth centuries.

The oldest parts of the Castelo dos Mouros (of the Moors) in Sintra, Portugal date from the eighth century. Enlarged over the succeeding centuries, it still presents a spectacular curtain wall. Corfe Castle, in Dorset, is celebrated for its size and historical importance; it was founded in the tenth century and was the scene of important events, including the assassination of Edward the Martyr in 978. The present structure is the result of modifications made during the Norman period, around 1100; it was largely destroyed during the English civil war in the seventeenth century.

The imposing ruins at Les-Baux-de-Provence (France) are particularly evocative. There was already a feudal court here in the tenth century, home to a noble family which claimed descent from King Balthazar, one of the Three Wise Men. The family were proud of their independence and of protecting the art of the troubadours. They managed to maintain their princely status. The citadel and castle were destroyed during the wars of religion in the sixteenth century. Just as imposing are the remains of the fortress of Medellìn in Estremadura, Spain (thirteenth century), and the splendid remains of Pembroke Castle, the former residence of the Earls of Pembroke. The manor was built in the twelfth century and destroyed during the time of Cromwell, but was admirably and accurately restored in the early twentieth century.

Vestiges of the extensive walls of the eighth-century Château de Loches (France) remain, including the rectangular main tower; the turreted walls surrounding the tower date from the twelfth century.

Ruins of the castle of Les-Baux-de-Provence, France. 10th-14th century.

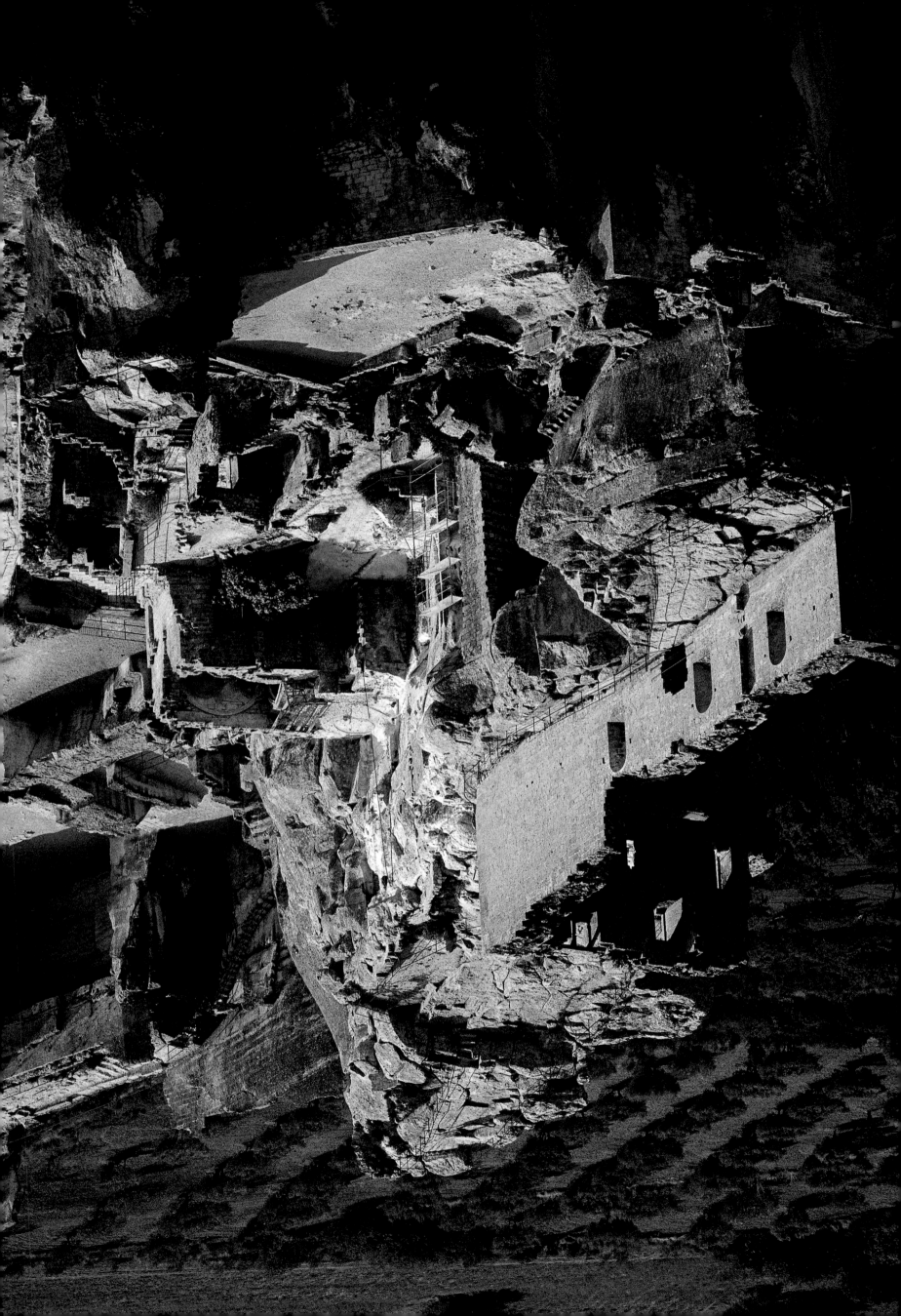

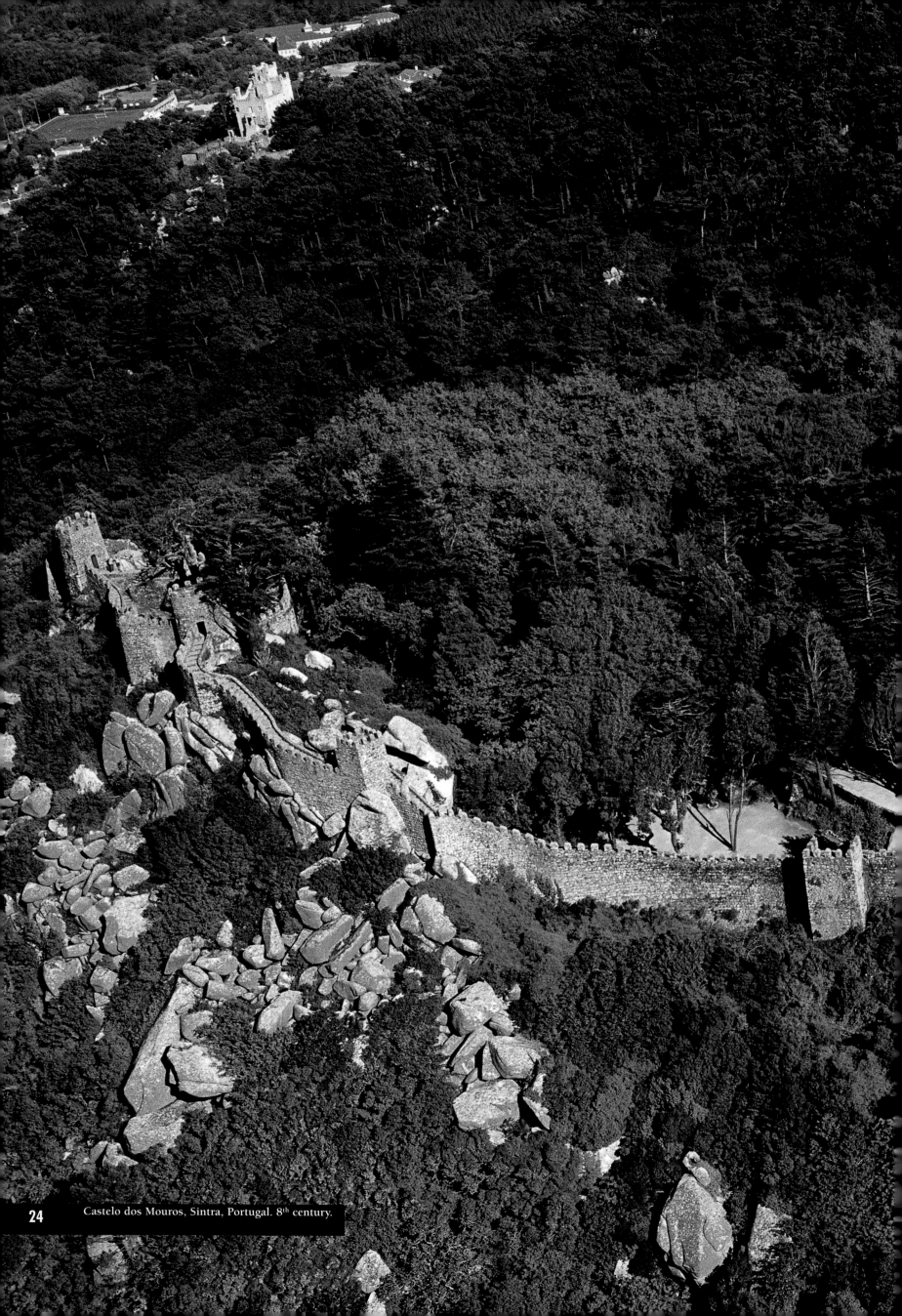

Castelo dos Mouros, Sintra, Portugal. 8th century.

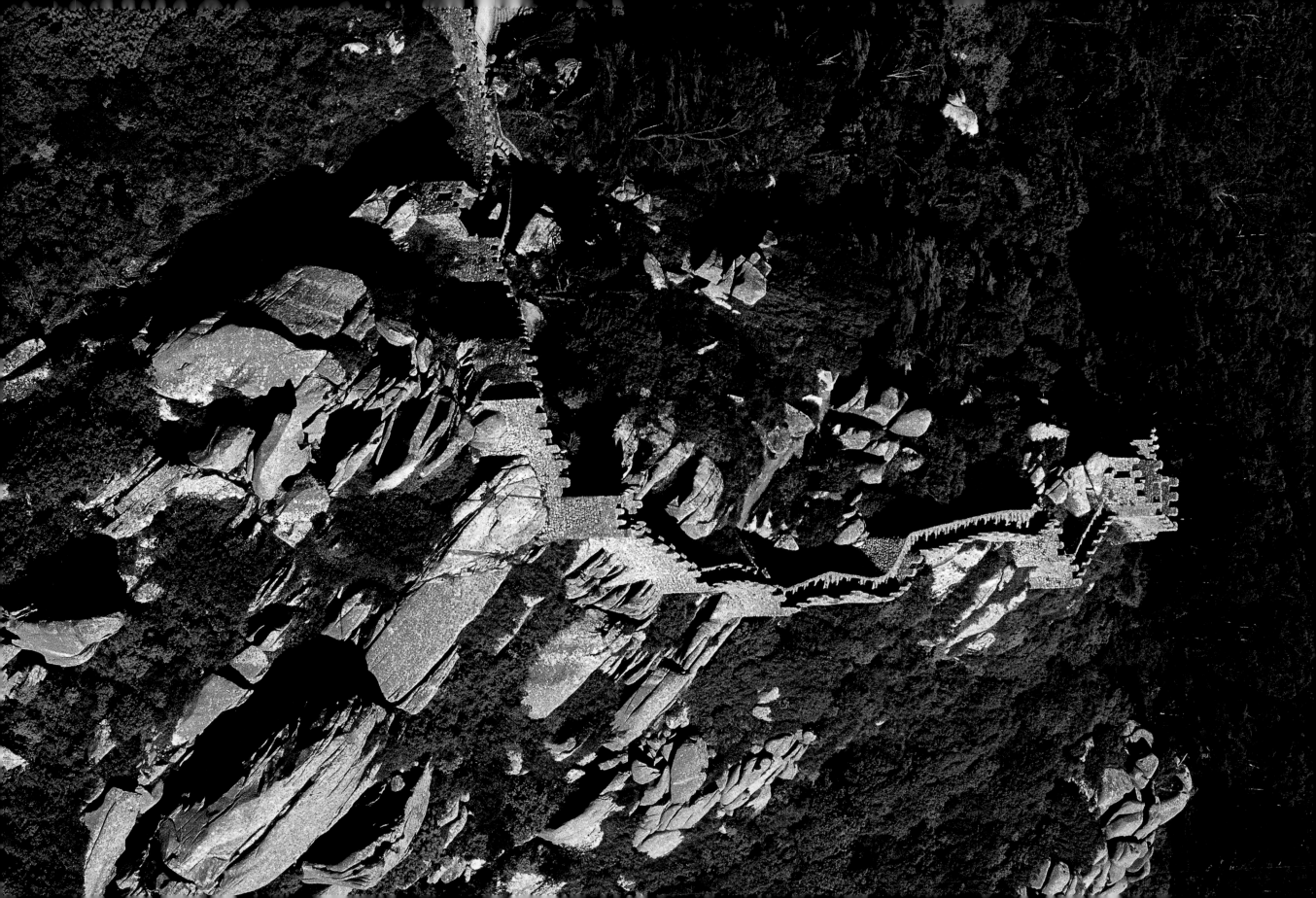

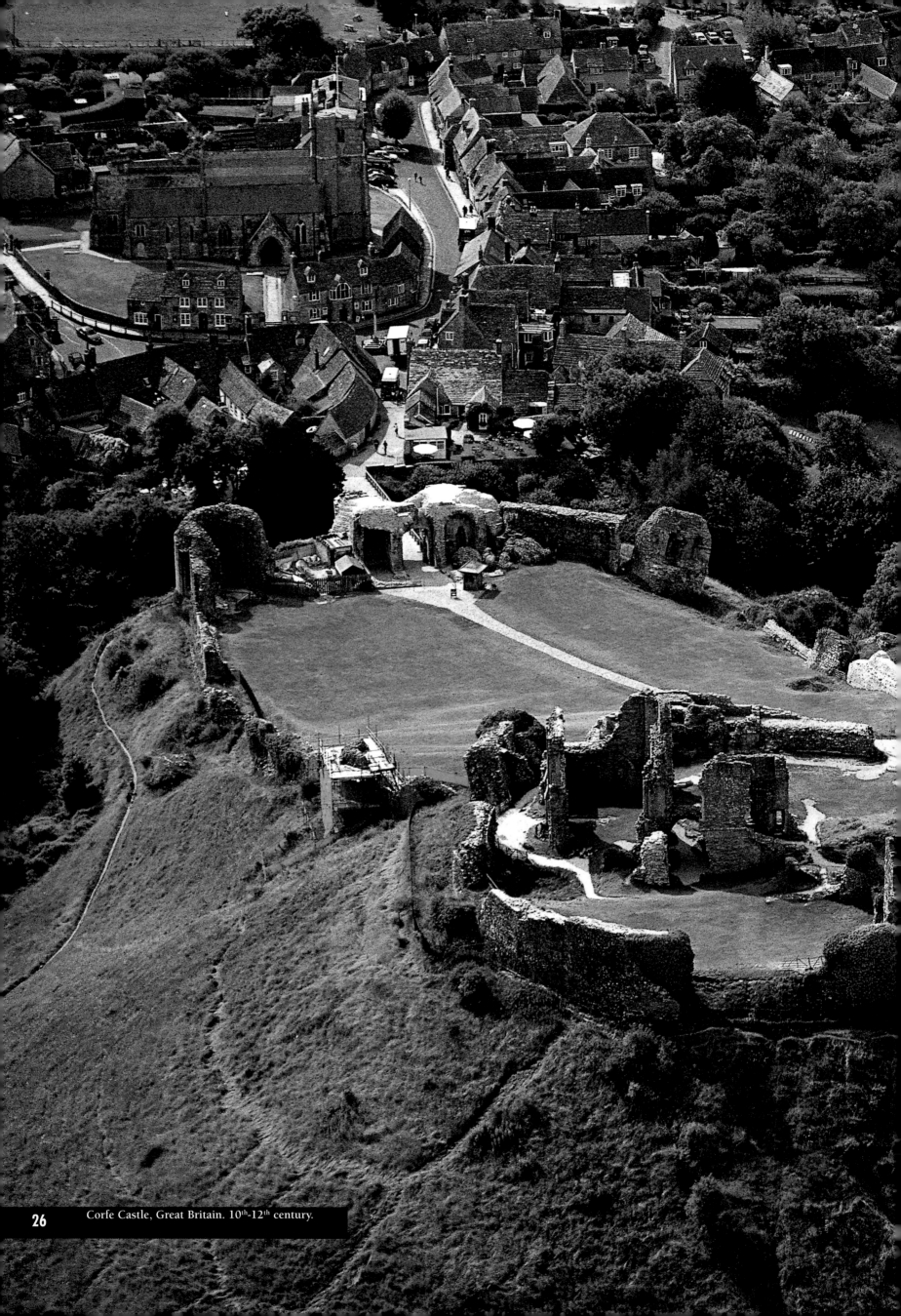

Corfe Castle, Great Britain. 10th-12th century.

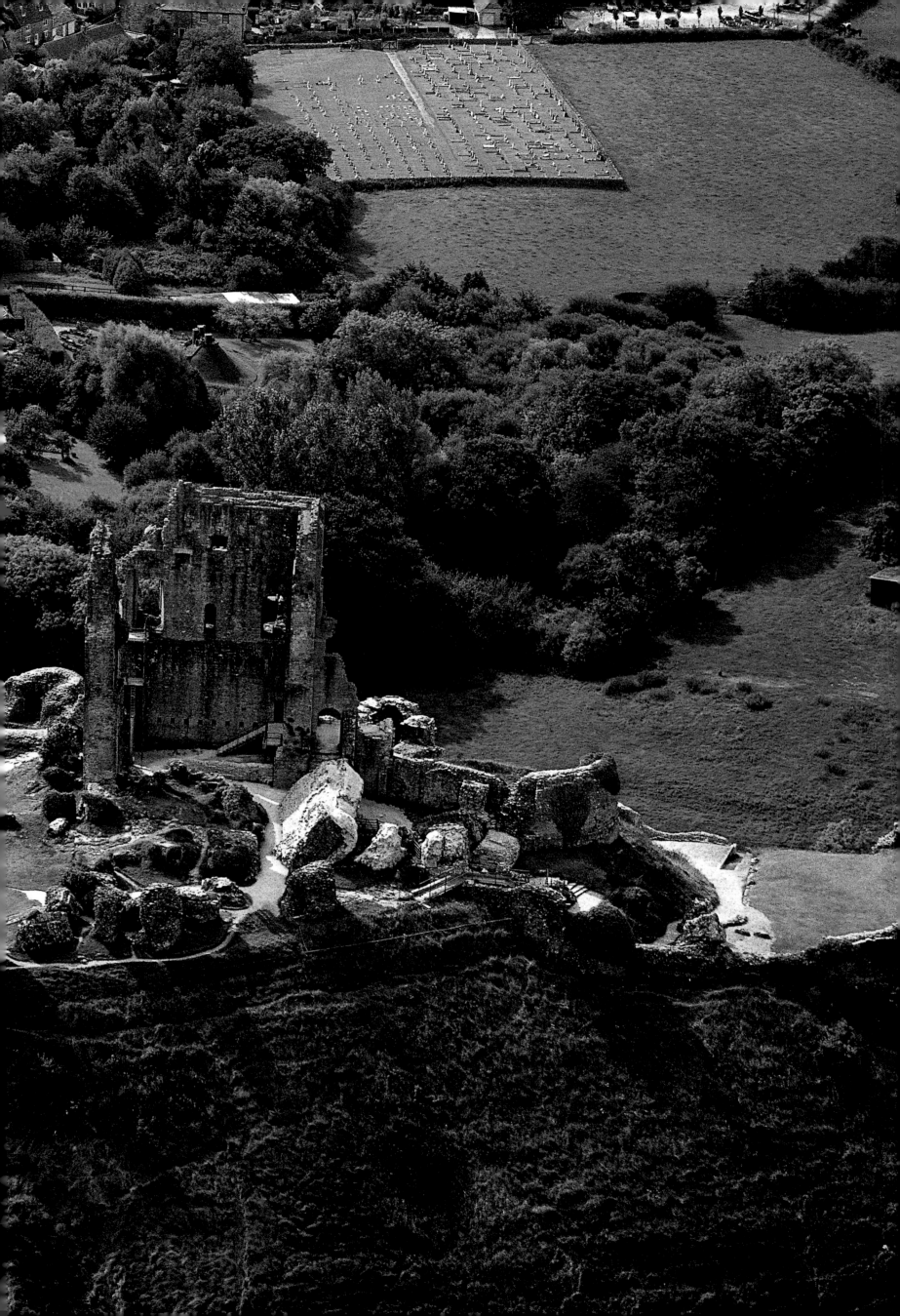

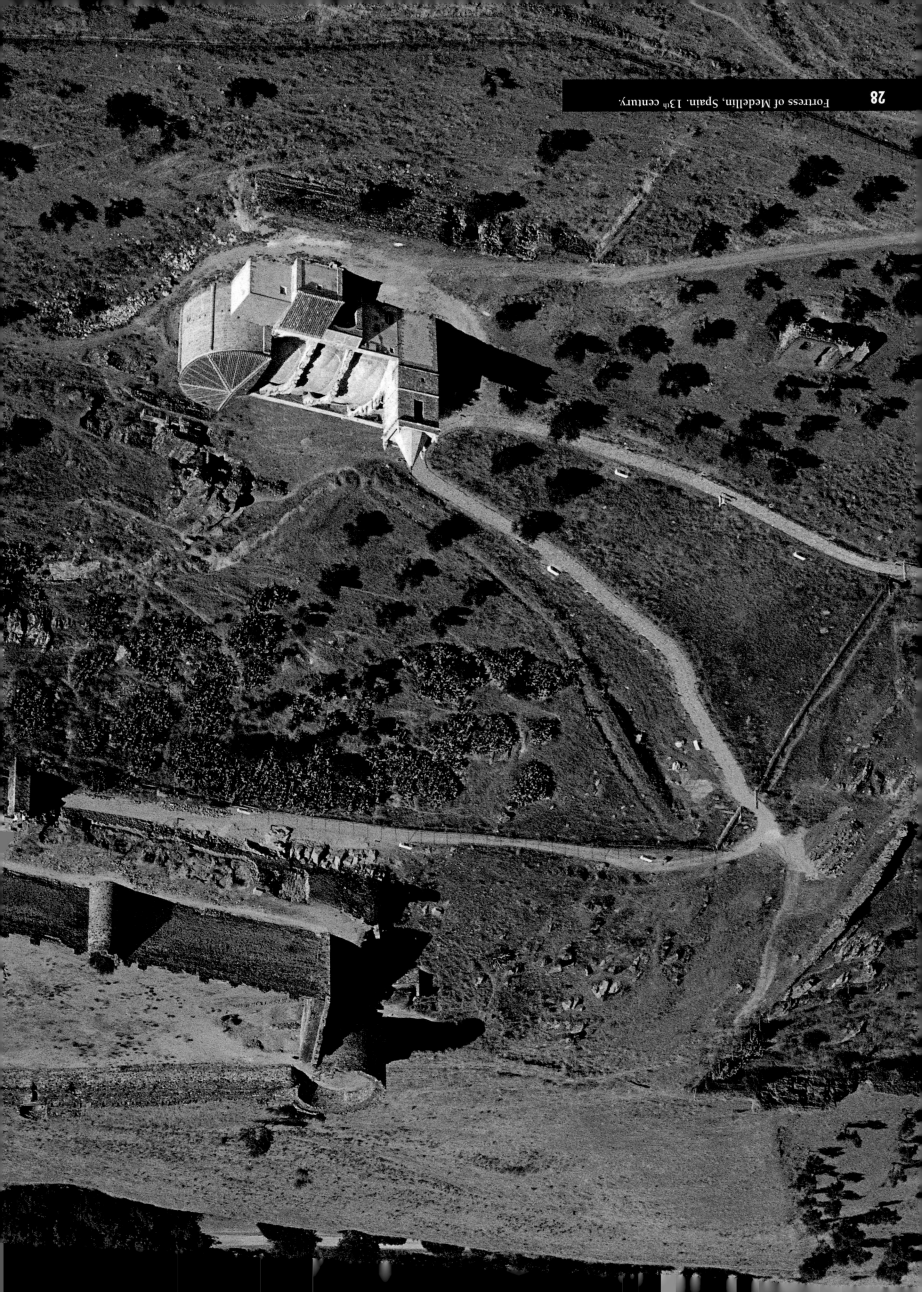

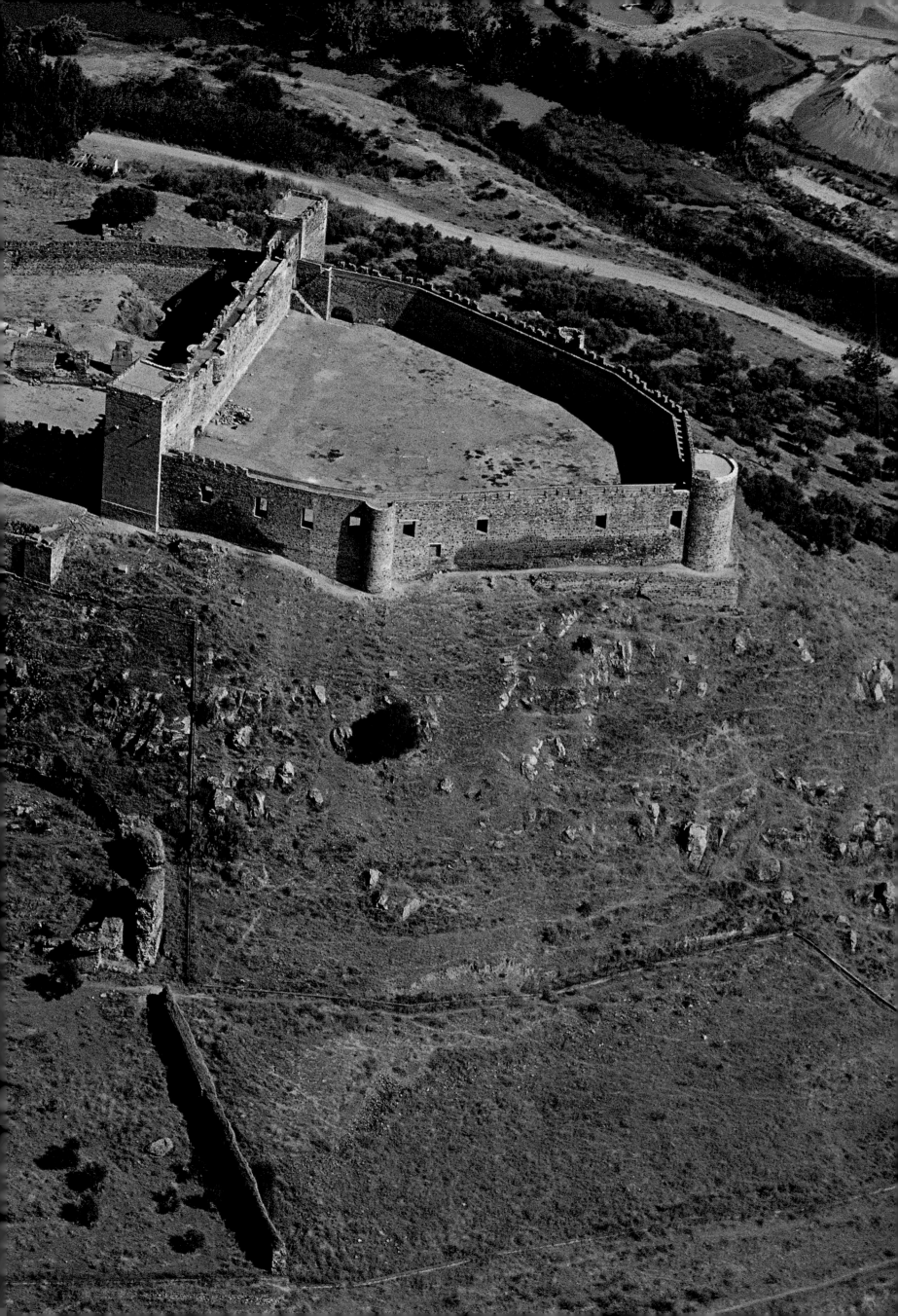

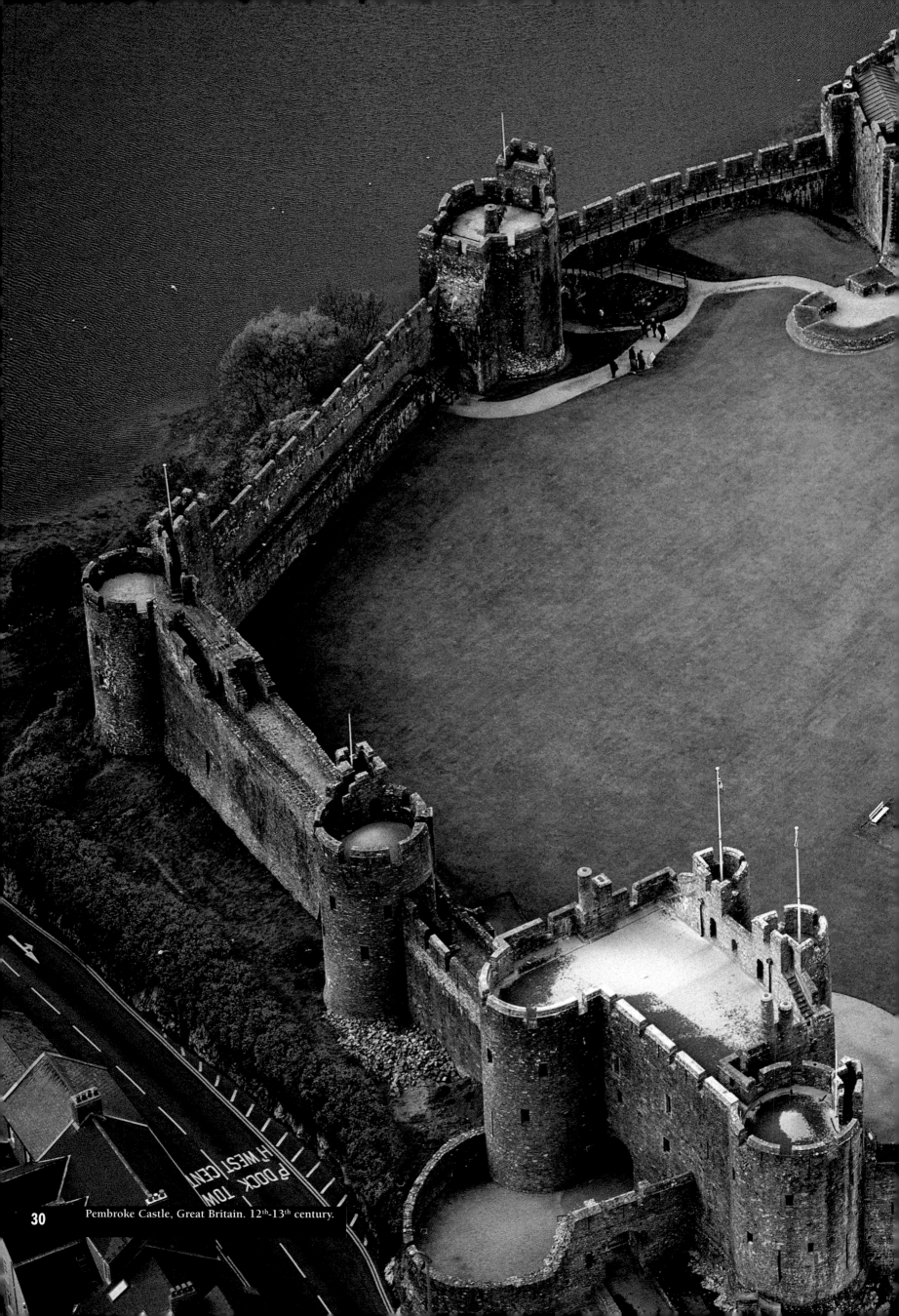

Pembroke Castle, Great Britain. 12th-13th century.

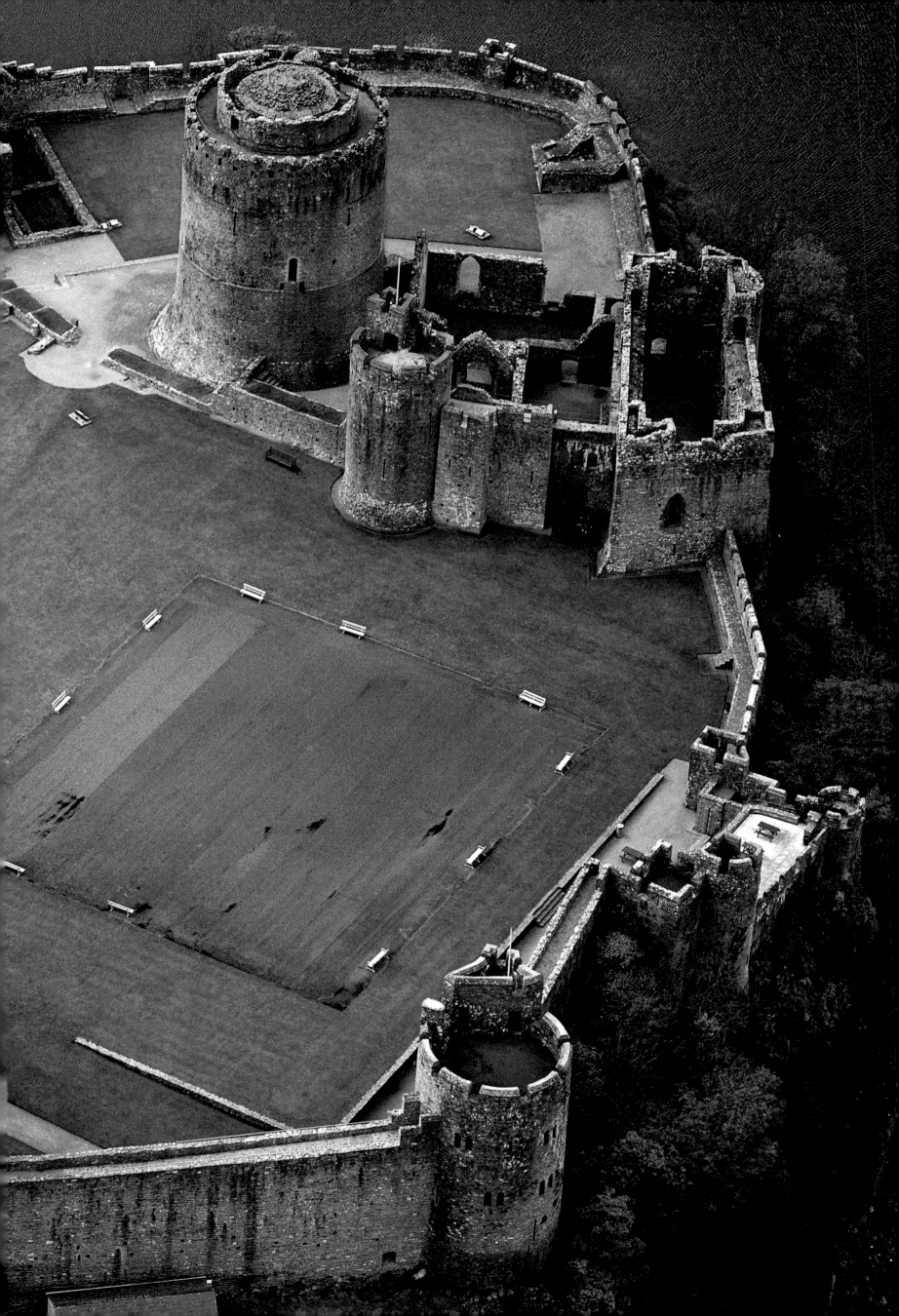

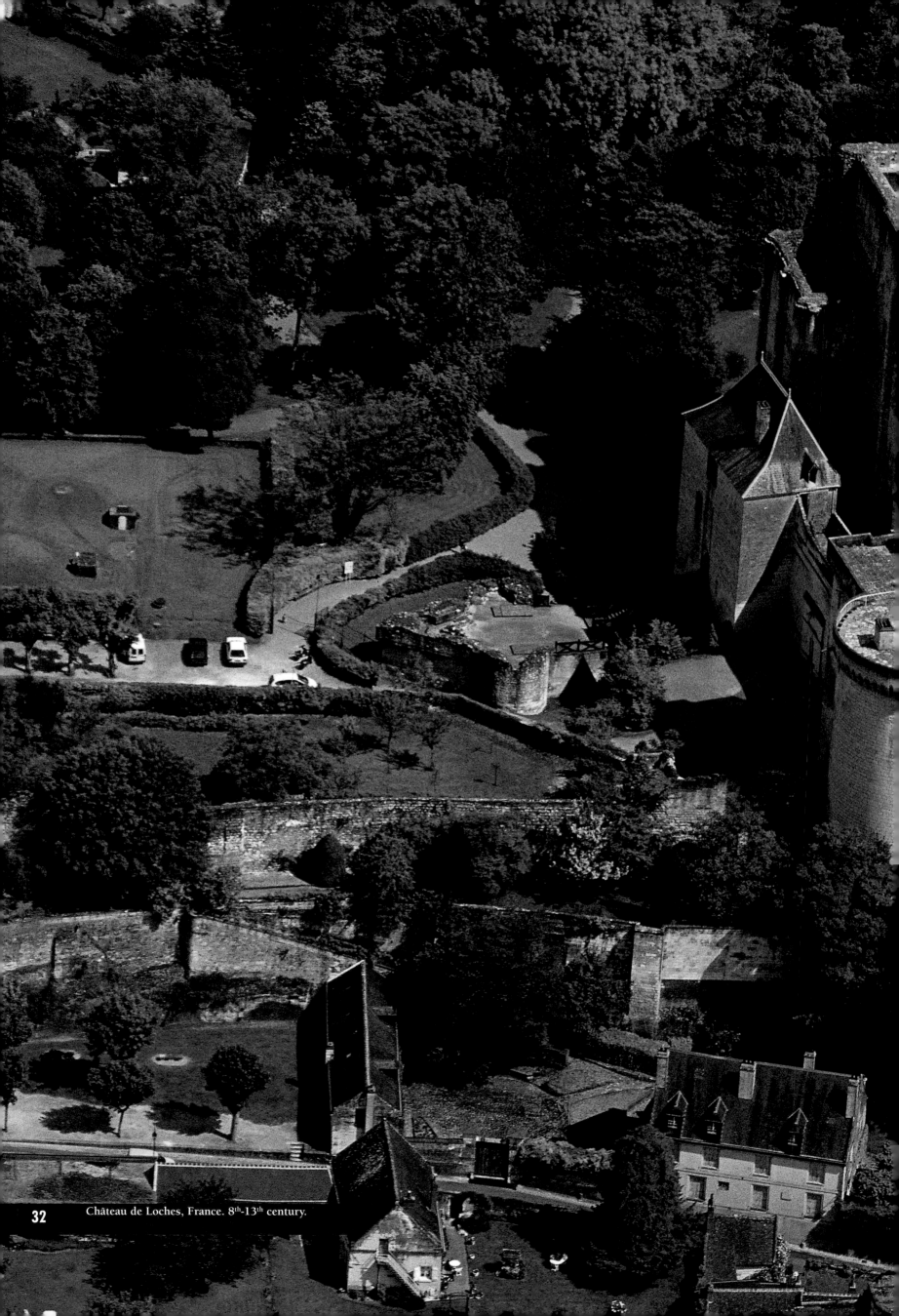

Château de Loches, France. 8th-13th century.

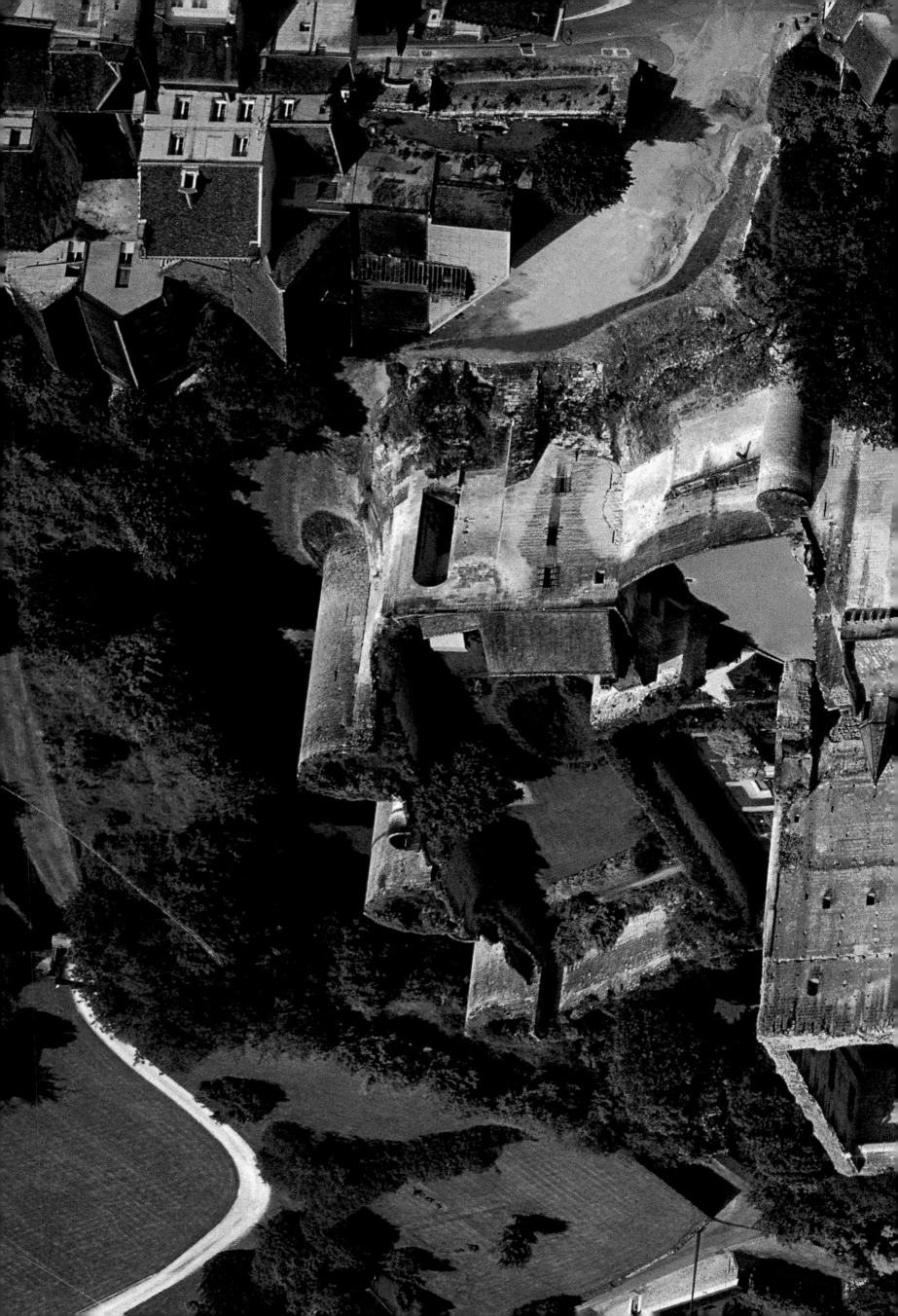

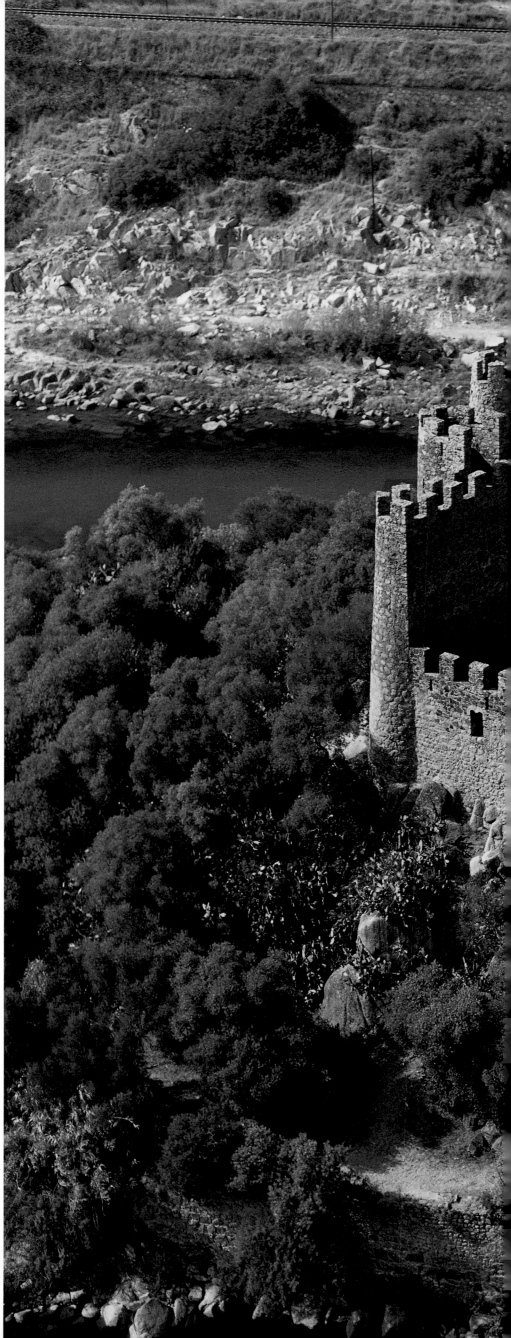

Castello del Volterraio, Portoferraio, Italy. 11th century.

Military garrisons

The photographs that follow document the style of castle built as a garrison by local powers to control the surrounding territory. They are compact structures with high protective walls and towers, and are made more inaccessible by the nature of their site. This page shows the ruins of the Castello del Volterraio, on the Island of Elba, built by the Pisans in the eleventh century. A not very convincing legend attributes its construction to the Etruscans from the city of Volterra. The photograph on the right shows the castle of Almourol, in Portugal, on the banks of the Tagus, erected by the Templars, the religious crusading order, in the second half of the twelfth century, when the Arabs were being progressively expelled from the Iberian Peninsula.

Castelo de Almourol, Portugal. 12th century.

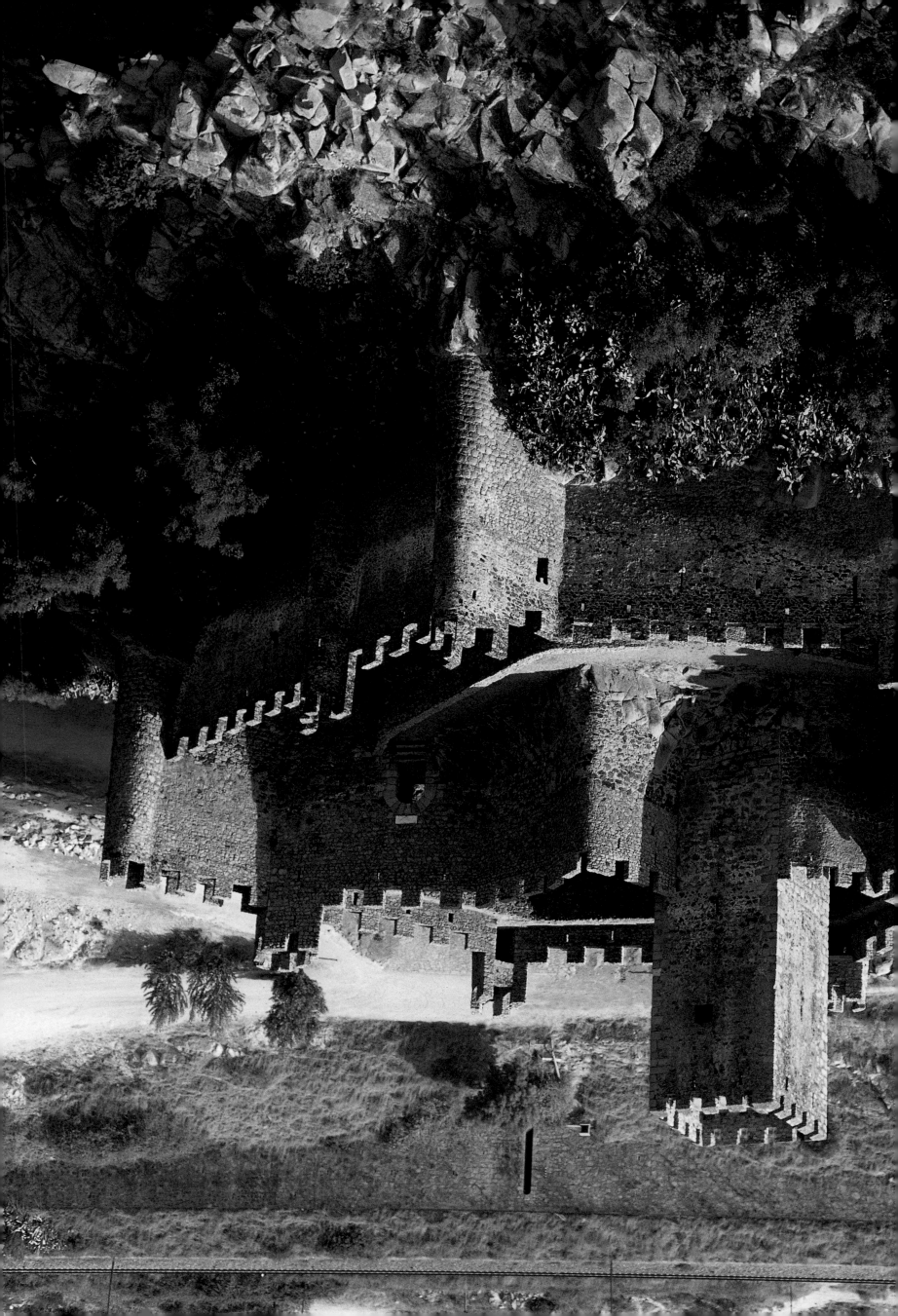

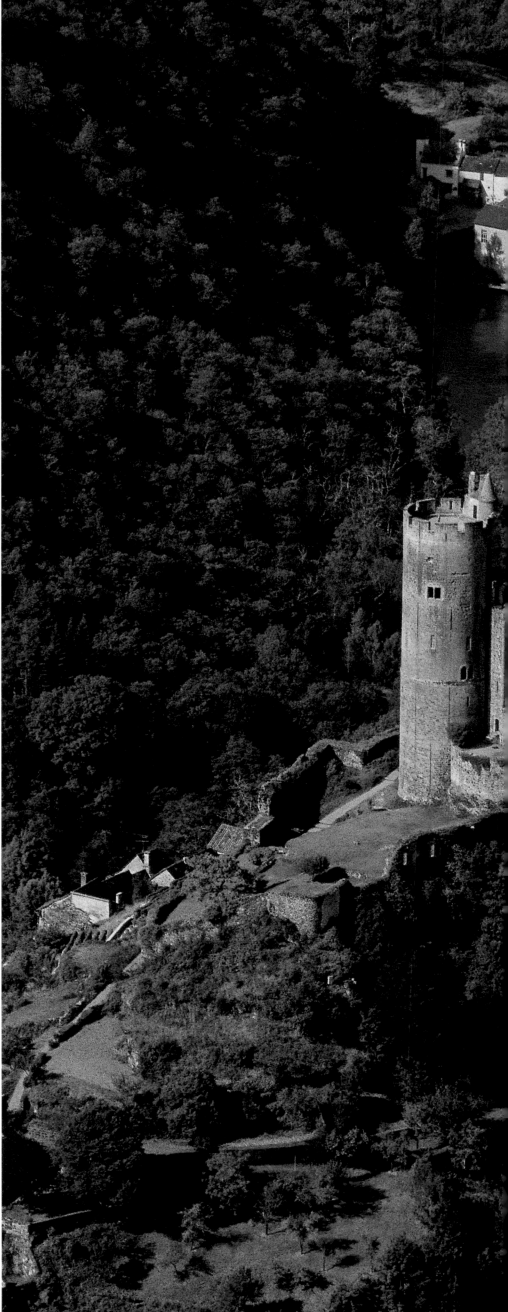

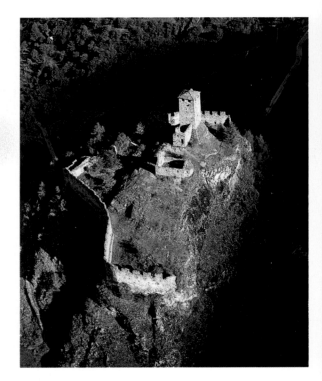

Castello di Graines, Italy. 12th century.

Mountain garrisons

The castle of Najac, in the Aveyron (France), was built shortly after 1200. It consists of a compact group of buildings surrounded by high walls with circular towers. It was built at the same time as the village below it, and was to guarantee its security and government. It is a typical example of what we now consider the medieval castle to have been: shut in and threatening.

This type of castle is mainly to be found in mountainous regions, and many other examples survive, for example the Castello di Graines, in the Ayas valley (Italy), and the castle in Rovereto, Italy, known as Castel Veneto, both built high above a valley to bar the way to invading armies, bands of brigands and other undesirable visitors. Graines was obviously planned and built in a single campaign whereas Castel Veneto consists of a group of buildings erected between the fourteenth and sixteenth centuries.

Château de Najac, France. 13th century.

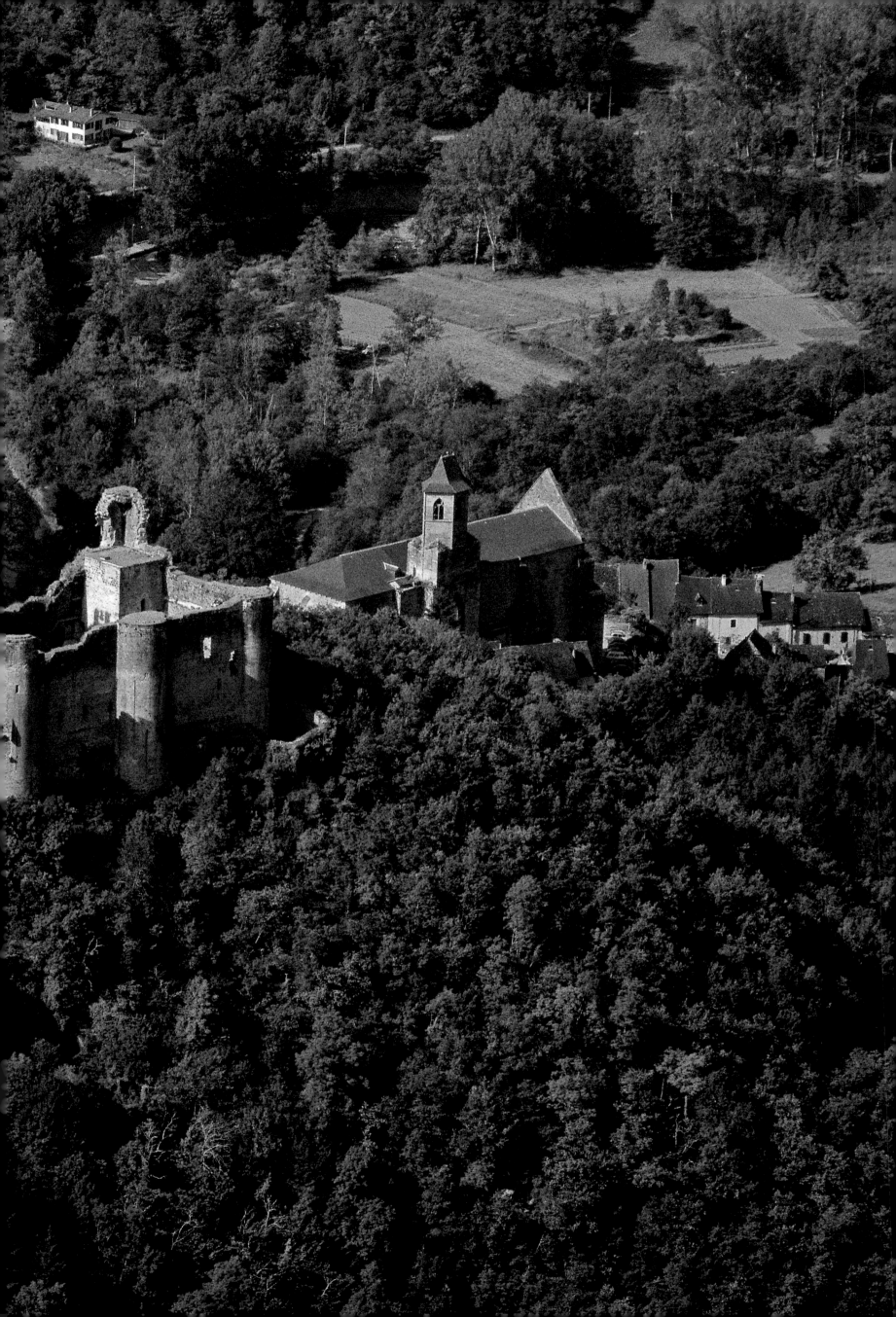

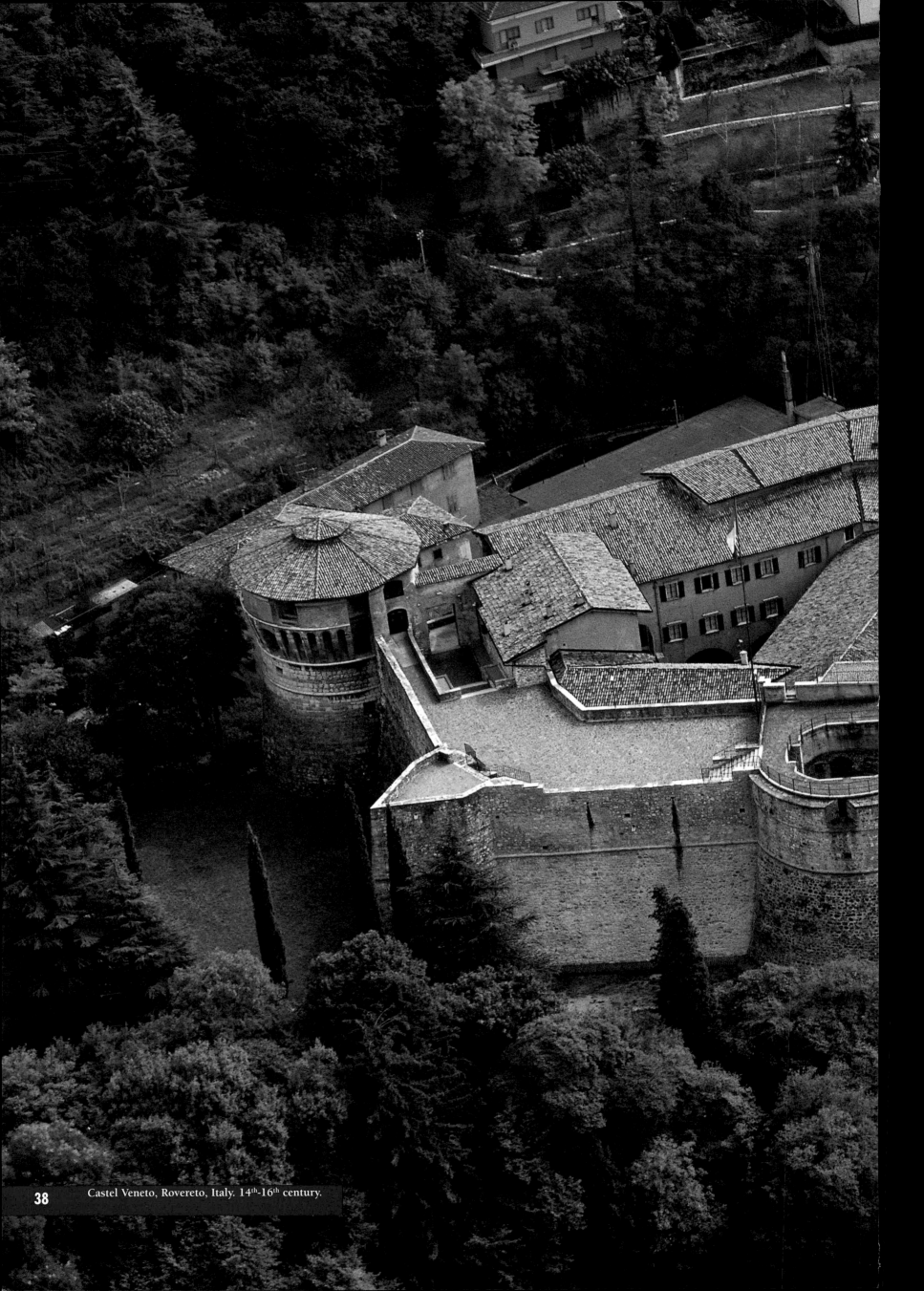

Castel Veneto, Rovereto, Italy. 14th-16th century.

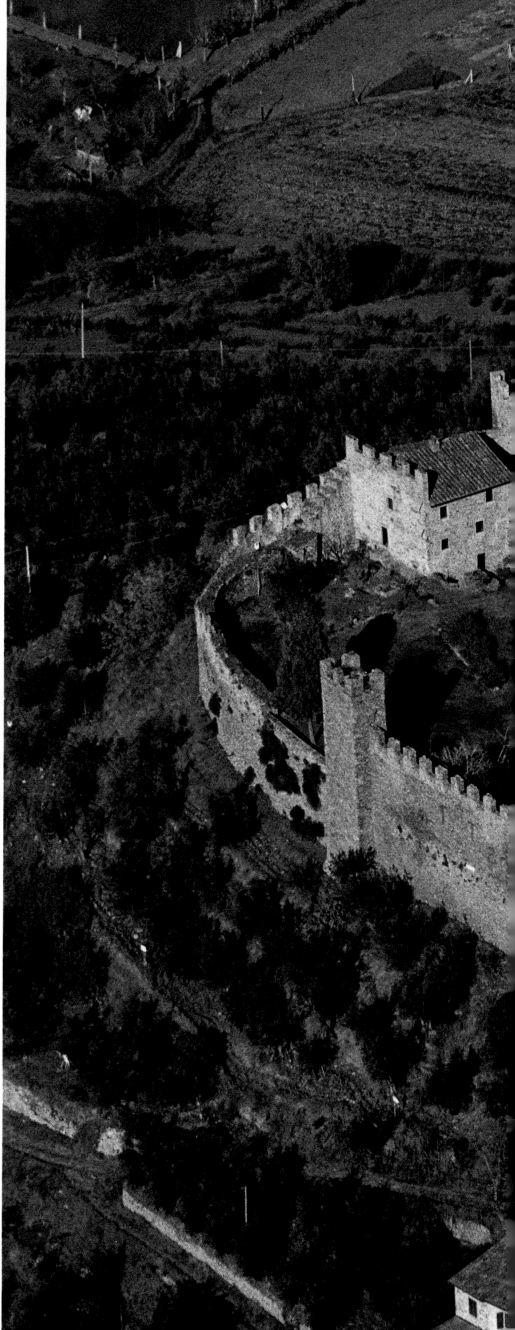

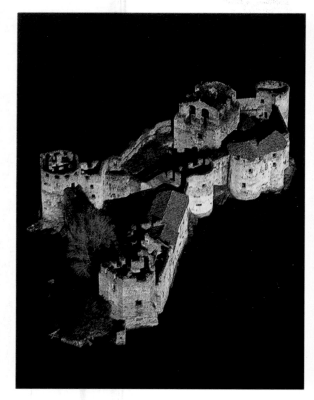

Castello di Cannero, Italy. 13ᵗʰ-15ᵗʰ century.

Continuity of design

Old models lingered, influencing castle architecture well into the fourteenth century, particularly in Italy; the same happened in cathedral architecture, when Romanesque traditions put up a strong resistance to the innovative construction methods of Gothic art. In some cases, as at Cannero on Lake Maggiore, the backward-looking architecture was a product of the circumstances: the present castle was built in the fifteenth century on the foundations of an earlier castle, dating from the twelfth century and destroyed in 1414 by the Viscontis from Milan as a punishment for its former owners for their devotion to brigandage. In other cases, as for example Montecchio Maggiore (Vicenza), with its echoes of Shakespeare, the fourteenth-century enclosure follows the original plan implicitly, with a few liberties taken with the design of the tall tower and walls.

These are examples of the survival in particular circumstances of fashions long superseded by history and technology; as if their owners were clinging to the certainties of tradition for reasons of economy or nostalgia.

Castello di Montecchio Maggiore, Italy.
14ᵗʰ century.

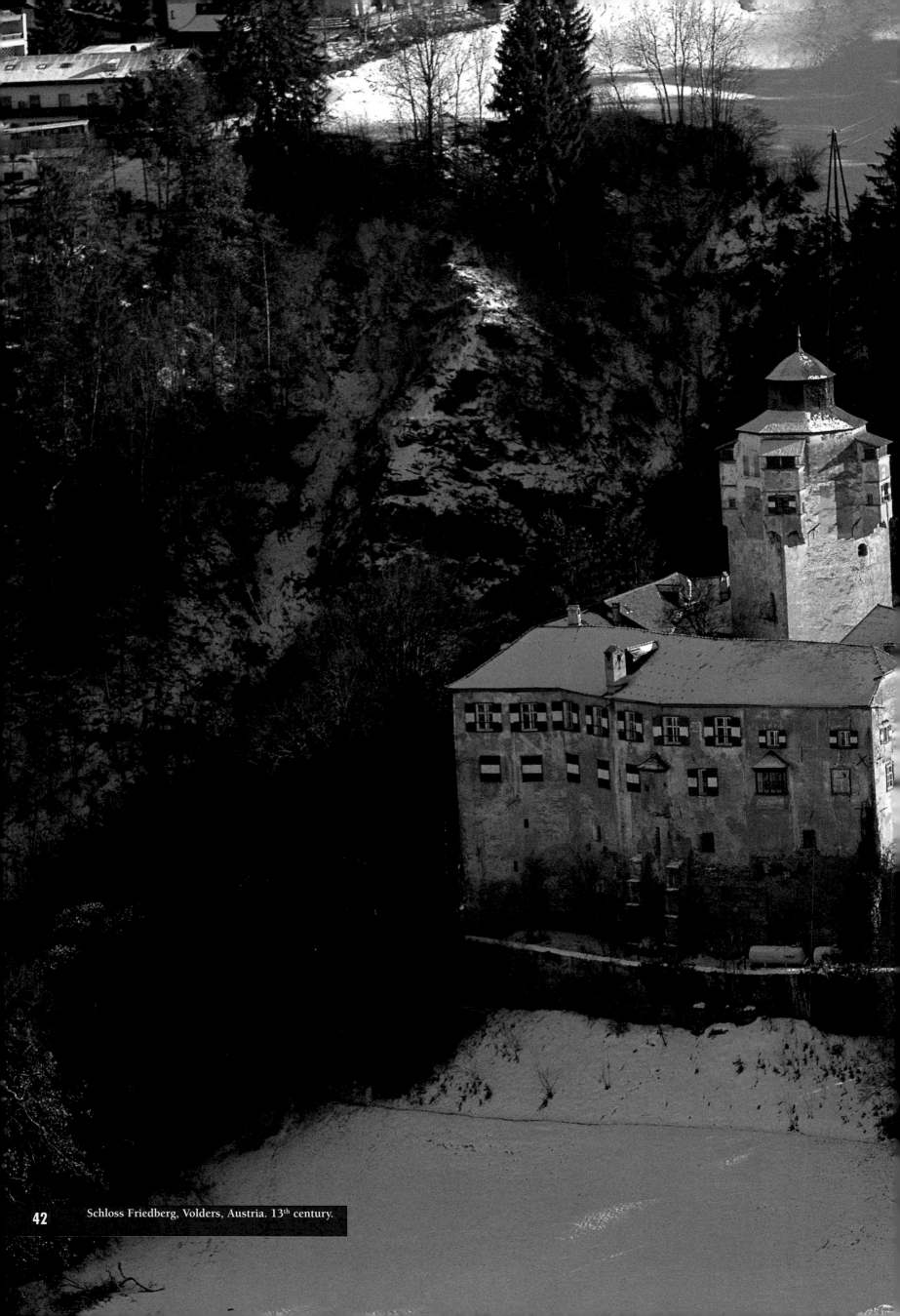

Schloss Friedberg, Volders, Austria. 13th century.

The golden age of the castle

The age of the castle

Between 1240 and 1250, Frederick II of Hohenstaufen, King and Emperor, ordered the building of the massive Castel del Monte (Italy), a landmark in the history of architecture. The castle was designed as a temporary residence (possibly for hunting expeditions); it was enclosed in a complex shell of fortifications by means of which Frederick hoped to guarantee his control of the Empire, particularly against those keen to challenge the legitimacy of his power. Castel del Monte is a building in which styles merge to perfection: the austere monumentality of Norman Romanesque, the structure and design quality of Gothic engineering and an adherence to formal unity which belongs to the classical world, as it was understood at the time. Some historians claim that the emperor himself drew up the general outline of the plan.

Between the twelfth and the thirteenth century the personal involvement of the architect in the design of a building became more marked, and this led to the development of different styles and forms which aimed to suggest the idea of perfection – a balance to which nothing could be added and nothing taken away without disturbing it. Buildings erected after the thirteenth century therefore were much less suited to enlargement or the addition of extensions. This means that important buildings have tended to either survive in their original form, or to have undergone complete rebuilding. Sometimes the original layout has been preserved, sometimes it has vanished without trace. The technical advances of the Gothic age provided a whole series of new building solutions, and also made possible complex and varied ways of joining structures together, through the study of static equilibrium.

The development of the institutions of late mediaeval Europe ensured that castle architecture flourished: demographic growth contributed to the generation of a highly complex economy; increased productivity and burgeoning business enterprise produced ever increasing wealth. The role of the feudal nobility within the hierarchy was becoming more settled, bringing with it well-defined fiscal and administrative obligations towards the central powers, which while limiting the independence of the nobility, increased its prestige and authority. The tendency was to create very large territorial holdings under royal patronage; as well as producing the first embryonic versions of some of today's modern nations.

In these regions, mainly Italy, France, the Iberian Peninsula, Great Britain and the German speaking countries of the Holy Roman Empire, the development of the forms and styles of the castle, and the adoption of specific characteristic features could almost be said to add up to a series of "national" styles. The materials and skills available were important in this development, of course, but so also was the institutional role of the overlord and his military commitment to the security and stability of the territory.

In some cases, in France for example, it is clearly evident that the building's main function is no longer defensive, even though the formal features are still there.

Castello di San Pietro in Cerro, Italy. 15th century.

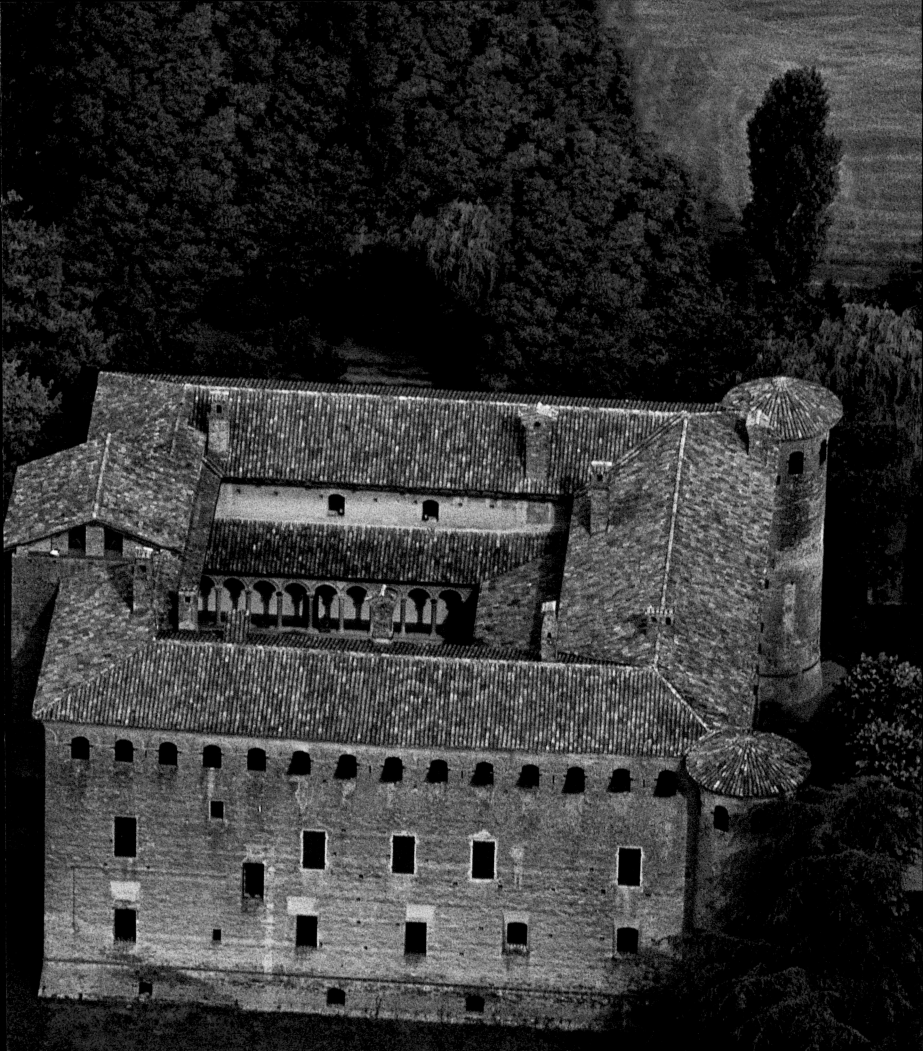

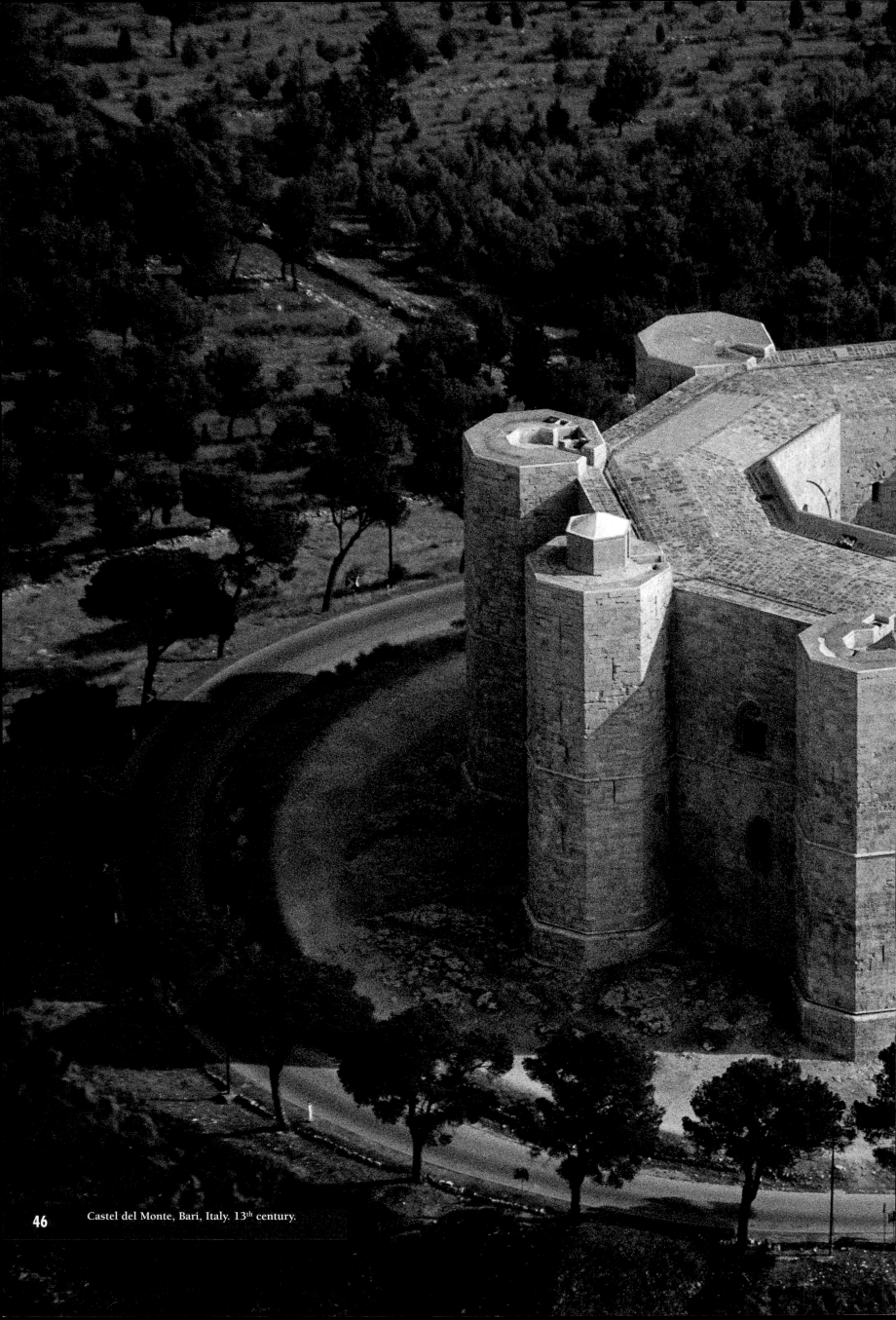

Castel del Monte, Bari, Italy. 13th century.

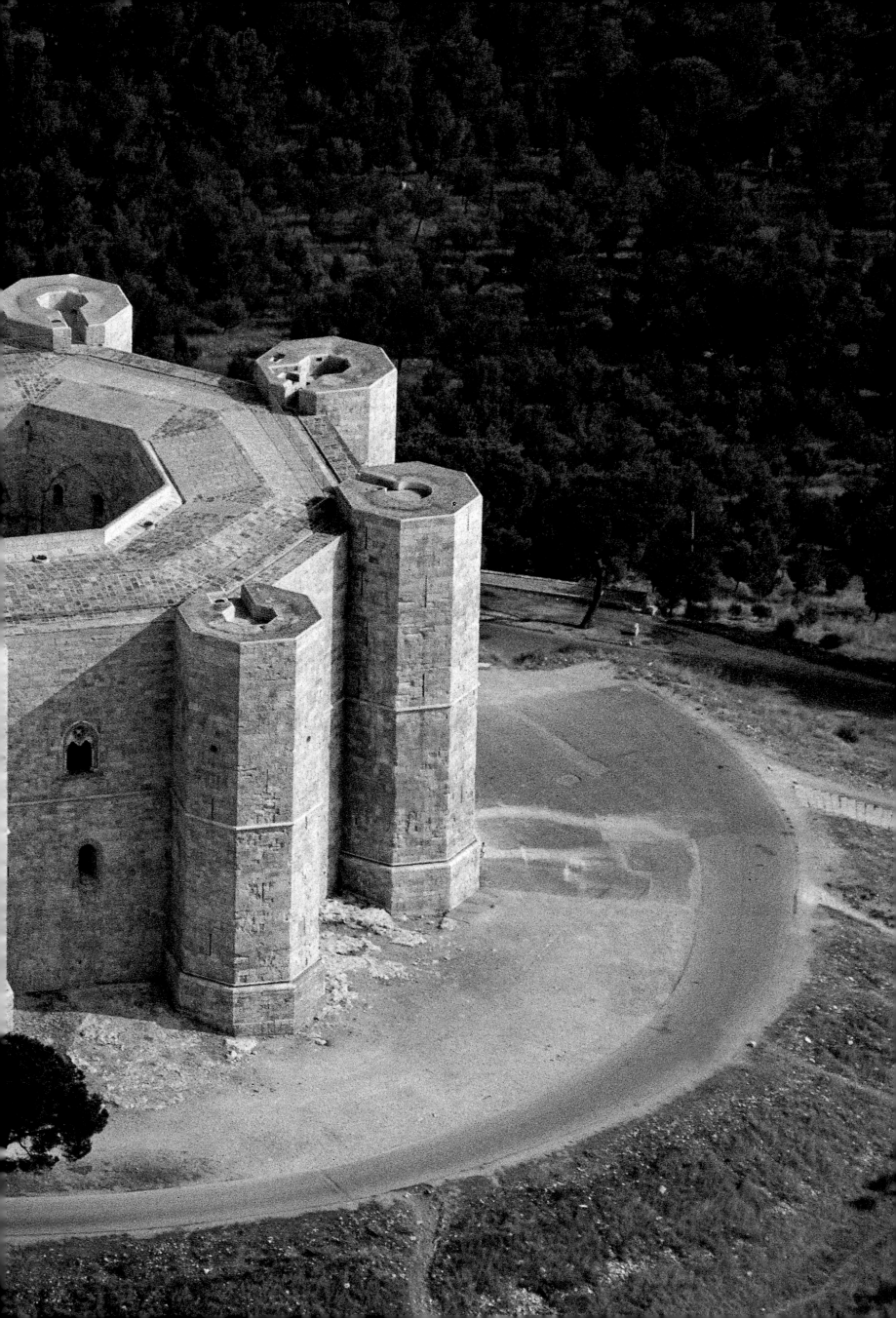

Italy

The *signorie* (seigniories) in Italy cannot be defined simply in terms of the feudal system, indeed they often seemed to be in direct competition with it. Some of them, particularly when established in cities with flourishing populations, imposed their own policies over the territory and this often required the construction of garrisons round about. This is probably the origin of the Castello di Sirmione, built in the thirteenth century, on the orders of Martino della Scala, Lord of Verona, to keep an eye on navigation on Lake Garda. An exceptional example, it consists of a dock surrounded by a wall with battlements and towers at the corners; there is only one small entrance for ships, and the landward side of the castle is protected by moats and tall towers. Also on Lake Garda, between the thirteenth and fourteenth centuries, the Scaligeri family built the Castello di Malcesine (see p. 60), sited threateningly on a rocky promontory in the northern part of the lake.

The type of castle which combines residential with defensive functions is well represented by the Castello di Fenis in the Aosta valley, built in about 1340 by the Challant family who were important members of the court of Savoia: a double wall tightly encloses a sturdy pentagonal building with numerous towers and keeps and a quadrilateral courtyard.

Other examples of this type can be found around Parma, where during the fourteenth and fifteenth centuries a complex system of castles was built to defend the city and the roads giving access to Liguria. The Rocca di Fontanellato also fits into this context: it was built in the fourteenth century by the Sanvitale family and transformed in the first half of the fifteenth century into an elegant Renaissance court – although the defensive walls remain.

One of the most celebrated of the castles around Parma, and one of the best preserved in the whole of Northern Italy, is Torrechiara. It was built between 1448 and 1460 in the valley of the river Parma, on the orders of Pier Maria Rossi, a former captain in the service of Maria Visconti. He managed to unite in one building the characteristics of an opulent Renaissance dwelling and a fortress, in a skilful synthesis of weighty size and regular formal detail. The Castello di Torrechiara has romantic associations: Rossi lived there for years with his lover, Bianca Pellegrini d'Arluno.

In Bellinzona, in what is now the Italian-speaking part of Switzerland, the ancient castle of Sasso Corbaro was built on the site of an older tower, part of the city's complex defence system: a watchtower to defend the duchy's estates.

Castello di Sirmione, Italy. 13th century.

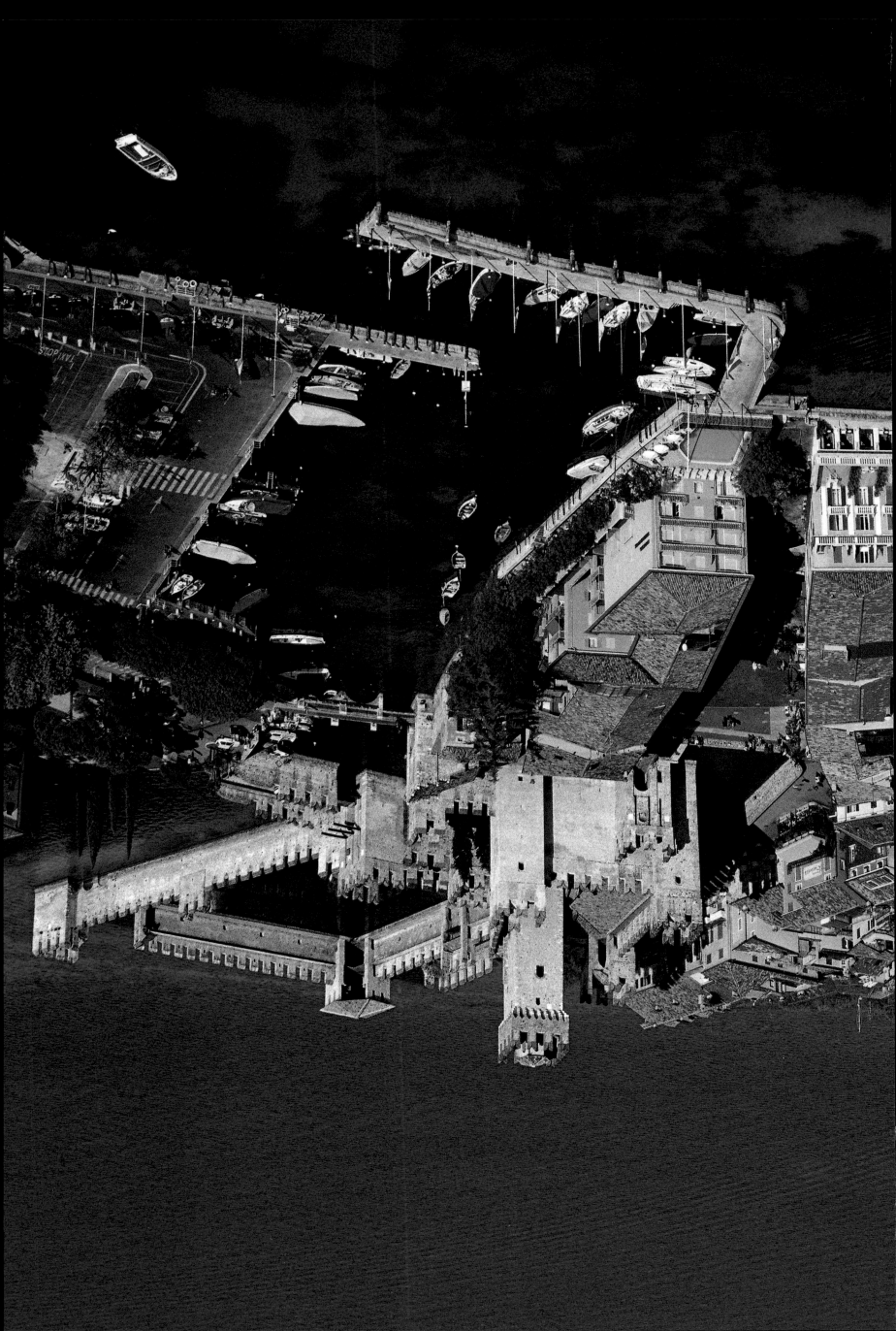

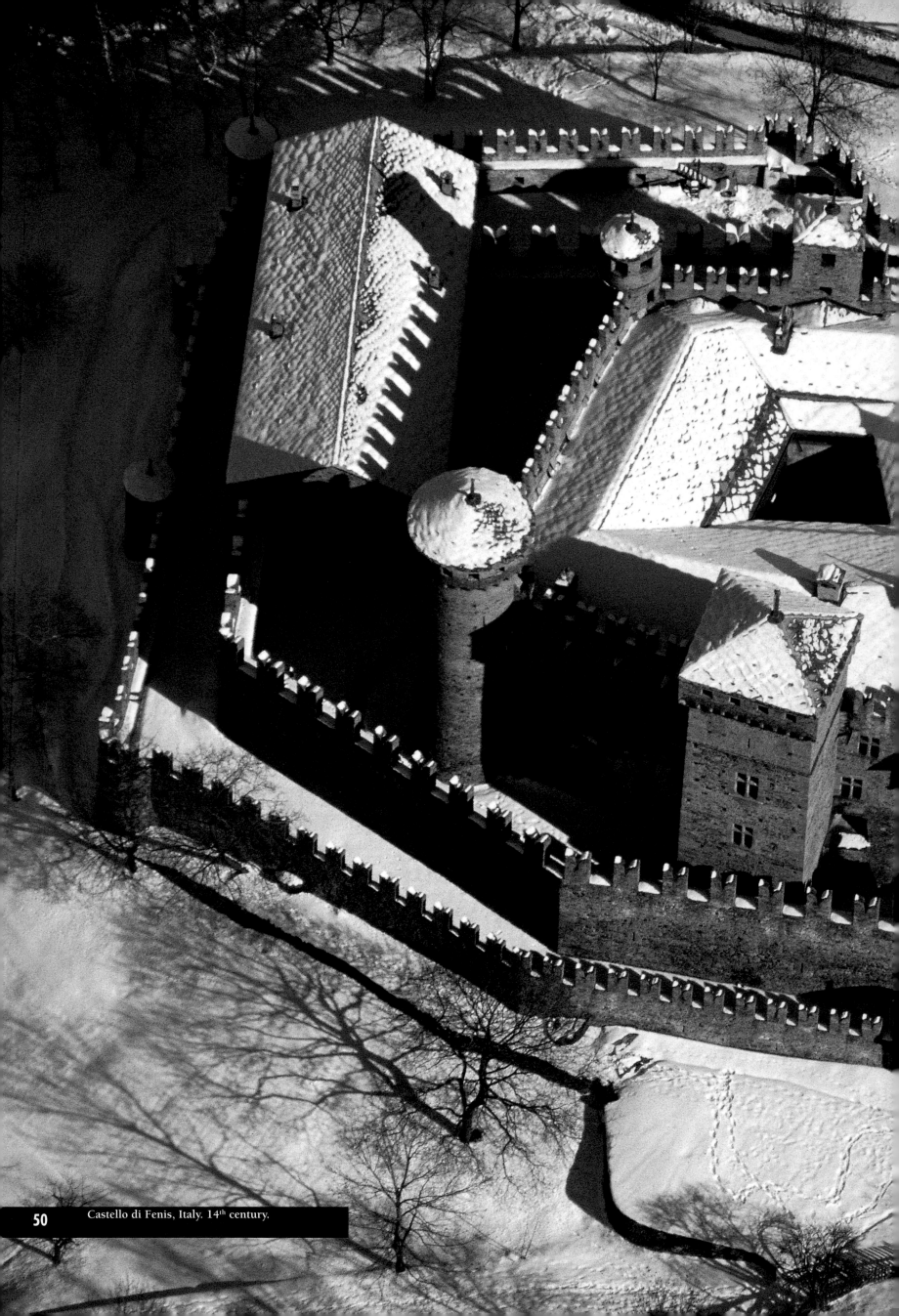

Castello di Fenis, Italy. 14th century.

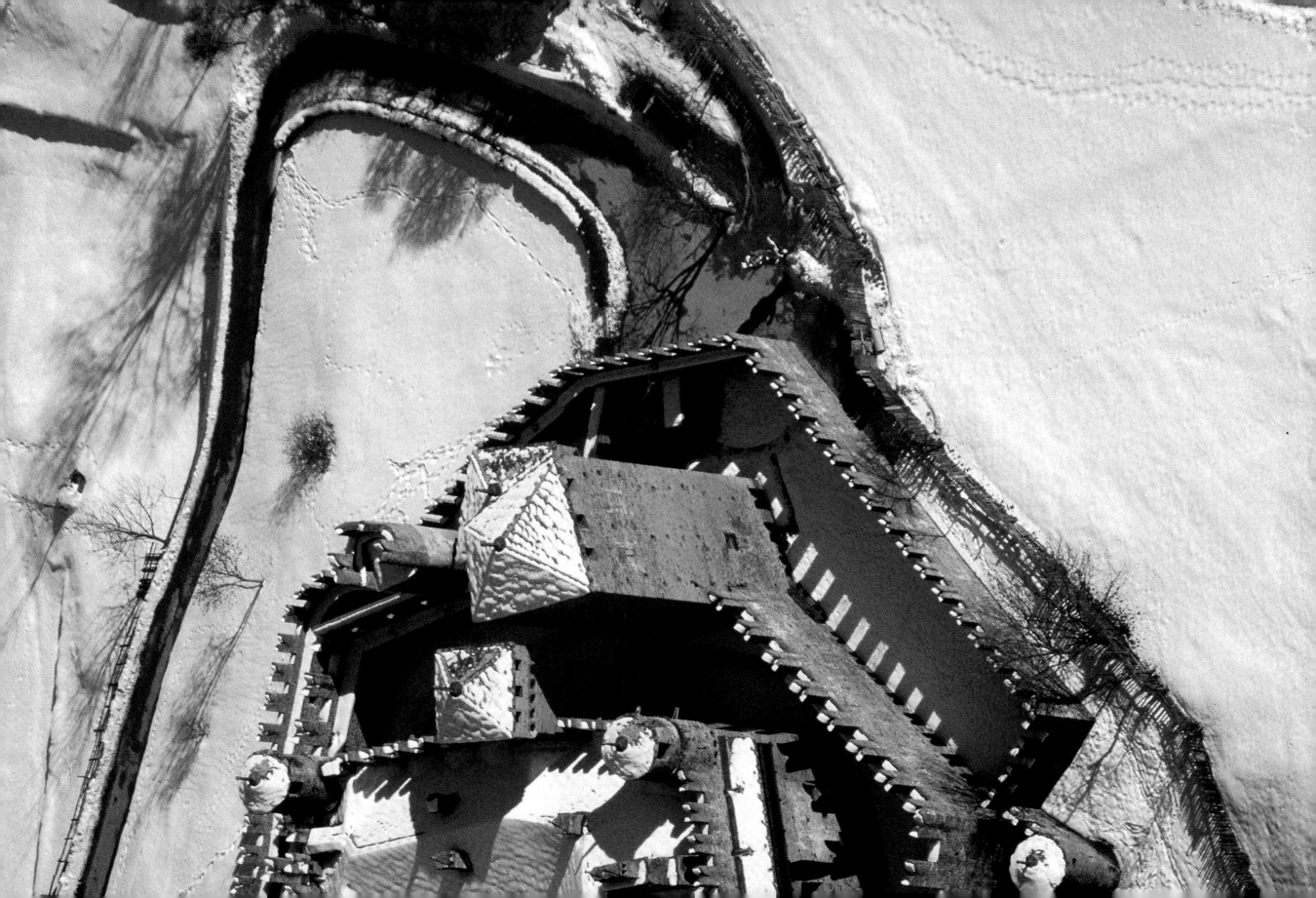

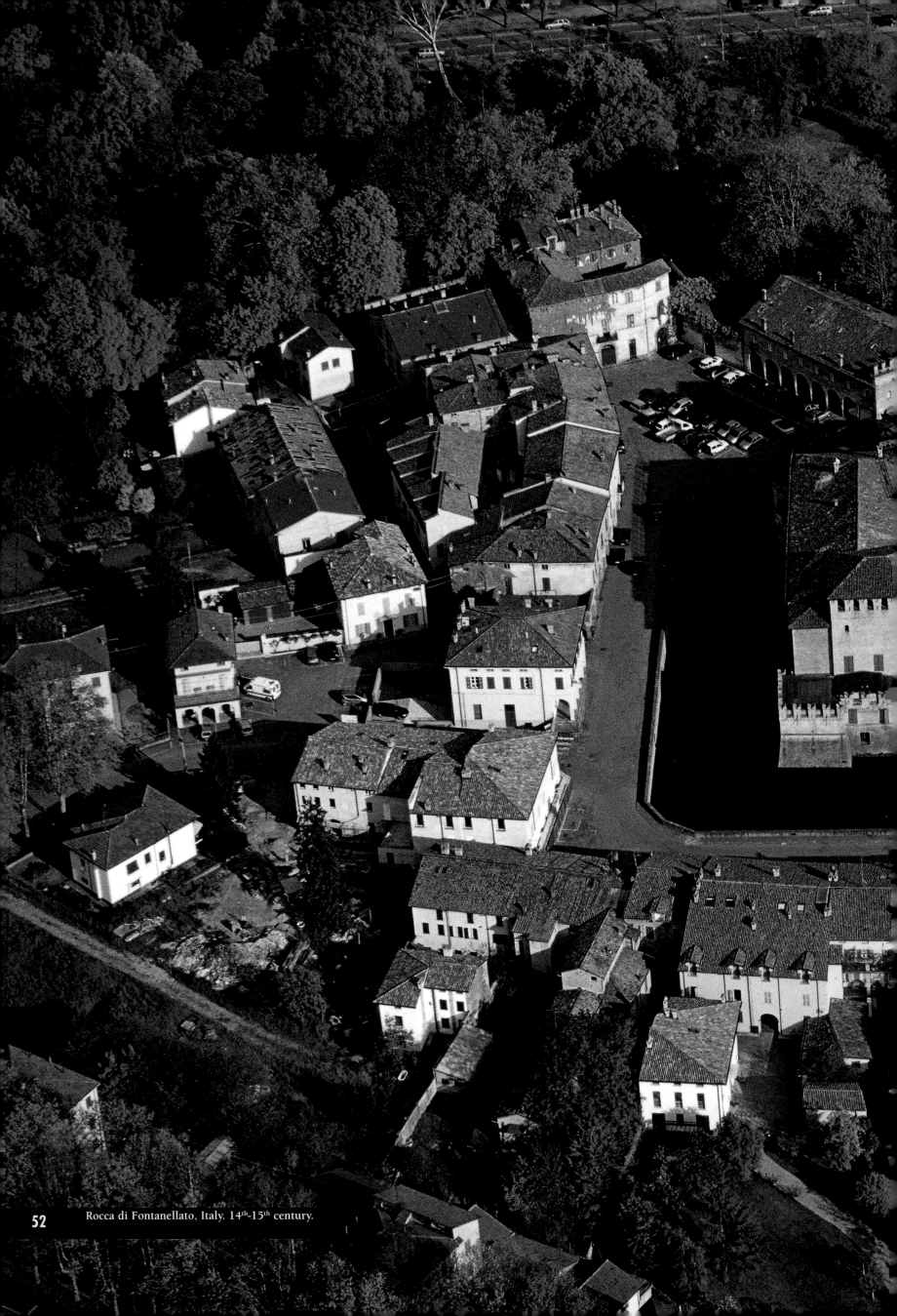

Rocca di Fontanellato, Italy. 14th-15th century.

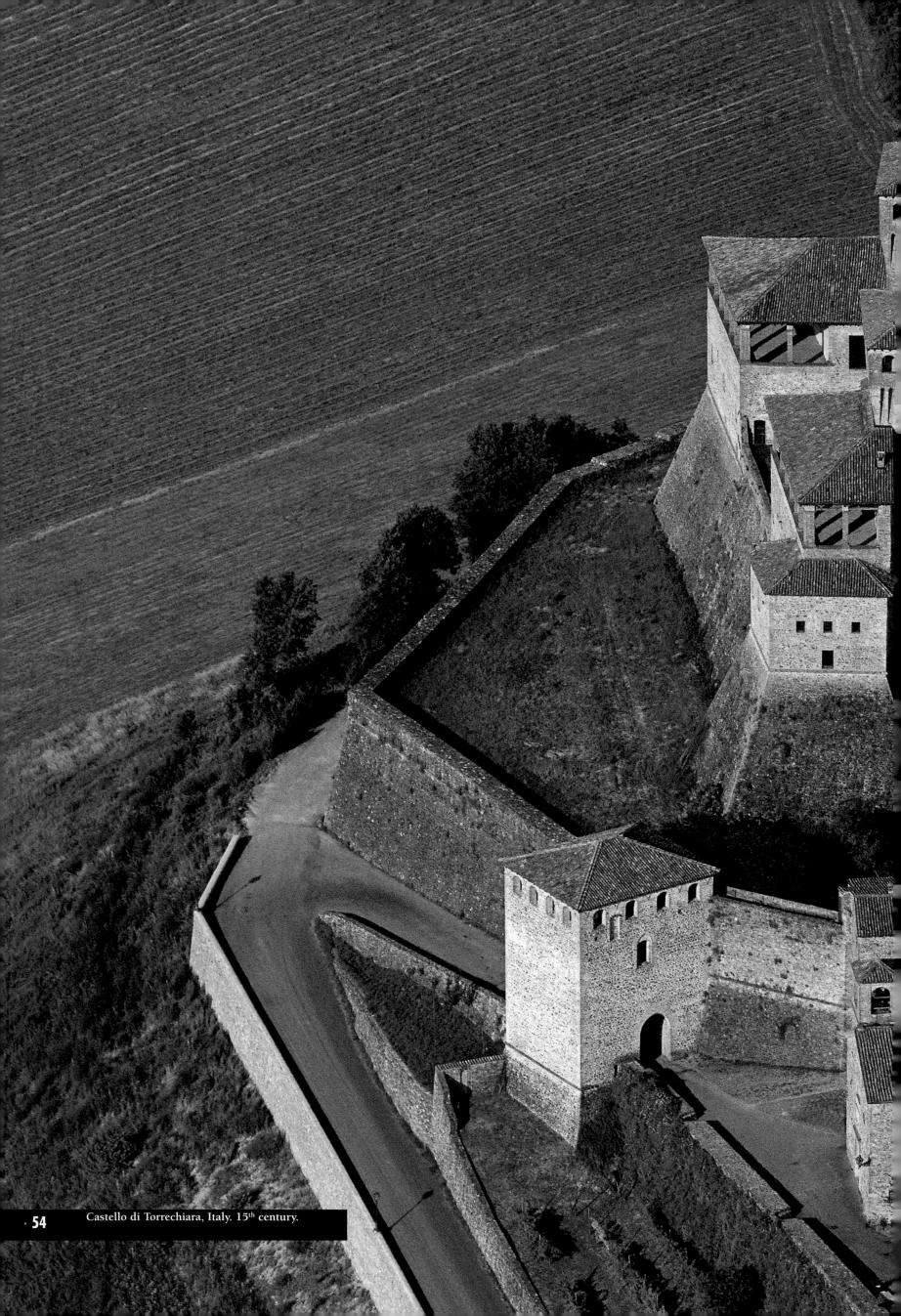
Castello di Torrechiara, Italy. 15th century.

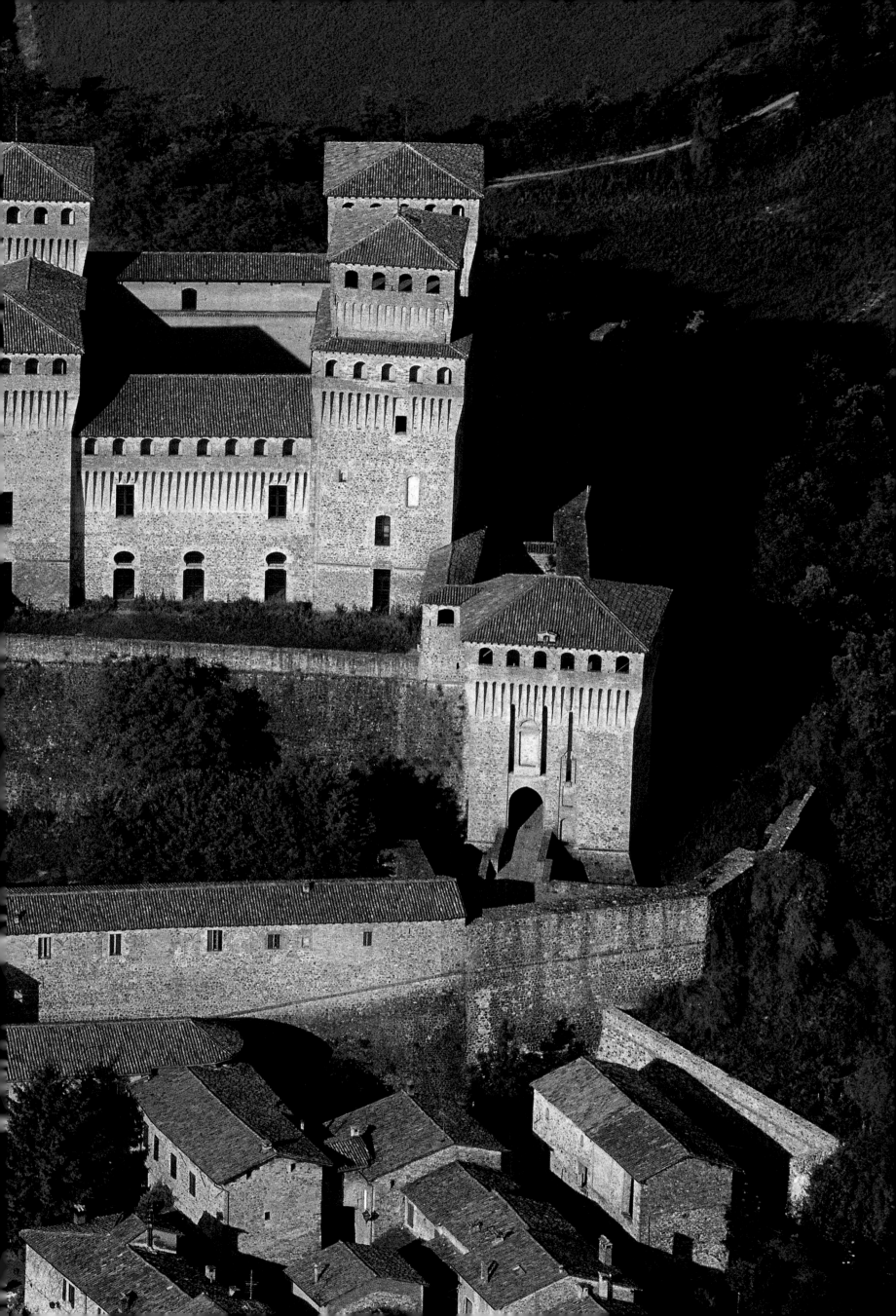

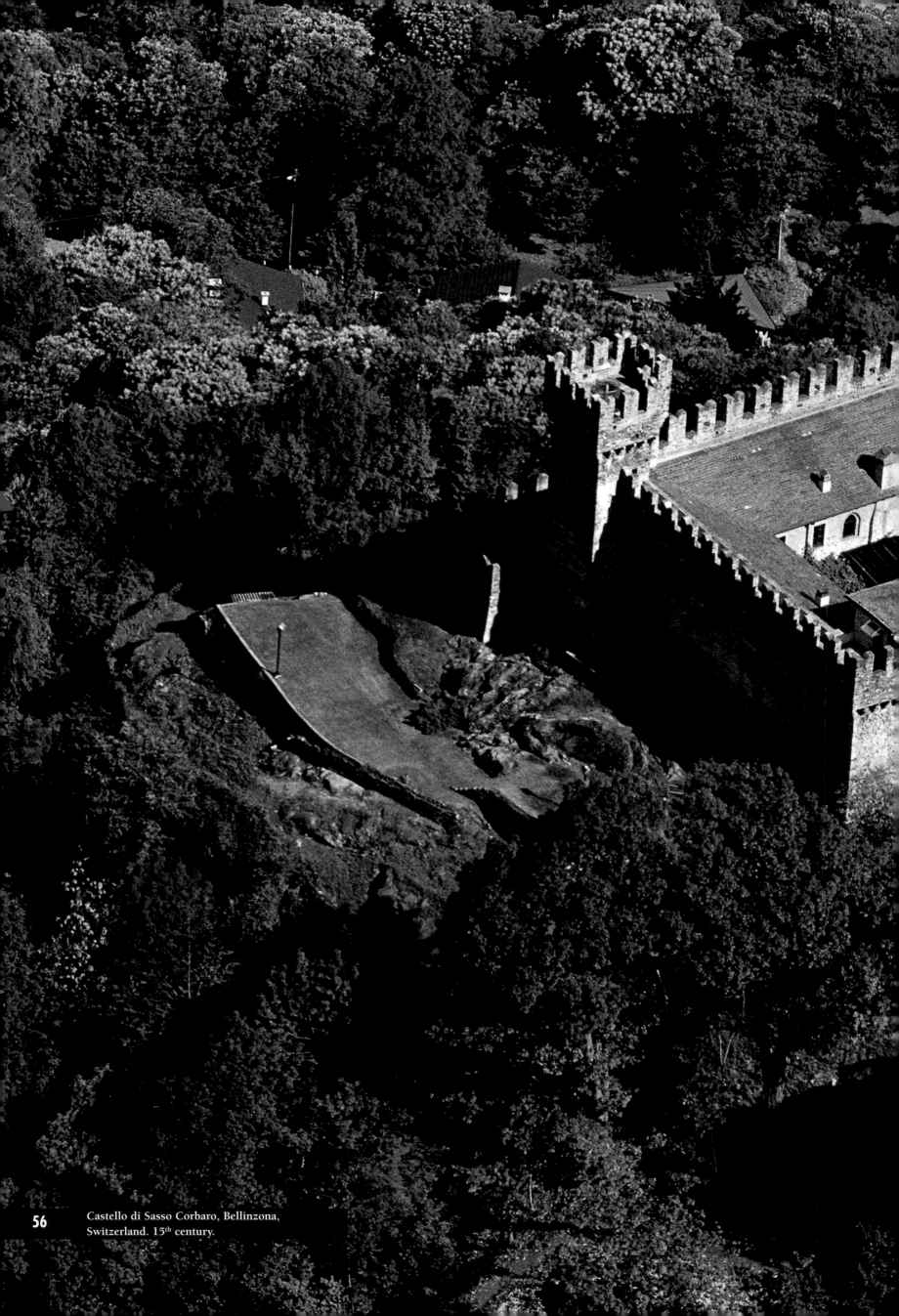

Castello di Sasso Corbaro, Bellinzona,
Switzerland. 15th century.

Some other examples

The Castello di Montisola was built in the early years of the fifteenth century around an older cylindrical tower (unusual in mediaeval Lombardy, where rectangular towers were preferred); it is a fine example of a minor residence, a real manor house in the true sense of the word. Like so many others, it bears witness to the endless variety of Italian castles. Also very individual are the massive Castello di San Pietro in Cerro (see p. 45), the delicate Castello di Malcesine, perched above the waters of Lake Garda, and most notably the noble ruins of the Aragonese castle of Ischia. Dating from the second half of the fifteenth century the latter is built on the foundations of a much older fortress, on a small island containing other venerable buildings. Particularly interesting in this large group of buildings is the way in which the island's system of defences makes use of the rock formations surrounding it.

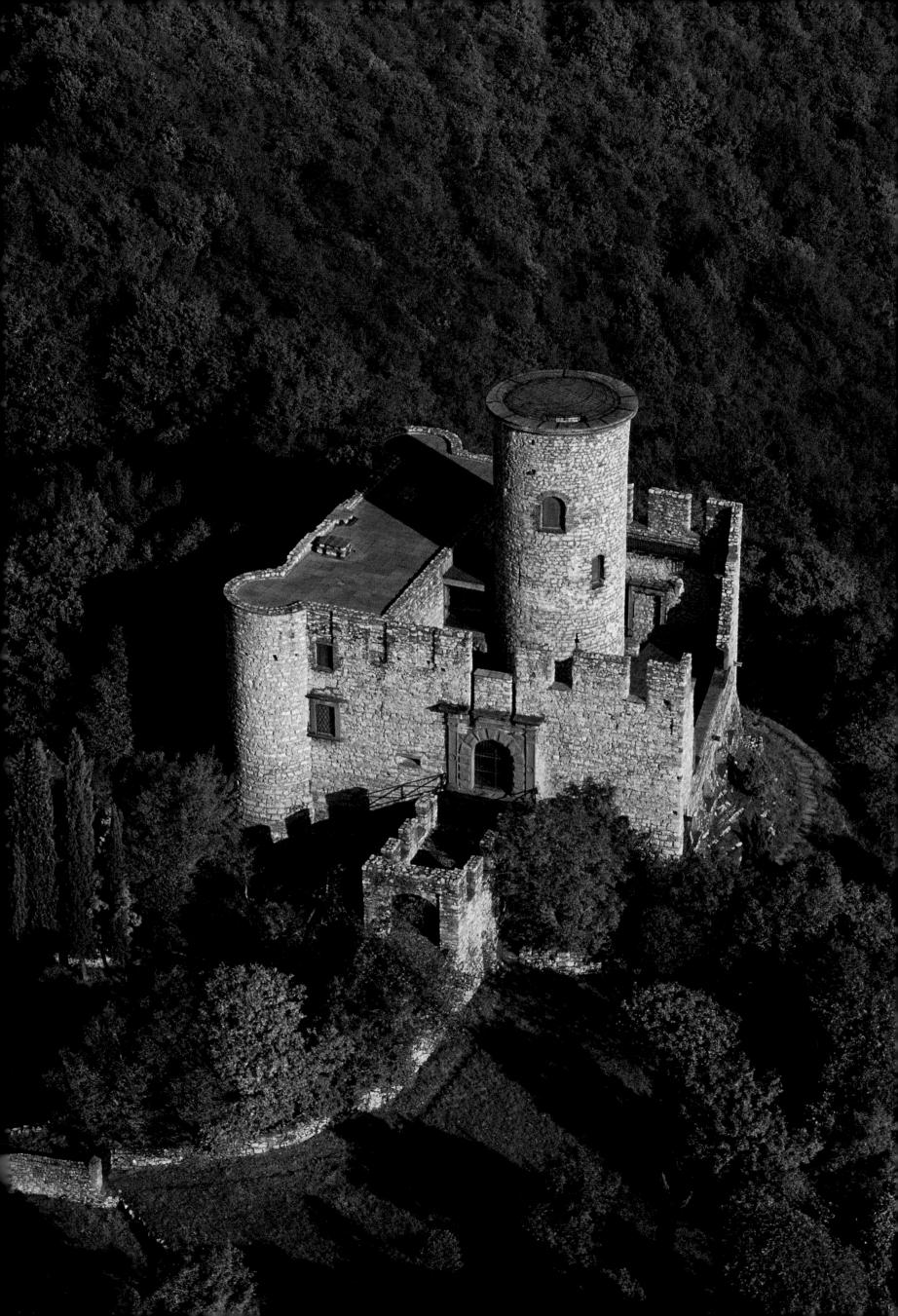

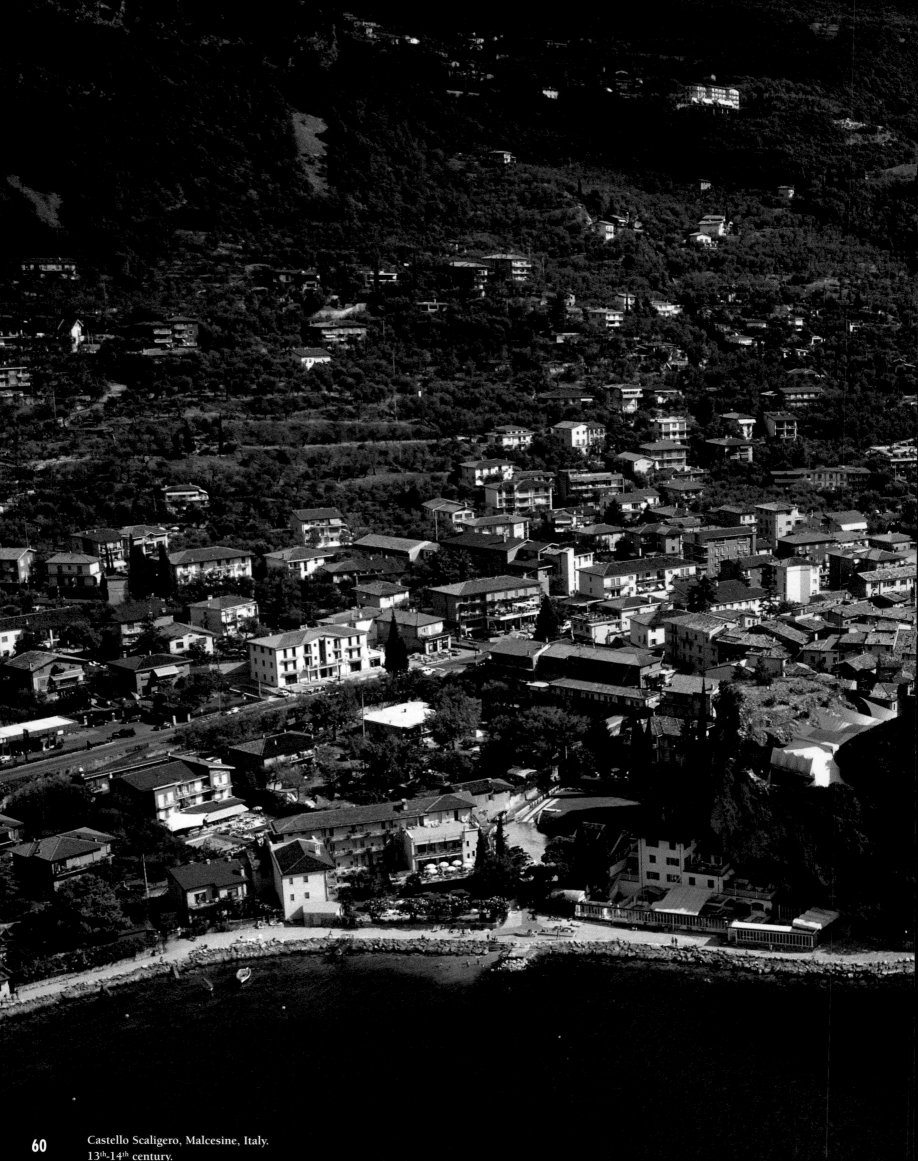

Castello Scaligero, Malcesine, Italy.
13th-14th century.

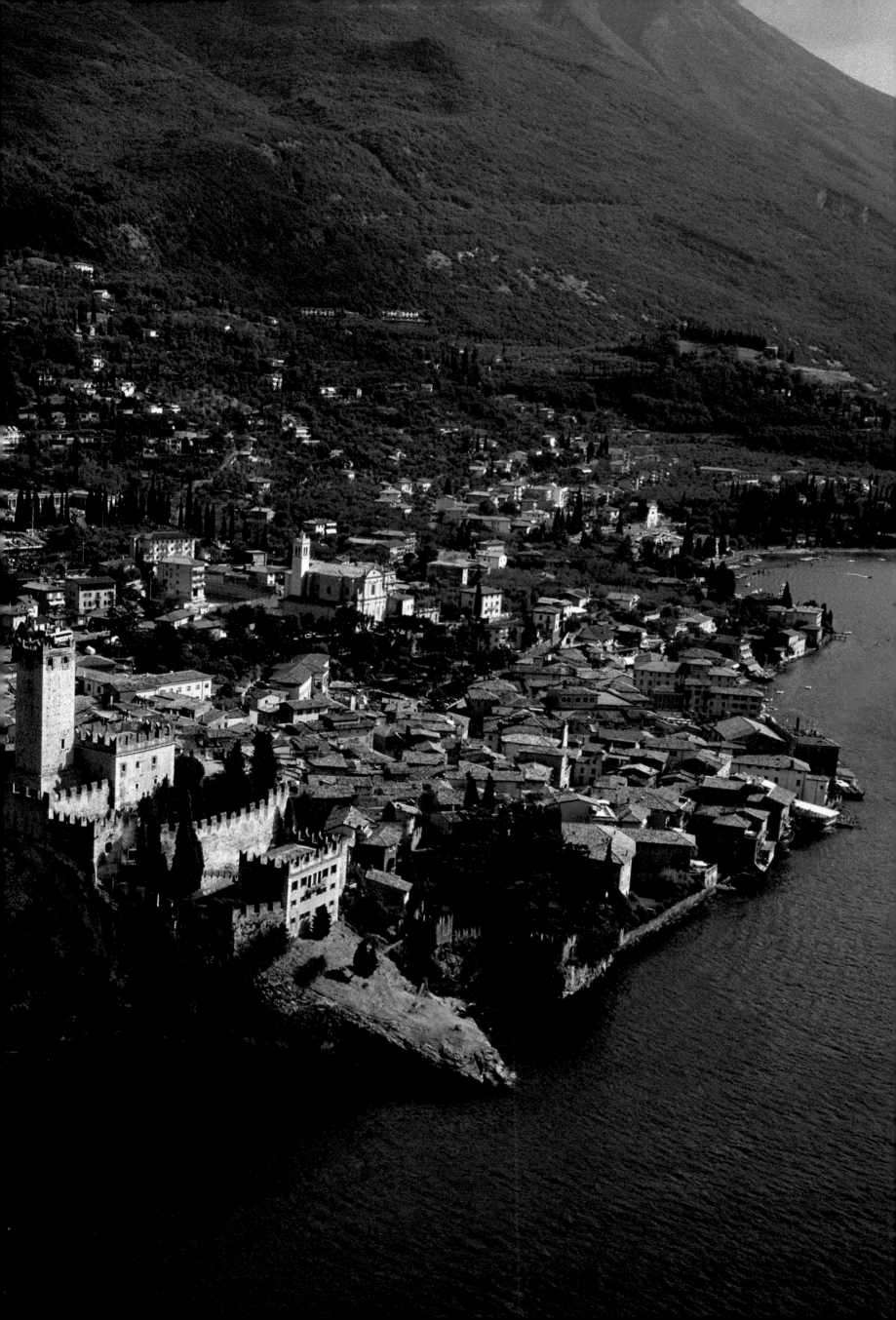

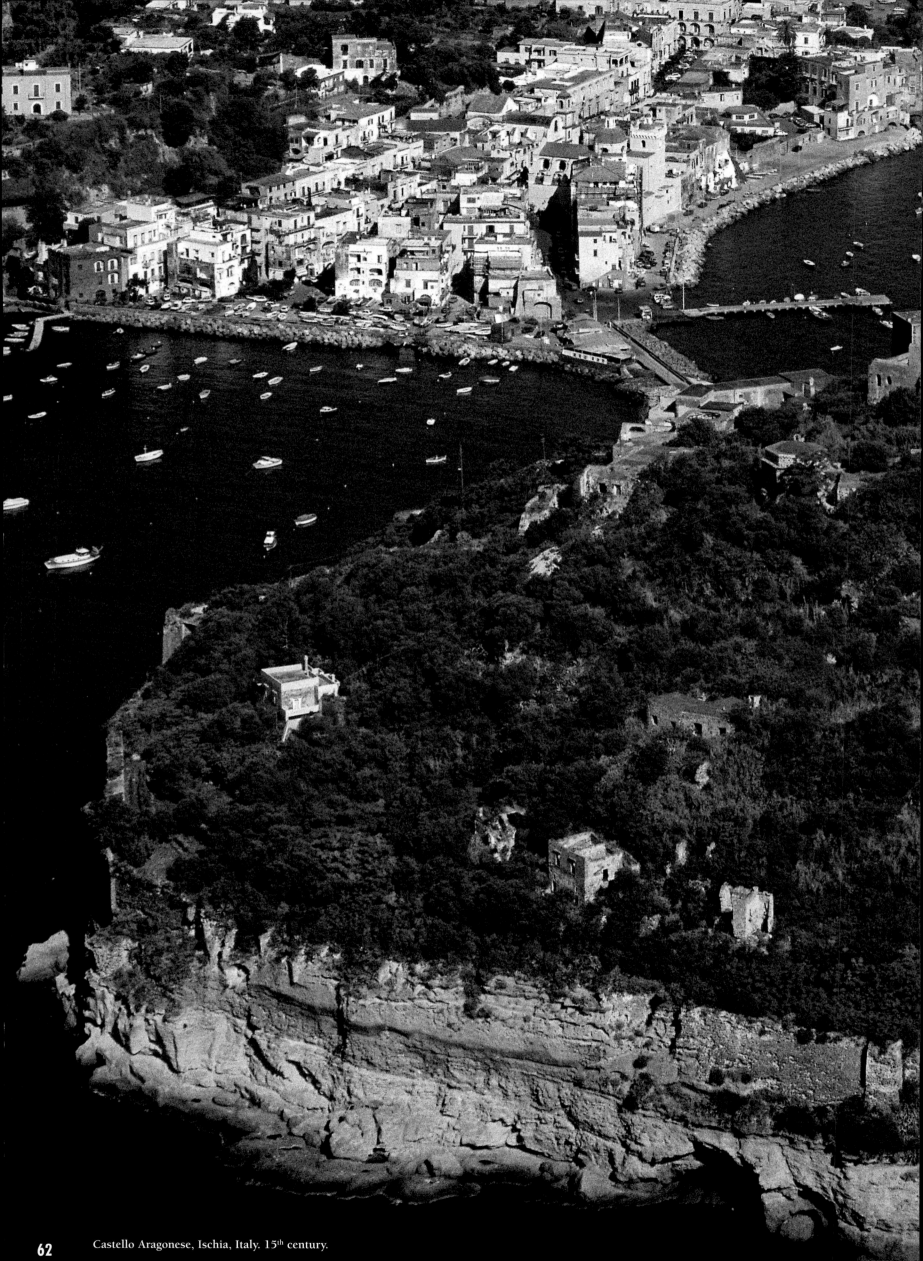

Castello Aragonese, Ischia, Italy. 15th century.

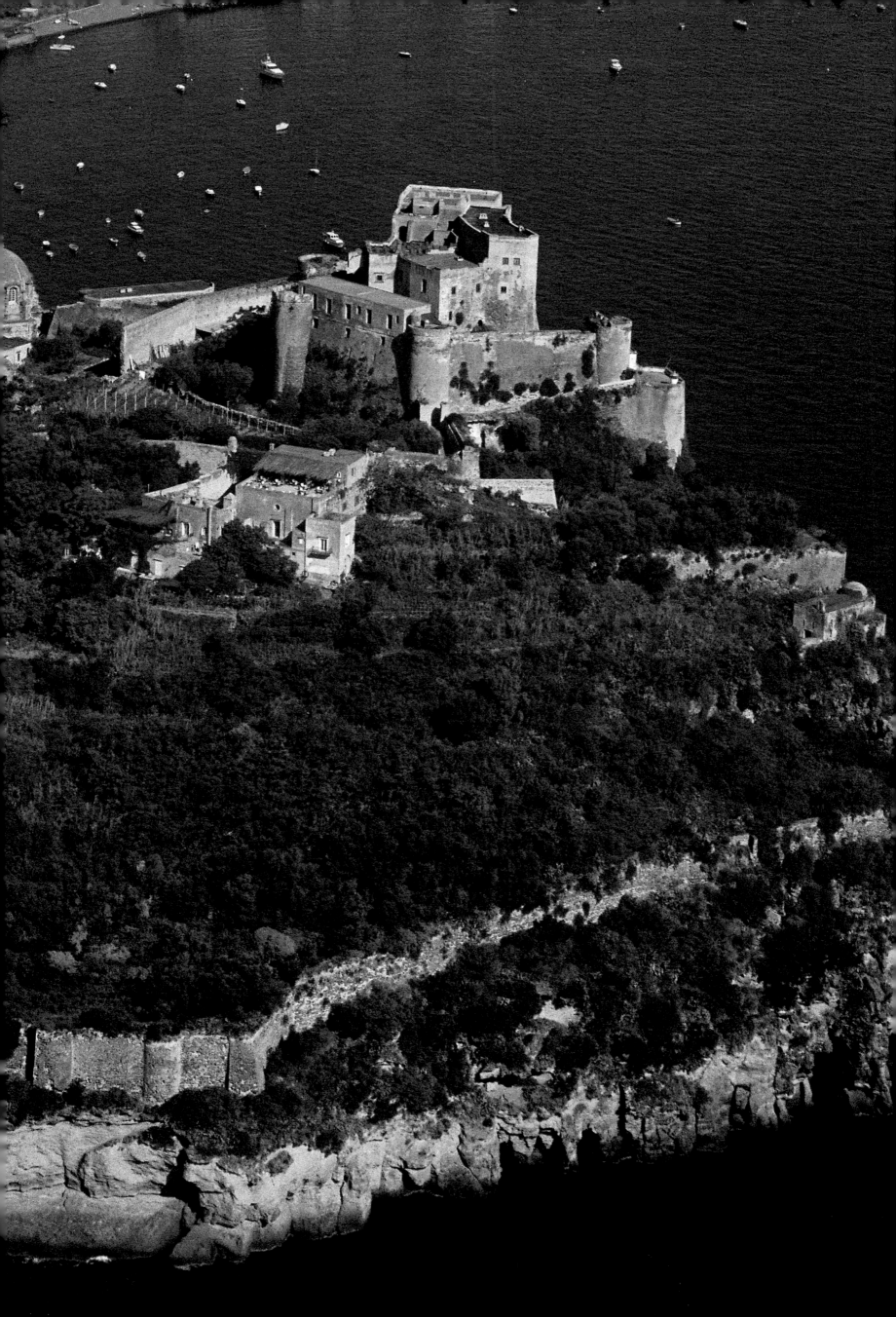

The Iberian peninsula

The mediaeval architecture of the Iberian peninsula is characterised by Arab influence. The histories of Spain and Portugal were strongly marked by the progressive "reconquest" of the peninsula, which ended only in 1492 when the last Muslim lords of Granada were expelled. This might suggest that a mixture of building styles would emphasise the new Christian character of the two countries, but in reality the cultural influence of the caliphate was enormous – as it was in Norman Sicily.

The *mudejar, plateresco* and *manuelino* styles, typical Spanish and Portuguese interpretations of late mediaeval European styles, are strongly tinged with the decorative tradition of Islamic art, with its colours and small formal patterns: these striking, brightly coloured patterns provided an alternative to the use of images – forbidden in Islam. The same tendency is clearly visible in the structure and shape of castles: elegant crenellations top massive quadrilateral or cylindrical towers, seeming to dissolve their weight and surface area. Two good examples can be seen at Beja and Almodovar.

The taste for colour can also be seen in the use of coloured materials for the outer walls, as for example in the Castillo de Guadamur, near Puebla. The ancient castle of San Salvador de Verdera (El Port de la Selva, Costa Brava), with its thirteenth-century walls, looms over the fortified monastery of Sant Pere de Rodes which looks like a feudal castle itself with its complex system of adjoining towers.

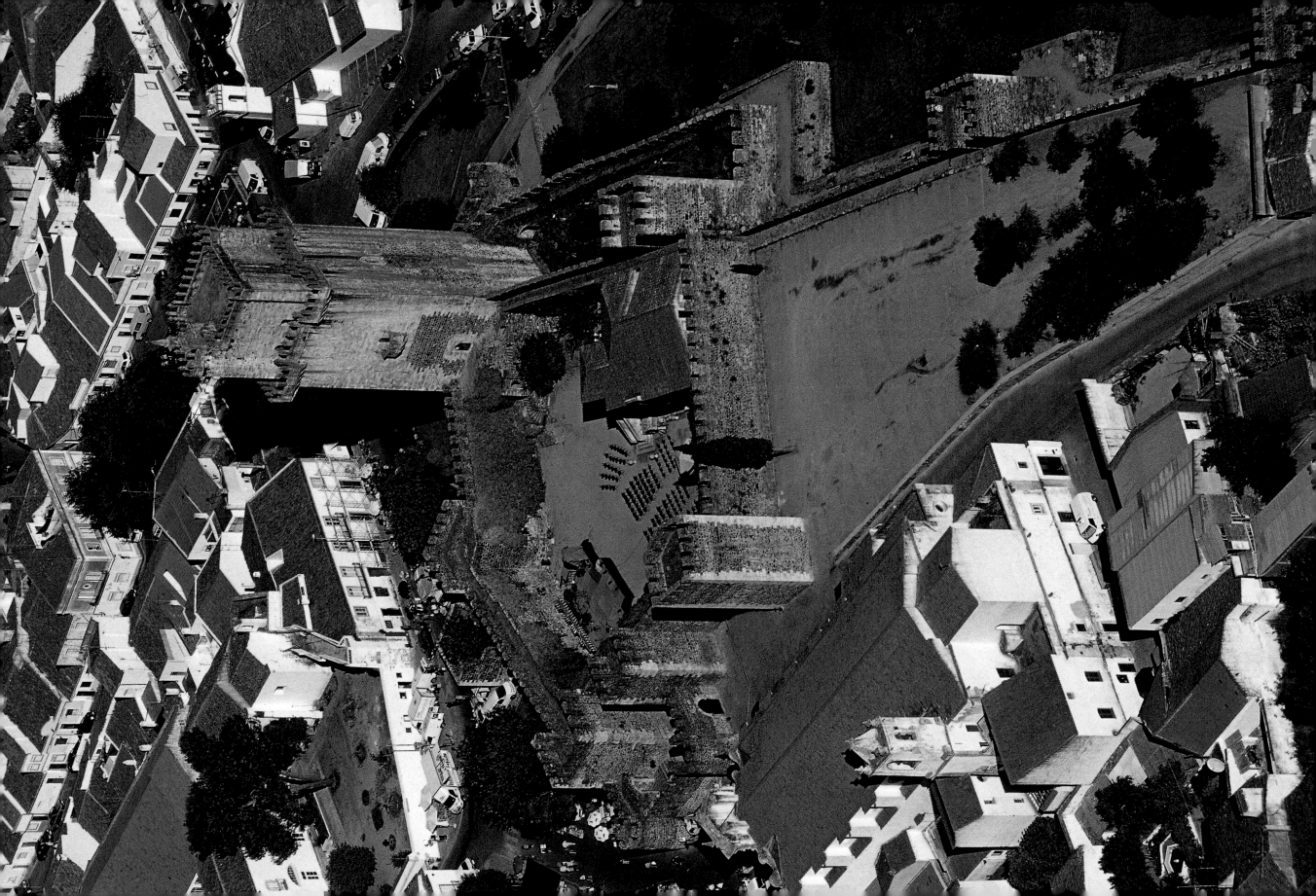

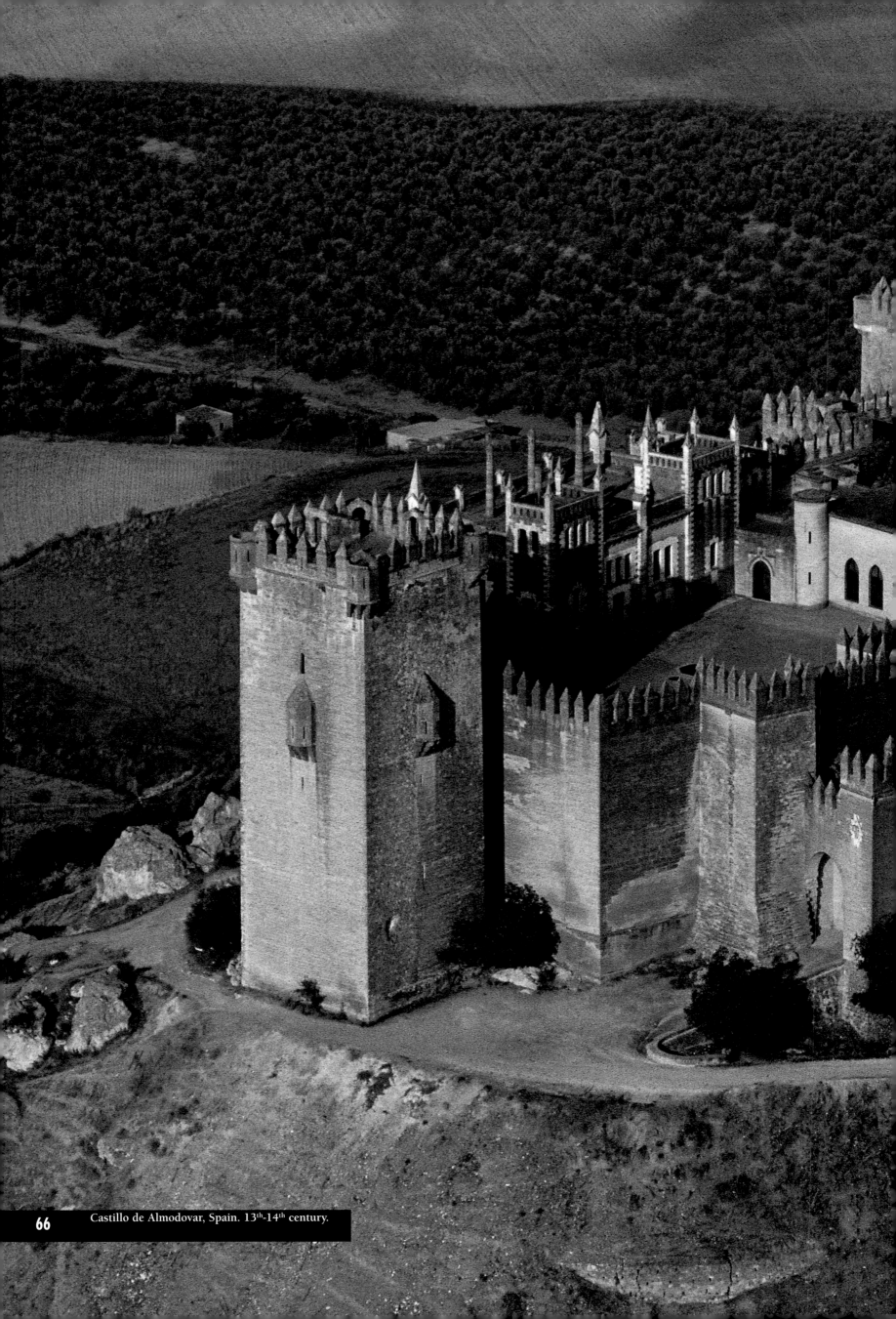

Castillo de Almodovar, Spain. 13th-14th century.

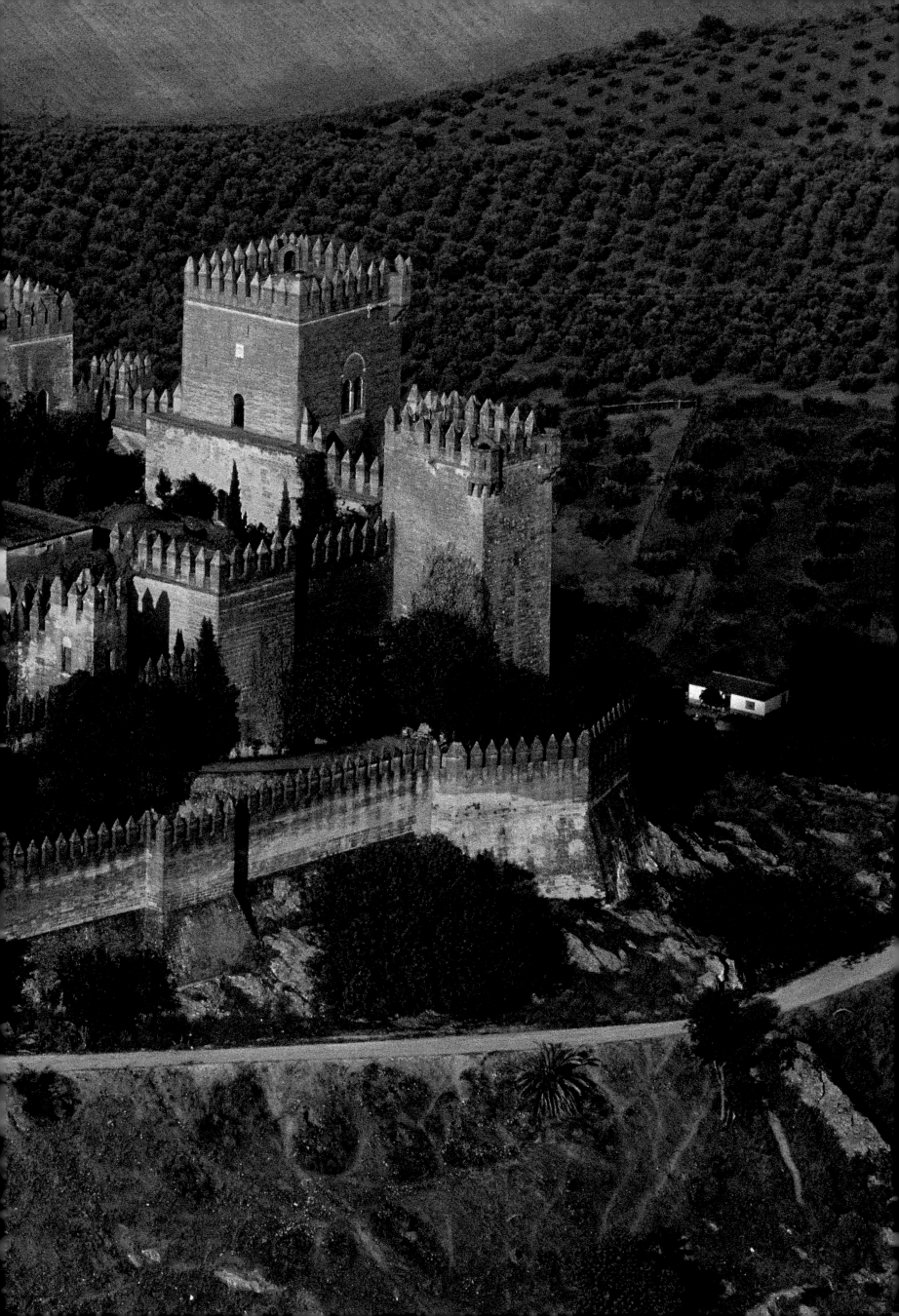

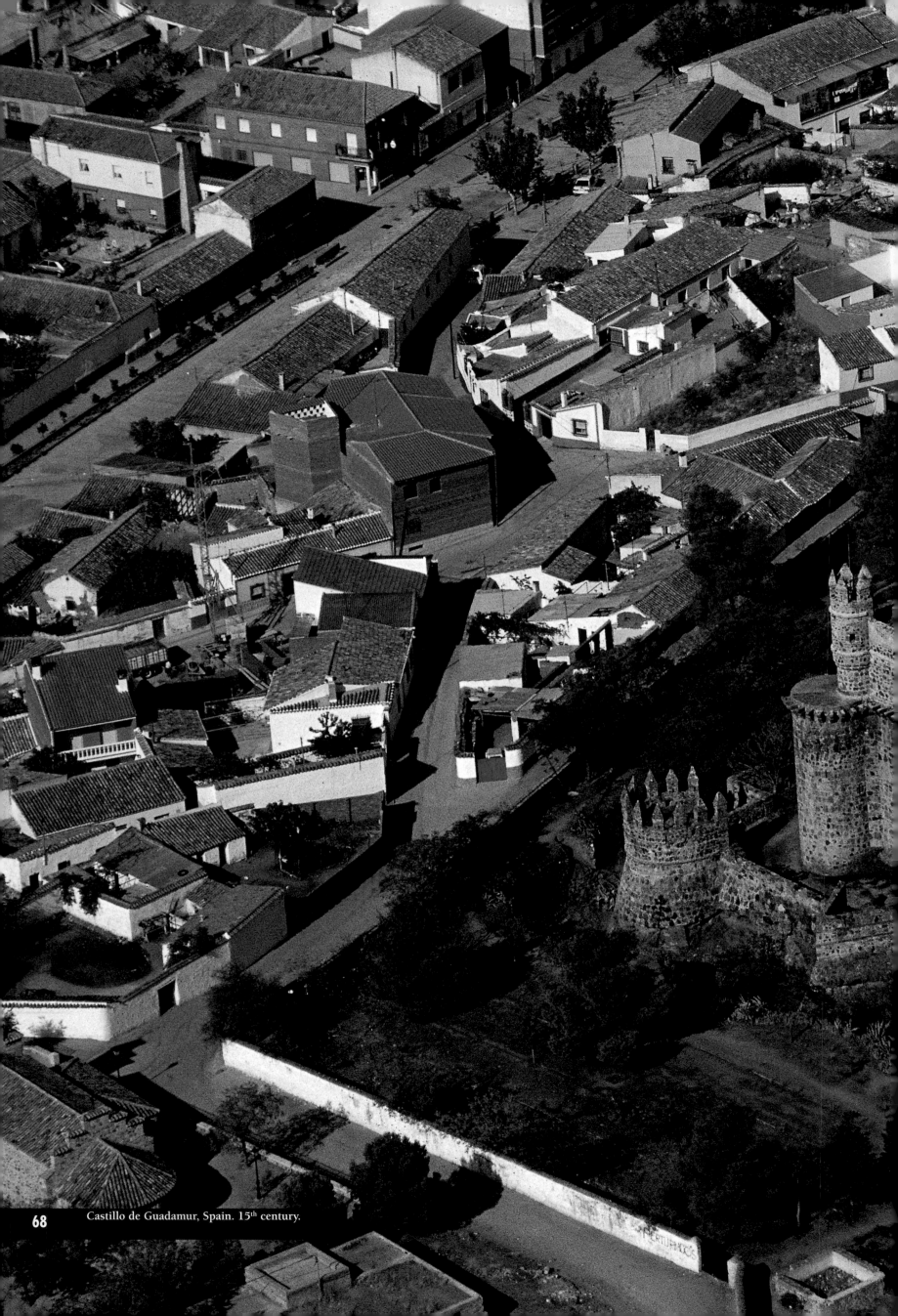

Castillo de Guadamur, Spain. 15th century.

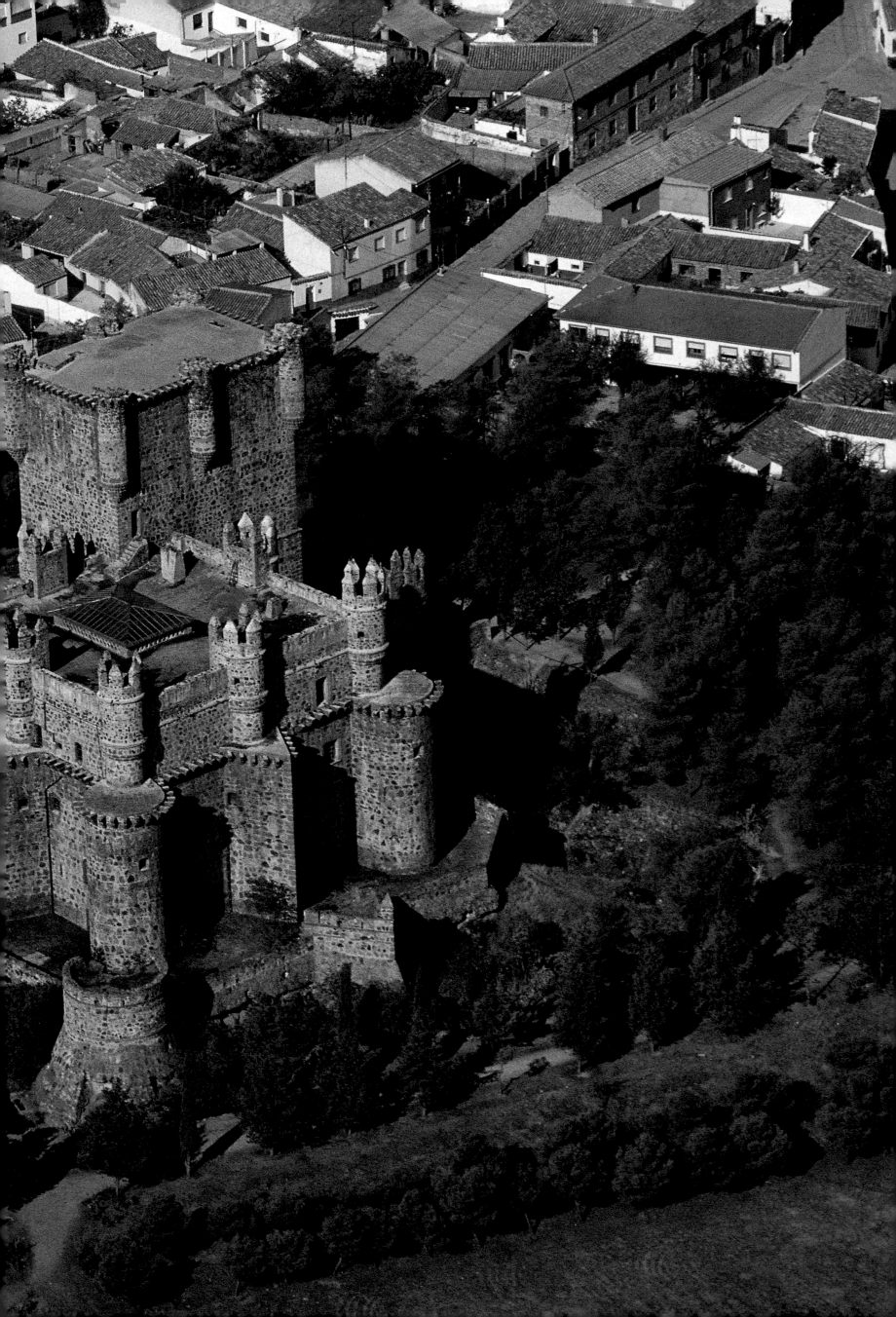

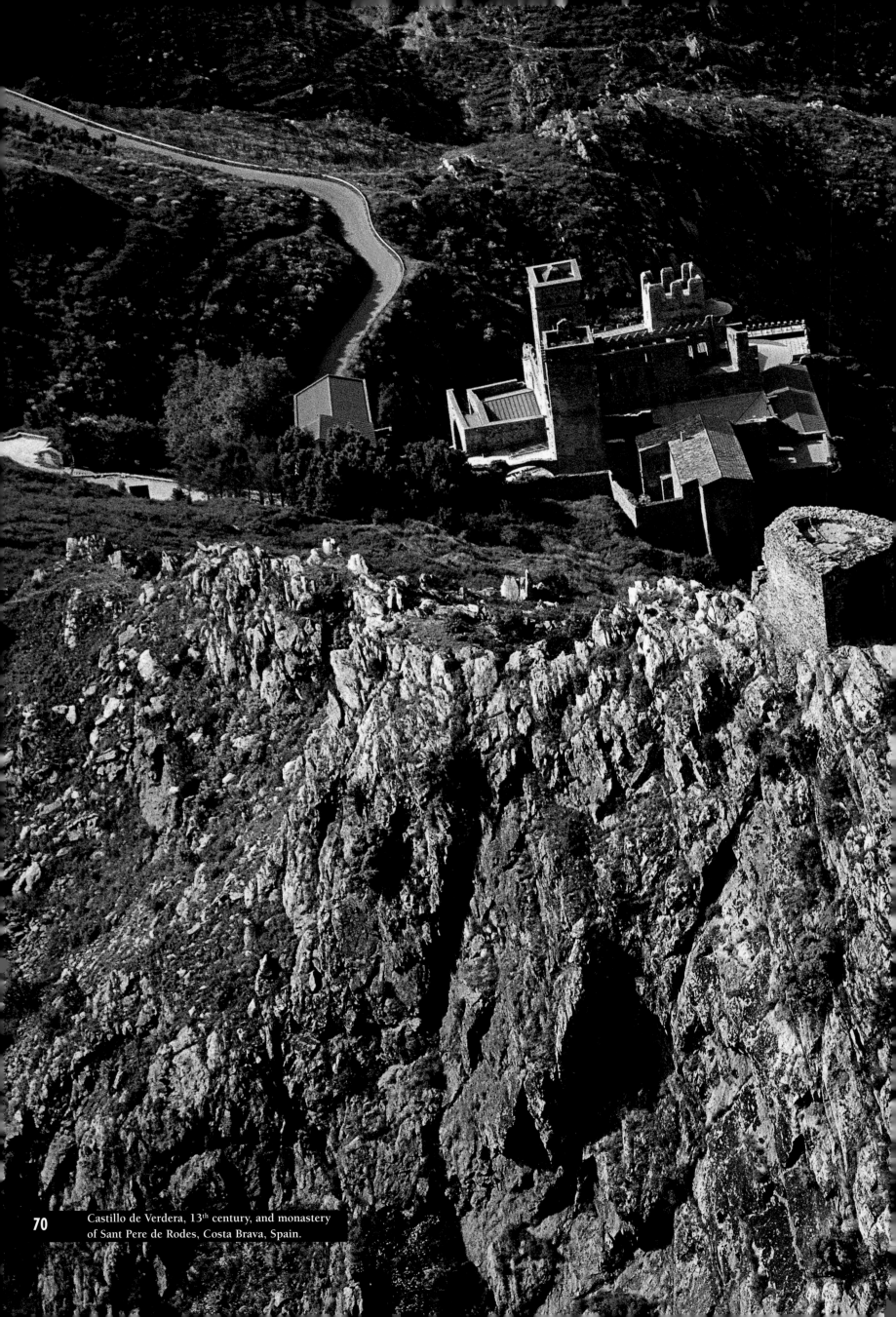

Castillo de Verdera, 13th century, and monastery
of Sant Pere de Rodes, Costa Brava, Spain.

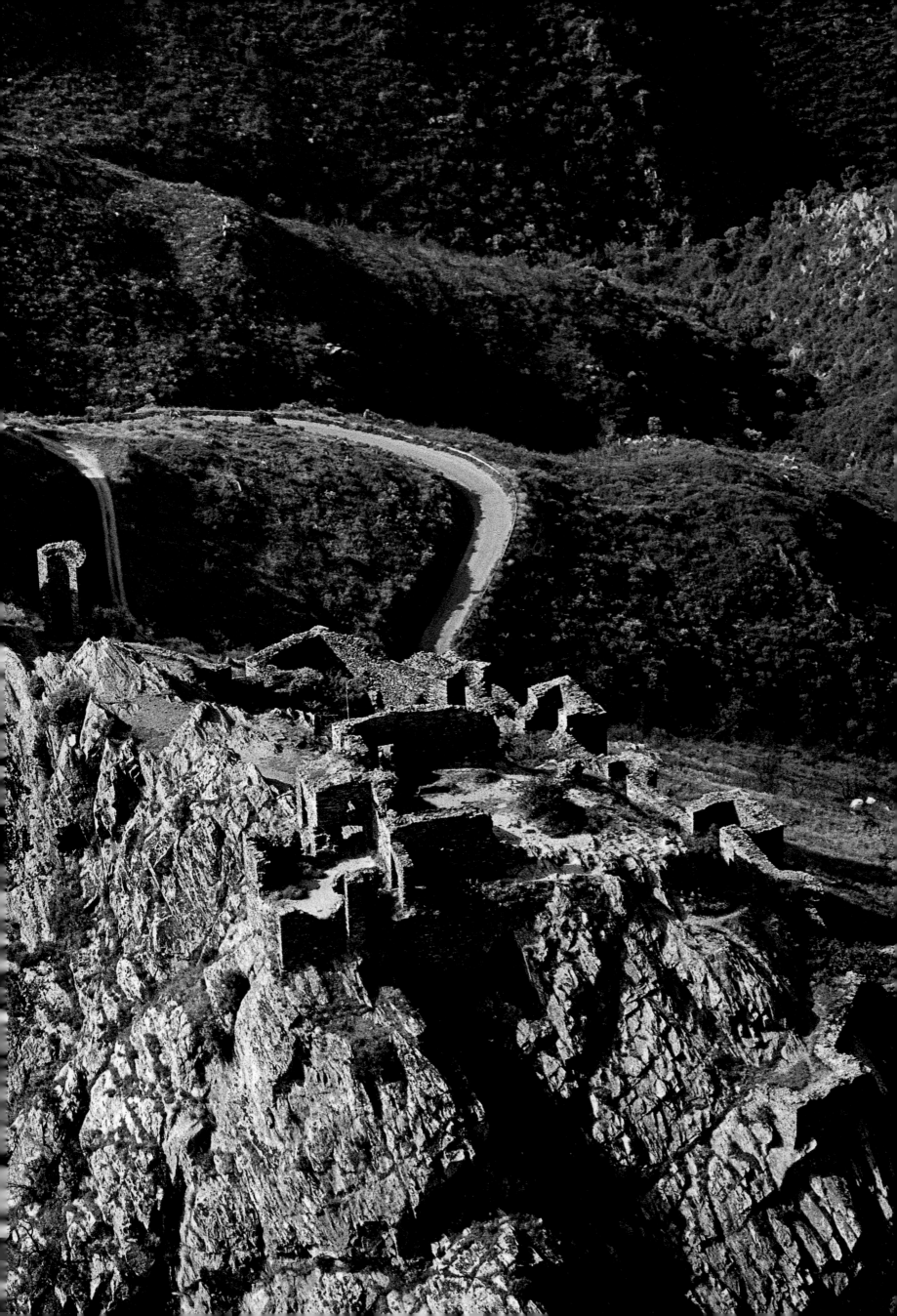

France

France's contribution to the development of castle architecture is noteworthy. The connection between the role of the local nobles and the development of the monarchy and its system of territorial control led to the development and diffusion of increasingly complex and elegant buildings, which nevertheless adhered substantially to the same design from the end of the Middle Ages, through the High Renaissance and on to the threshold of the Baroque period. Even today, it is easy to spot in the layout of the French countryside the legacy of private ownership; the farms are often clustered around a manor house of some description. In the early days, and for the whole of the thirteenth century, preparation for the Crusades and the welcoming of knights returning from fighting influenced land use considerably, and was also a decisive factor in the building of urban fortifications (see p. 214). Feudal nobles, bishops and princes vied with one another to build towers and castles. At Crest the imposing tower consists of three superimposed earlier buildings commissioned by the three great authorities: first the bishops in the mid twelfth century, then the Contes de Valentinois and finally the ruling house who transformed the tower into a prison.

The Château de Beynac is a series of buildings built on bastions and surrounded by a wall on the top of rocks overhanging the river. Its history was closely linked to the wars of religion and the Albigensian Crusade.

The grand castle complex at Uzès is the result of various building works carried out between the twelfth and the sixteenth century: the ducal castle has a tower erected in 1170 by Bermond d'Uzès. The two other towers are named "the bishop" and "the king".

Saint-Laurent-des-Arbres consists of a fortified church with a sturdy tower in front of it. Pontgibaud and Bressuire are two fine example of residential castles built inside much older, turreted walls.

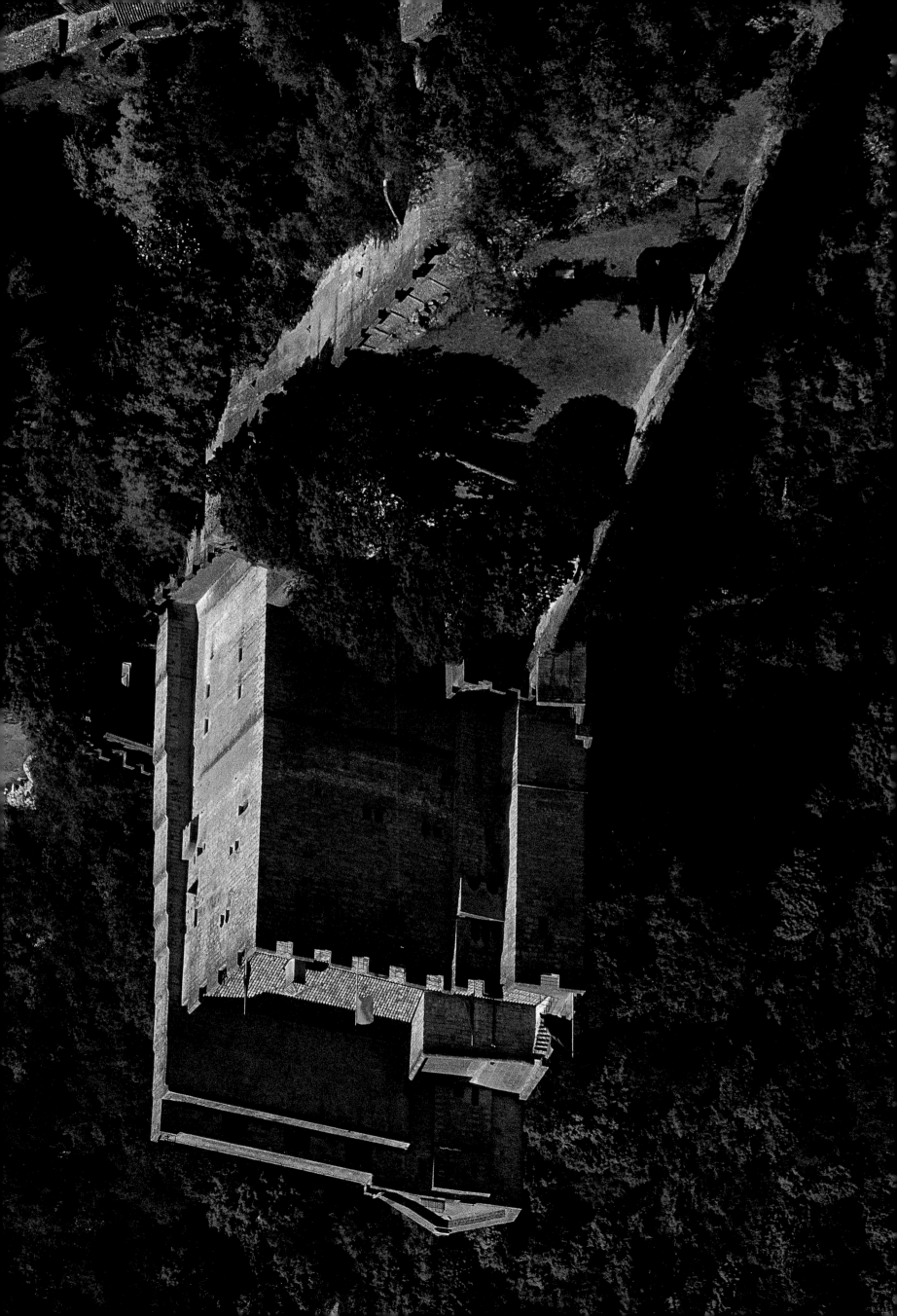

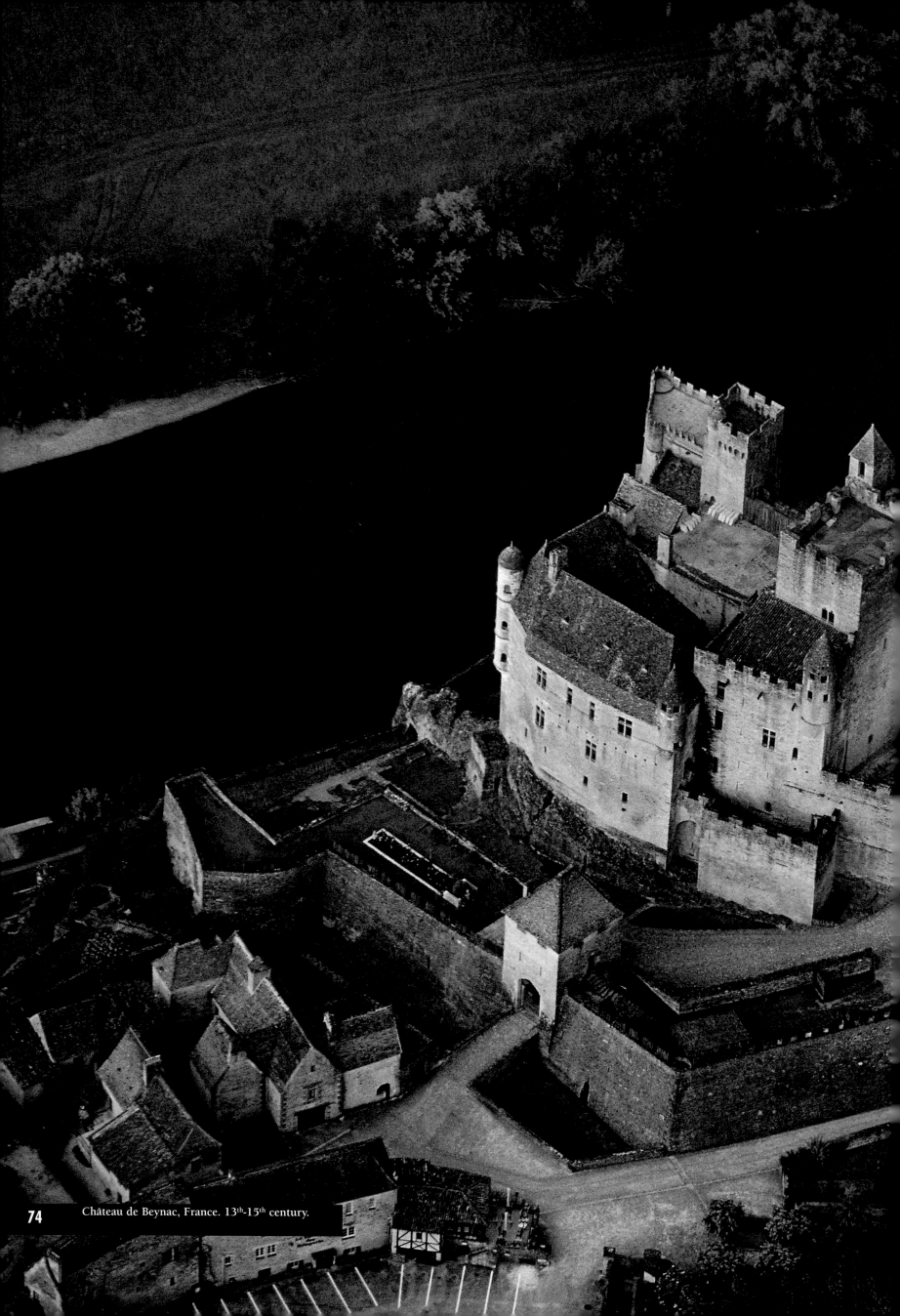

Château de Beynac, France. 13th-15th century.

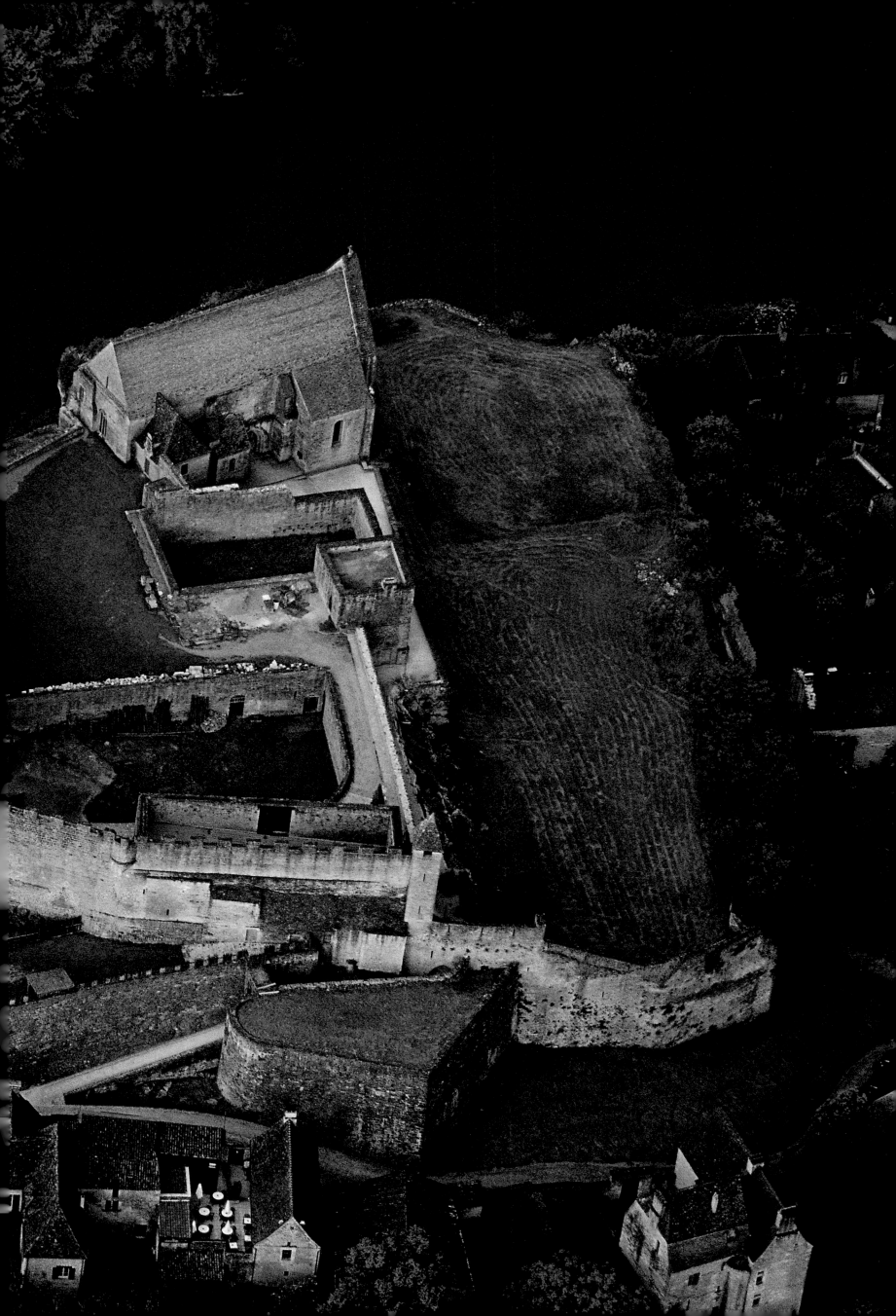

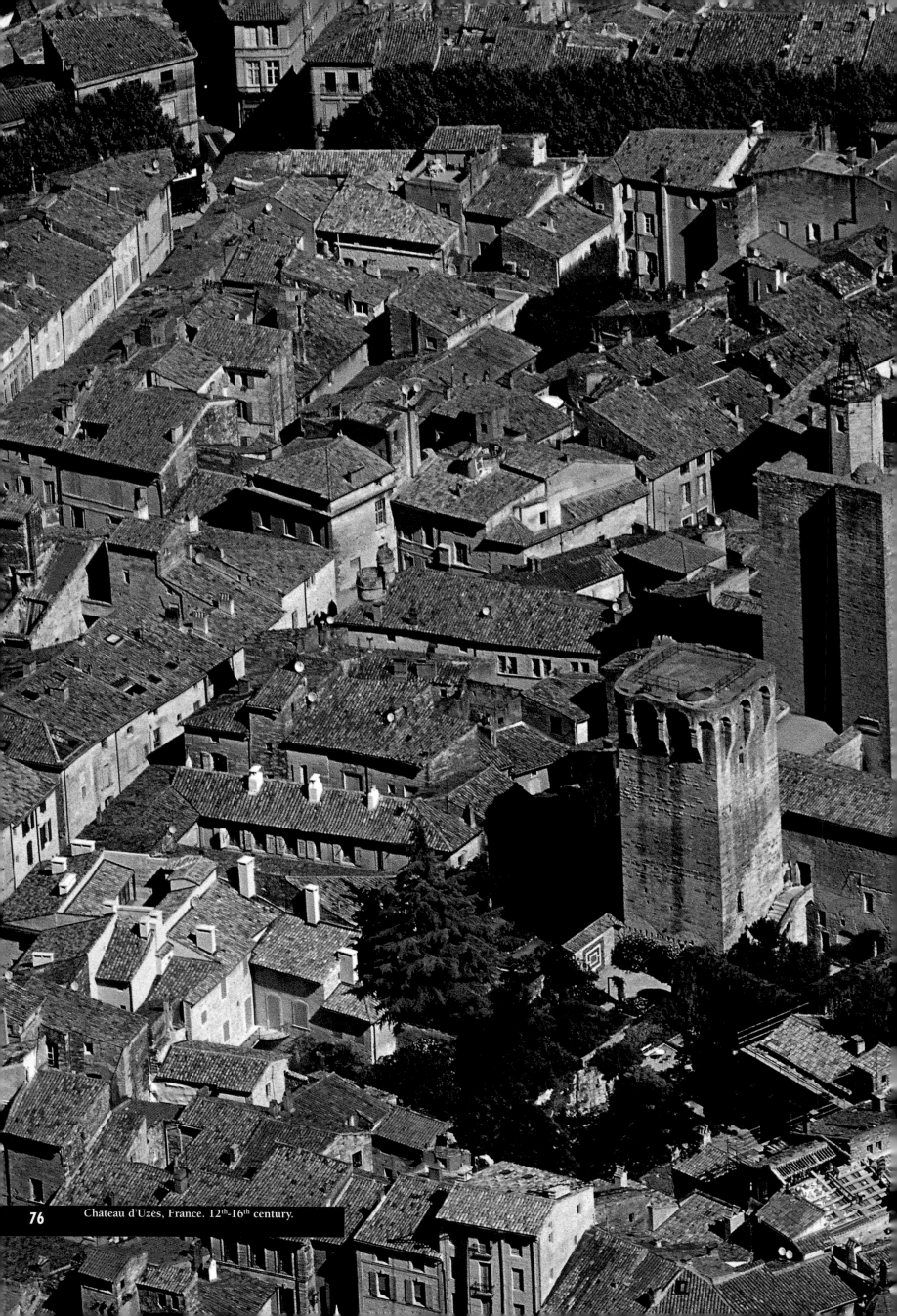

Château d'Uzès, France. 12th-16th century.

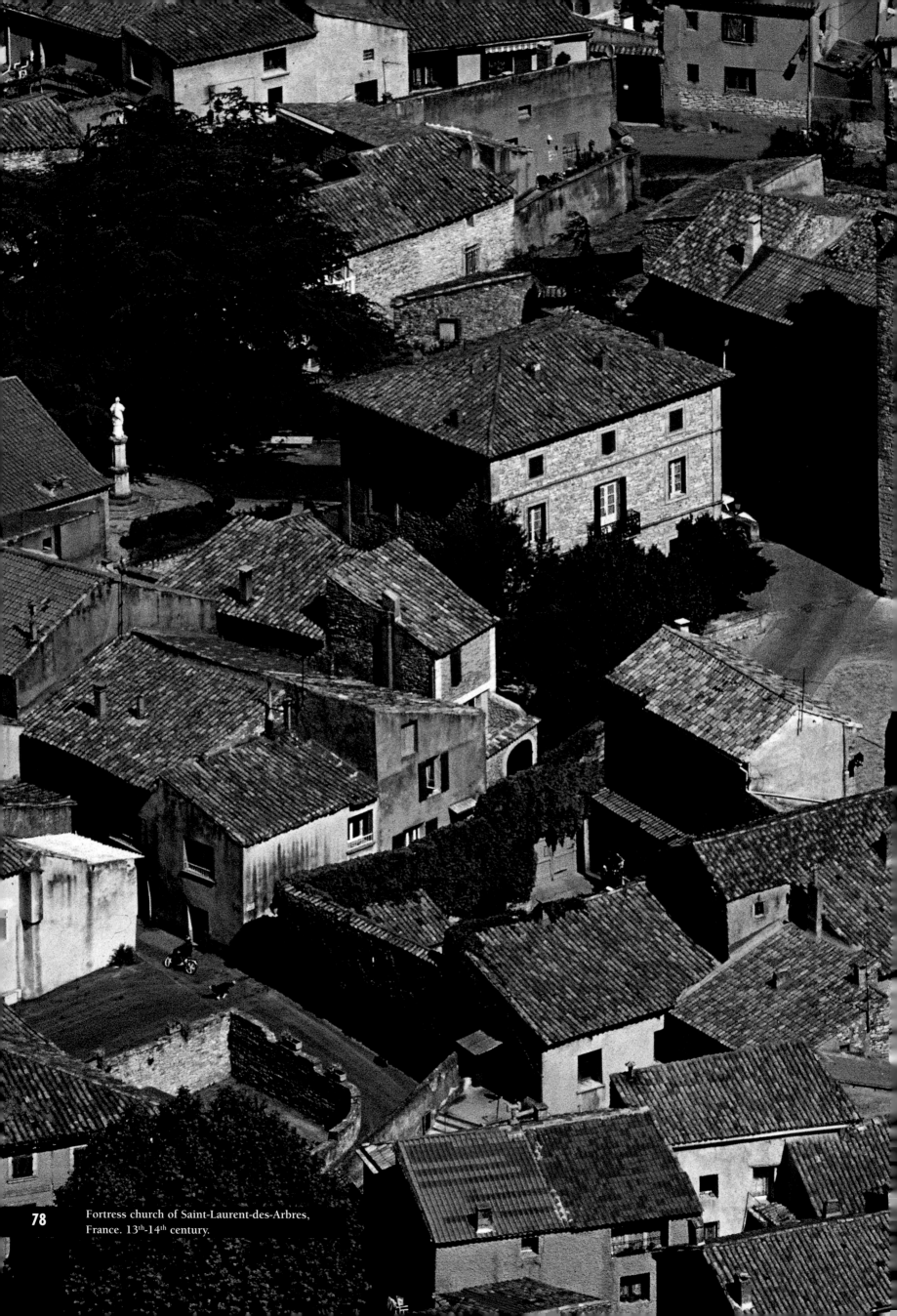

Fortress church of Saint-Laurent-des-Arbres,
France. 13th-14th century.

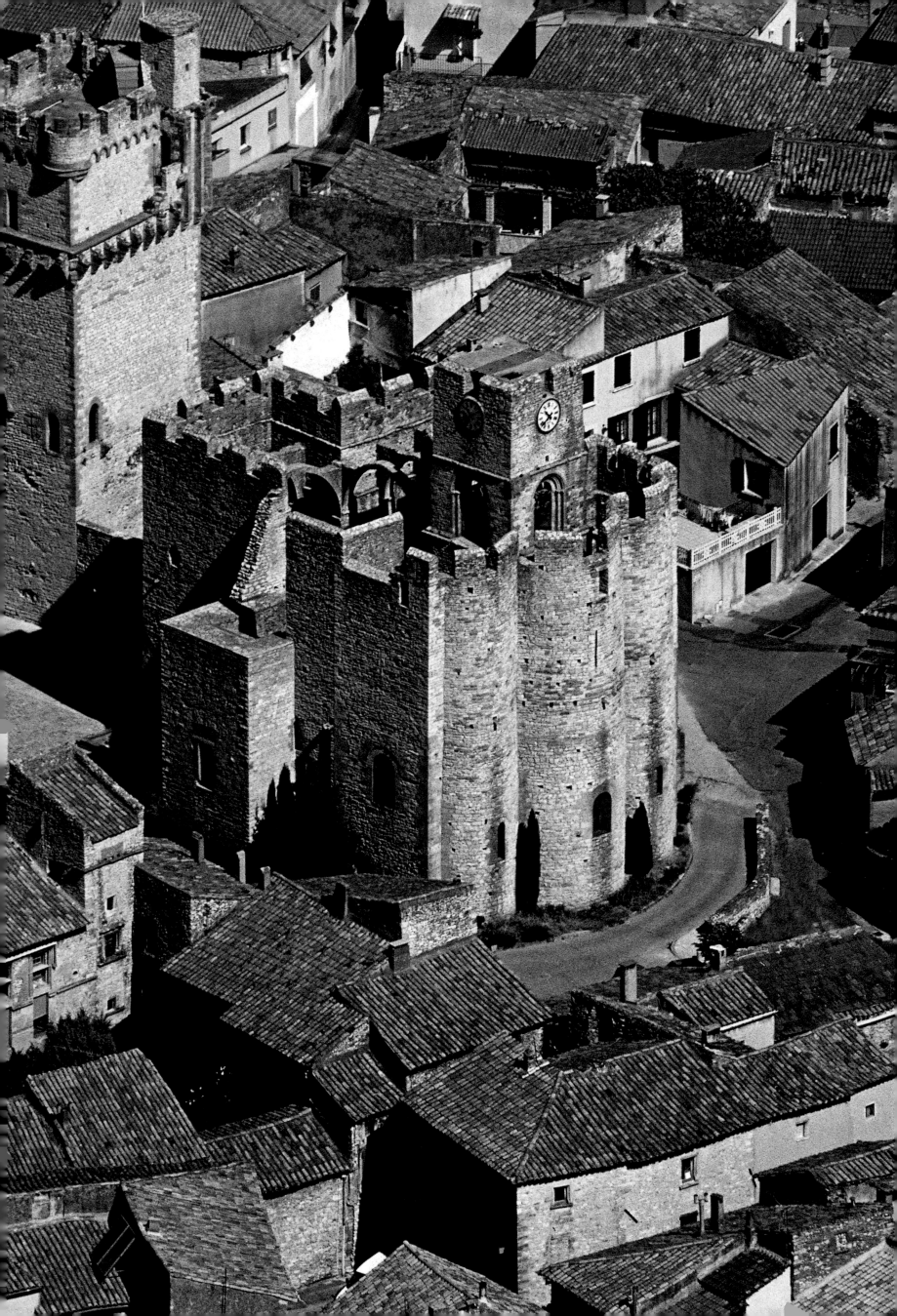

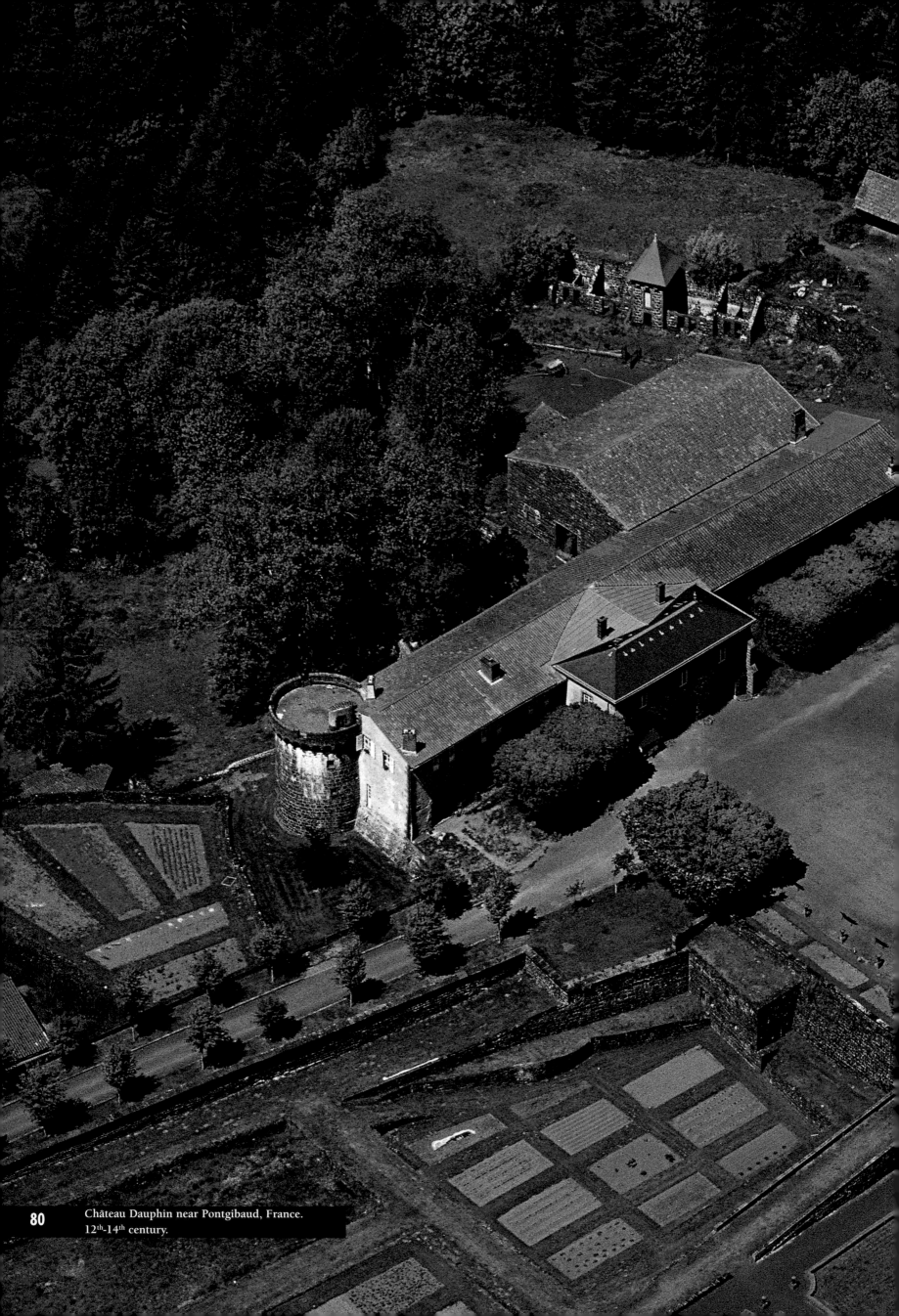

Château Dauphin near Pontgibaud, France.
12th-14th century.

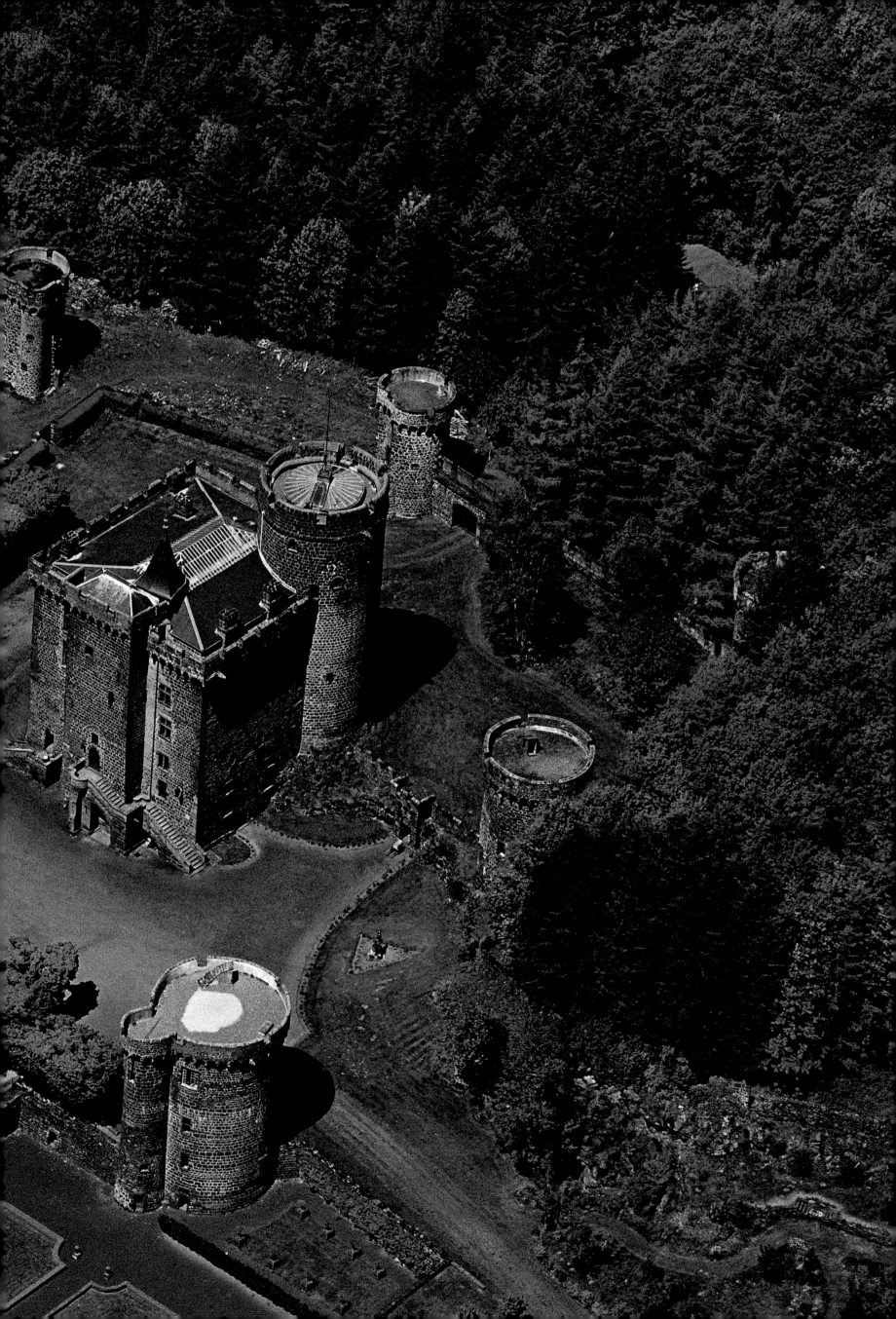

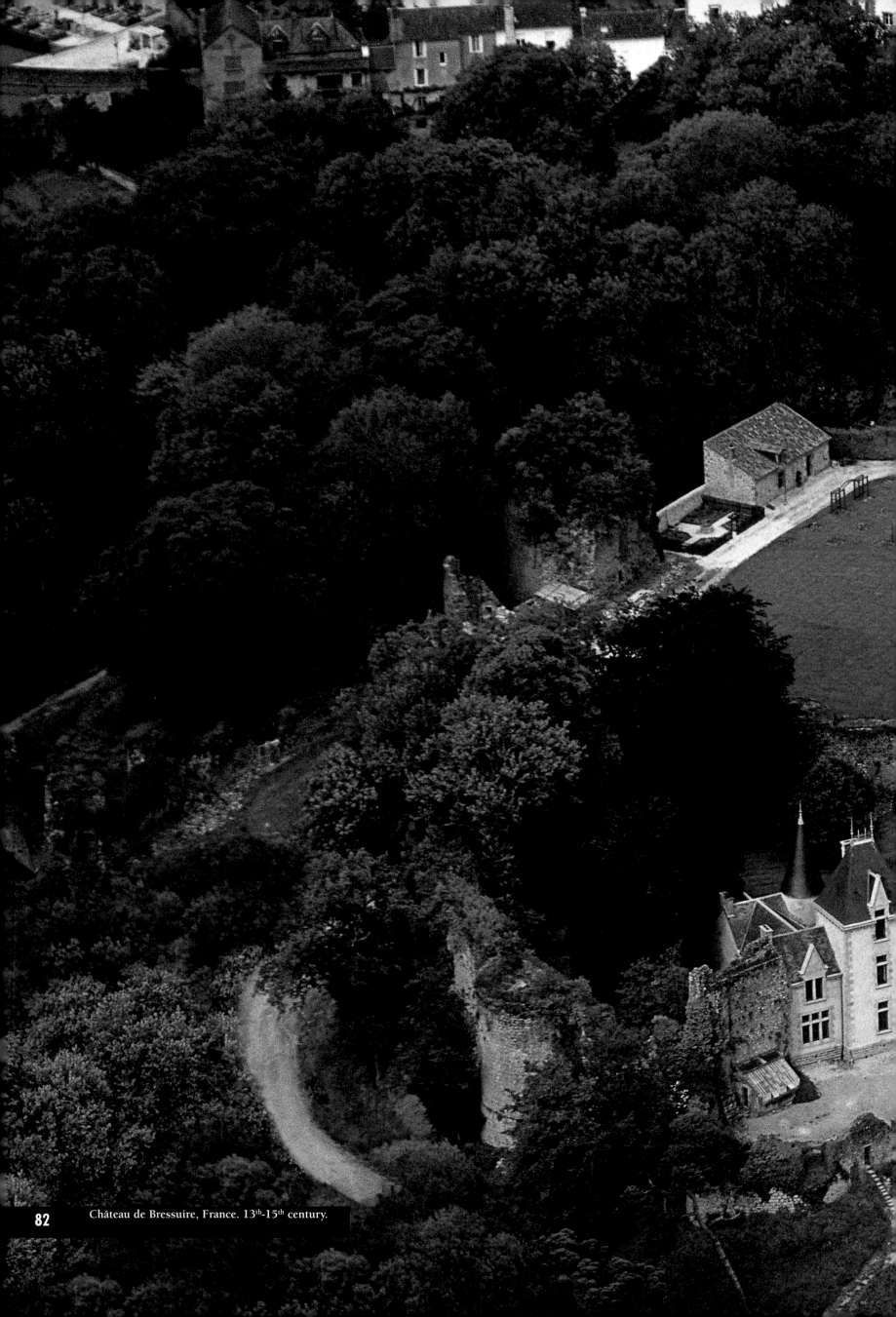

Château de Bressuire, France. 13th-15th century.

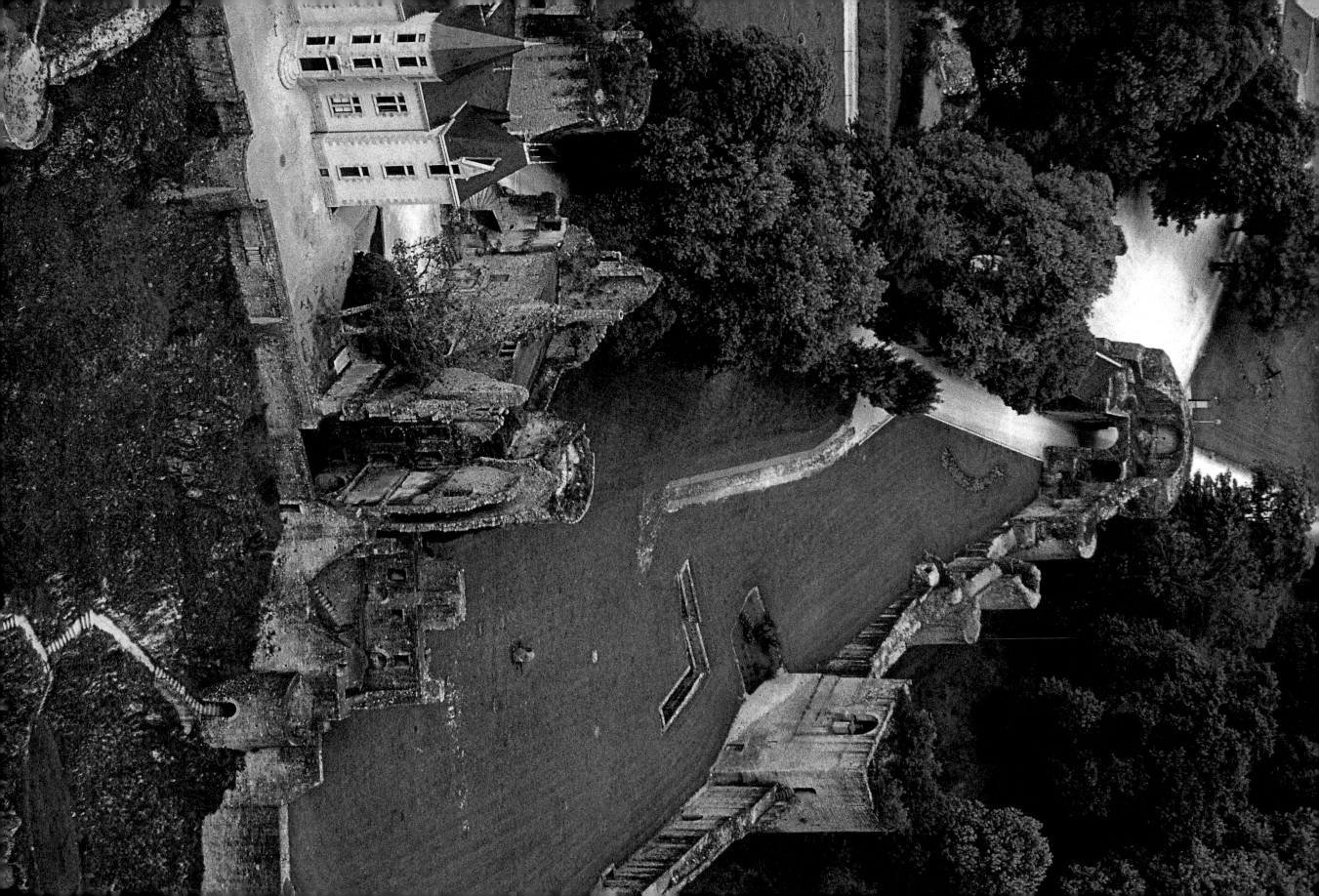

Developments

So far, we have discussed castles built for military use by ruling powers and castles built by feudal overlords, both of which types relied on fortress architecture for their security. Now gradually such buildings assumed more elegant forms, even in those parts designed for defence – and indeed the latter were no longer indispensable. A new style of building was emerging, quadrilateral in plan with a central courtyard – sometimes open on one side – and towers at the corners. The fortified wall, where it survived, became a way of defining the site and the access to the main building rather than a defensive structure.

Throughout France there was a definite preference for cylindrical and polygonal towers, with a conical or pyramidal roof; these framed a building with elegant windows, steeply pitched roofs, chimneys and dormer windows. Terraces and water features often took the place of outer walls, taking over their role as the first obstacle to access while not blocking the view of the castle from the surrounding countryside, nor the view of the countryside from the castle. Within this main historical trend there exist innumerable variations.

On the opposite page can be seen the garden created on the raised terrace in the Palais de la Berbie in Albi, a complex structure which also includes a fortified church, built by the local bishops in 1228. Today the castle houses the Musée Toulouse-Lautrec.

On the following page is one of the three characteristic bridges with towers over the river Lot, part of the grandiose defences of the town of Cahors. This is followed by various examples of the way the castle developed into an opulent residence: the Château de Langeais, built for Louis X1, and the elegant palace of Montreuil-Bellay, built inside the double walls of a former manor house.

The Château de Saumur presents a particularly imposing appearance: it was begun at the beginning of the second millennium and in 1356, after a series of vicissitudes, became the residence of the Dukes of Anjou, the Counts of Provence and the King of Sicily. It was Louis I of Anjou who set in train the total refurbishment of the castle, lending it the appearance we see today.

Finally, the Château de Königsburg, on the German border of Alsace, demonstrates how the architecture in this region is closer to the German tradition than it is to the French.

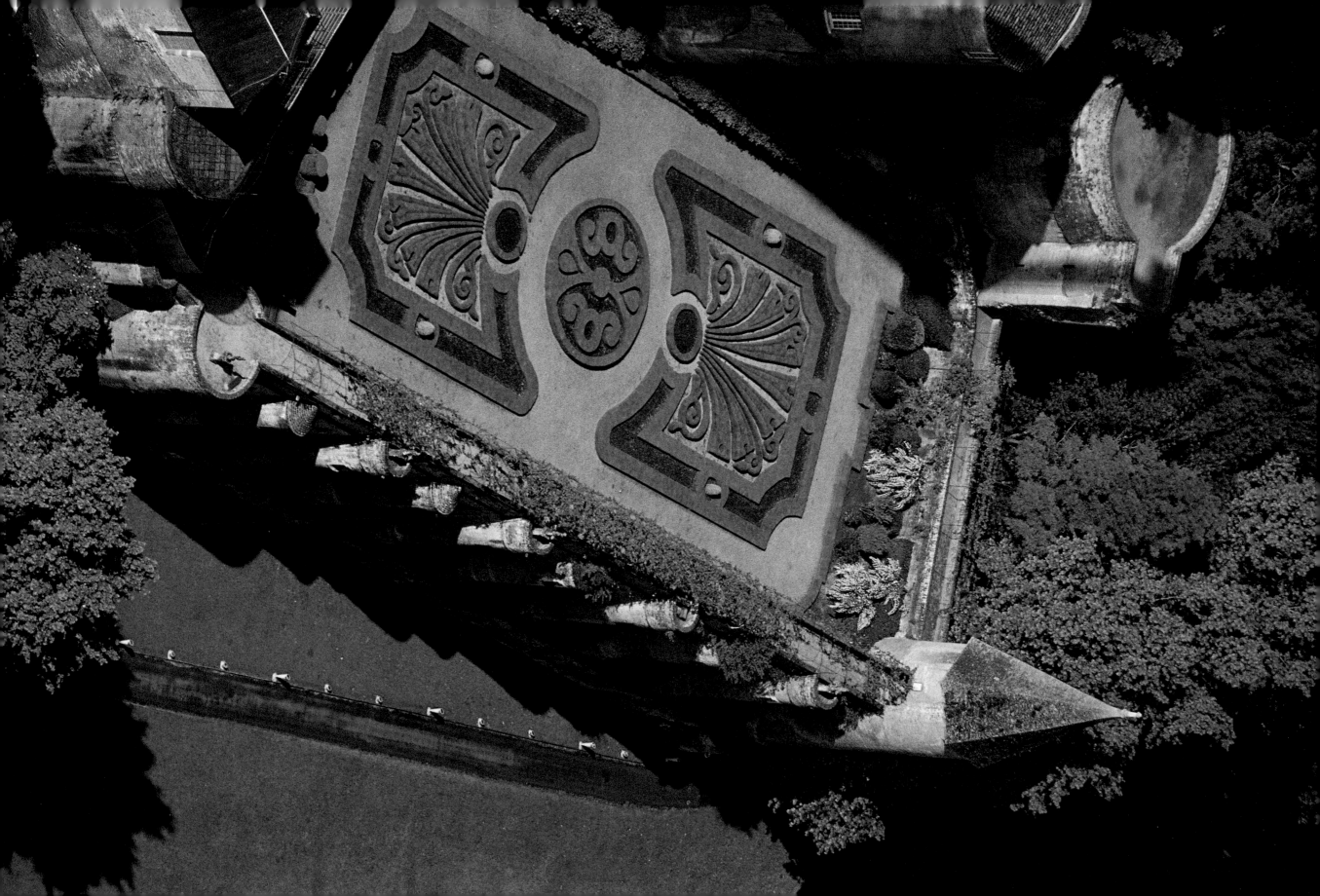

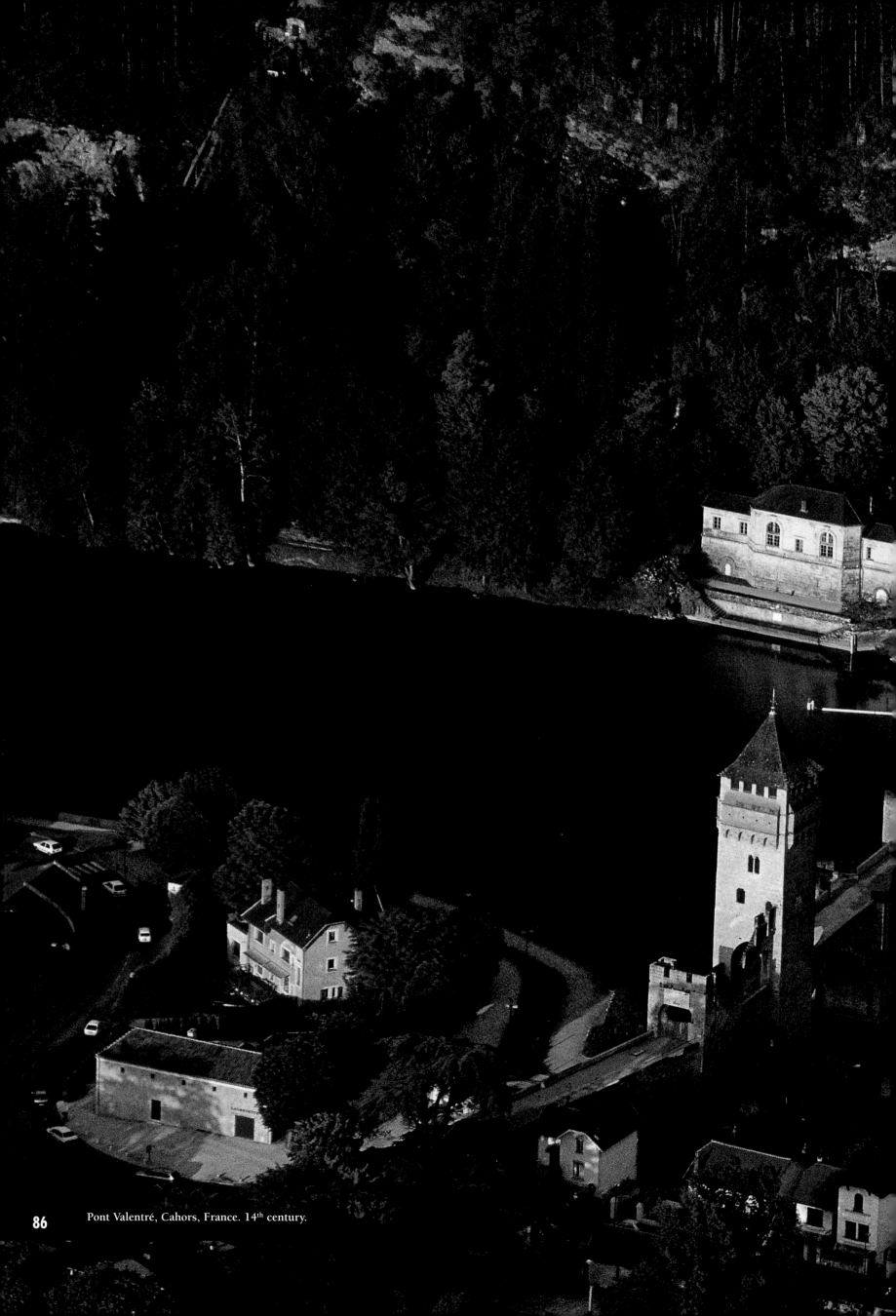

86 Pont Valentré, Cahors, France. 14th century.

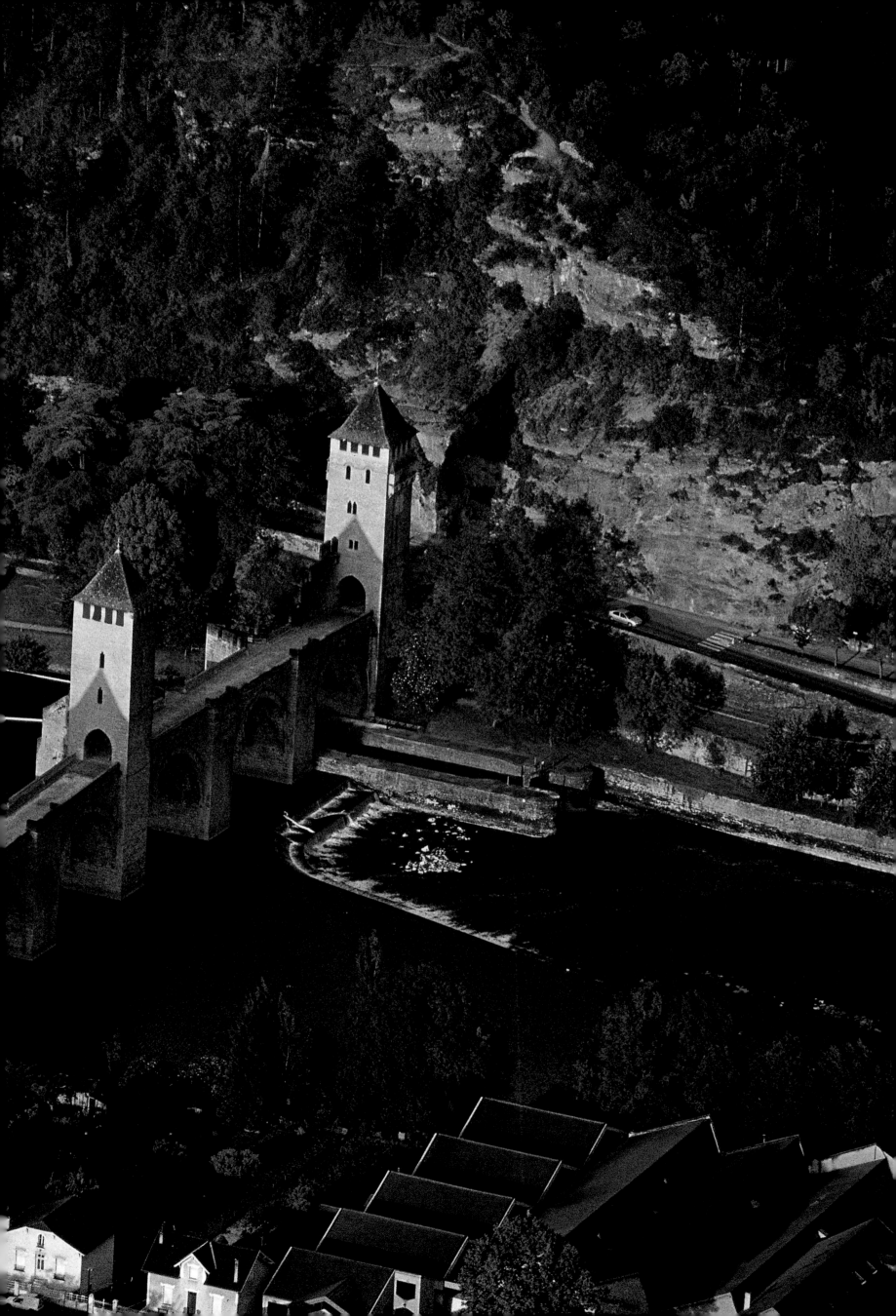

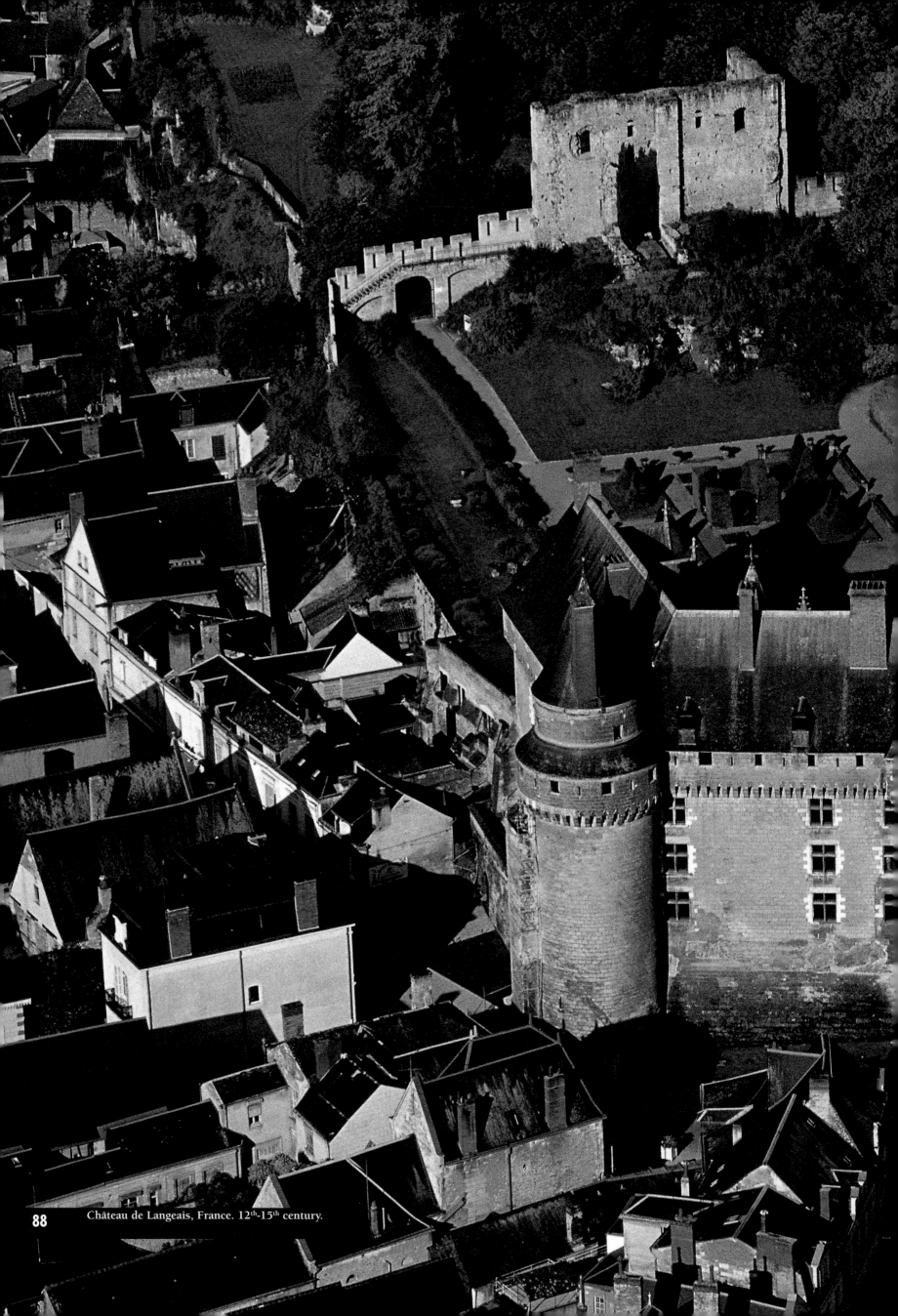

Château de Langeais, France. 12th-15th century.

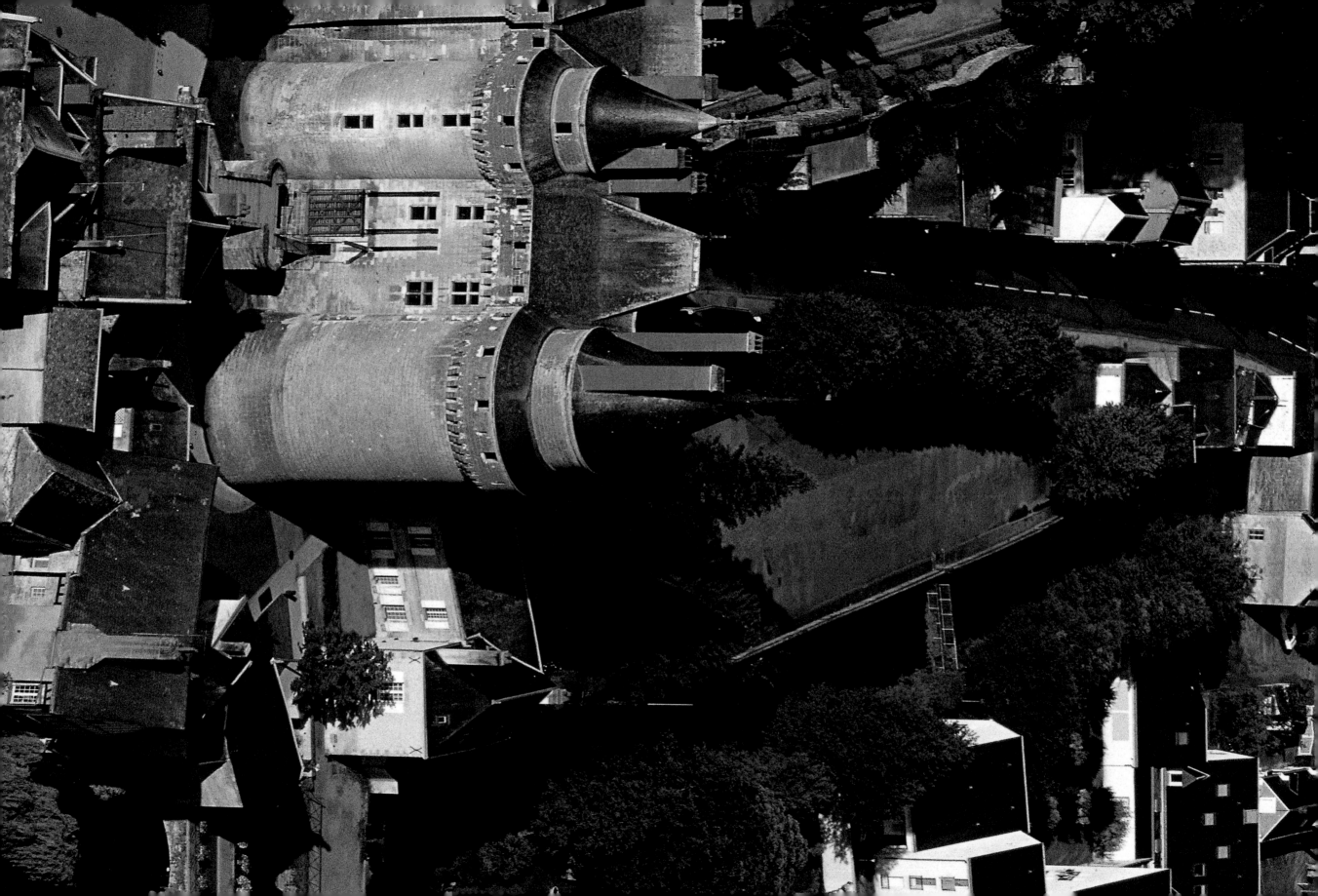

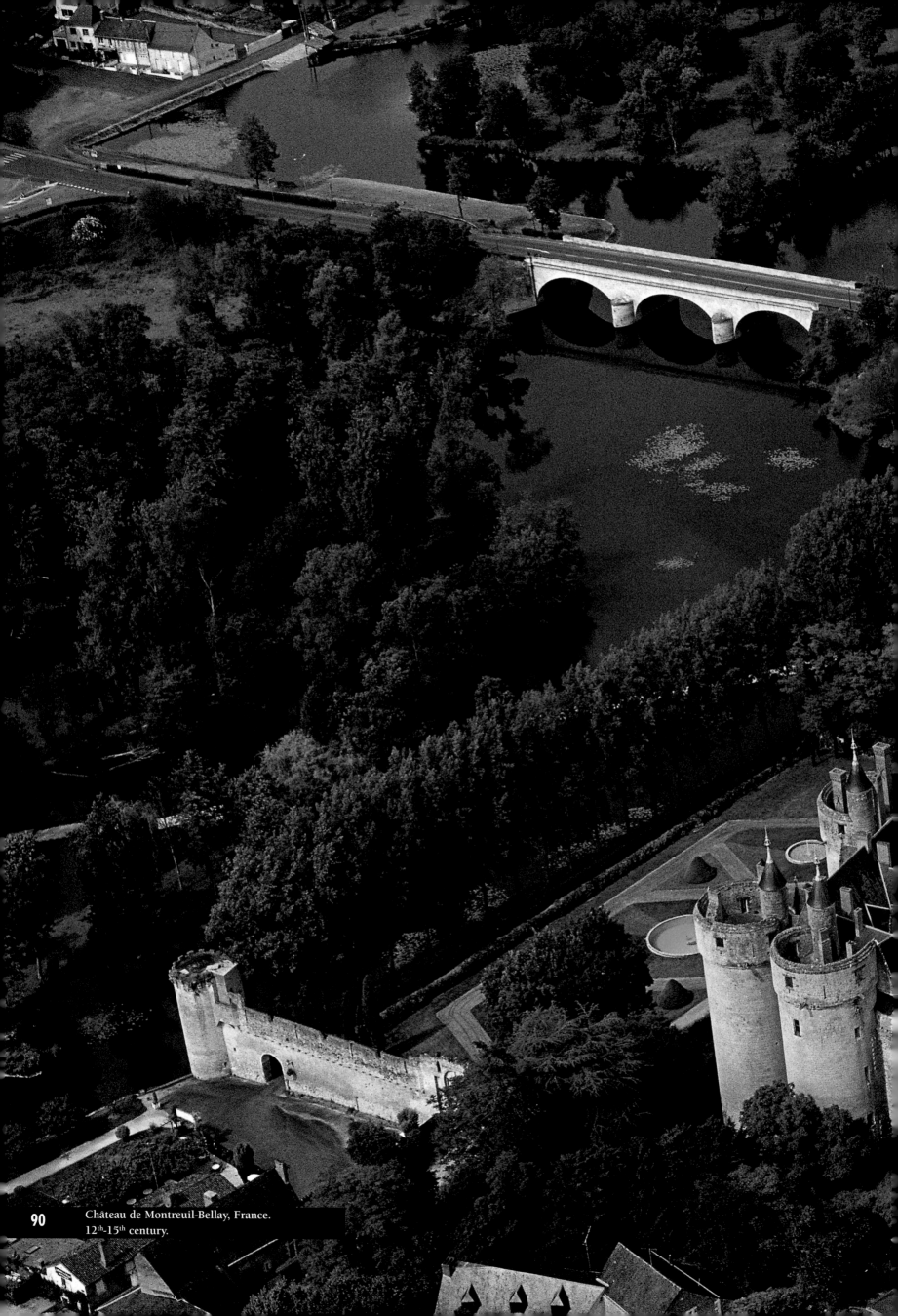

Château de Montreuil-Bellay, France.
12th-15th century.

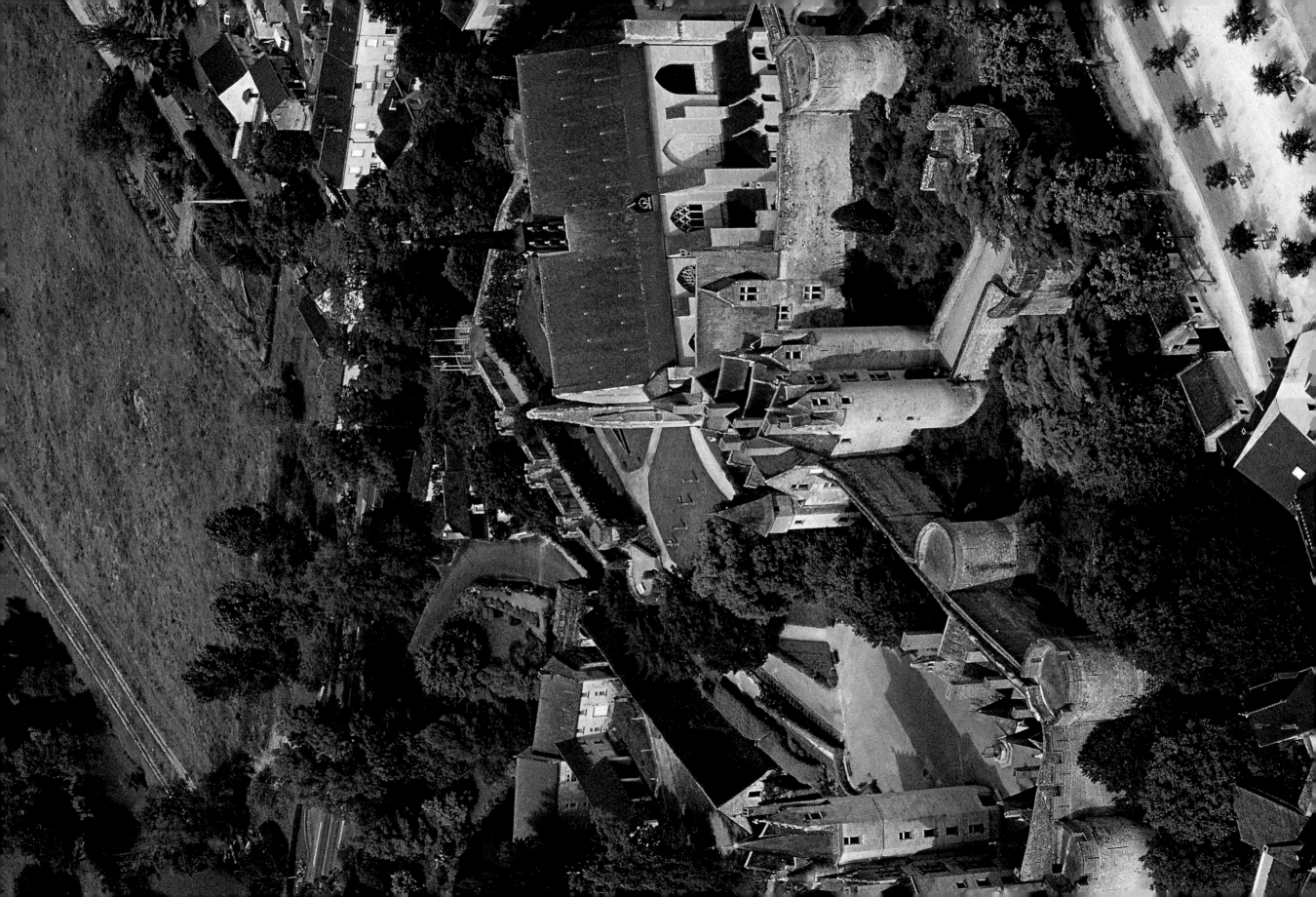

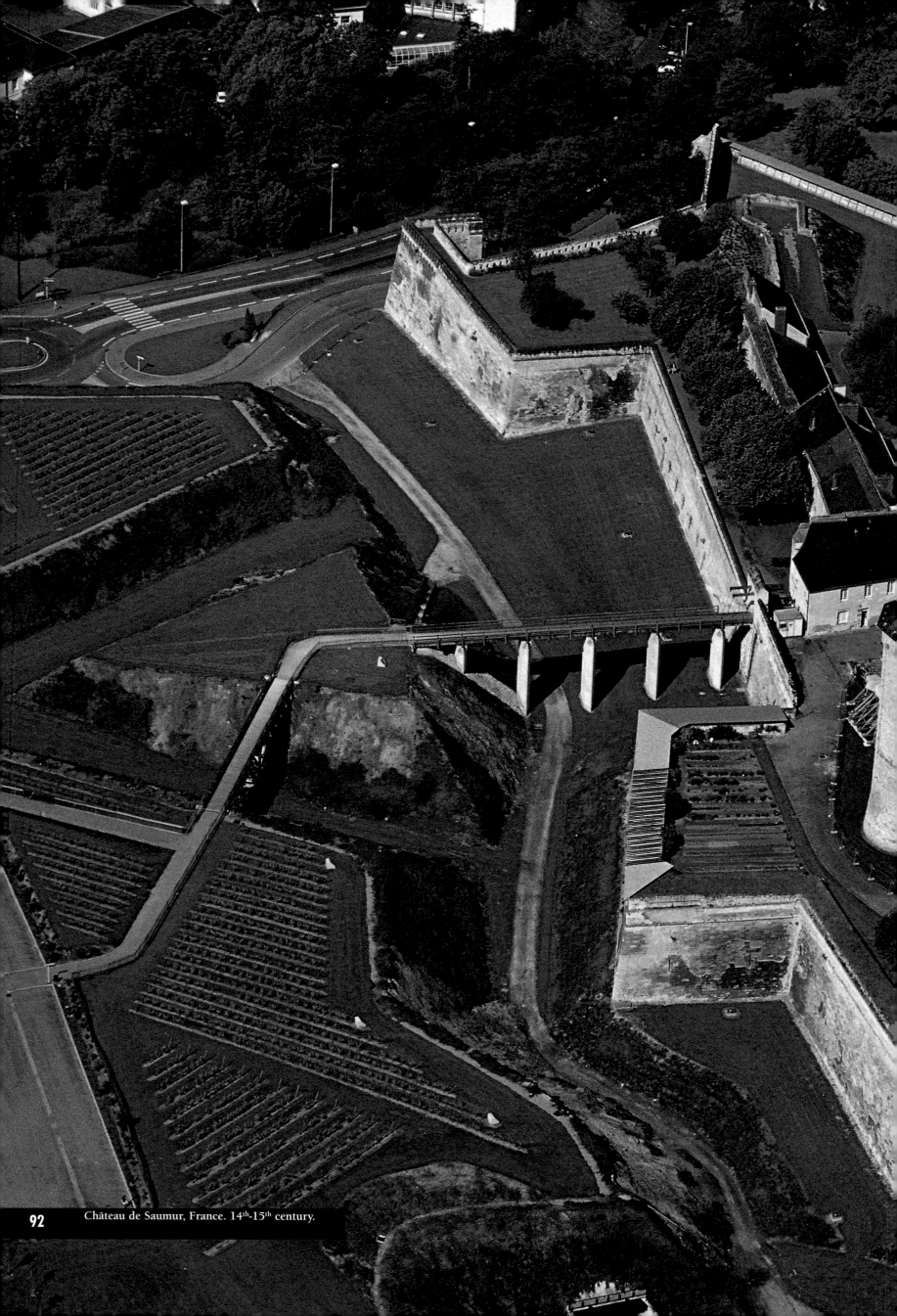

Château de Saumur, France. 14th-15th century.

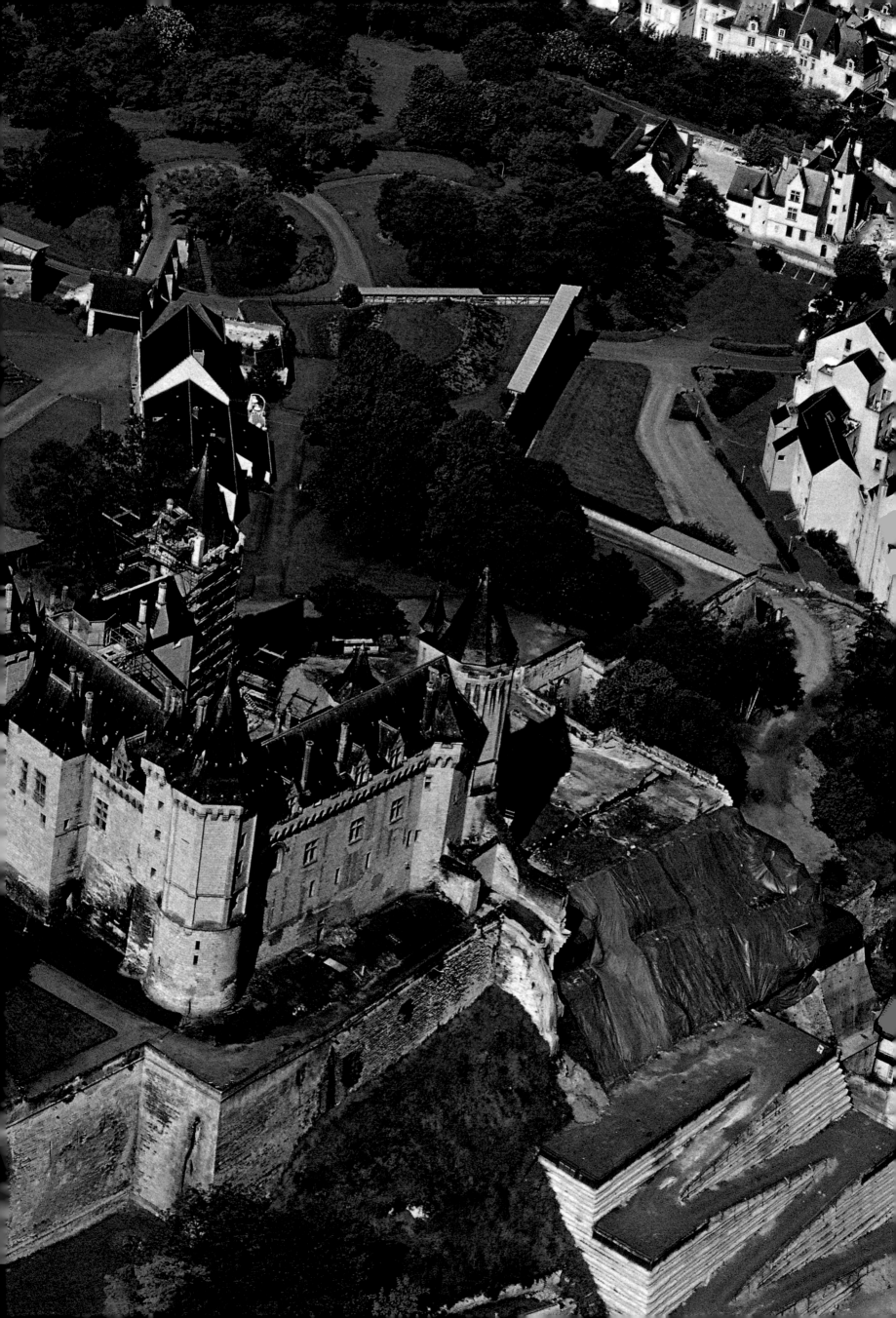

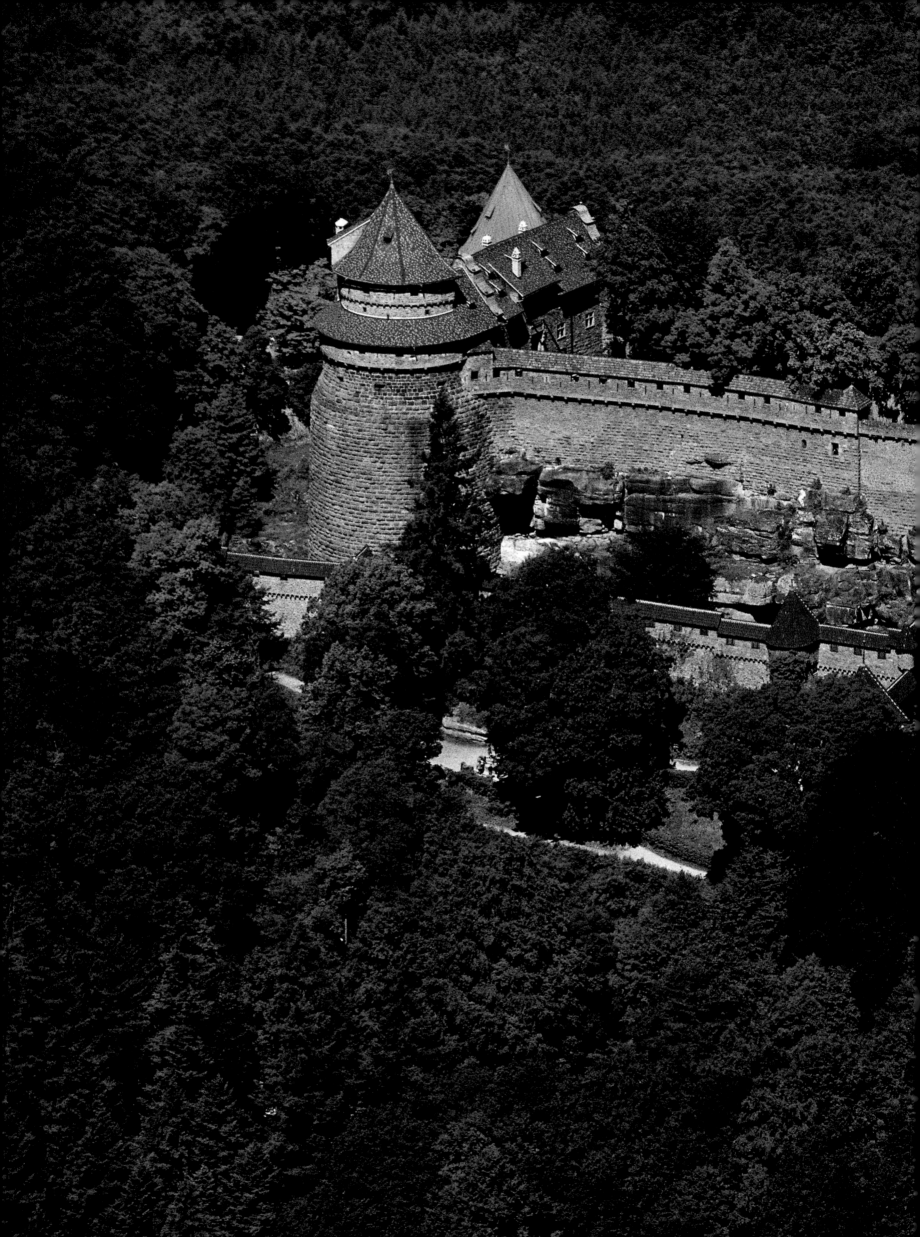

Château de Königsburg, France. 13th-15th century.

Princely residences

The most ostentatious type of French *château*, typified by those built in the Loire region of central France, began to appear at the end of the fifteenth and the beginning of the sixteenth centuries.

The most famous of all is Chenonceaux. The front portion was built between 1513 and 1521 on the bed of the river Cher, a tributary of the Loire, on the foundations of an old mill. Sold by Antoine Bohier to François I in settlement of his father's debts, the palace was then given by Henri II to his mistress Diane de Poitiers, who retained it until the death of the king. Later Catherine de Médicis, wife of Henri II, commissioned the architect Philibert Delorme to add the long building which crosses the river at the back. There are few places in the world as romantic as Chenonceaux.

The castle of Azay-le-Rideau, on the river Indre, was built on the site of a former manor house at the same time as the front portion of Chenoceaux.

The Château d'Ussé was built in the early sixteenth century: its present appearance is the result of a series of additions, beginning with the erection of the tower in 1485 and lasting until 1760; the Renaissance style has been retained throughout, however.

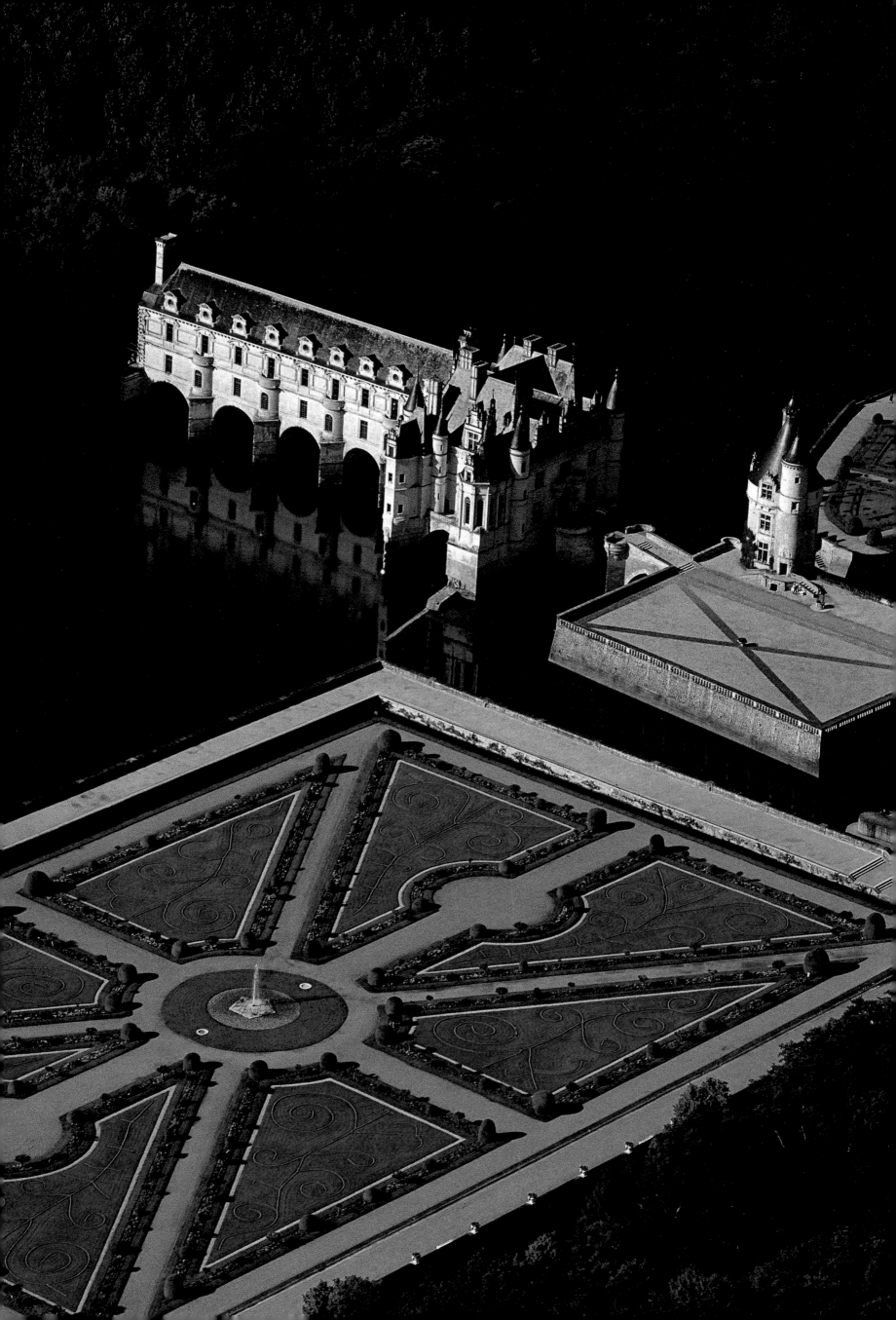

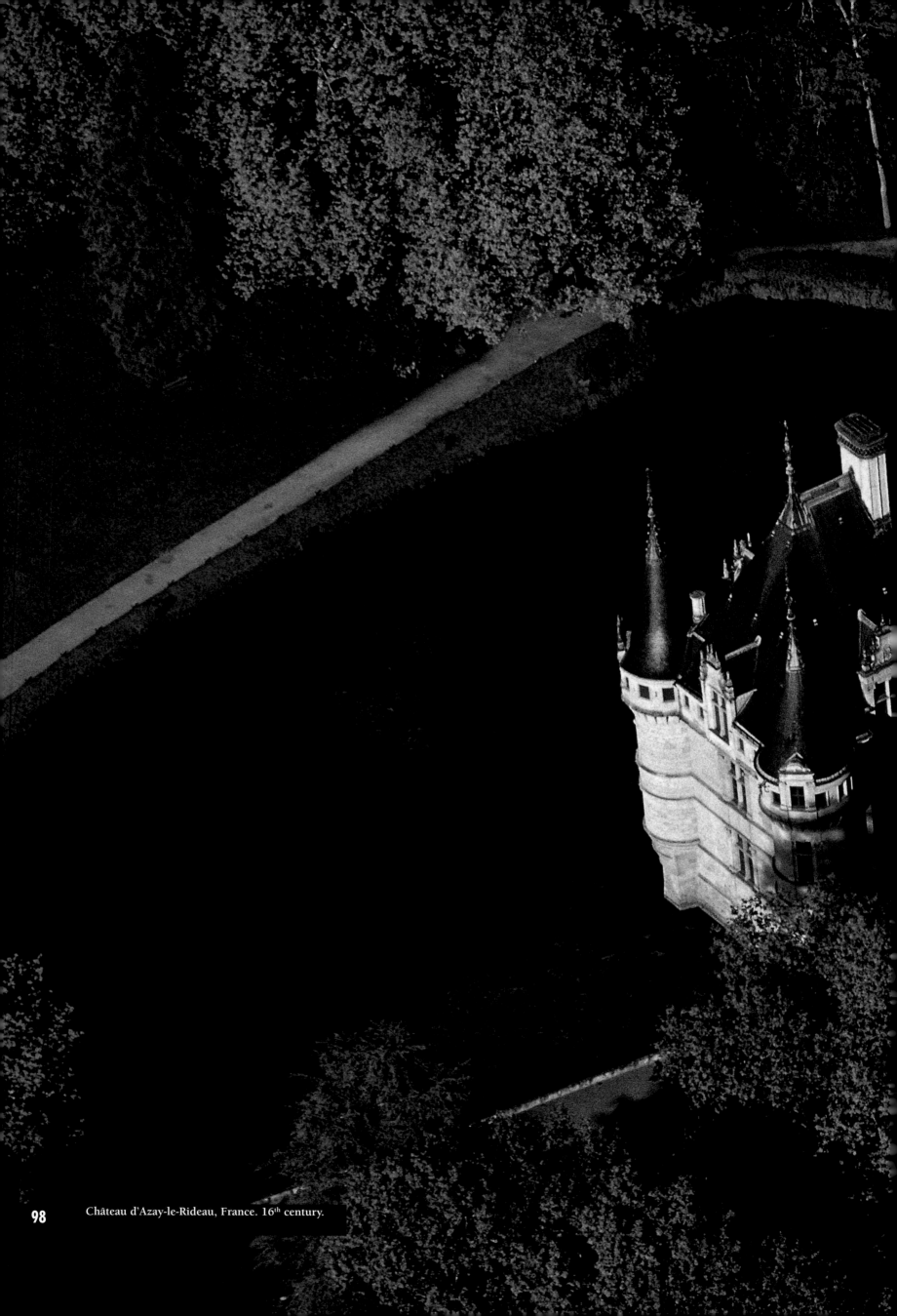

Château d'Azay-le-Rideau, France. 16th century.

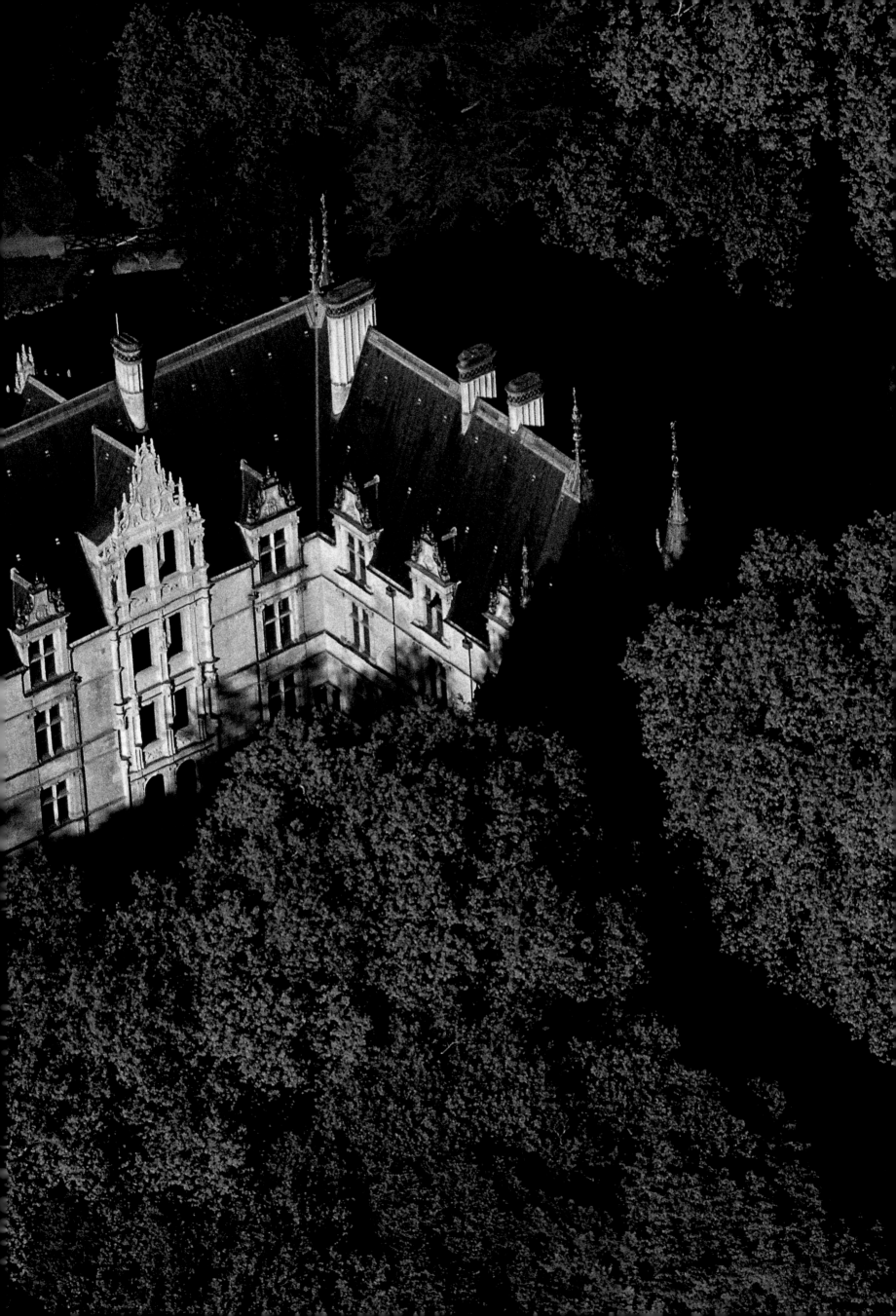

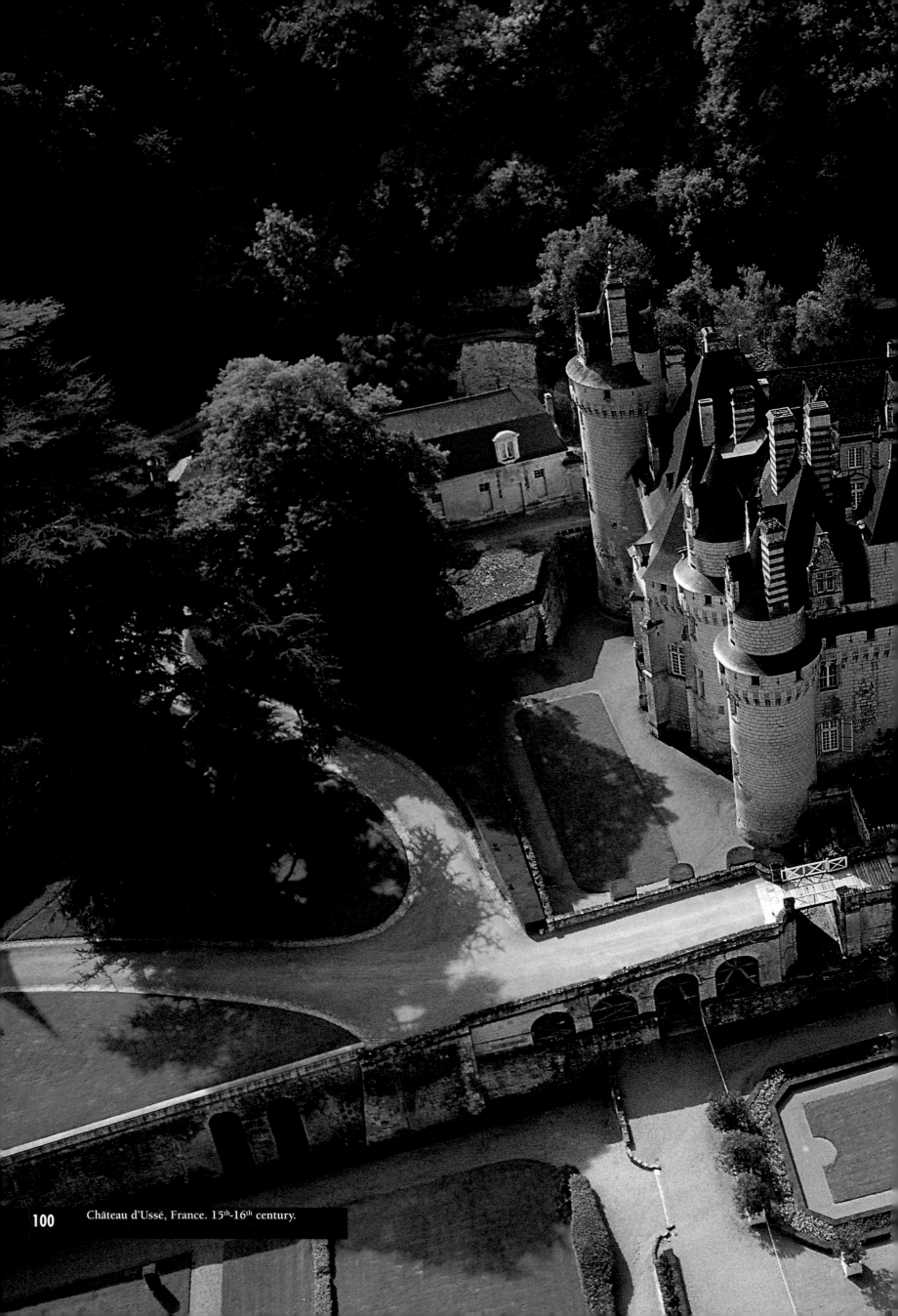

Château d'Ussé, France. 15th-16th century.

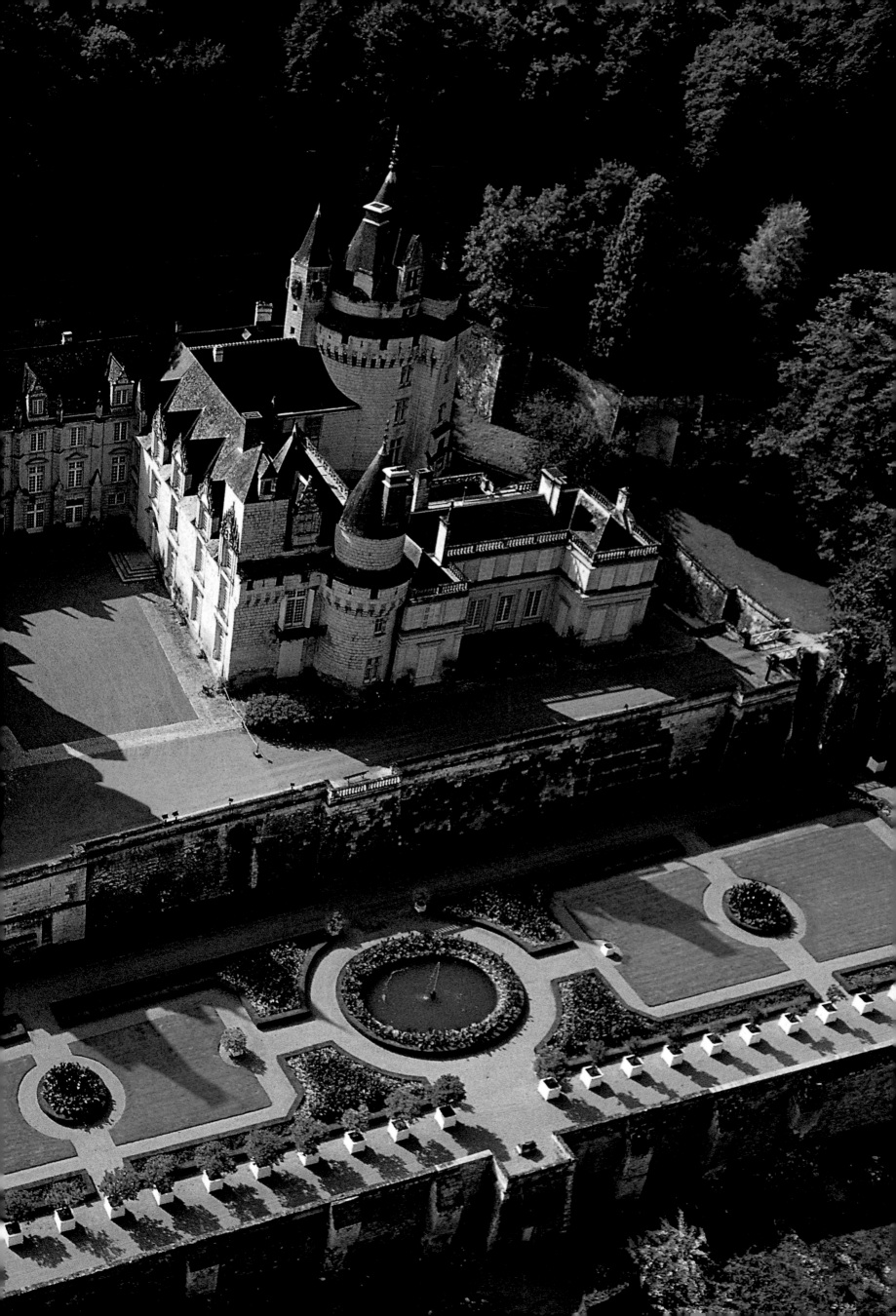

Great Britain

English folklore, and even the history of England, teem with legends and stories connected with some castle or manor house: these are summed up in the myth of Avalon and King Arthur. Here as in France the administration of the island has always been linked to land ownership and the feudal hierarchy. In addition, the story of Britain is littered with battles between contesting leaders, and the unification of the country, in the relative security provided by the surrounding sea, often unleashed ferocious skirmishes and reprisals.

A decisive turning point was reached in the eleventh century, at the time of William the Conqueror, and one of its consequences was that numerous large military buildings were constructed to ensure the control of the territory. Examples are the Tower of London (see p. 144), Dover Castle (see pp. 198 and 200), and Warwick Castle on the banks of the River Avon; although legend has it that this castle was begun in 915 by Ethelfreda, daughter of Alfred the Great, it was in fact built at the command of William the Conqueror in 1068. Its present shape is the result of a series of additions and enlargements, all completed before the fifteenth century.

Manor houses with open courtyards and fortified farms, of which a fine example is Stokesay Castle on the Welsh borders, were supplemented by compact, heavily defended structures with curtain walls reinforced by cylindrical towers, moats and crenellated roofs.

Charlecote Castle faces the River Avon between Warwick and Stratford. It was built in the Elizabethan style between 1551 and 1558 and was embellished in the eighteenth century by the addition of a typical English park designed by Lancelot "Capability" Brown; the building was completely remodelled in the nineteenth century.

Stokesay Castle, Great Britain. 13th century.

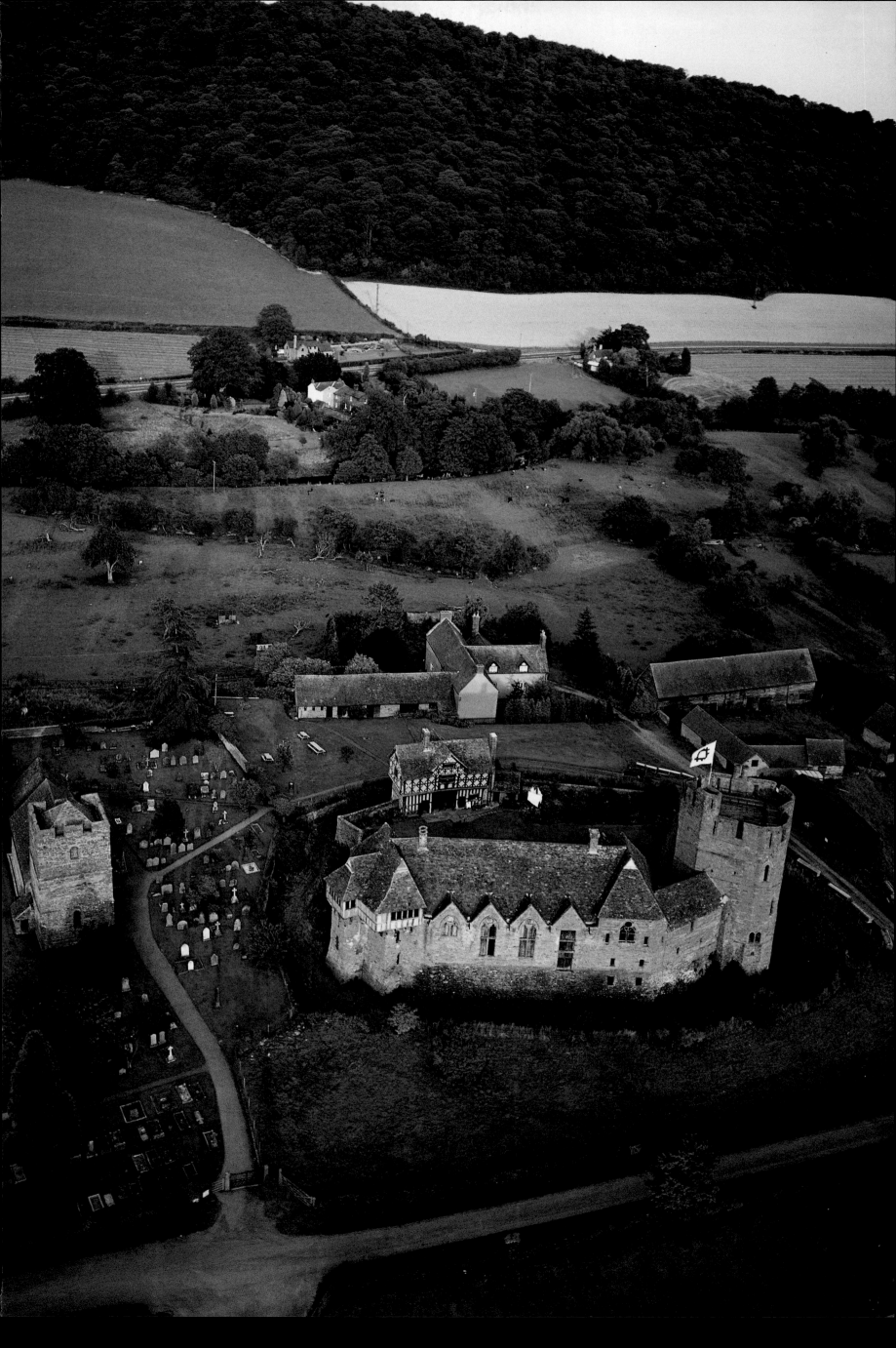

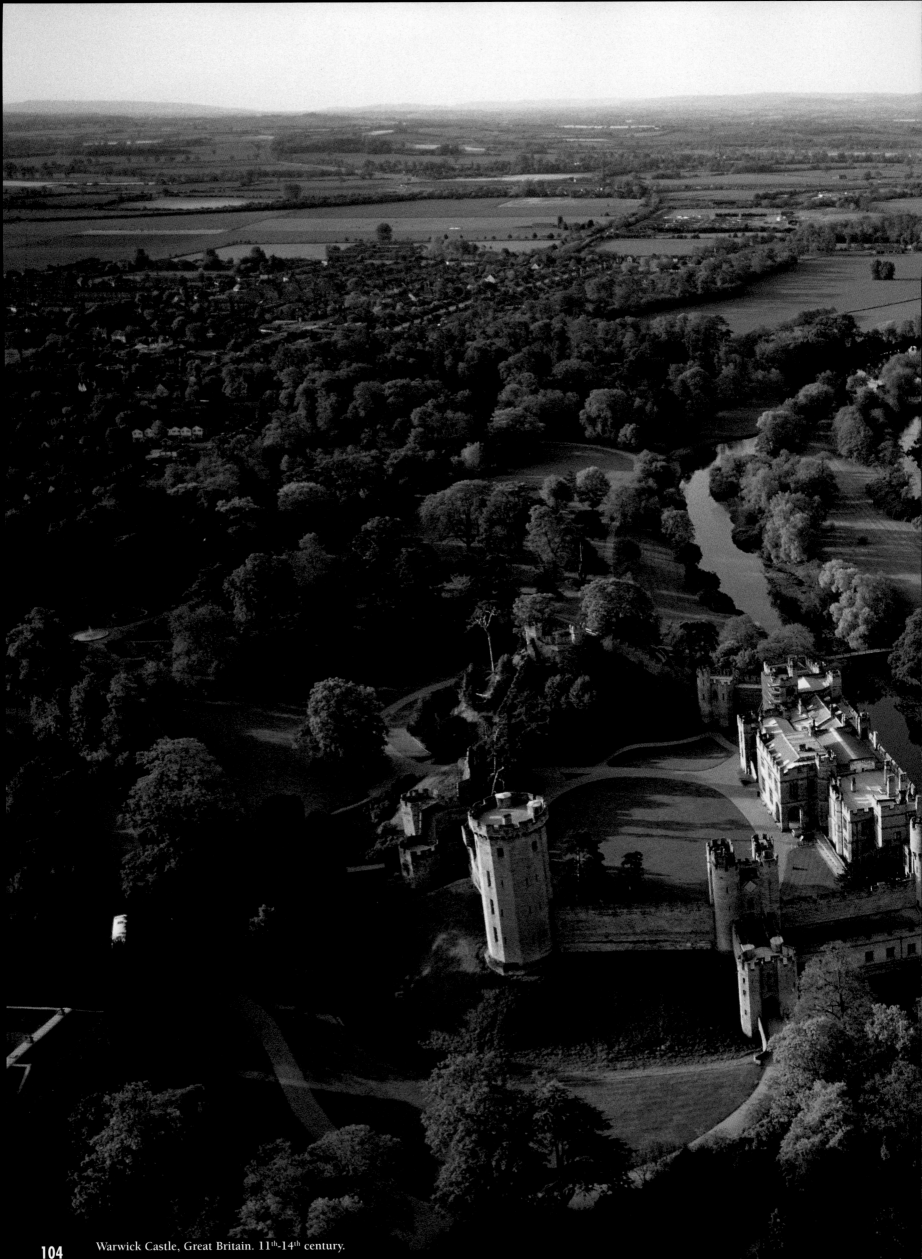

Warwick Castle, Great Britain. 11th-14th century.

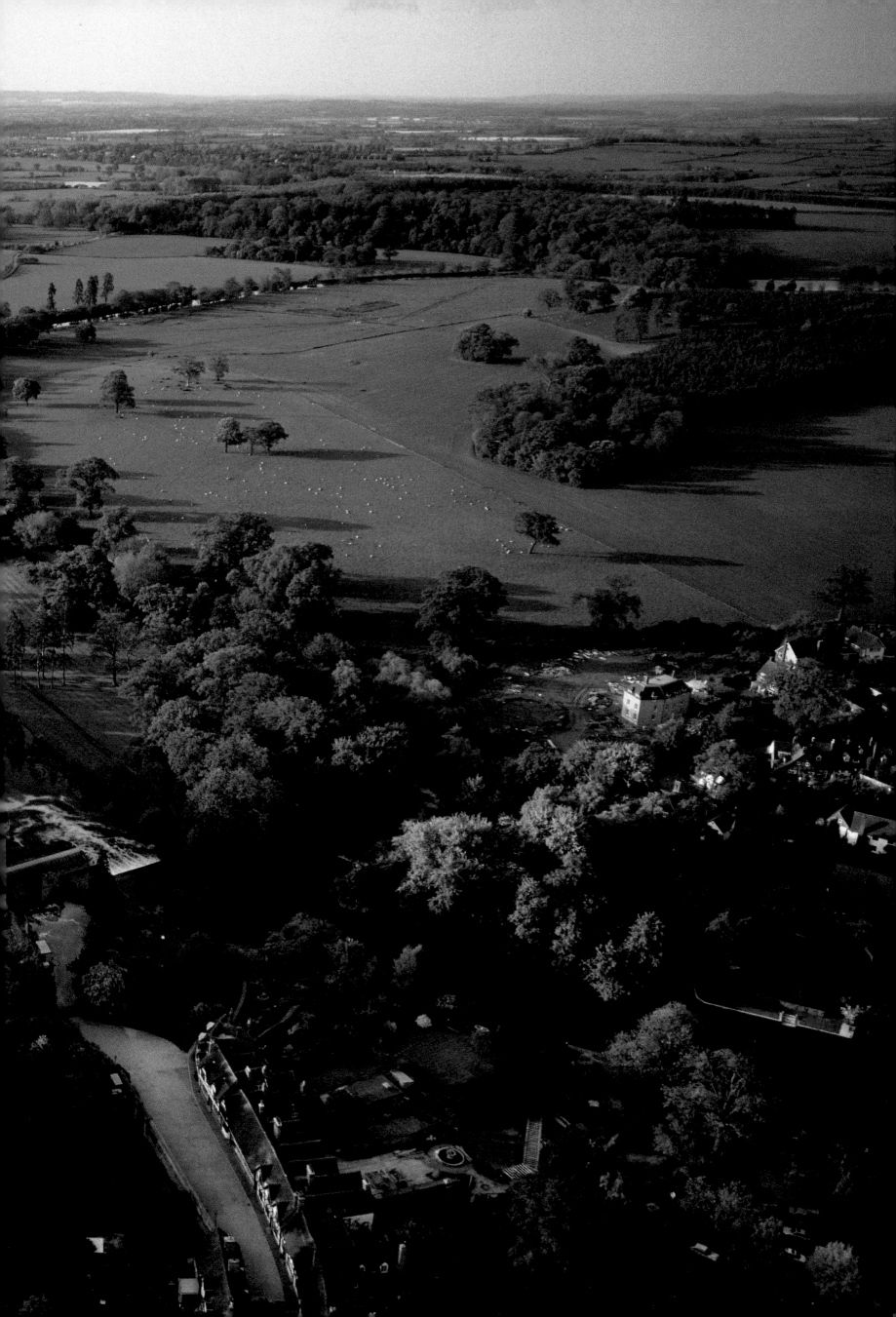

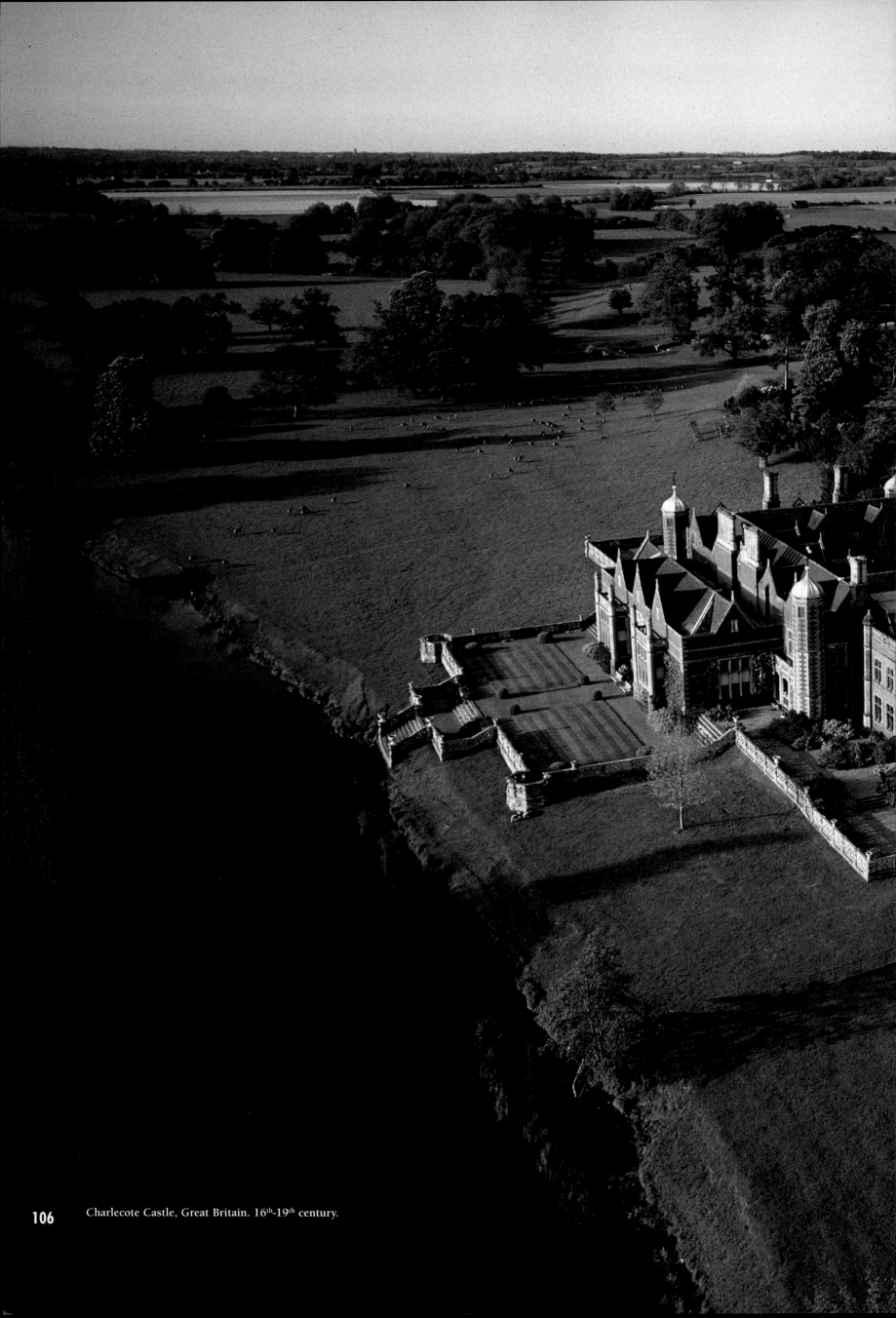

Charlecote Castle, Great Britain. 16th-19th century.

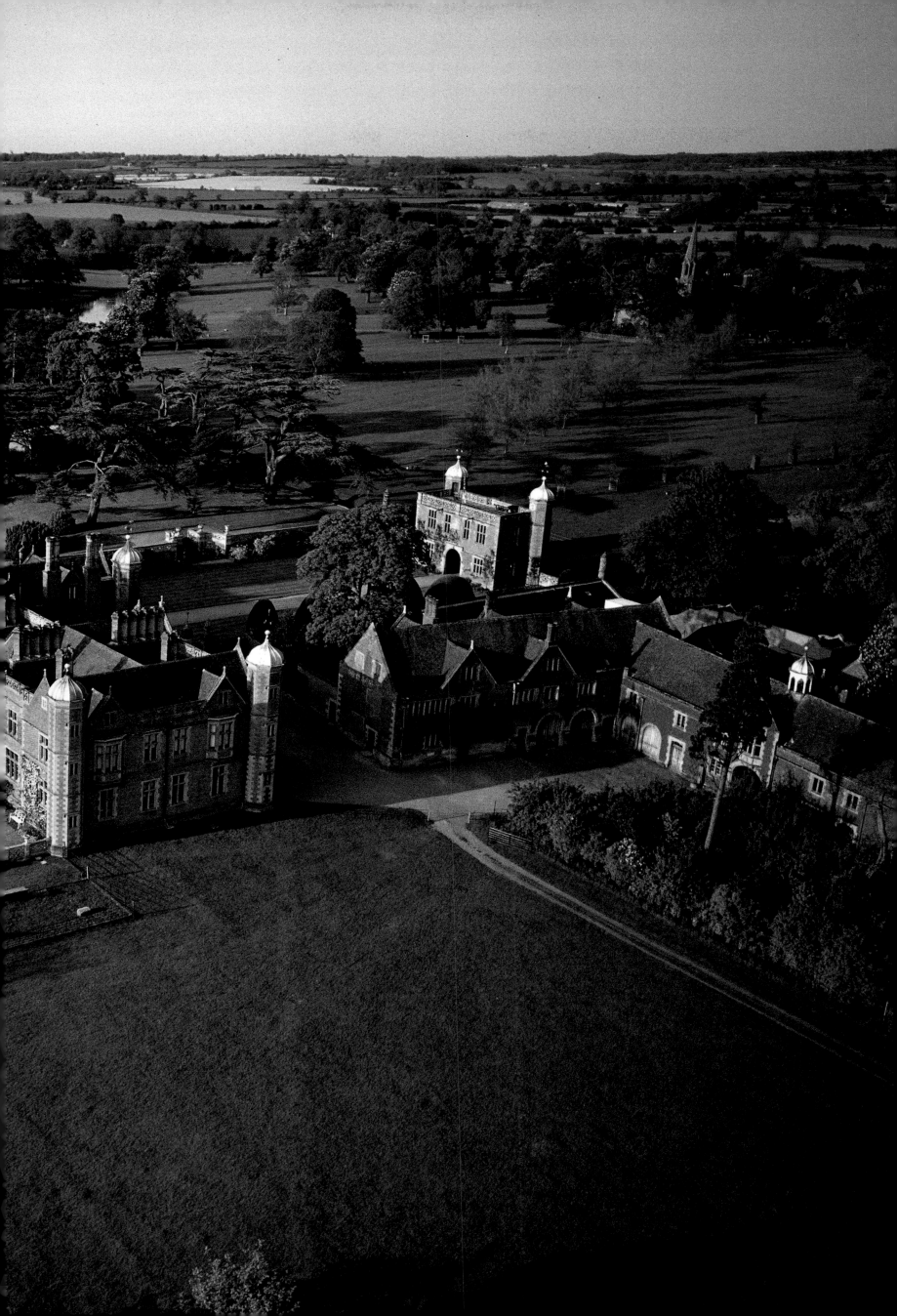

Castles on water

After the thirteenth century, the quadrilateral castle built around a courtyard with cylindrical towers at the corners and large keeps or buildings in located at mid wall became increasingly common. These often emerged from a pool of water, which was crossed by means of an embankment with a drawbridge at the end.

In some cases, as at Caerphilly in Wales, the castle is surrounded by terraced bastions.

Although these buildings became more refined as the years went by, the basic plan did not change; in fact it survived until the fifteenth century. On the page opposite are the romantic ruins of Bodiam Castle, built in 1385 in the centre of an artificial pond.

Fourteenth-century Herstmonceux Castle has alternating quadrilateral and cylindrical towers; while the Gothic manor house known as Hever Castle, seat of the Boleyn family (Anne Boleyn was probably born there) until bought and restored by the Astors in the early twentieth century, has a large castellated tower to protect the entrance and a covered bridge to connect the back of the castle with the village.

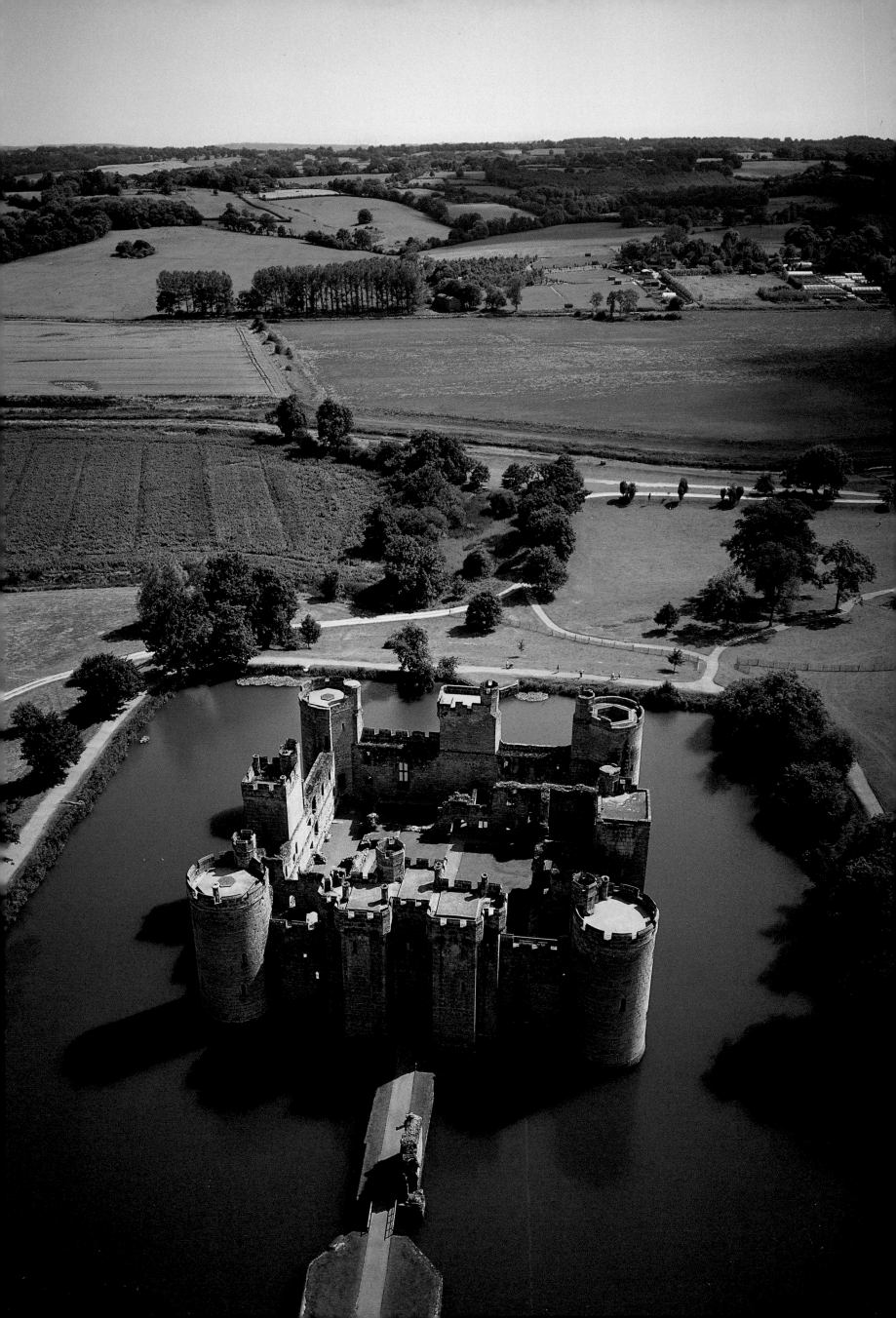

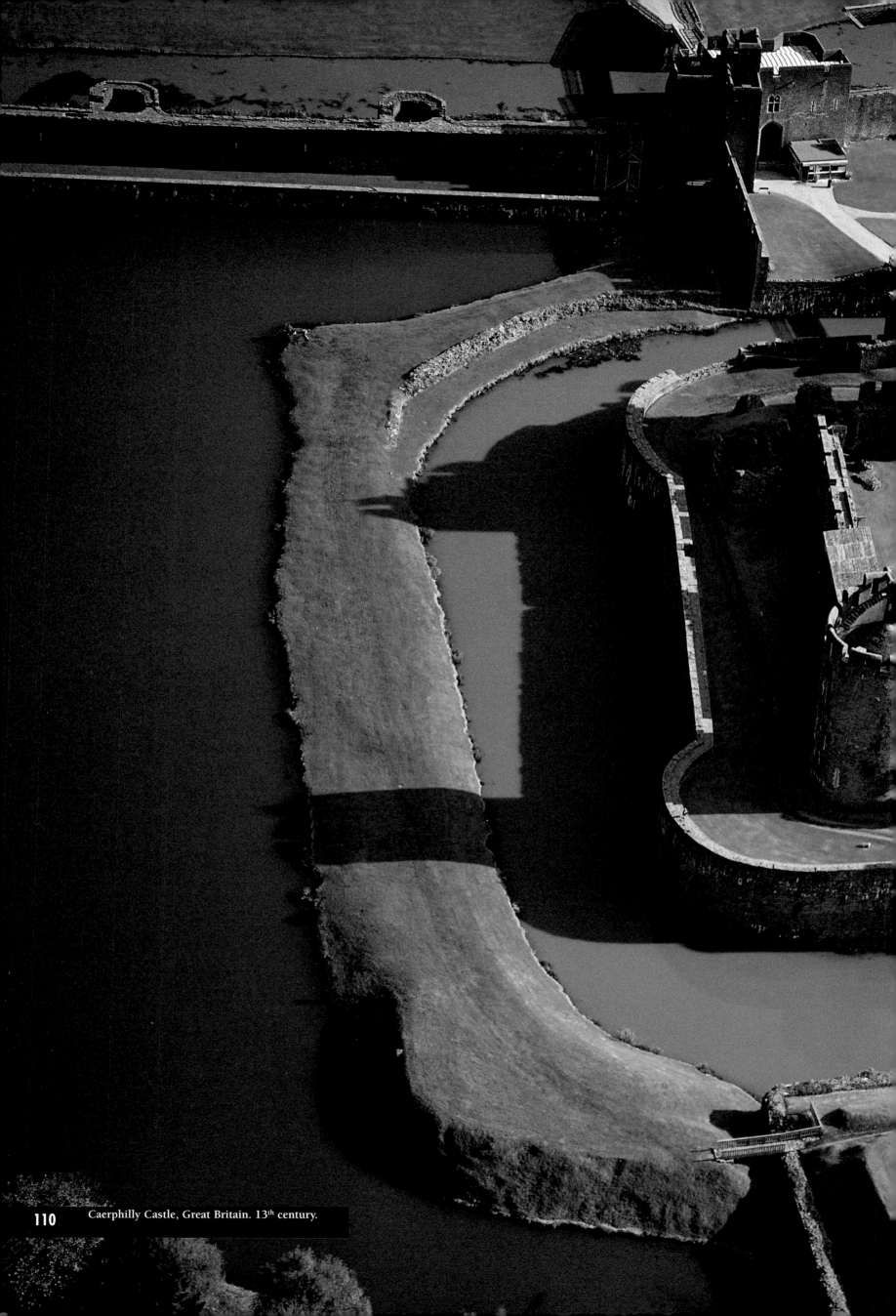

Caerphilly Castle, Great Britain. 13th century.

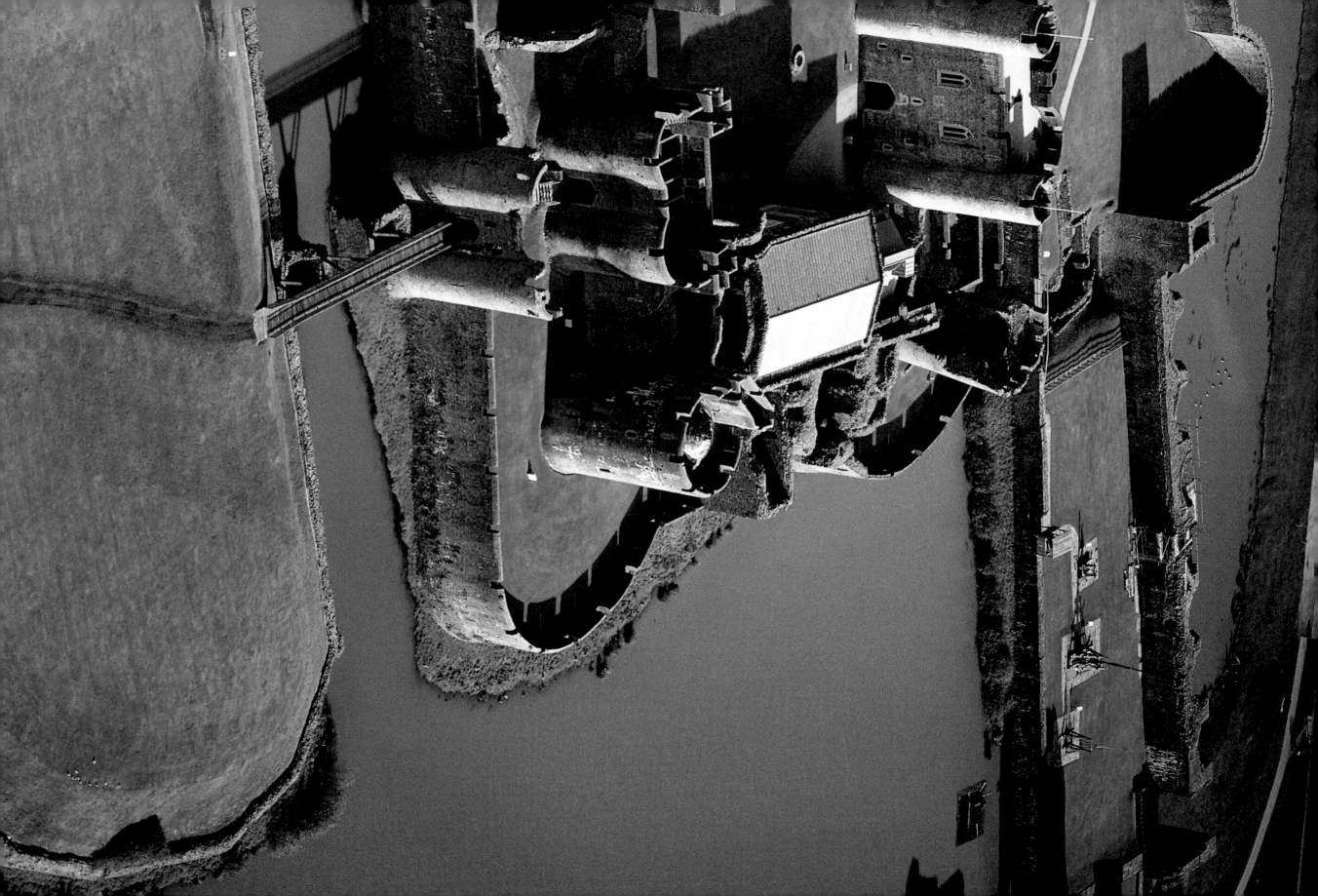

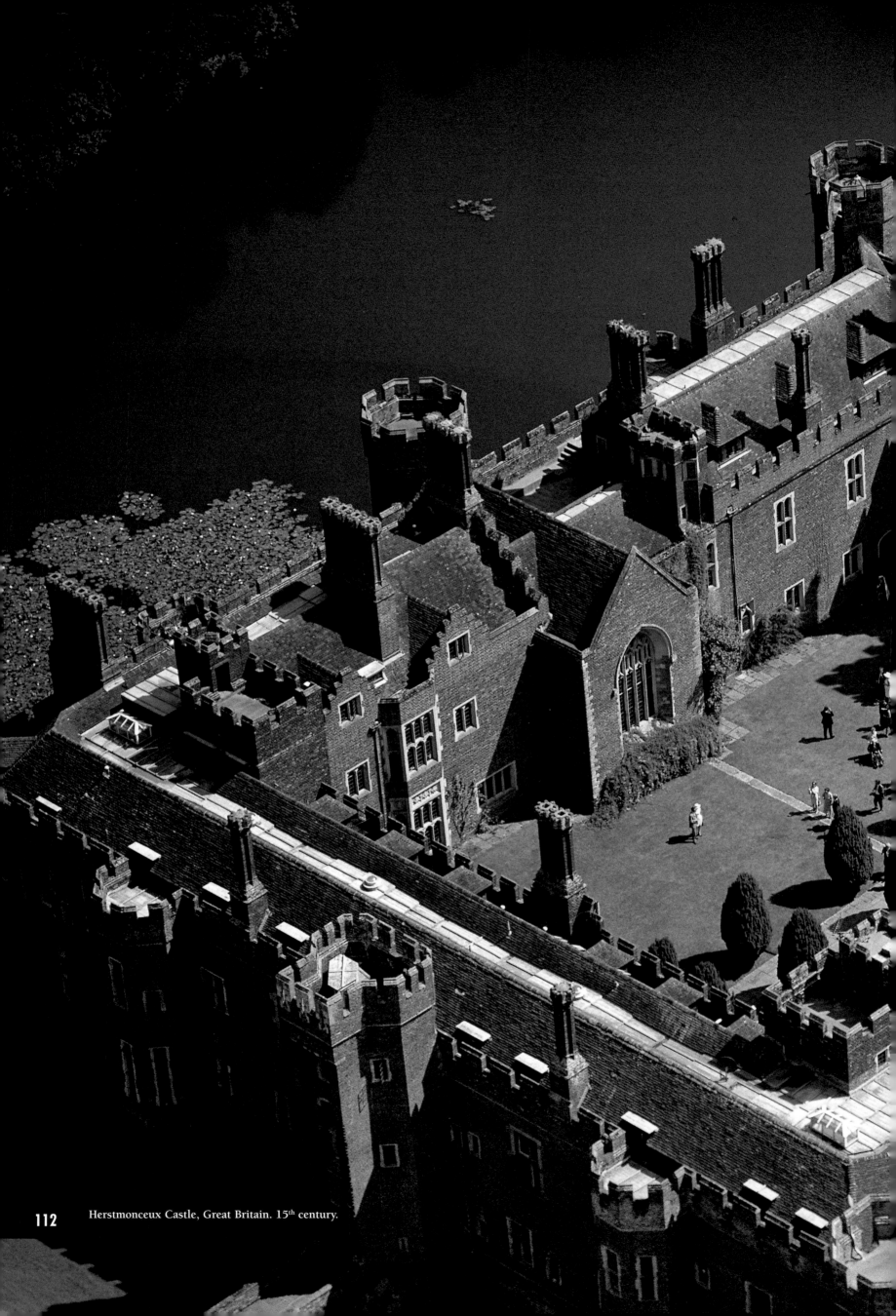

112 Herstmonceux Castle, Great Britain. 15th century.

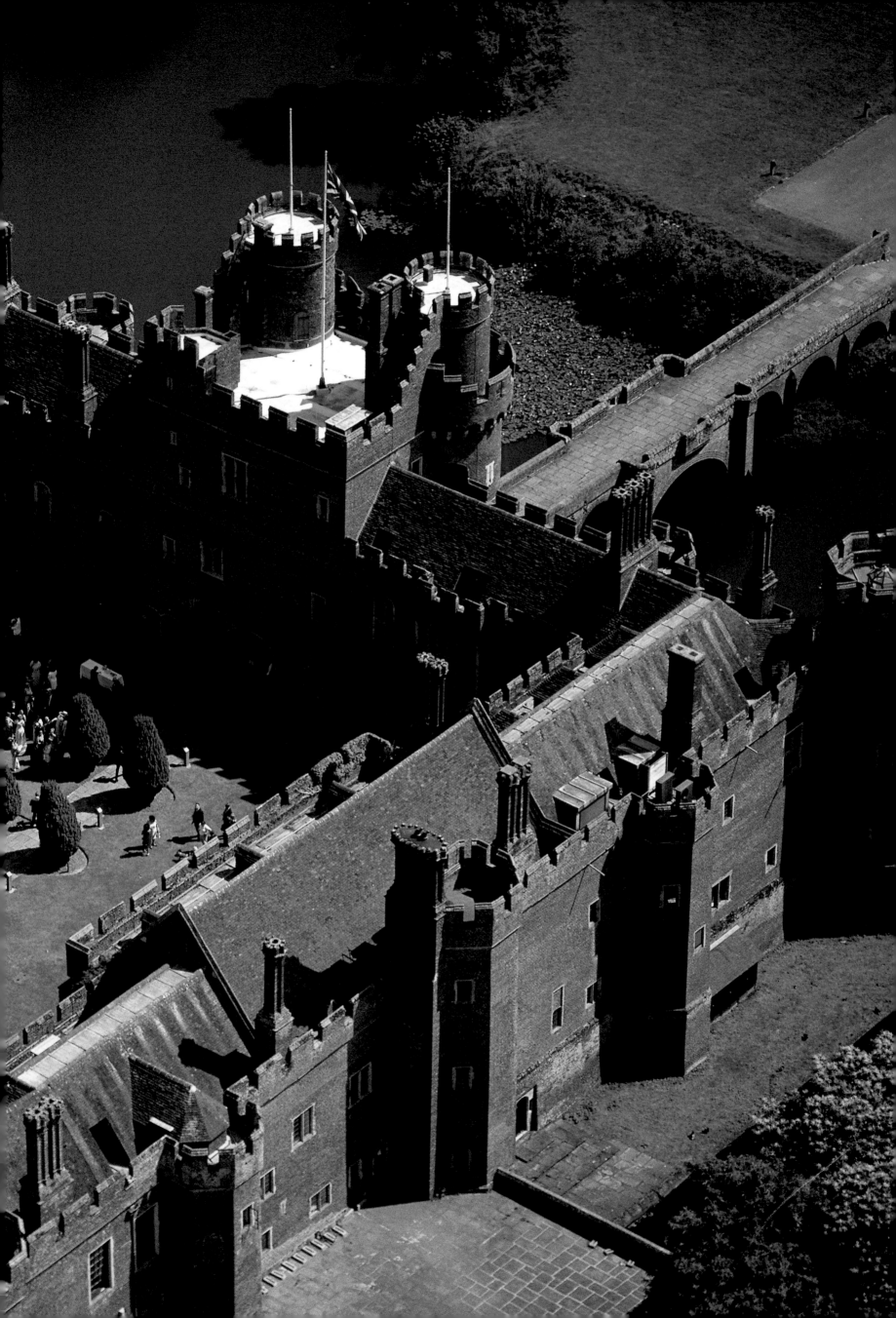

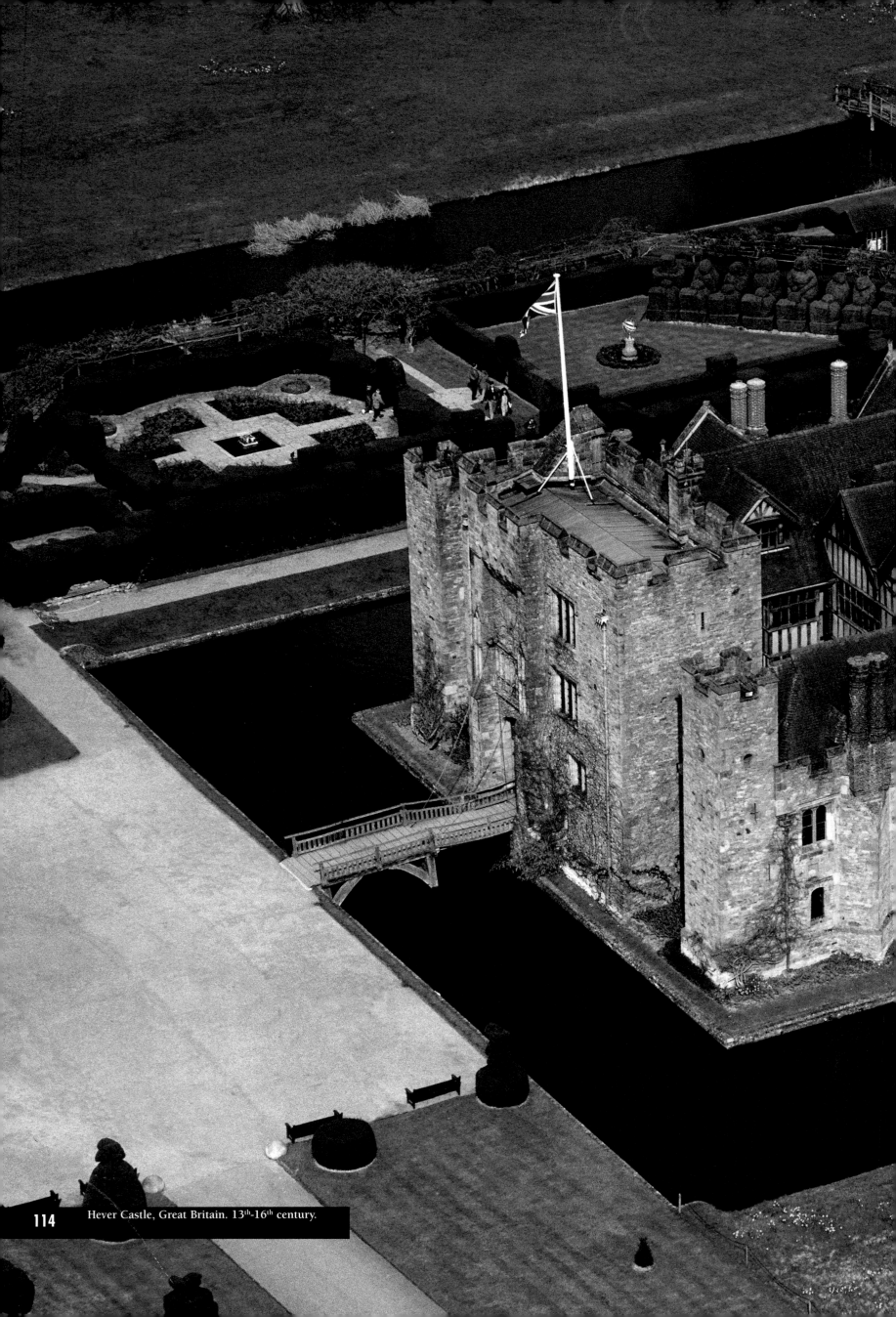

Hever Castle, Great Britain. 13th-16th century.

Epilogue

The English nobleman's house soon developed into a luxurious residence, abandoning the characteristics proper to a castle. This took place partly because the territory became relatively secure (from the sixteenth century on), and partly due to the influence exercised by the classical designs of Andrea Palladio which enjoyed remarkable popularity in England. This did not however prevent costly alterations being made to ancient manor houses in the nineteenth century, as at Belvoir Castle in Leicestershire; the results were romantic but not very historically convincing. The nineteenth-century revival afflicted the whole of Europe and a large number of buildings in the mediaeval style were erected.

The construction of large mansions in England allowed a wide diversity of styles to be tried out: the Gothic tradition and Palladian classicism somehow managed to survive and to co-exist.

This is reflected in the terms used to describe houses: words such as *manor, house, mansion* or *castle* often fail to reflect the exact characteristics of the buildings to which they refer. It sometimes appears that the choice of words is linked to history rather than to any correspondence with this or that type of building.

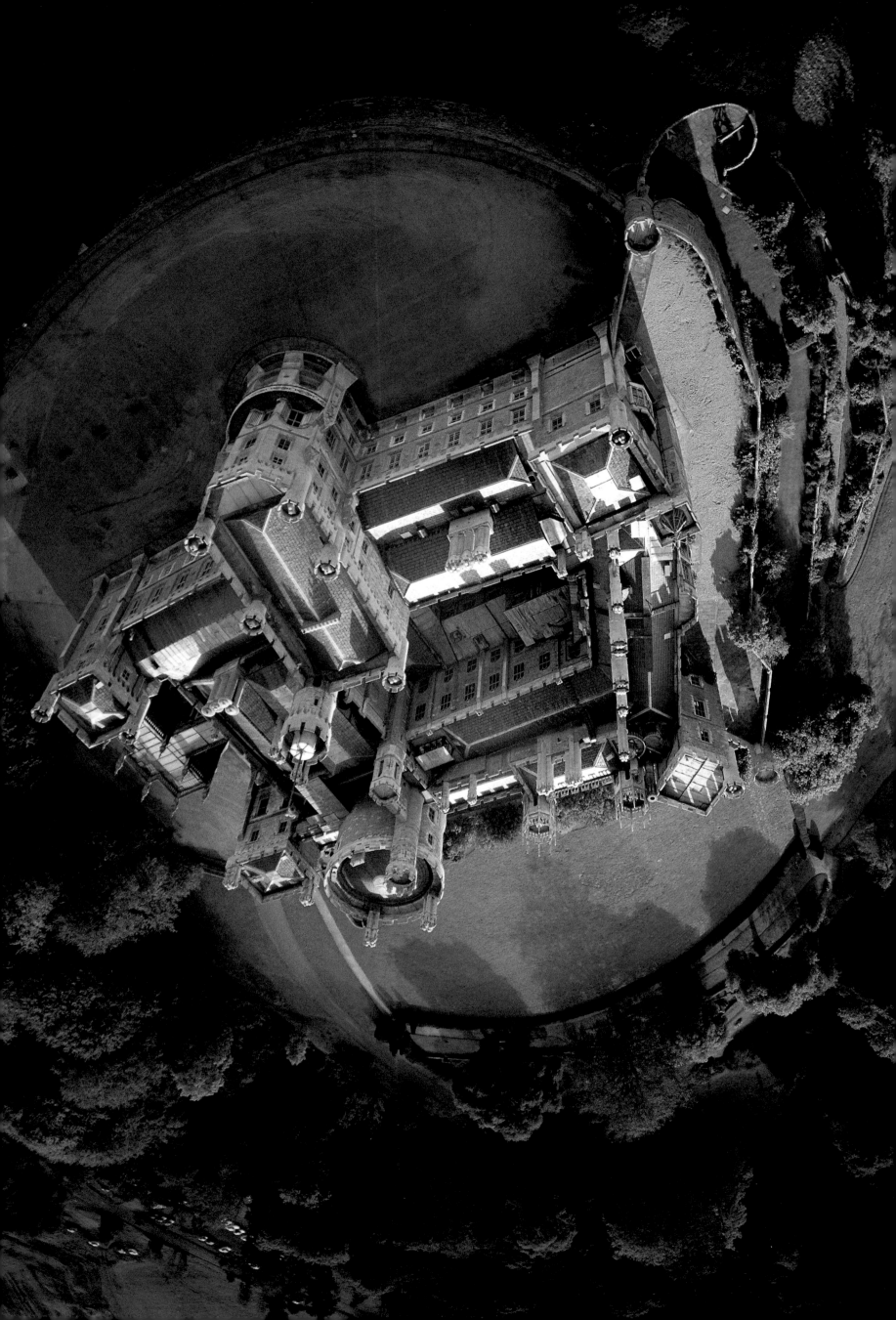

The German-speaking regions

In the Middle Ages and early modern period the vast region lying between the borders of the kingdom of France to the west and the Slav population to the east, the Baltic to the north and the Alps to the south was divided into various principalities and grand-duchies which together constituted the nucleus of the Holy Roman Empire. Some of these, for example Bavaria, Bohemia, Saxony and Brandenburg, played a determining role in the balance of power; some of the other territories which appeared temporarily on the scene were to have a crucial role to play in the future, for example Austria and Prussia. The internecine power struggles and the relationships with other emerging European powers meant that German castle architecture retained the basically defensive appearance that had characterised it at the outset. Almost invariably, German castles consist of imposing, weighty structures with battlements and often also very steeply pitched roofs.

Their elevated position made it difficult to build towers at each corner to observe and defend access routes to the castle. However, security was assisted by the steepness of the approach roads. With only a few exceptions, they possessed only one or two tall towers, either quadrilateral or cylindrical, with conical or pyramidal roofs to modify the austere appearance of the buildings. There were often small towers and platforms as well. In the early stages, simple structures predominated with a single cylindrical tower, as at Biedenkopf and St. Goarshausen (Schloss Maus). An atypical (and in some respects exceptional) case is Schloss Thurandt, a collection of buildings of different dates and aspects, visually unified by the presence of two tapering towers.

Kufstein am Inn (Austria) and Stahleck am Rhein (Germany) are both massive fortresses perched above the river.

Harburg and Coburg are like fortified citadels: the first includes administrative and residential buildings plus a church within its high walls; the second is more of a fortress with fortified slopes or glacis rising to the terrace at the top where the buildings of the princely residence are to be found.

The castle of Maus, St. Goarshausen, Germany. 14th century.

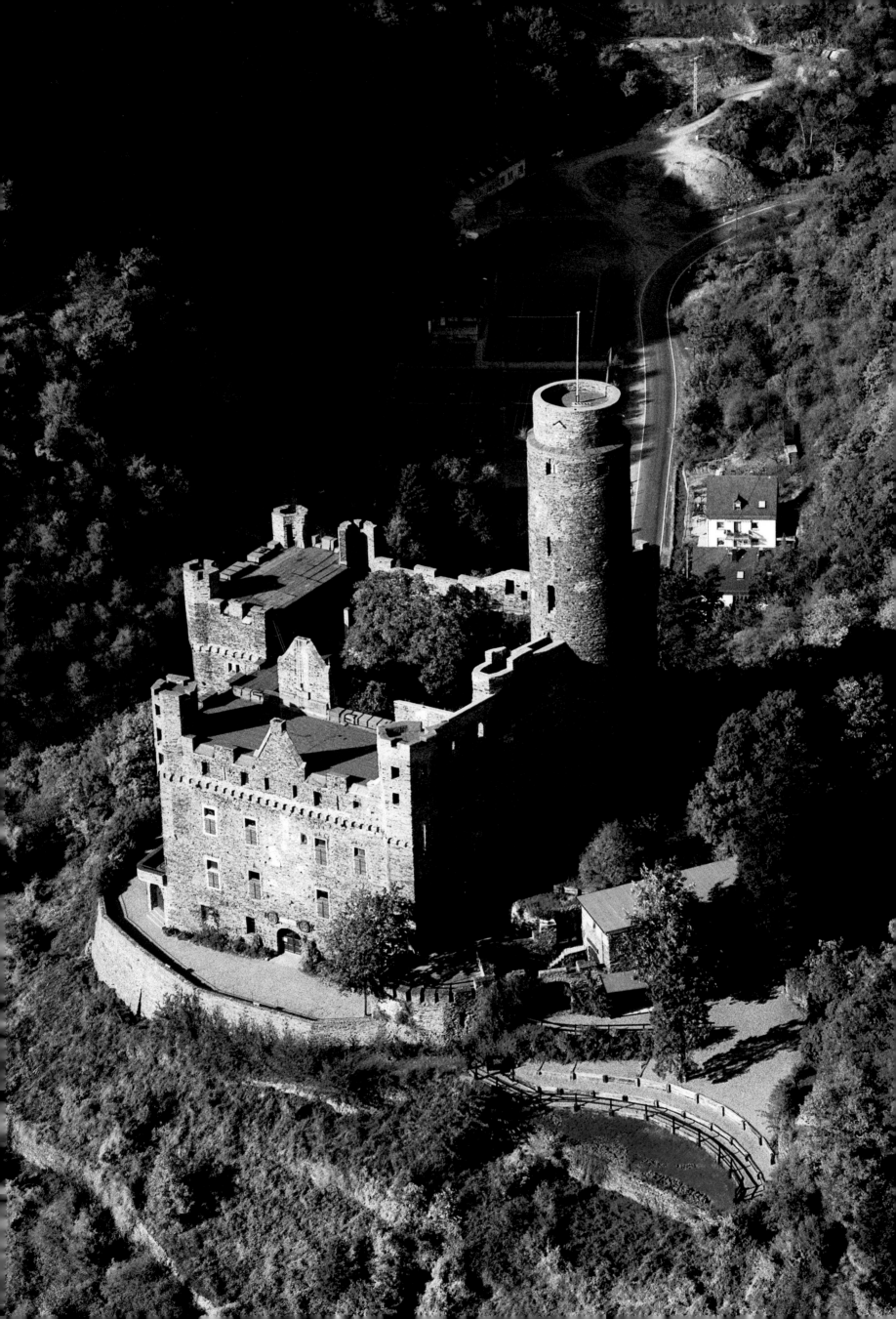

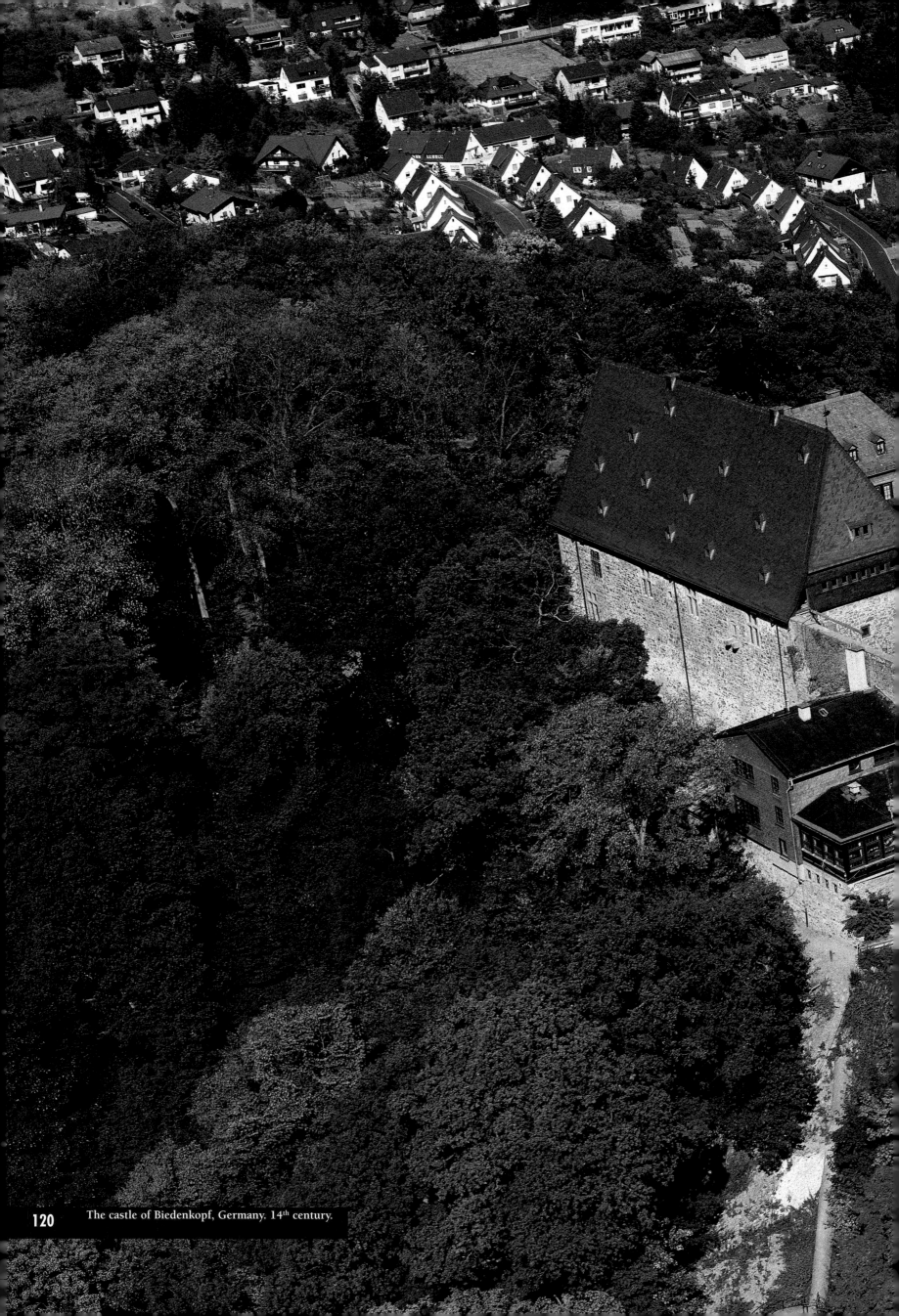

The castle of Biedenkopf, Germany. 14th century.

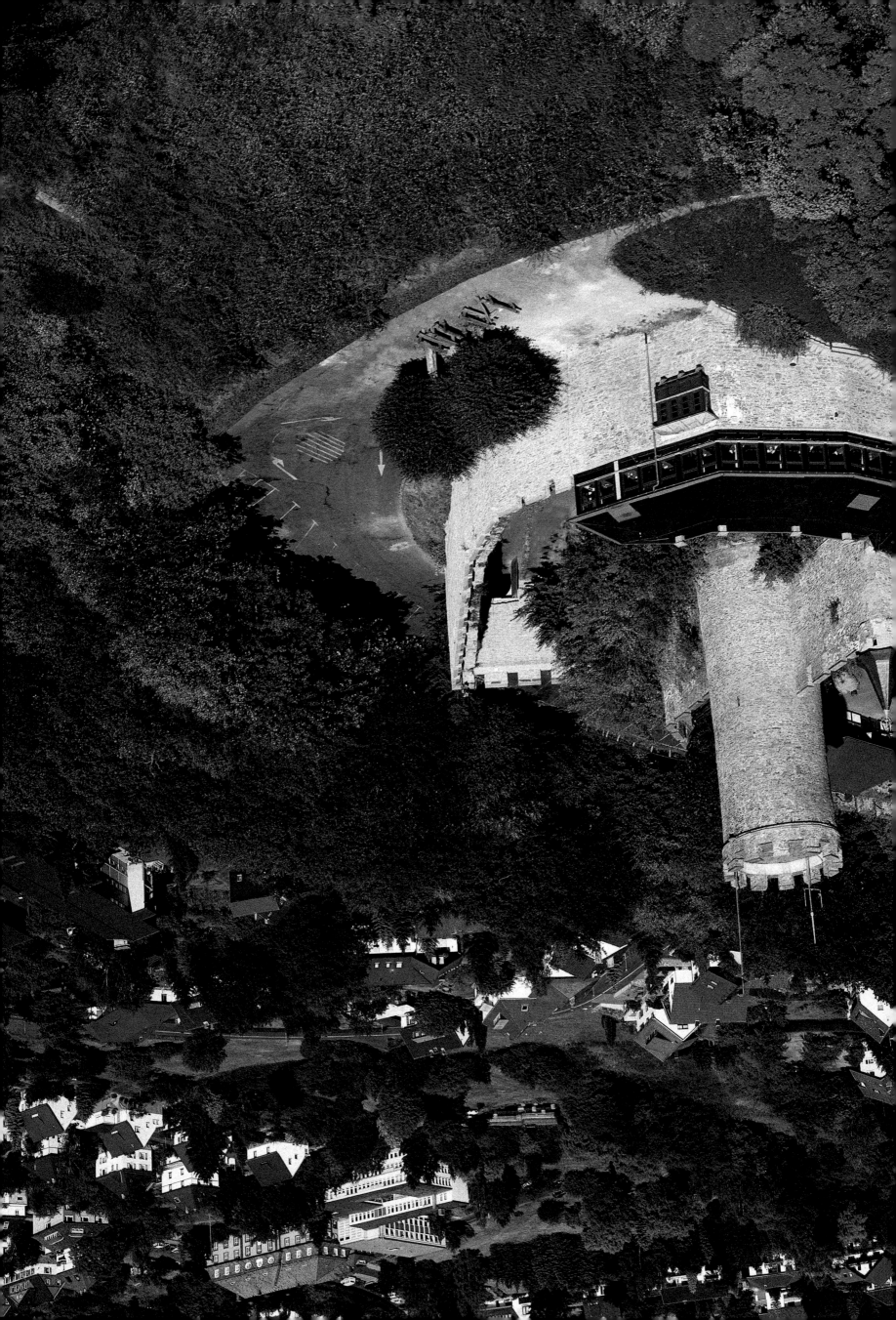

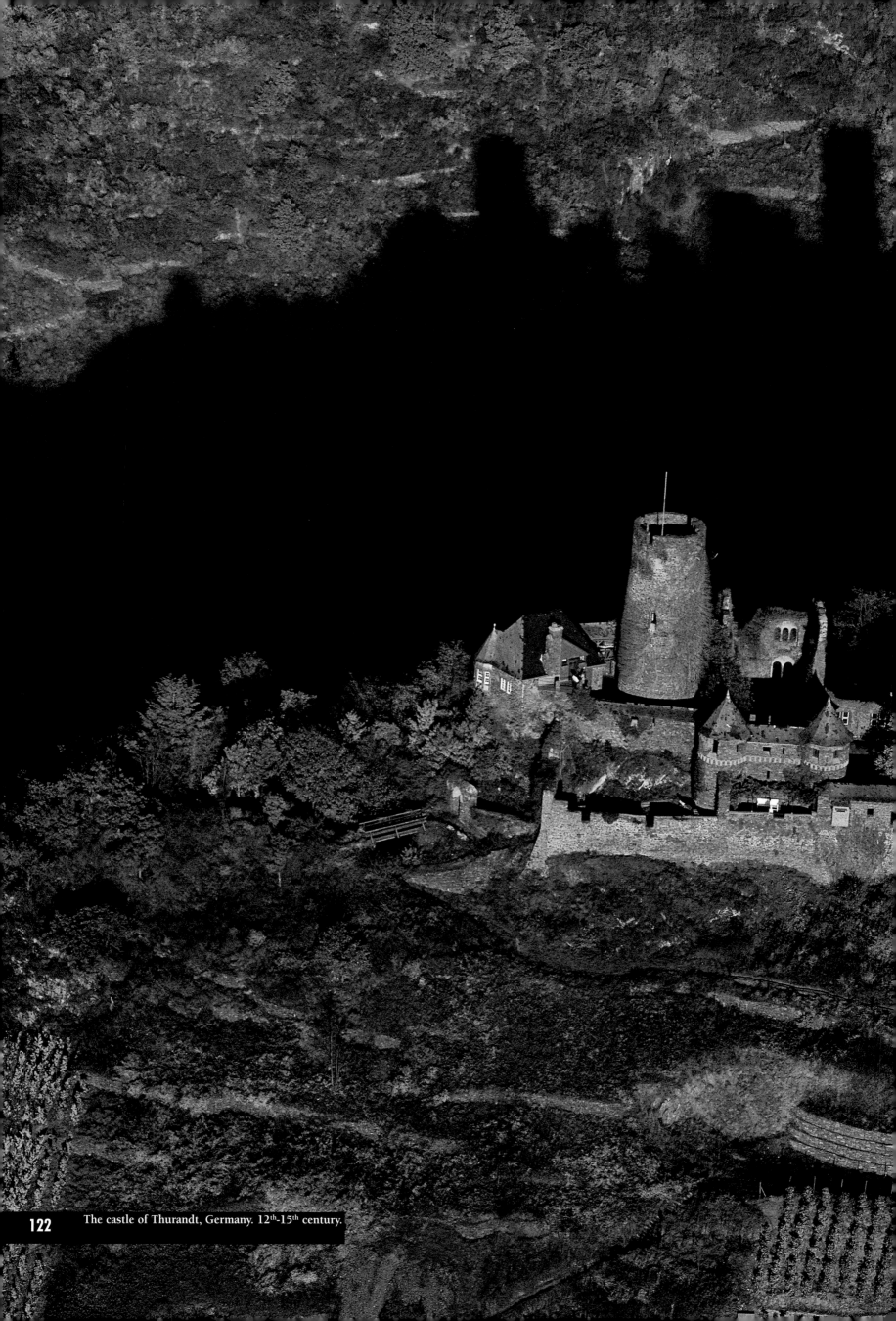

The castle of Thurandt, Germany. 12th-15th century.

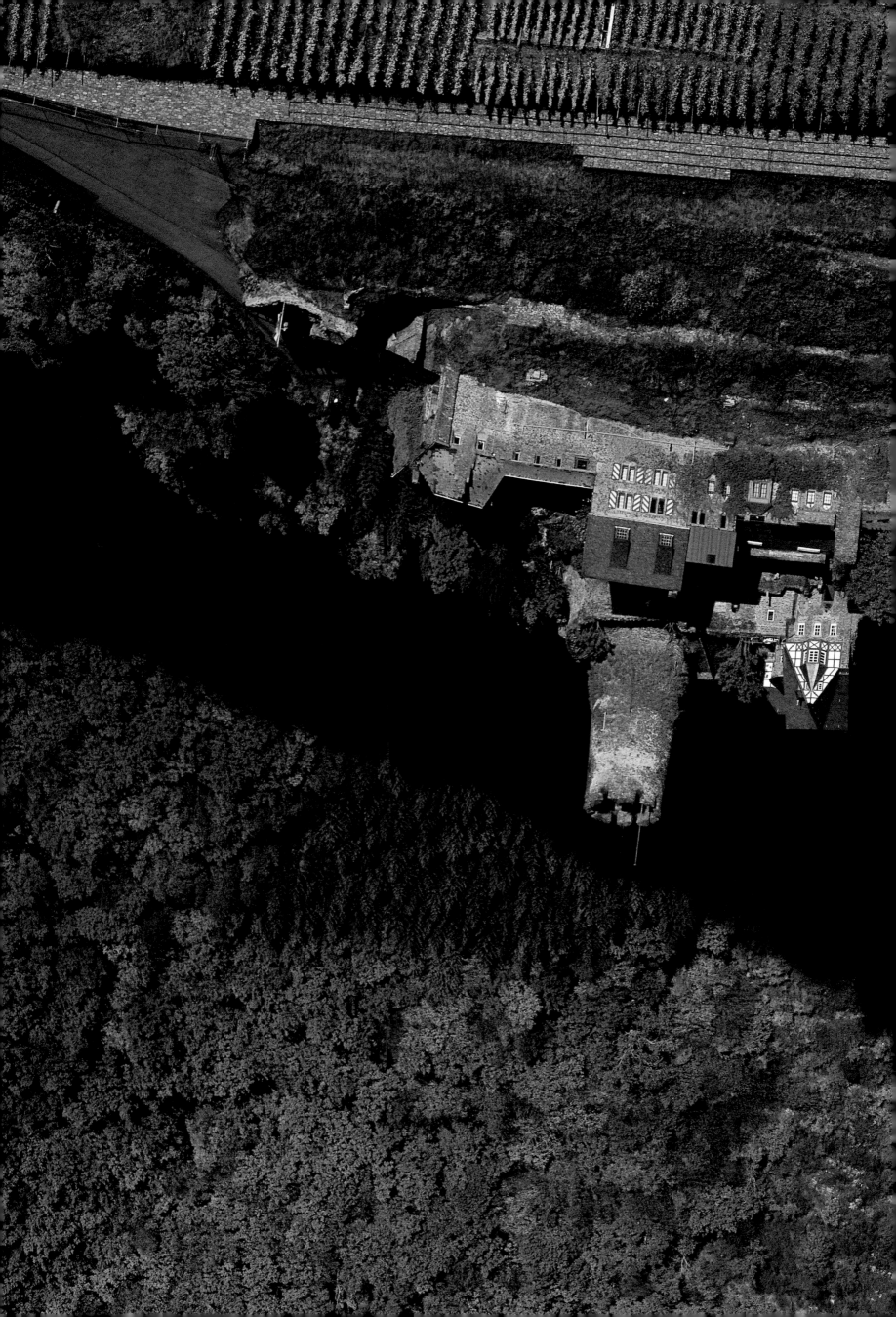

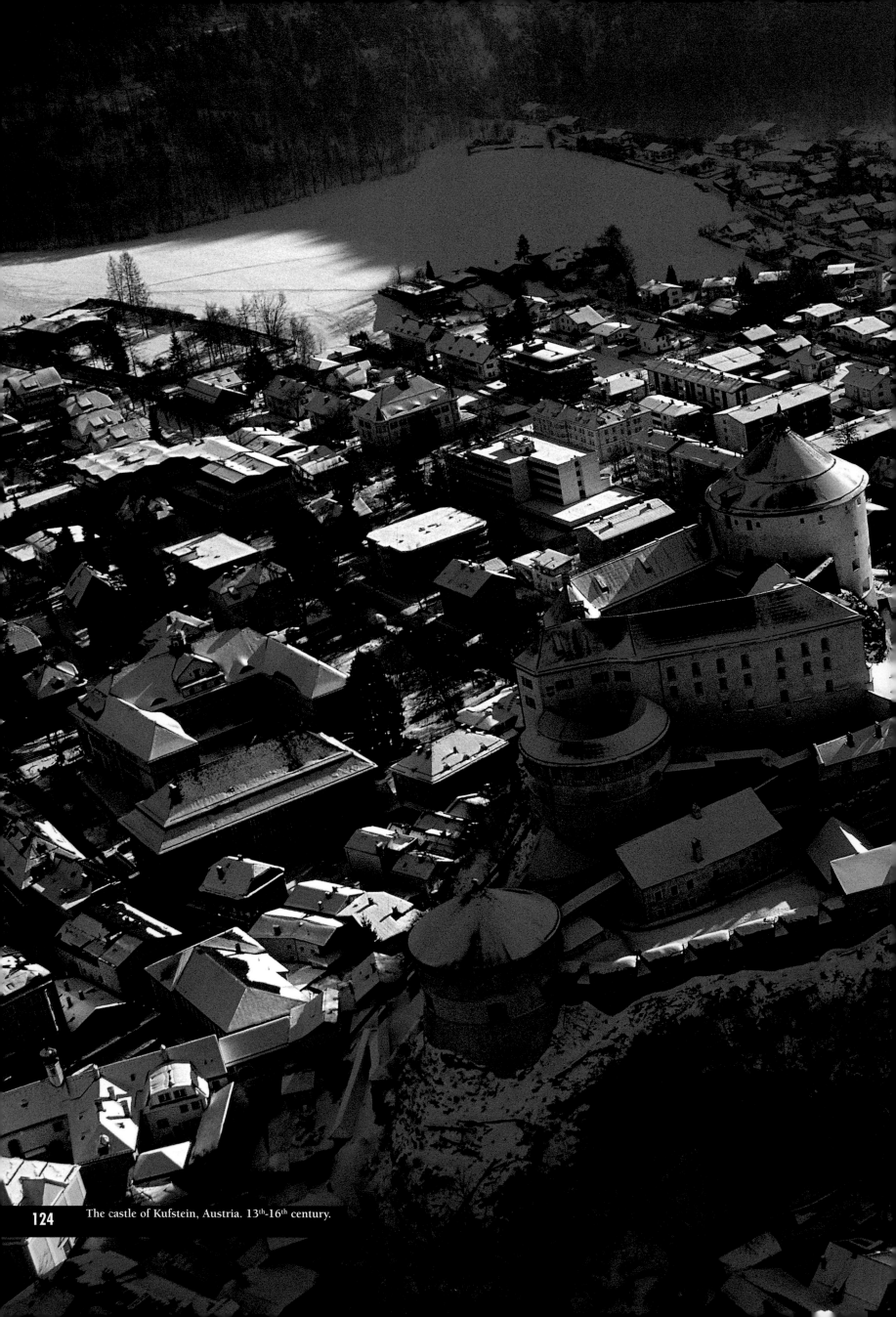

The castle of Kufstein, Austria. 13th-16th century.

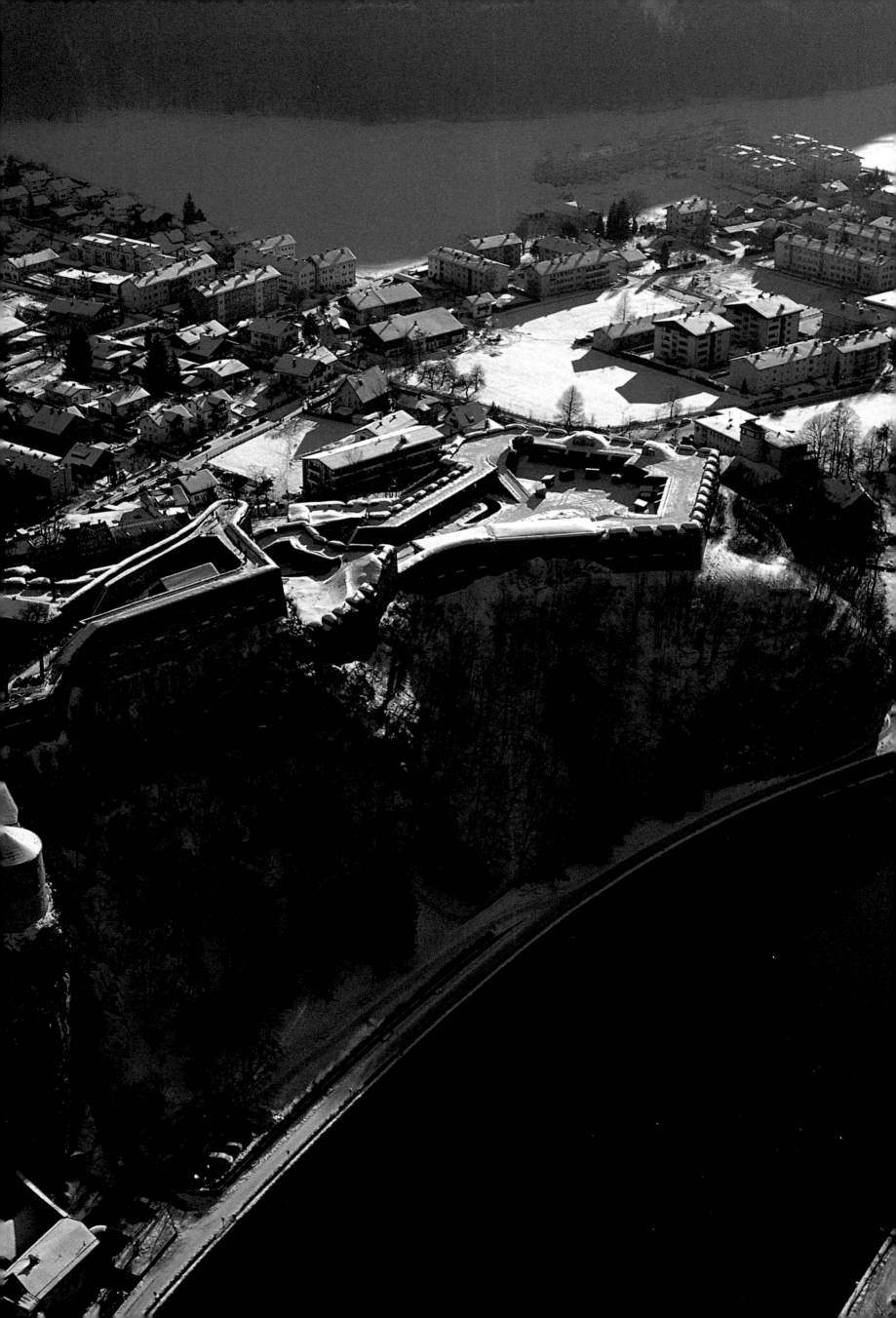

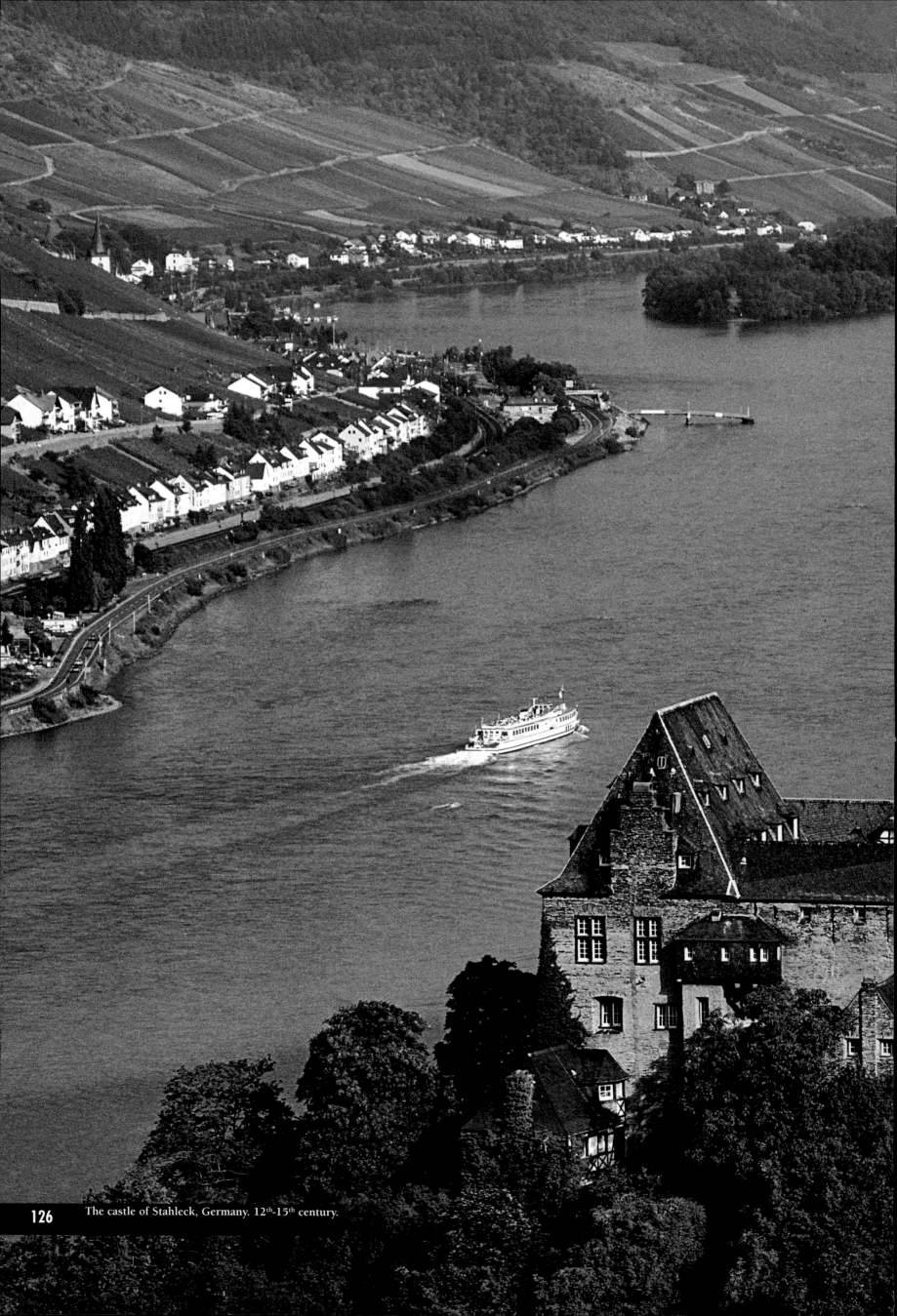

The castle of Stahleck, Germany. 12th-15th century.

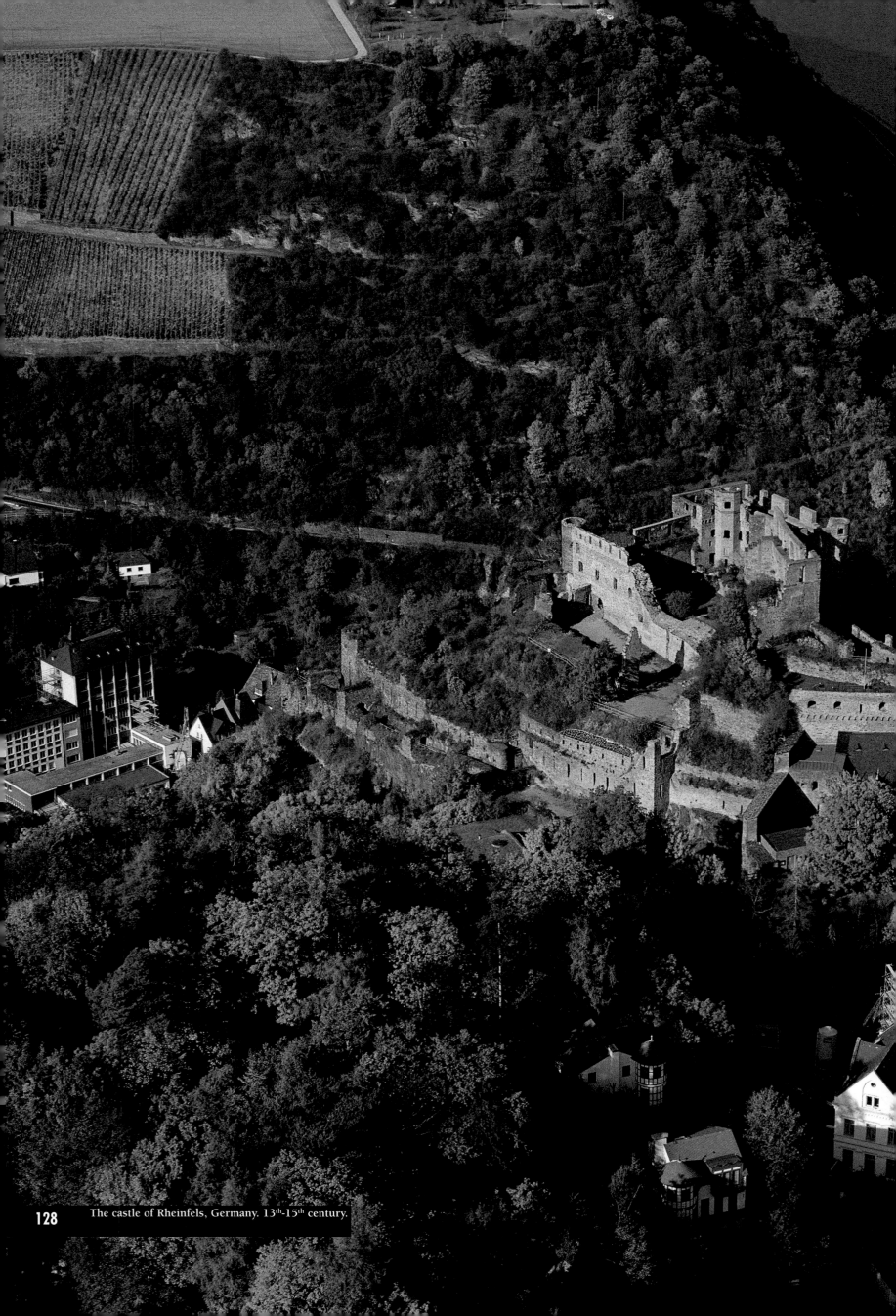

The castle of Rheinfels, Germany. 13th-15th century.

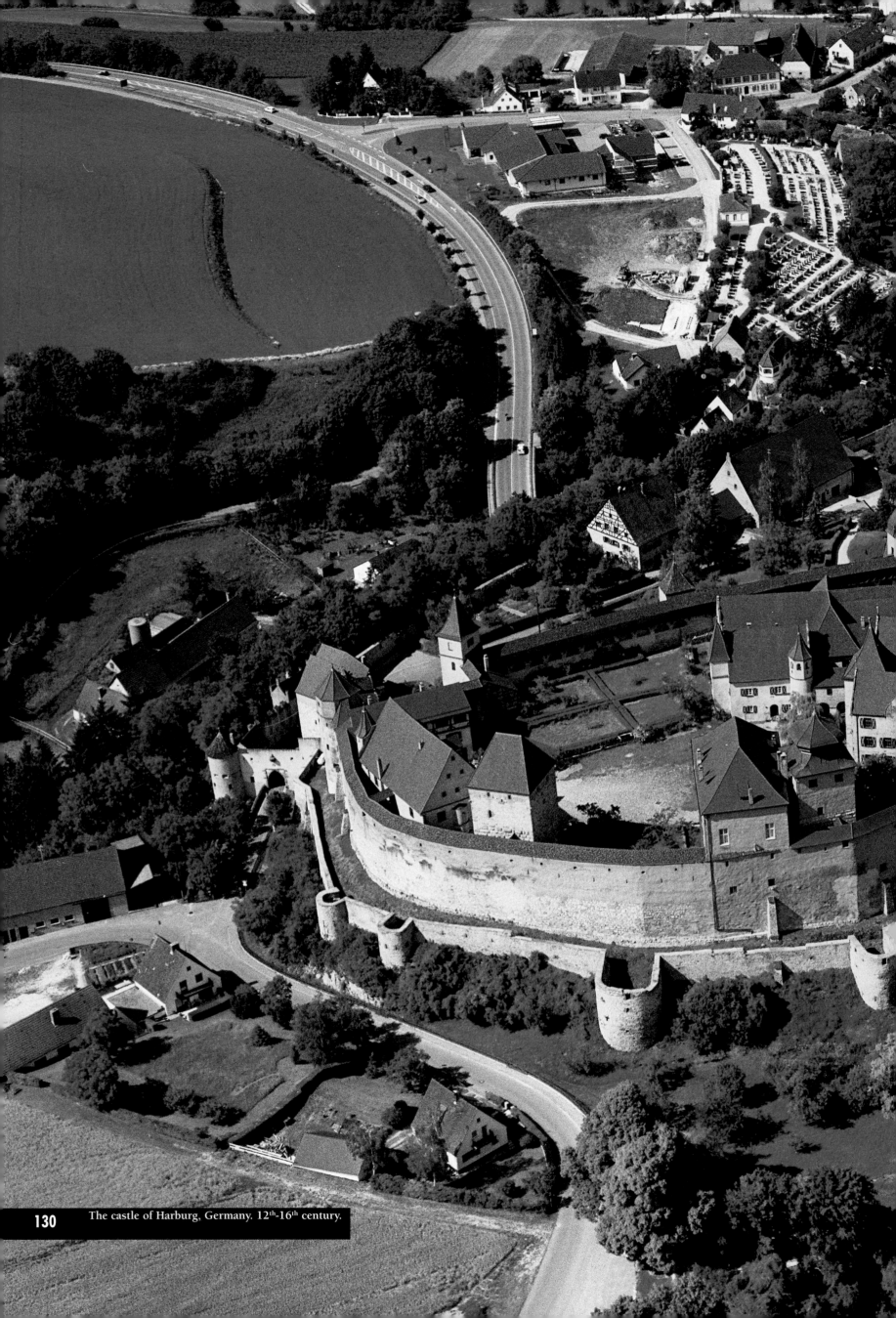

The castle of Harburg, Germany. 12th-16th century.

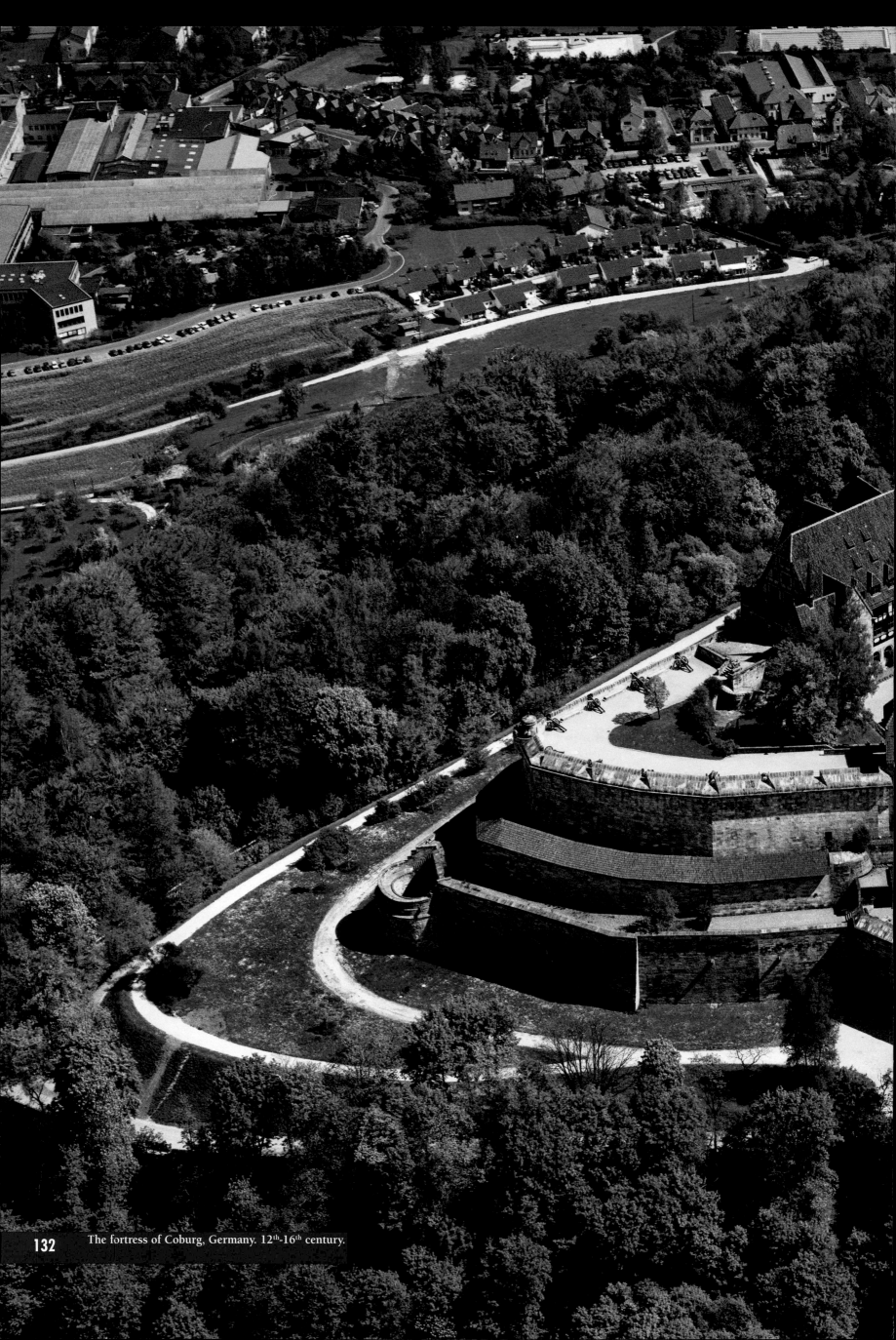

The fortress of Coburg, Germany. 12th-16th century.

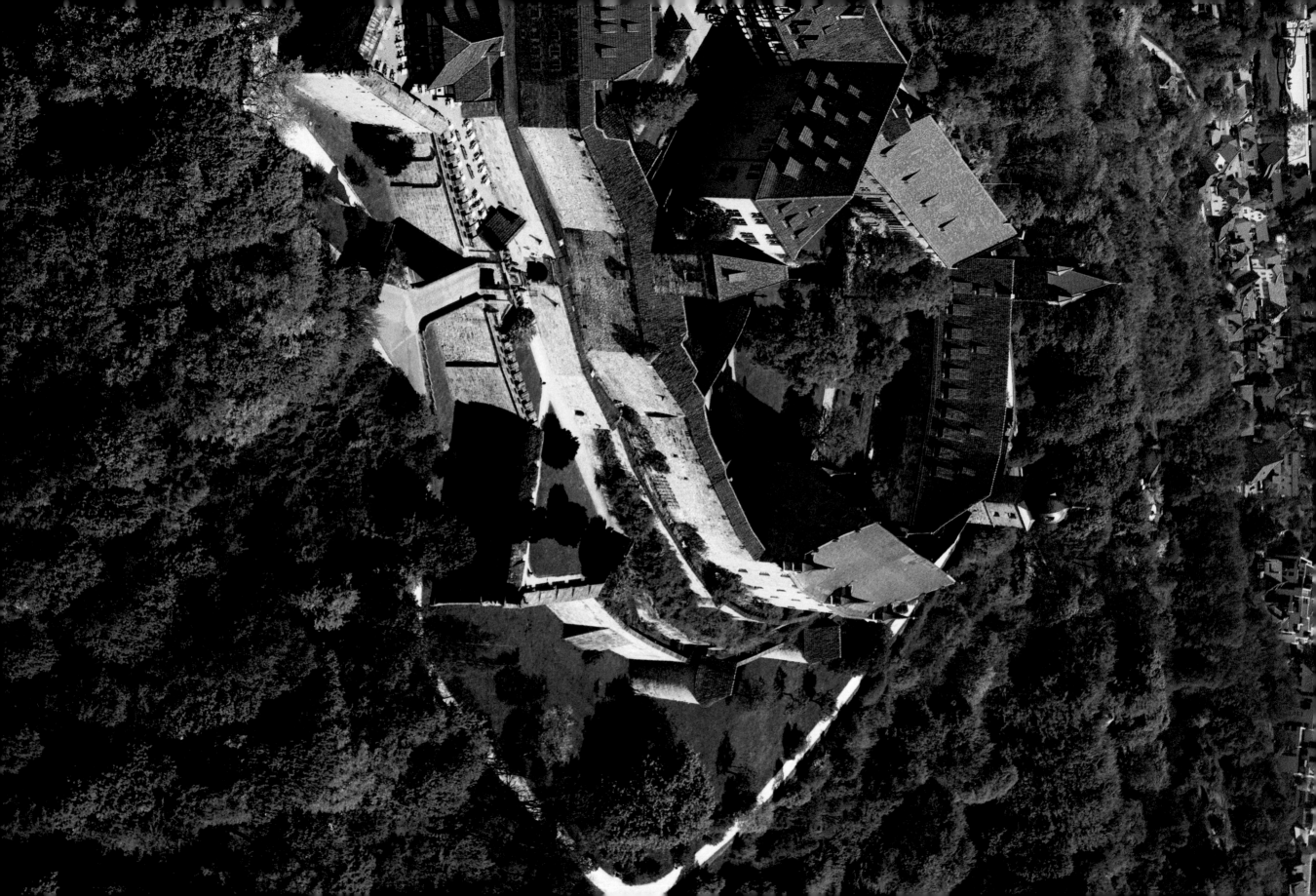

Some late examples

As the historical events of the fifteenth and sixteenth century opened the way to the modern period, castle architecture – as we have seen – tended to assume a more elegant appearance and to lose its military characteristics. The Holy Roman Empire, however, was a strong factor in resistance to change, and as a result, elegance was slower to arrive and was to be found principally in outlying or semi independent states; as if the need for defence against neighbouring states was stronger in the interior of the country. Some castles spring to mind: the romantic Schloss Anif in Austria, an elegant manor house built on the water, and the royal castle of Helsingor in Denmark, with sloping lawns and impressive defensive bastions yet nevertheless elegantly designed and richly decorated. In Sweden we find the curious fortress of Borgholm; even in its present ruinous state it clearly displays its regular quadrilateral plan with cylindrical towers at the angles, presiding over a star-shaped glacis with lawns. Ancient in origin but much restored over the centuries is the castle of Hohenzollern; before being rebuilt in its present style, it played a very important defensive role.

The castle of Anif, near Salzburg, Austria. 16th century.

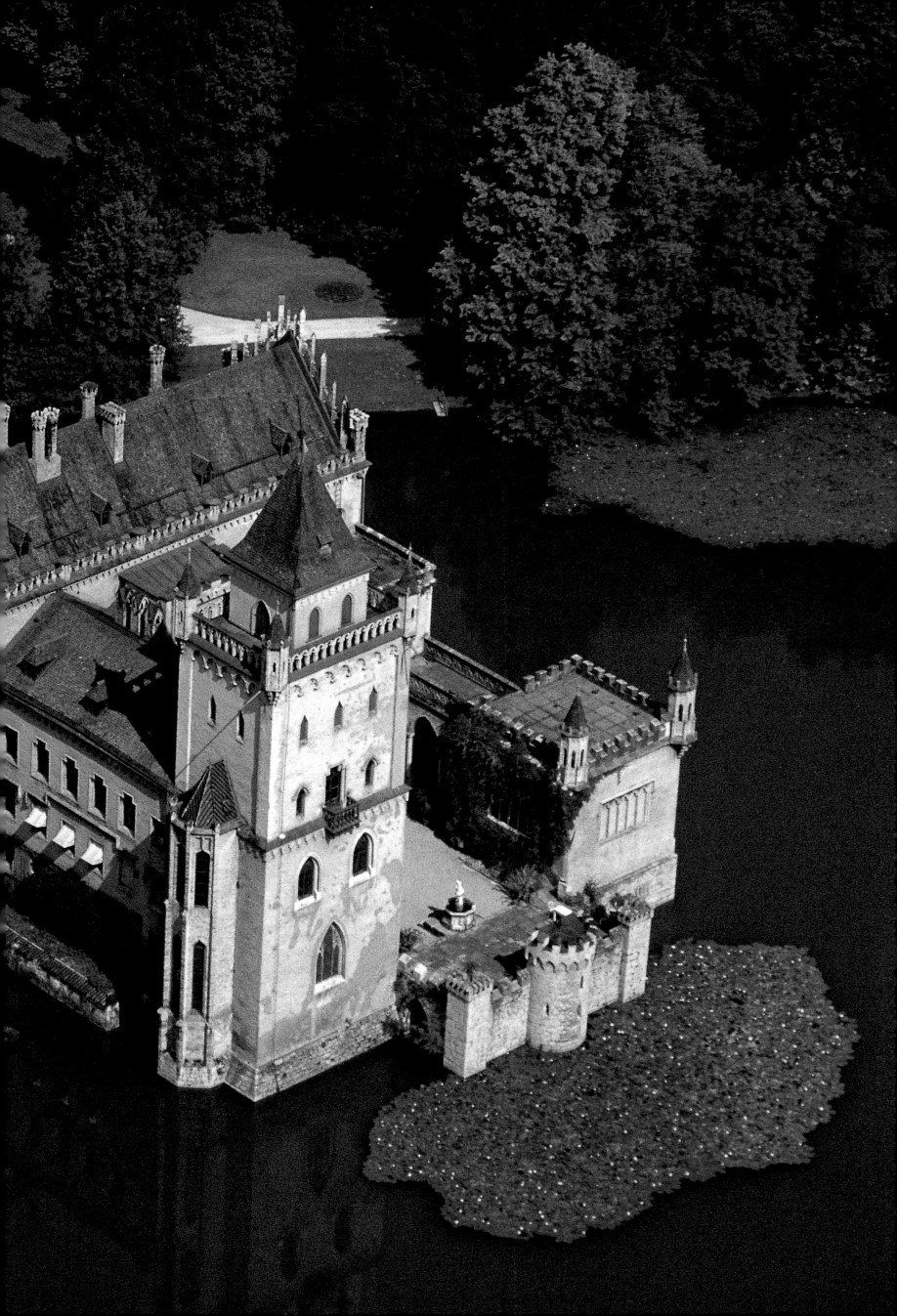

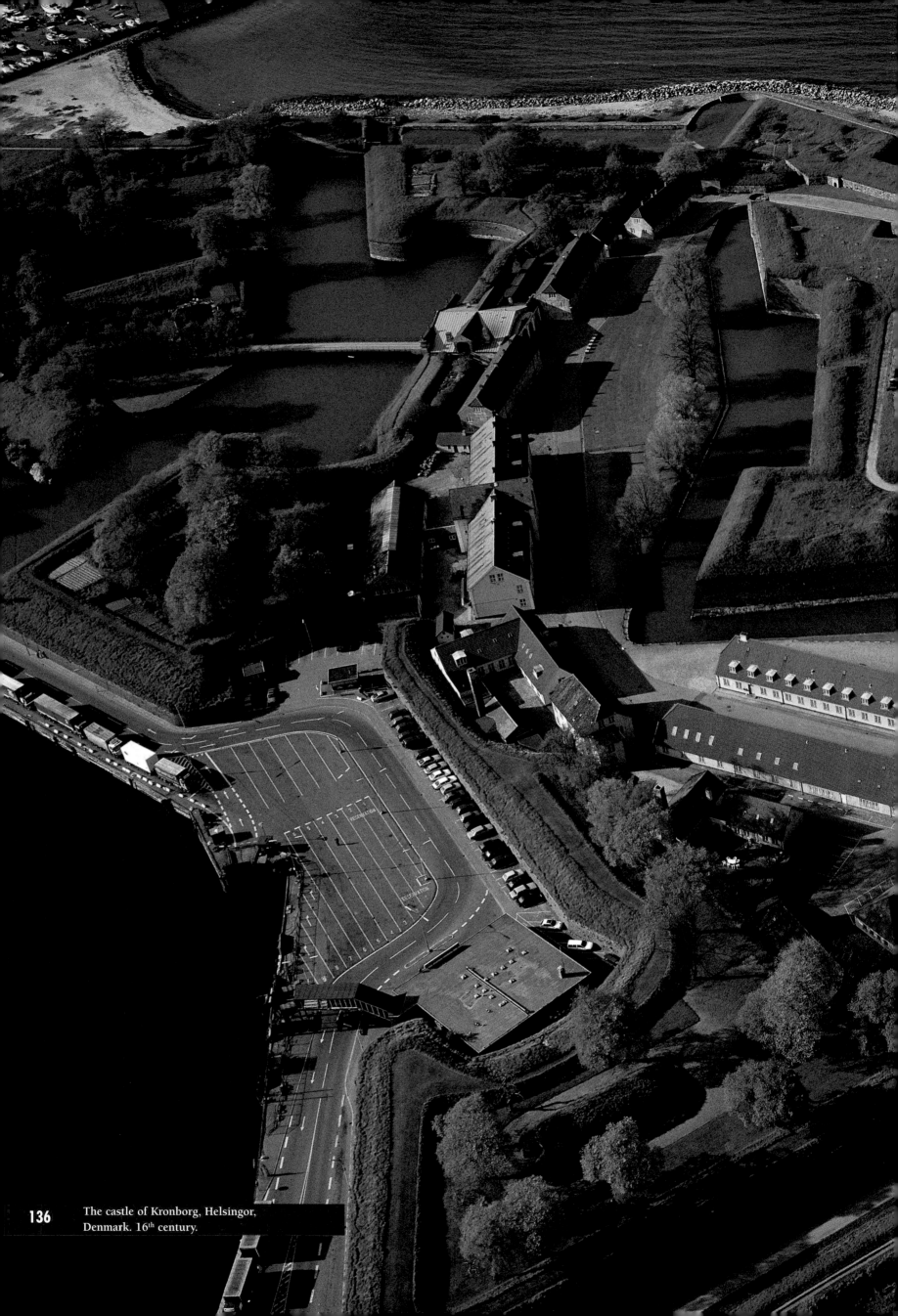

The castle of Kronborg, Helsingor,
Denmark. 16th century.

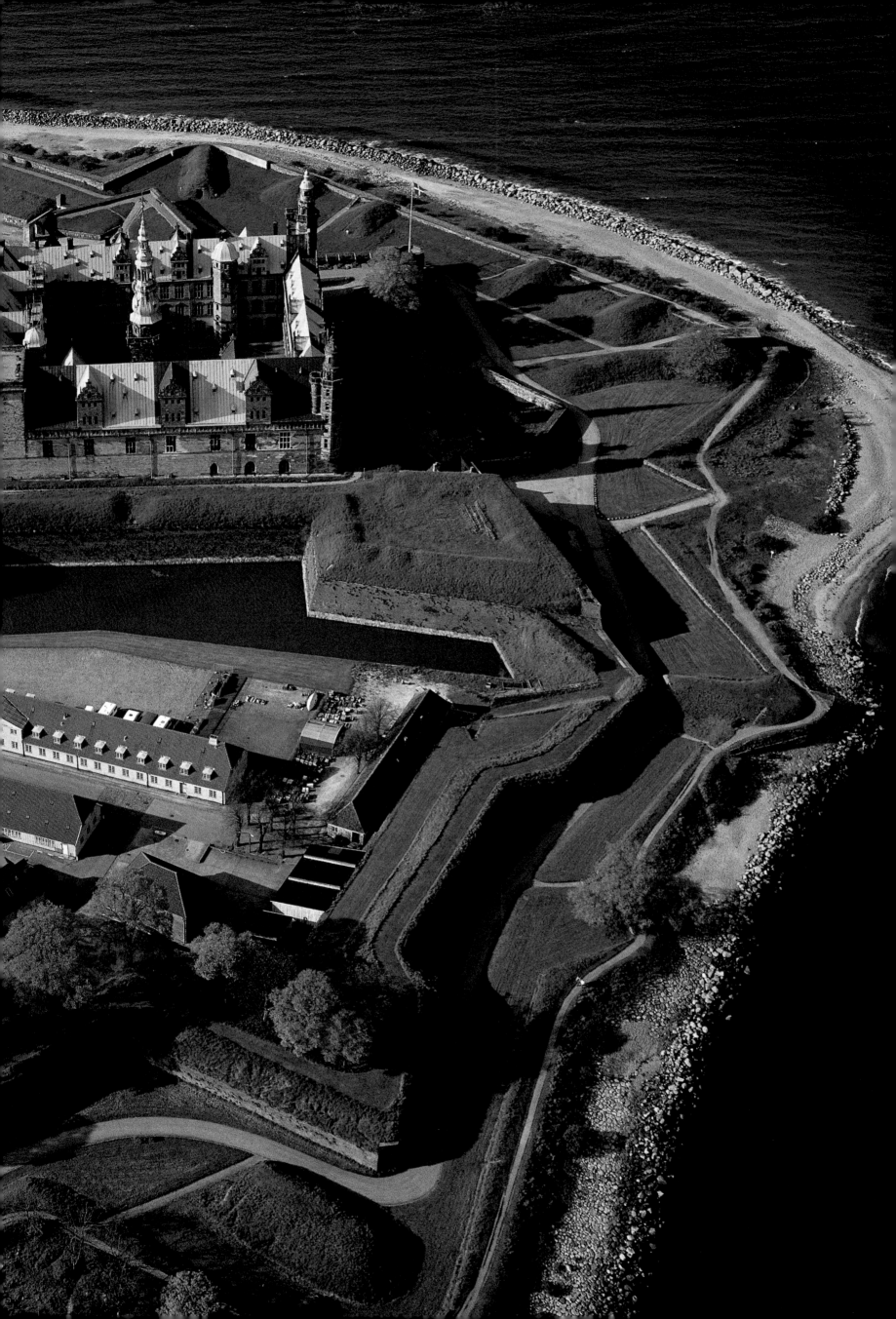

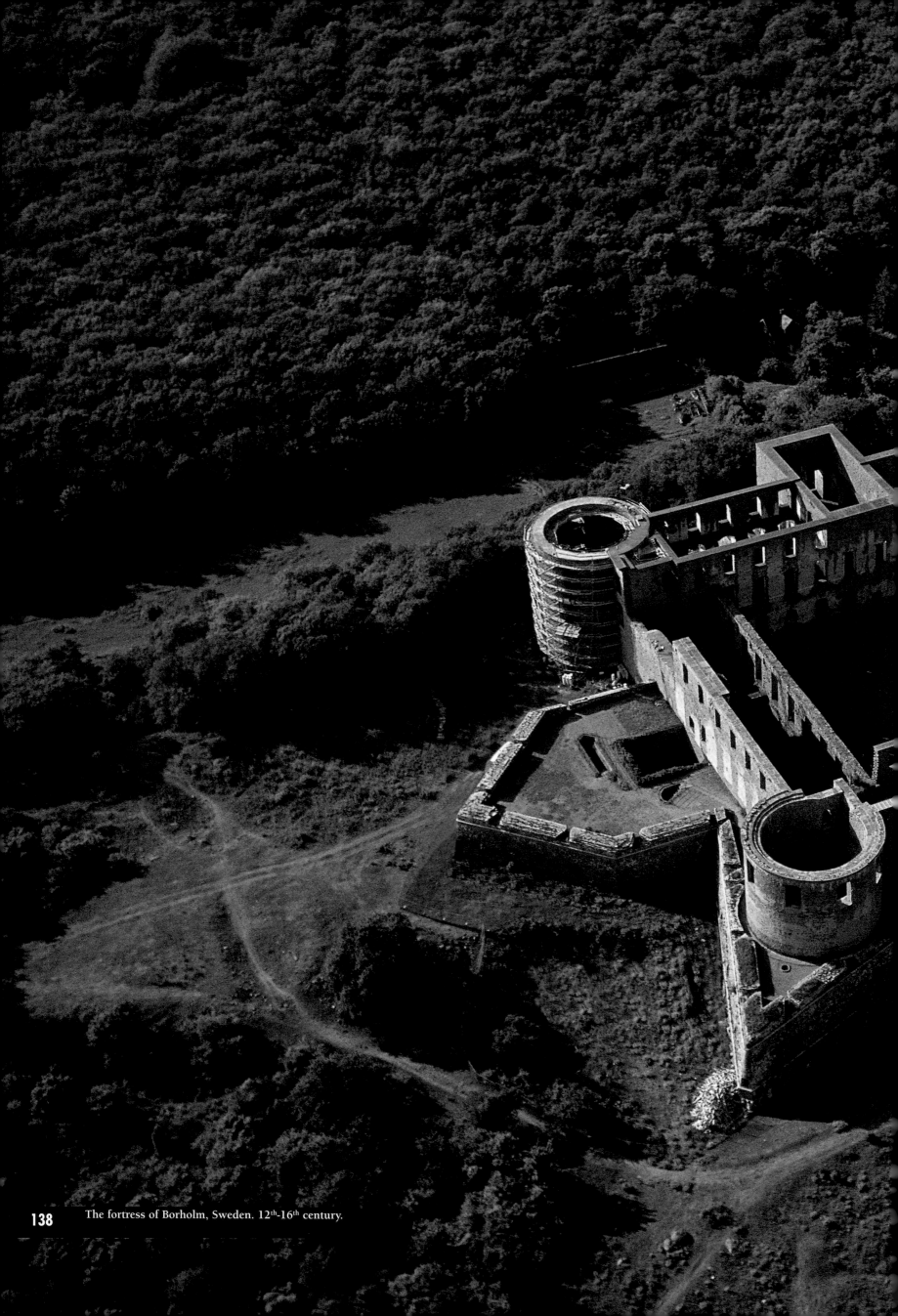

The fortress of Borholm, Sweden. 12th-16th century.

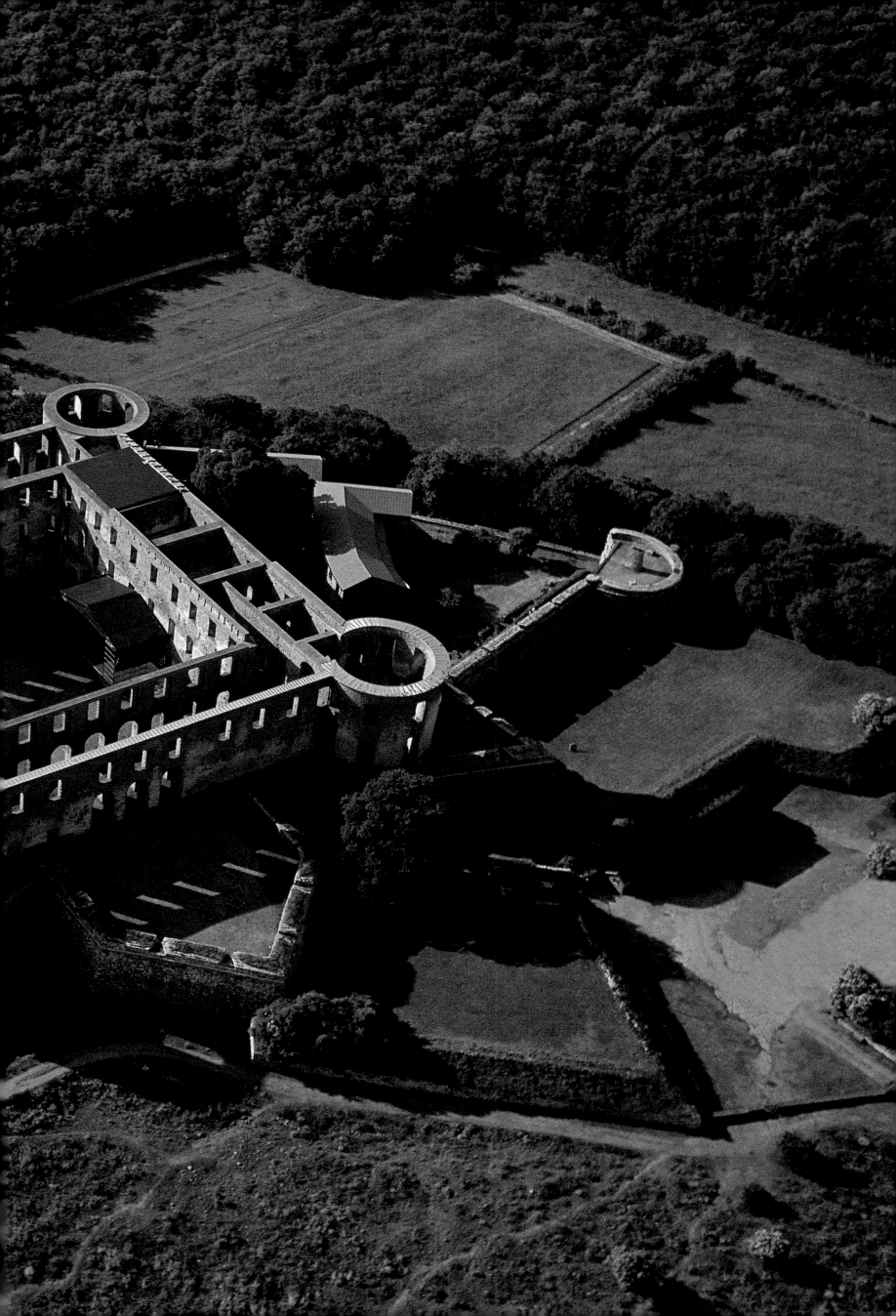

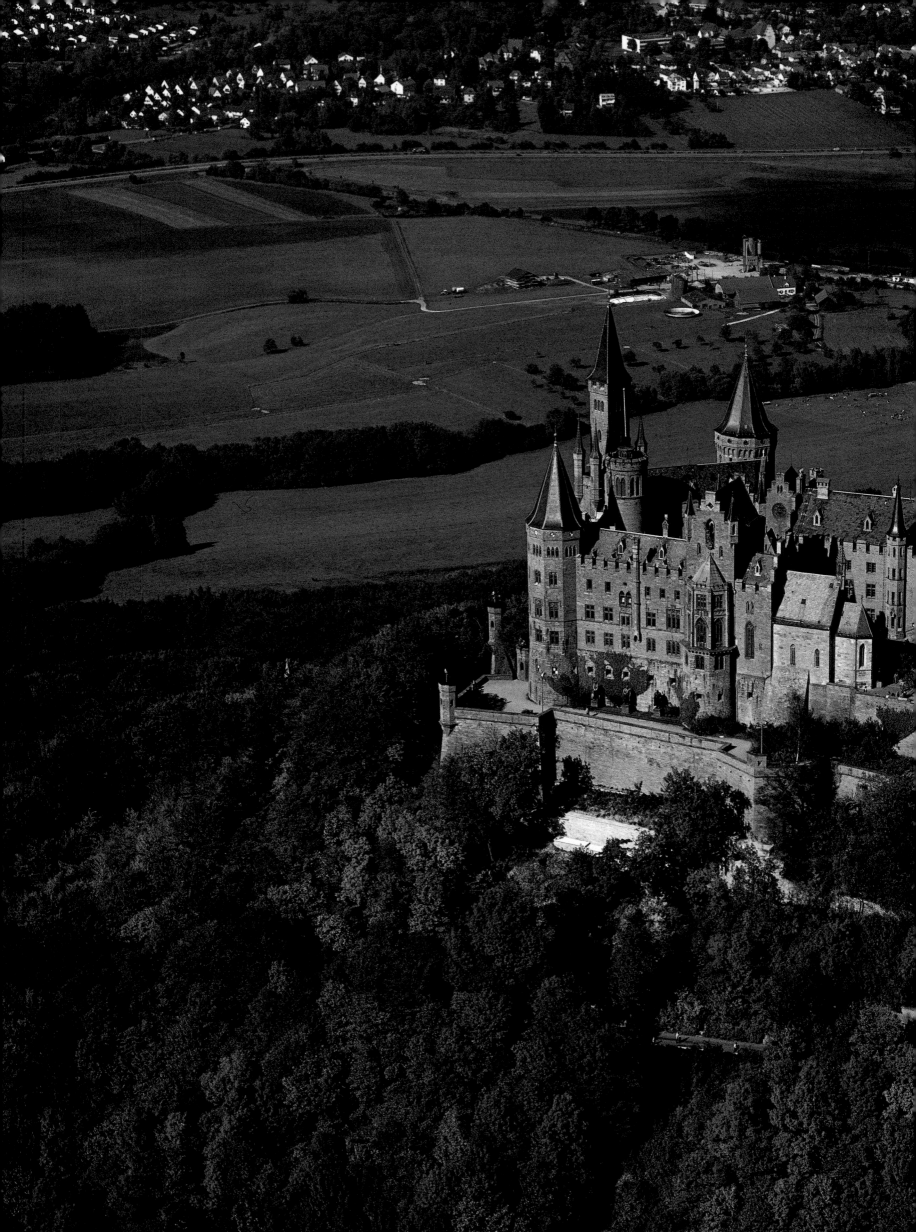

The castle of Hohenzollern, Germany.
11th-18th century.

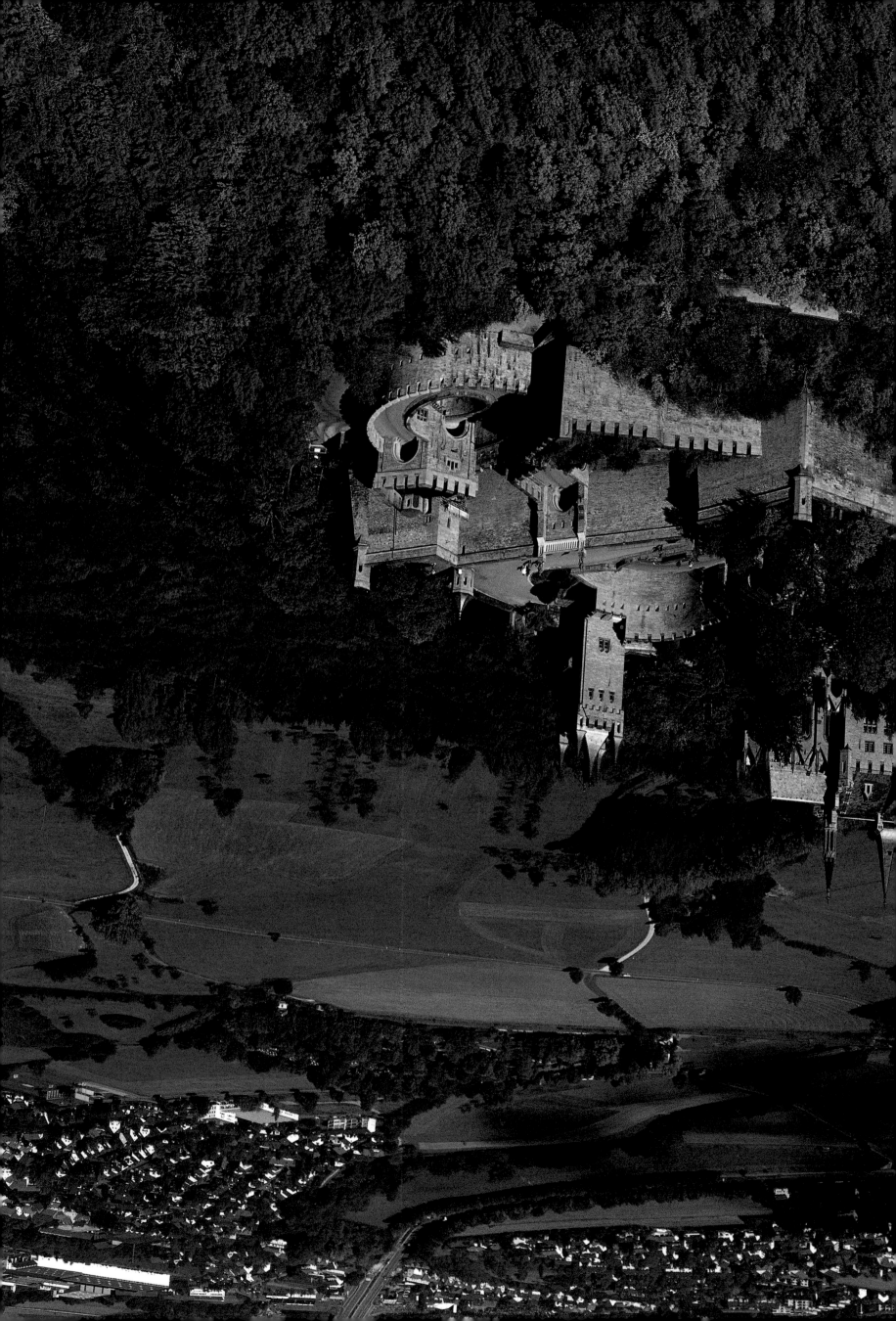

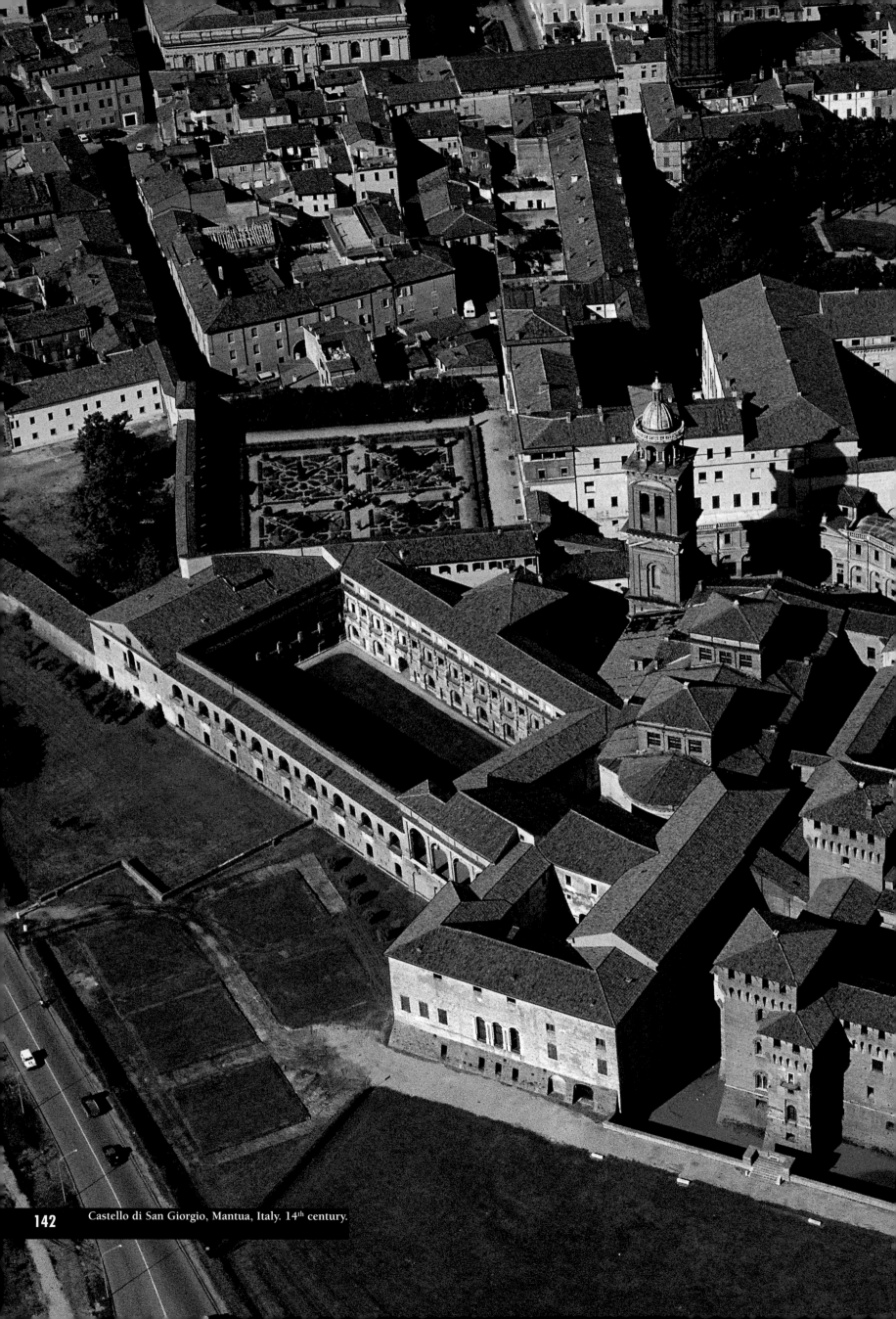

Castello di San Giorgio, Mantua, Italy. 14th century.

Fortresses and city castles

The Tower of London

A number of castle complexes emerged inside or alongside the cities for which they were intended. A few words of warning, however, about the definition of such structures, as it is difficult to decide on the distinction between a village and a town, on one hand, and between a fortress originally designed as the seat of a feudal overlord, and one built to defend the city. Urban castles have presided over such a train of historic events that it is almost impossible to make any clear-cut classification. Let history be their witness, therefore: some of these large buildings have become identified with the events that have taken place in the cities of which they are part, whether they are built within the city or walls or look down in it from some nearby eminence. Sometimes in fact the fortified citadel had its origins in the castle itself (see p. 224).

Some imposing groups of buildings have almost come to symbolise the city they stand in, like the cathedral only more so. The most celebrated of these is certainly the Tower of London. Tradition has it that it was built on the site of a pre-Roman fort; the central keep was built in the eleventh century by William the Conqueror, the double encircling wall was built in the thirteenth century by Henry III and his successor Edward I and, finally, the outer bastions were constructed during the reign of Henry VIII, in the sixteenth century. Built originally as a fortress, the tower later became a royal palace and finally a state prison: it was the scene of many gory episodes and some celebrated death sentences were inflicted there, including the decapitation of Anne Boleyn, of the philosopher Thomas More and the writer and navigator Walter Raleigh. Nowadays it is difficult to distinguish the various phases of its construction and restoration.

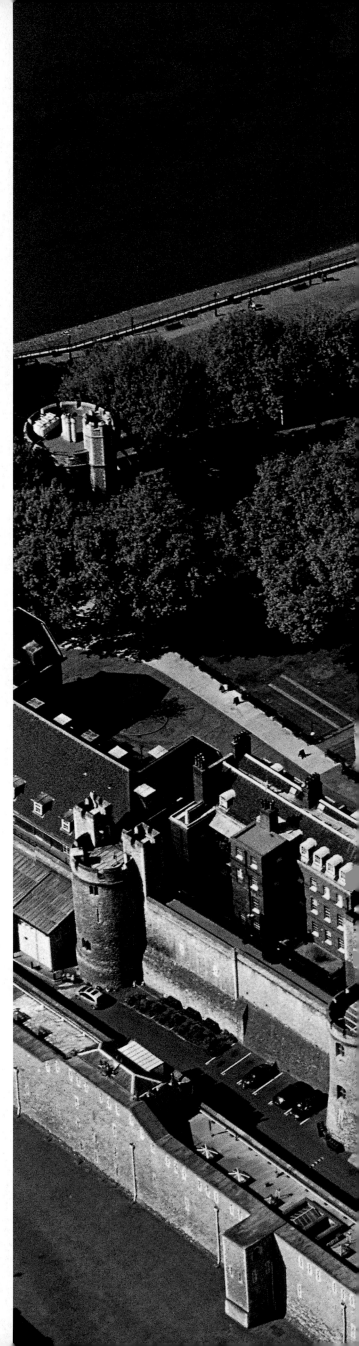

144 The Tower of London, Great Britain.
11th-16th century.

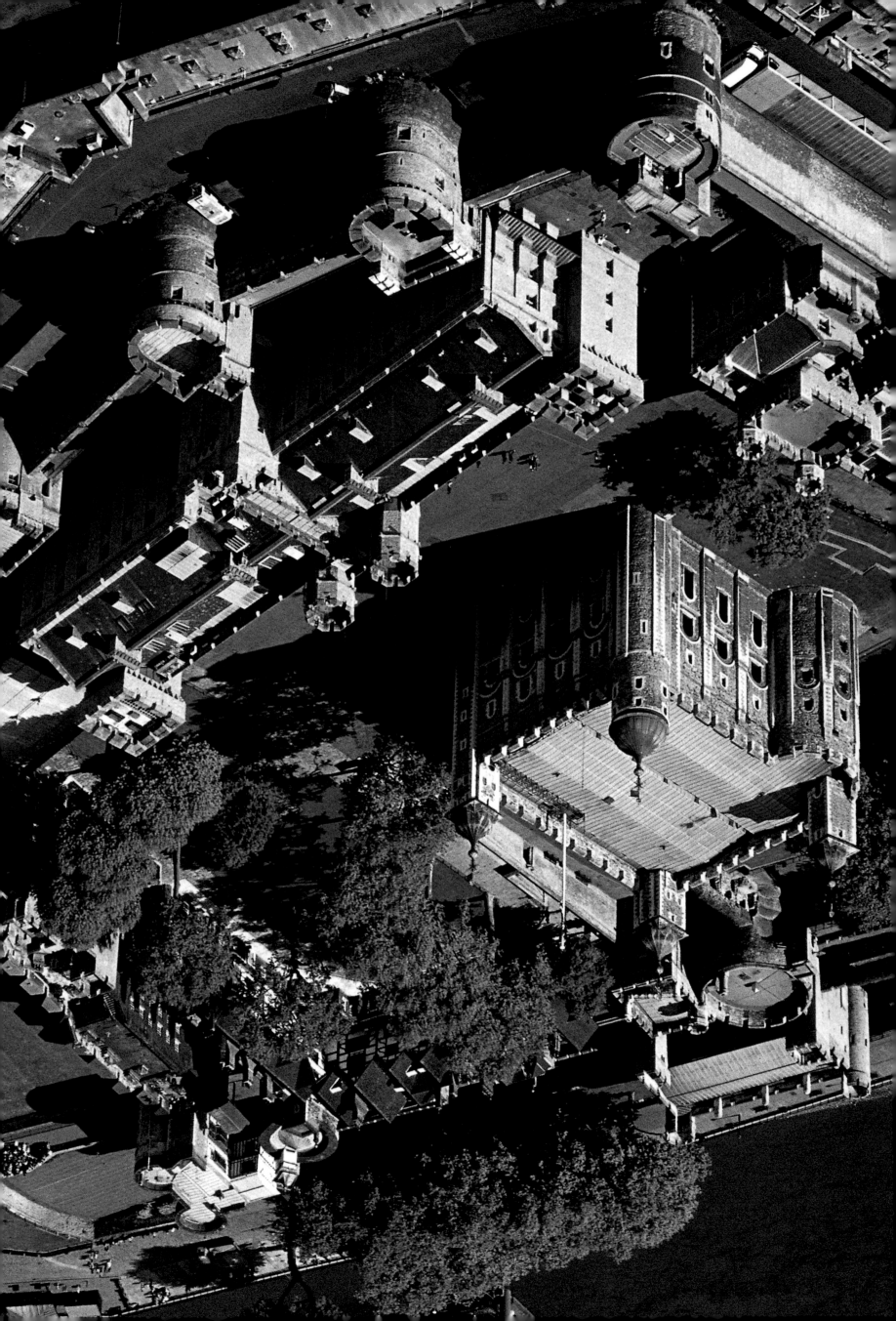

Historical sites

Many city castles boast histories as colourful as that of the Tower of London, histories which include destruction, reconstruction, restoration and alteration for a change of use; the resulting complicated structures mirror the chain of events to which they have born witness. Others reflect a more unified plan. In order to illustrate the different types, let us study some examples.

The Castello dell'Imperatore, in Prato, is a fine example of a garrison built by the central authorities to guard a strategically important site. It was built in the thirteenth century, as part of Frederick II's programme of consolidation of the imperial dominions; it allowed a close watch to be kept on the road joining Southern Italy to Central Europe.

The Alhambra first emerged in the ninth century on a cliff dominating the city of Granada; in the thirteenth century it was enlarged and transformed into a royal palace on the initiative of Muhammad al-Ahmar, founder of the dynasty of the Lords of Granada. His successors continued with the building work until the mid-fourteenth century and, after the expulsion of the Arabs, the emperor Charles V caused a luxurious Renaissance palace to be built with an original circular courtyard.

The fortress of Angers is one many defensive buildings built on the orders of Louis IX. It consists of a large walled enclosure on the banks of the river Maine, reinforced by seventeen cylindrical towers which were previously adorned with battlements. Inside there are various buildings dating from the fifteenth century which contrast strongly with the bleak, imposing curtain wall.

The Palais des Papes in Avignon was built during the fourteenth century, during the pontificates of Benedict XII, Clement VI and Innocent VI. It is a vast construction, one of the masterpieces of Gothic architecture thanks to the juxtaposition of a series of courtyards and buildings; the overall appearance of the palace is given coherence by the succession of very tall blind arches around the perimeter.

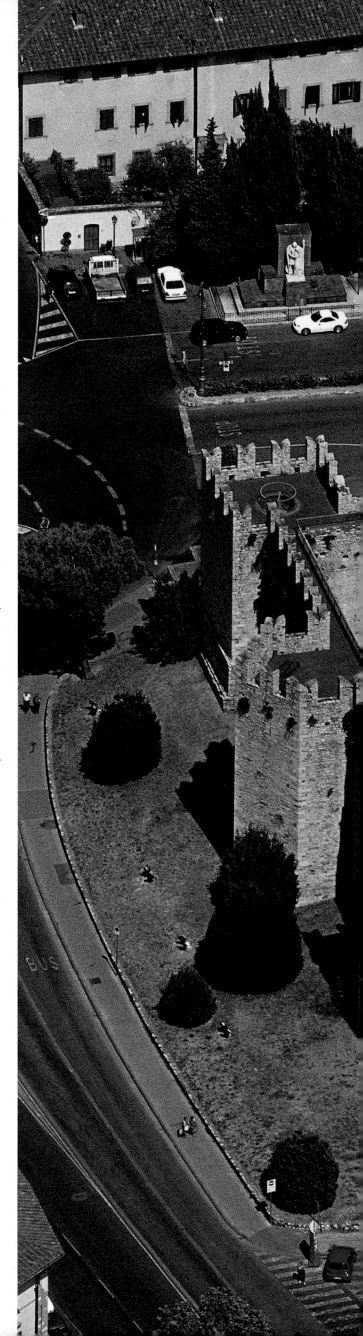

Castello dell'Imperatore, Prato, Italy. 13th century.

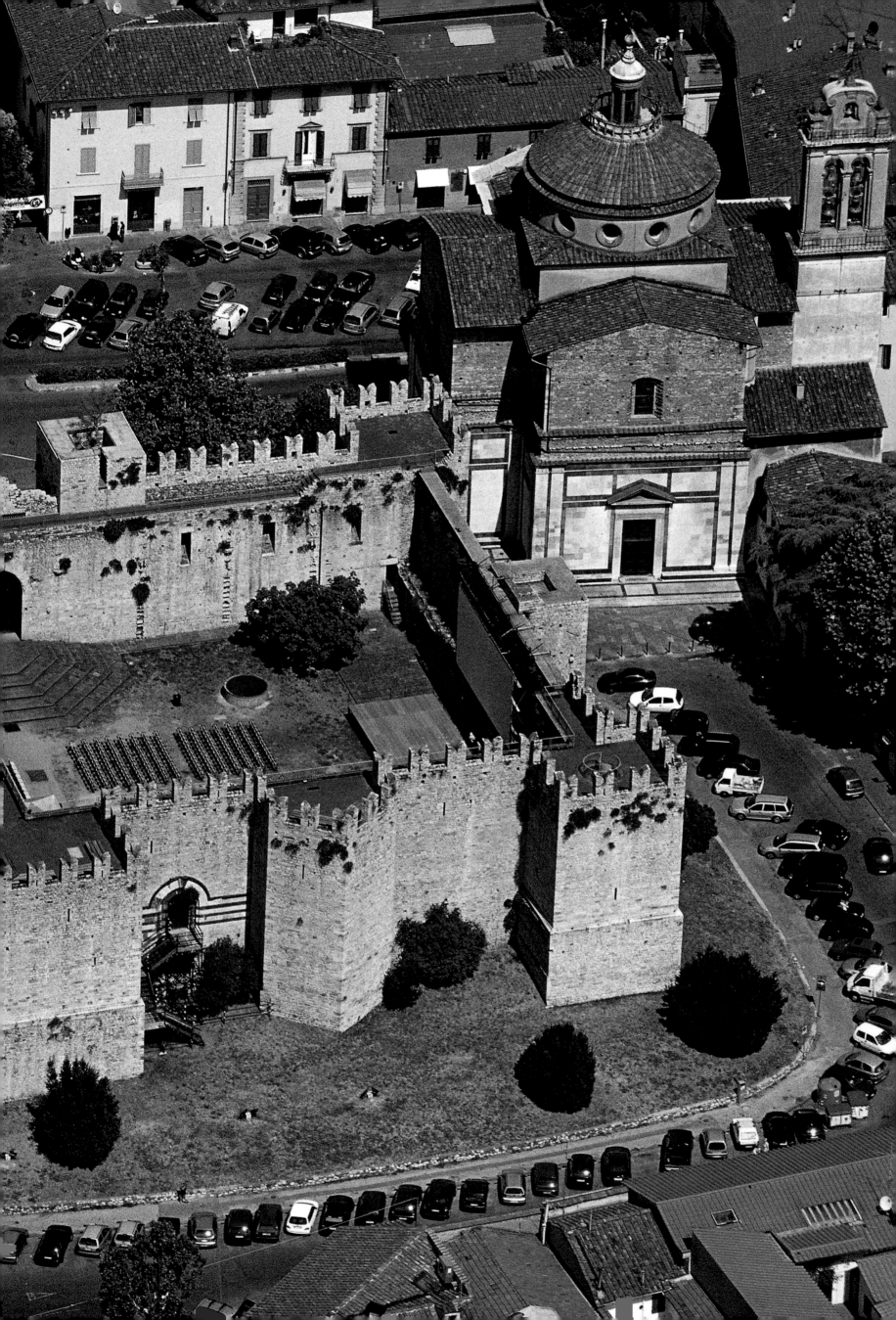

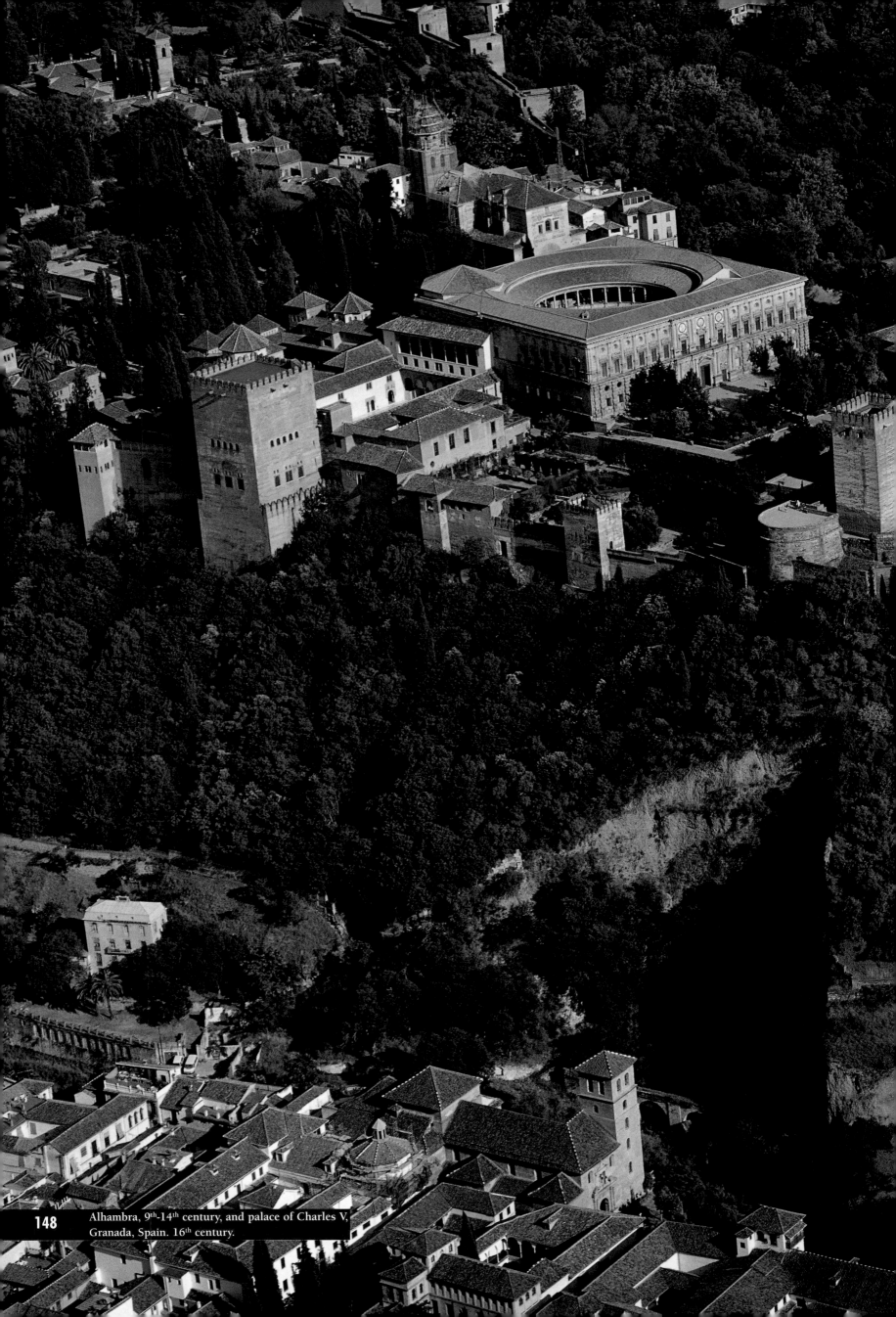

Alhambra, 9th-14th century, and palace of Charles V,
Granada, Spain. 16th century.

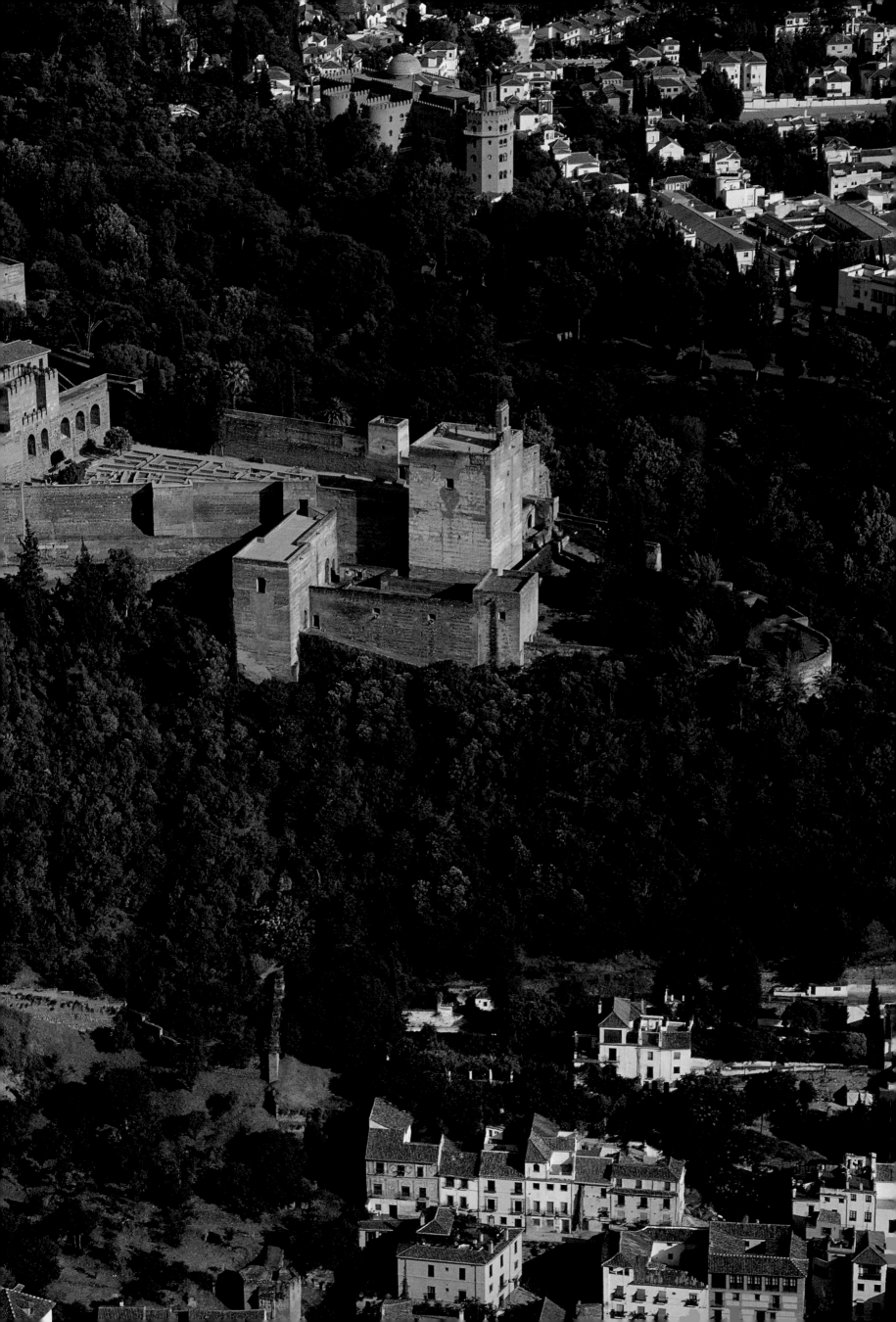

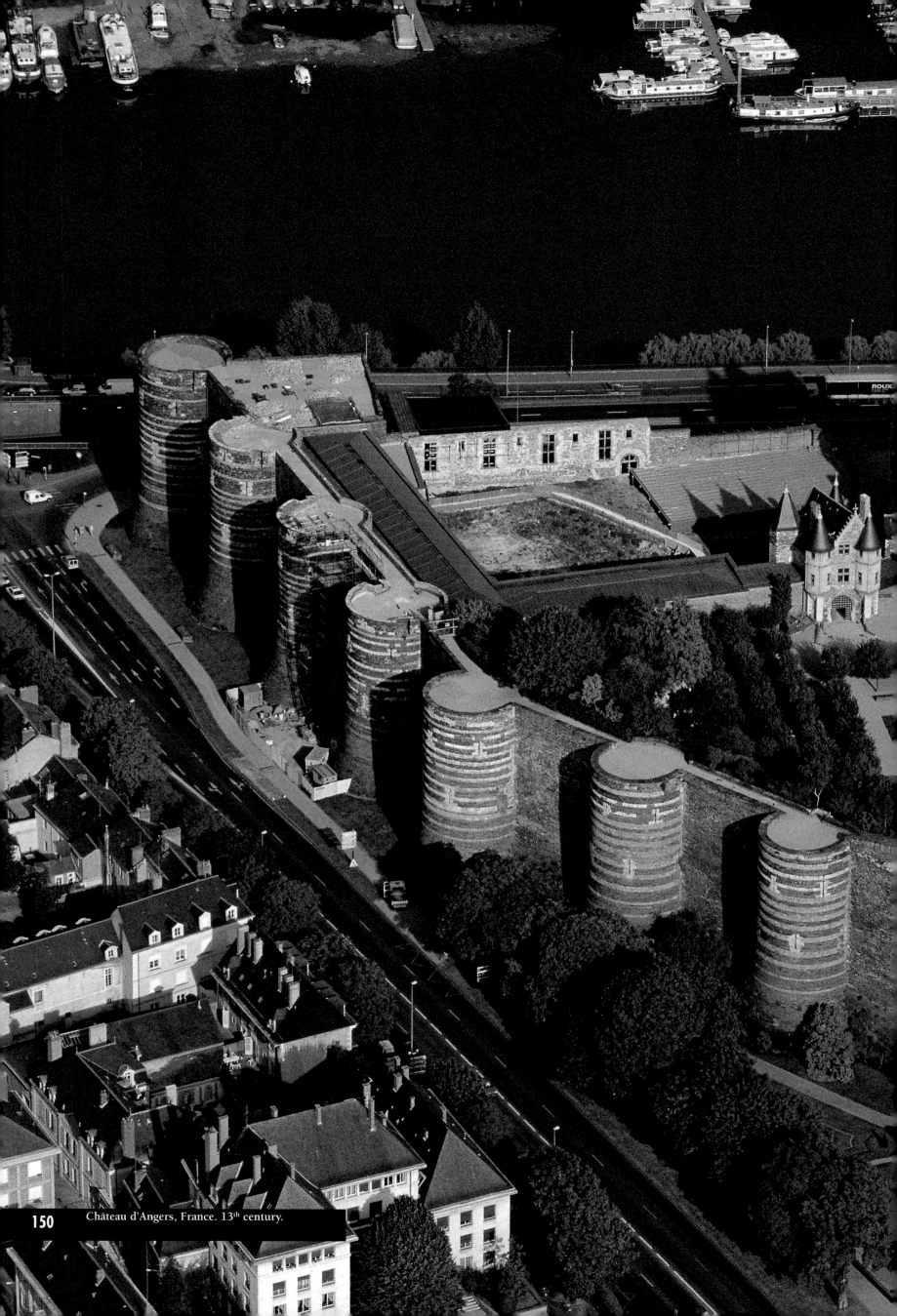

Château d'Angers, France. 13th century.

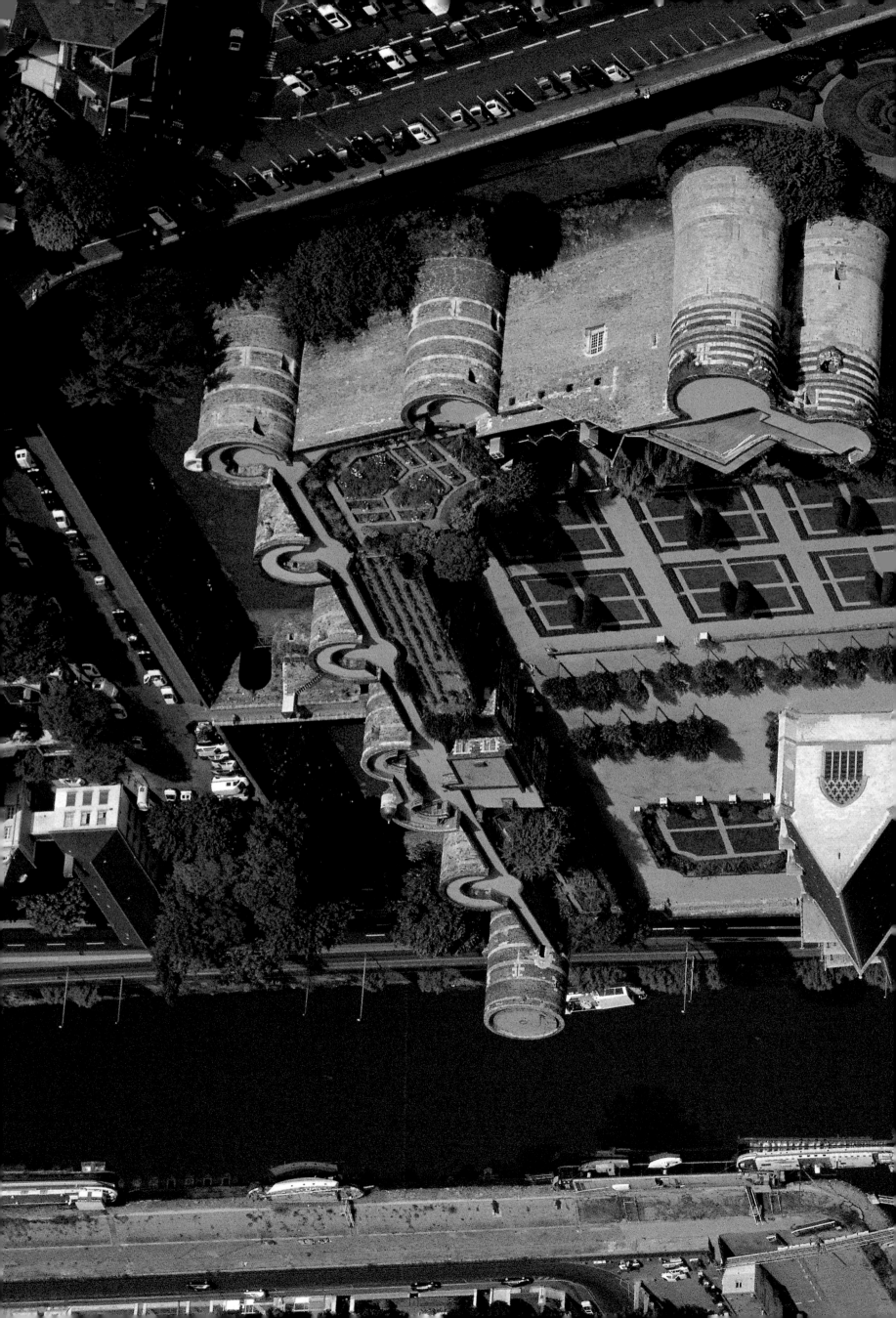

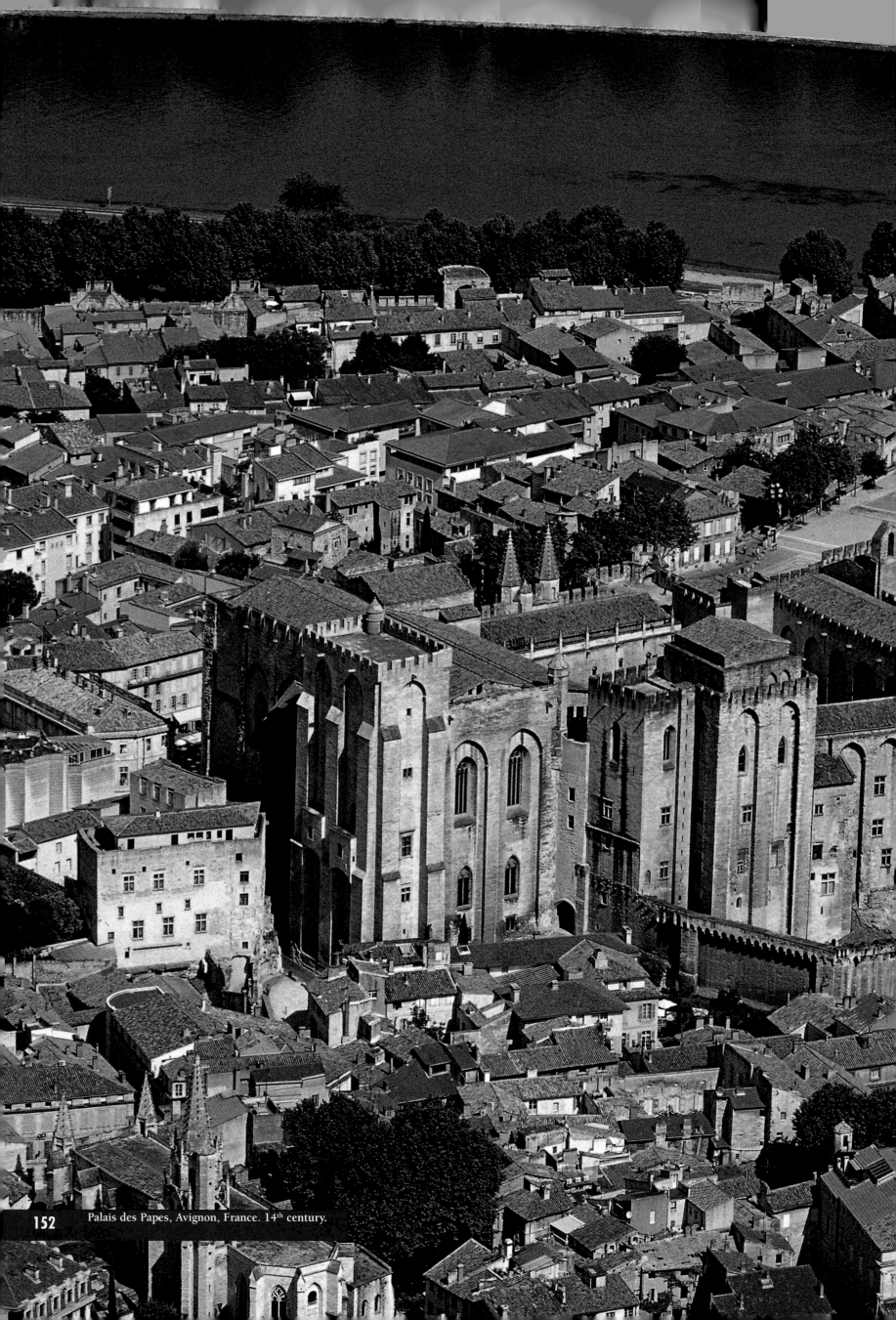

Palais des Papes, Avignon, France. 14th century.

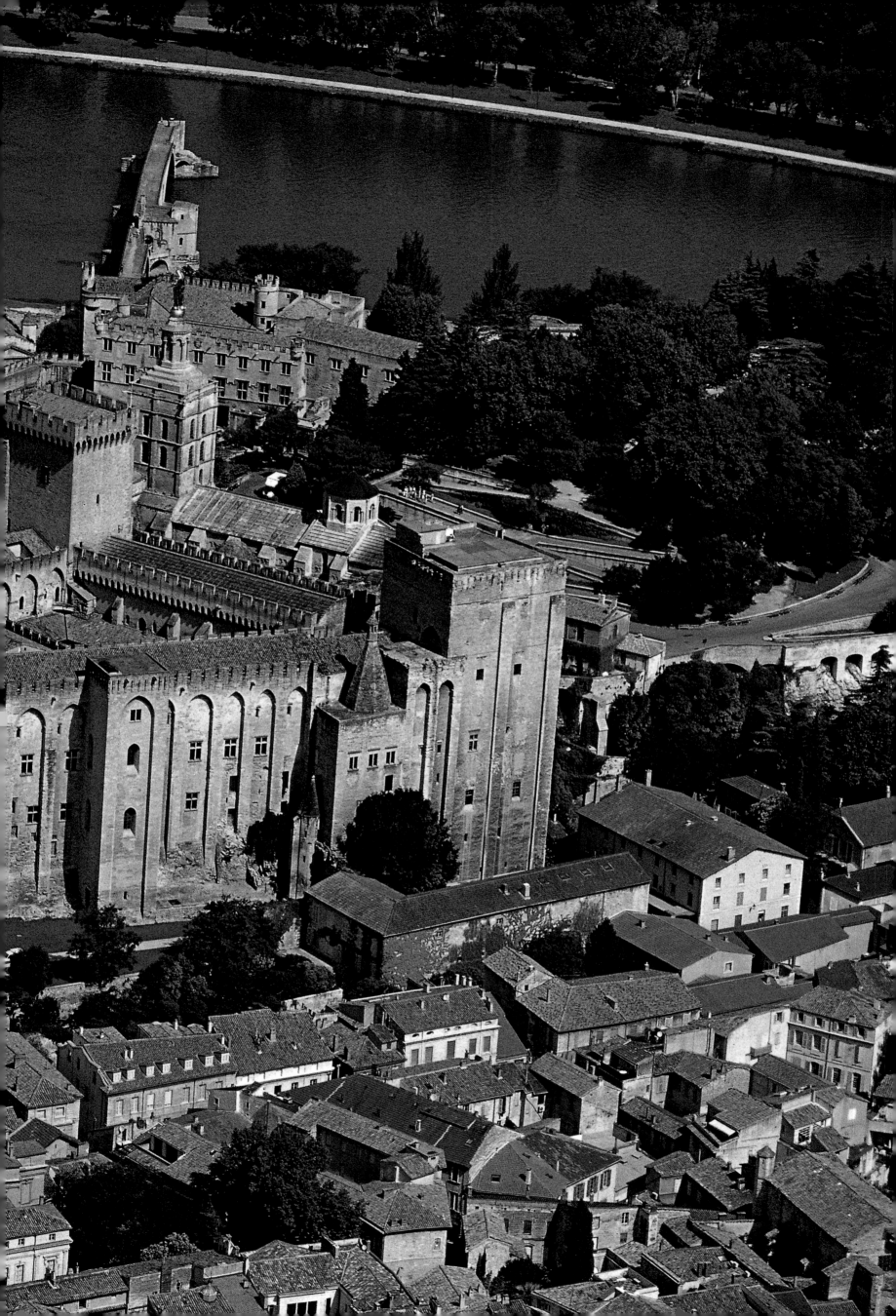

Above the city

Above the small town of Chinon, on a small hill overhanging the river Vienne in the Loire valley, looms an ancient, part-ruined fortified complex. It consists of three distinct buildings: the twelfth-century Fort St-Georges and the thirteenth century Château du Milieu and the Château du Coudray. A curtain wall built in several stages between the tenth and fifteenth centuries joins the three buildings into a unique structure overlooking the small town below. This was the seat of princes and the site of many historical events, including the meeting between King Charles VII and Joan of Arc. It continued to grow inside until the town below lost its importance.

The royal castle of Amboise also looks down over the city below. It was founded in 1492 by Charles VIII and completed during the reign of François I. The sprawling collection of buildings of different dates gives a clear account of the shift from the Gothic to the Renaissance style.

The *Burg* in Nuremberg also belongs to this type. The castle is tucked in at the highest point of the city walls; it was begun in the eleventh century and enlarged to its present proportions in the fifteenth by Frederick III. One of the oldest fortresses of all is the Alcazar in Segovia, founded in the eleventh century; it owes its present shape to the reconstruction ordered by Henry II of Castille and Leon in about 1350, and further enlargement by John II in the early fifteenth century.

In later centuries the construction of such fortresses reached grandiose proportions, as in Salzburg or Heidelberg. The castle in Salzburg was built during the War of Investitures and remodelled in about 1500 as a residence for the prince-bishops. Heidelberg was built in the fifteenth century for Ruprecht III, king of Germany and prince-elector of the Holy Roman Empire.

The fortress of Marienberg, perched on a low hill above the city of Würzburg, is also highly impressive. It was begun in the twelfth century as a residence for the prince-bishops, who lived there until the beginning of the eighteenth century when a new palace was built for them in the town. It was enlarged during the second half of the fifteenth century and given large star-shaped bastions in 1650. Inside the fortress the small round Carolingian church demonstrates the antiquity of the site.

Another interesting example is the Belvedere in Florence: this was built at the end of the sixteenth century by the architect Bernardo Buontalenti and is located on a series of spacious layered bastions with sloping lawns. On the highest glacis stands a construction with the appearance of a Renaissance villa.

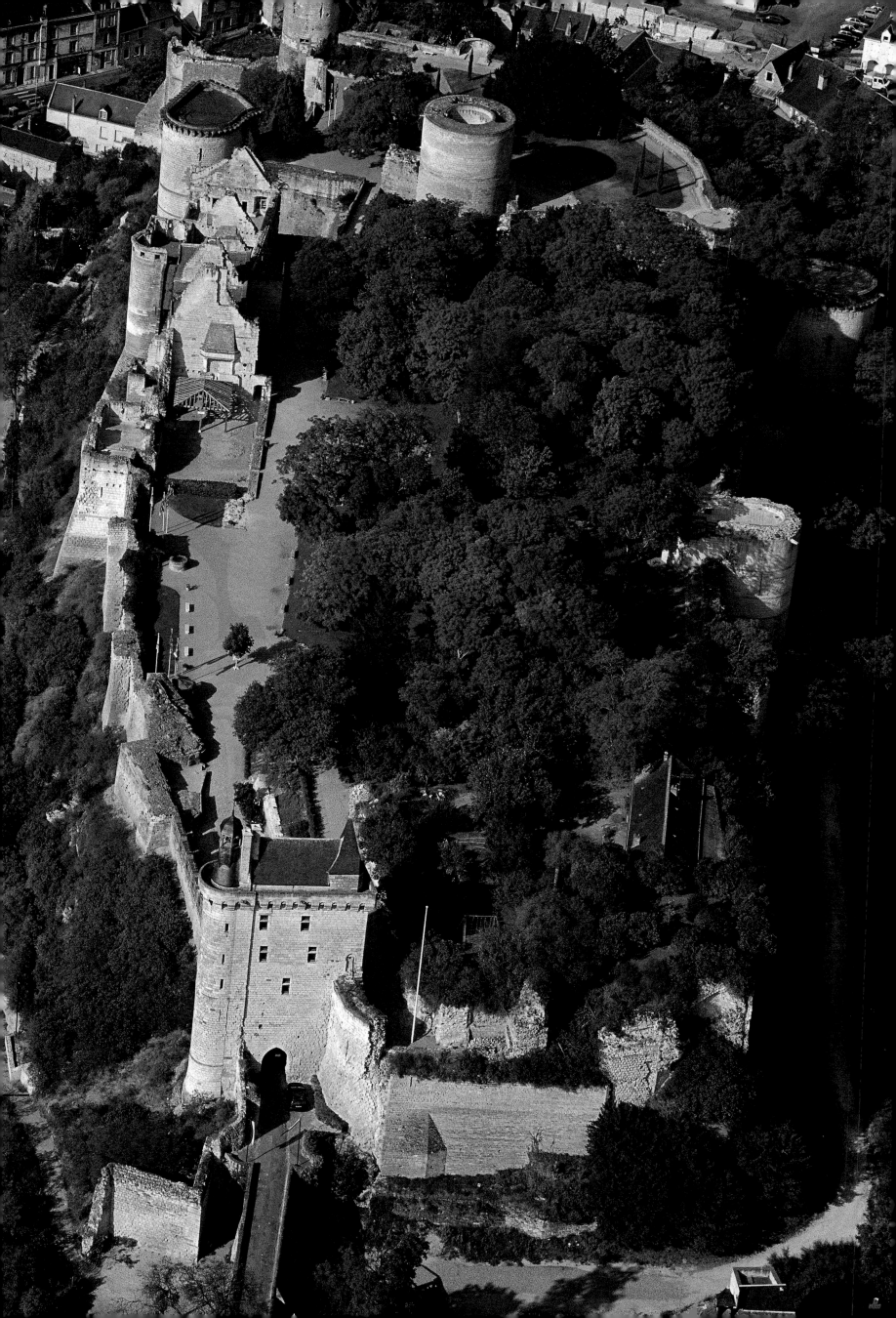

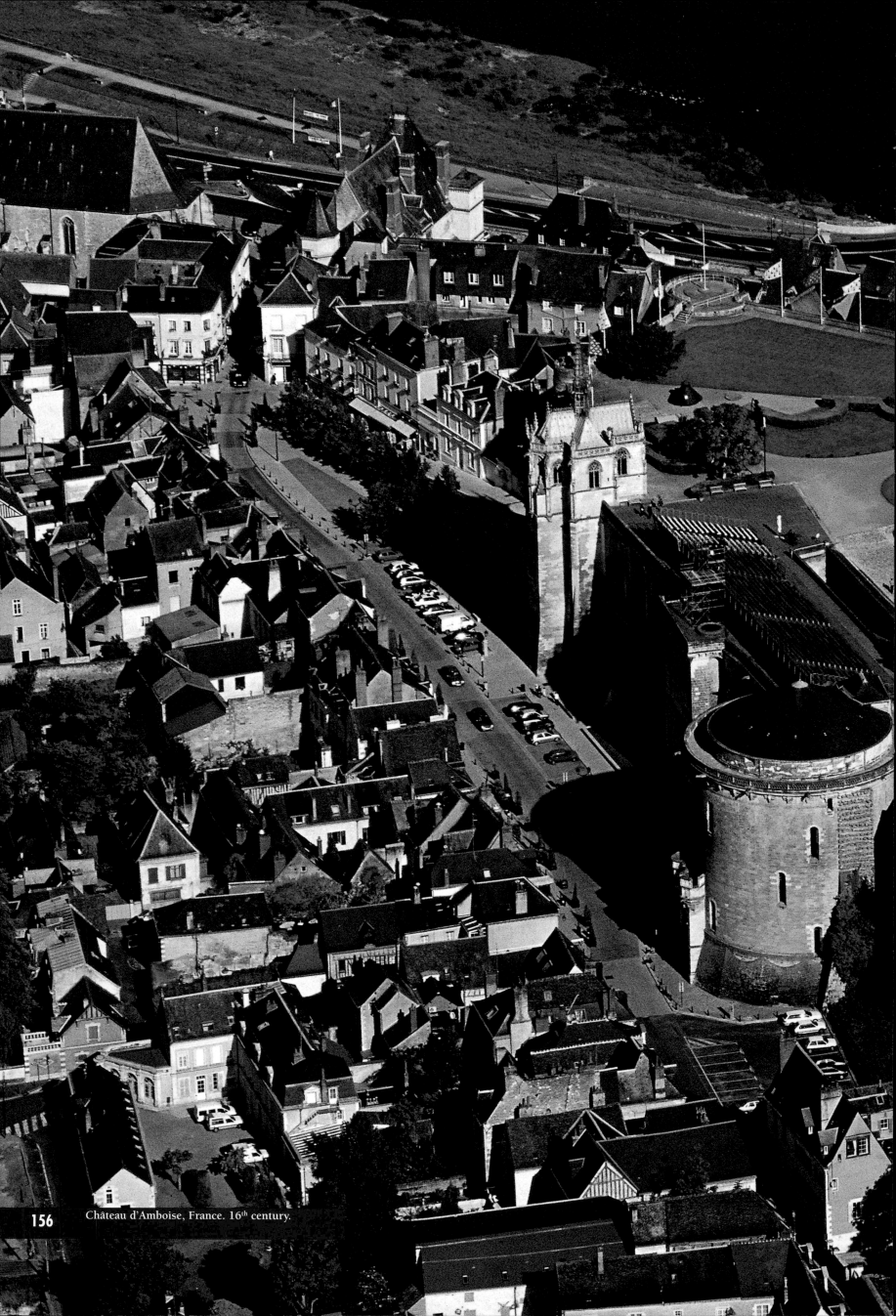

Château d'Amboise, France. 16th century.

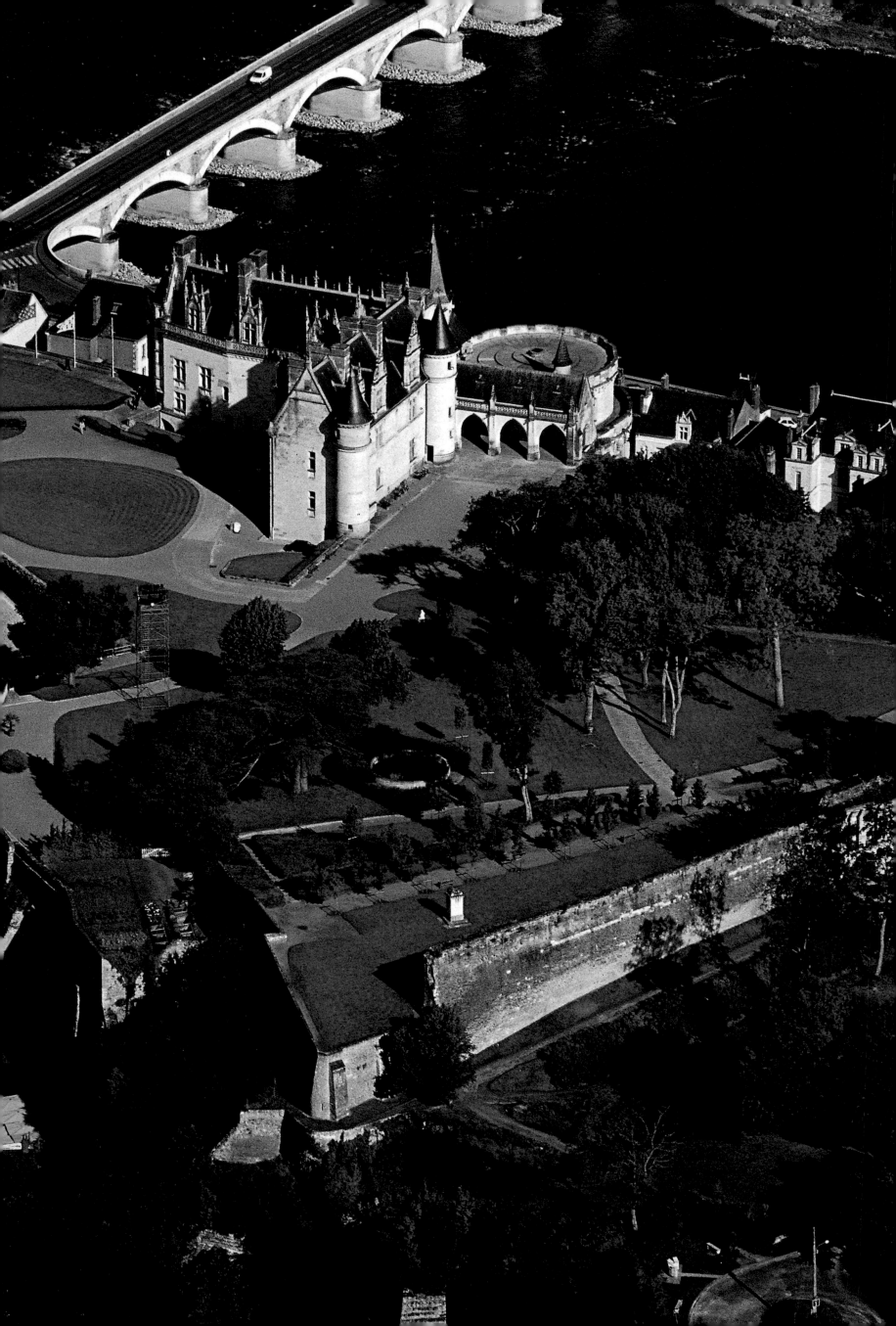

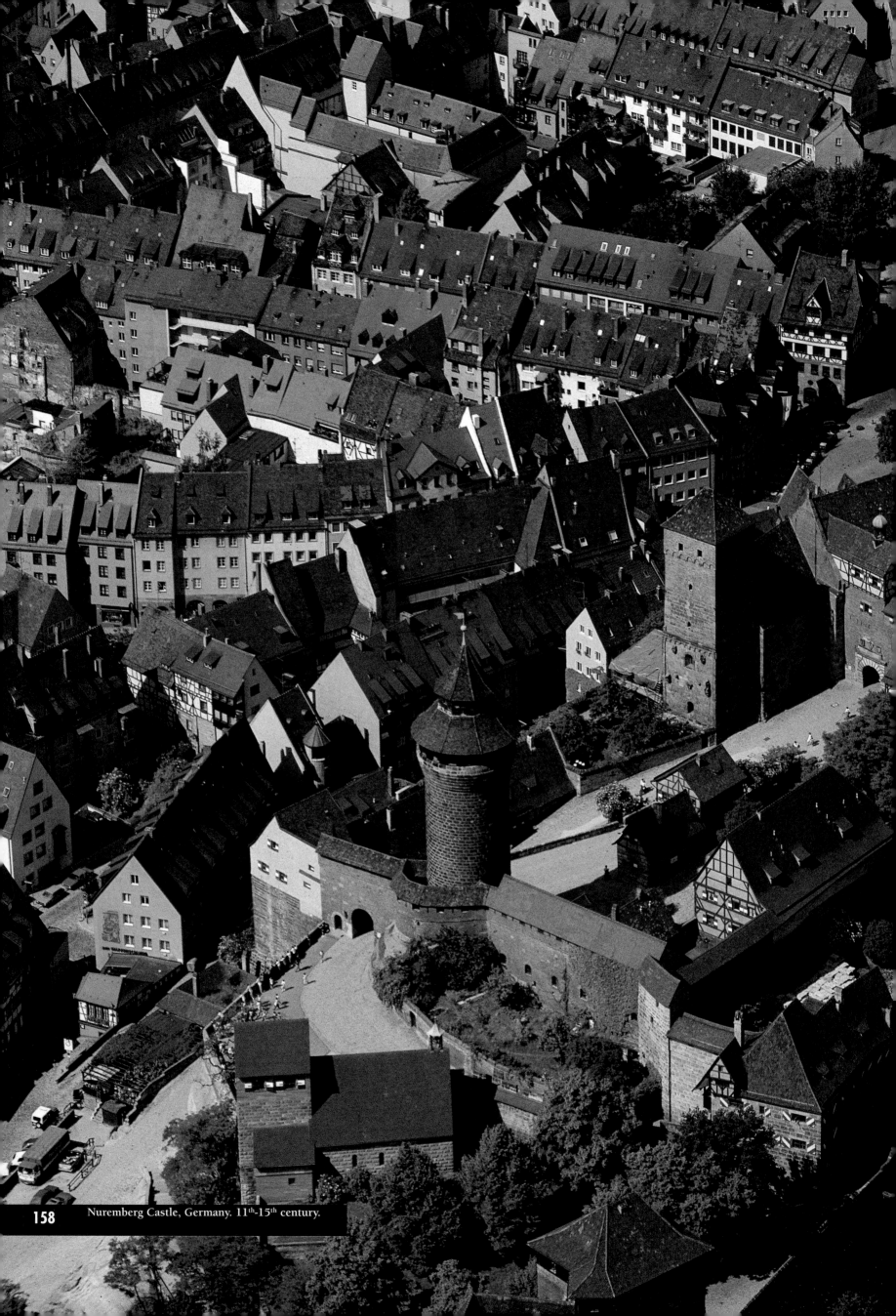

Nuremberg Castle, Germany. 11th-15th century.

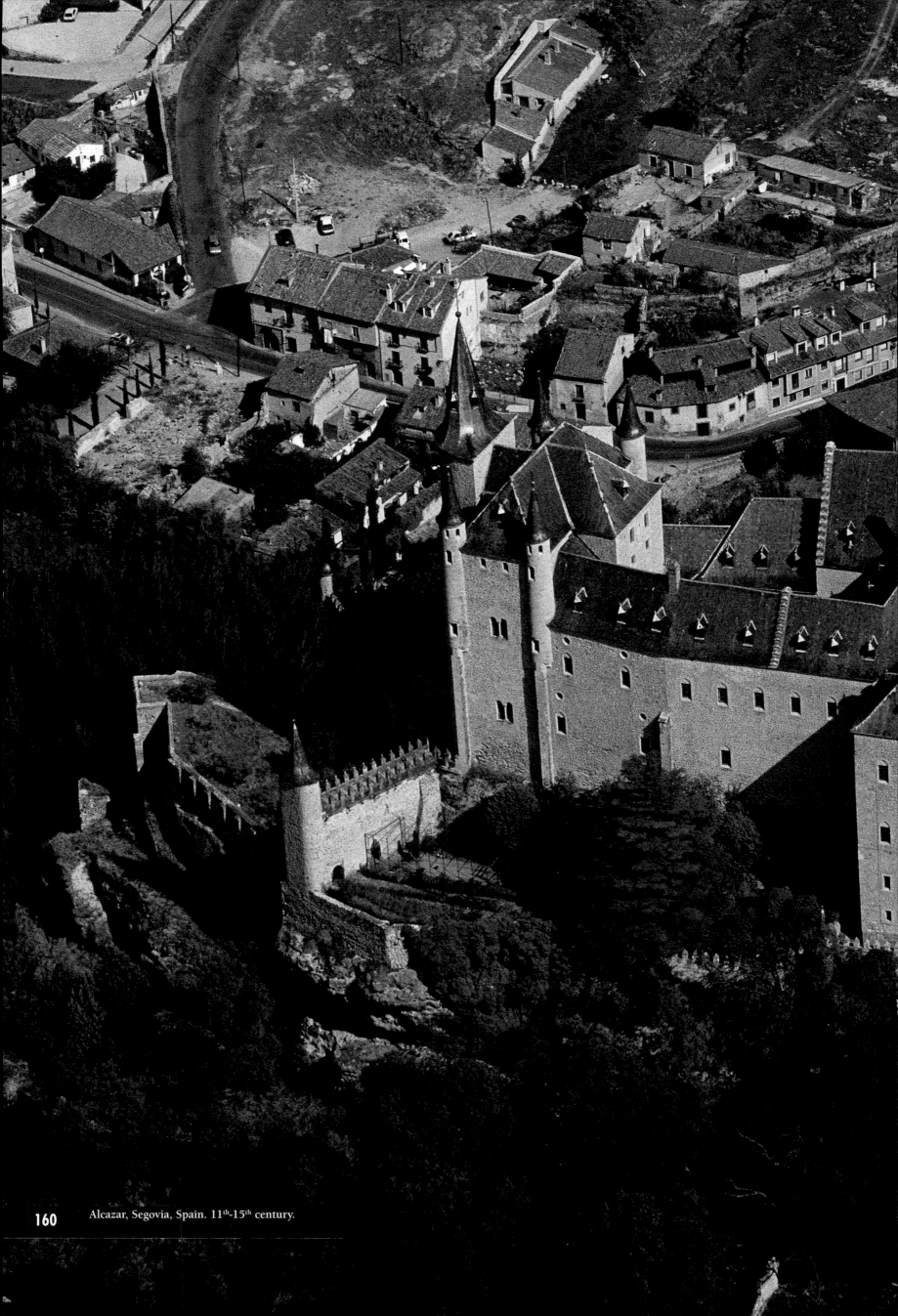

Alcazar, Segovia, Spain. 11th-15th century.

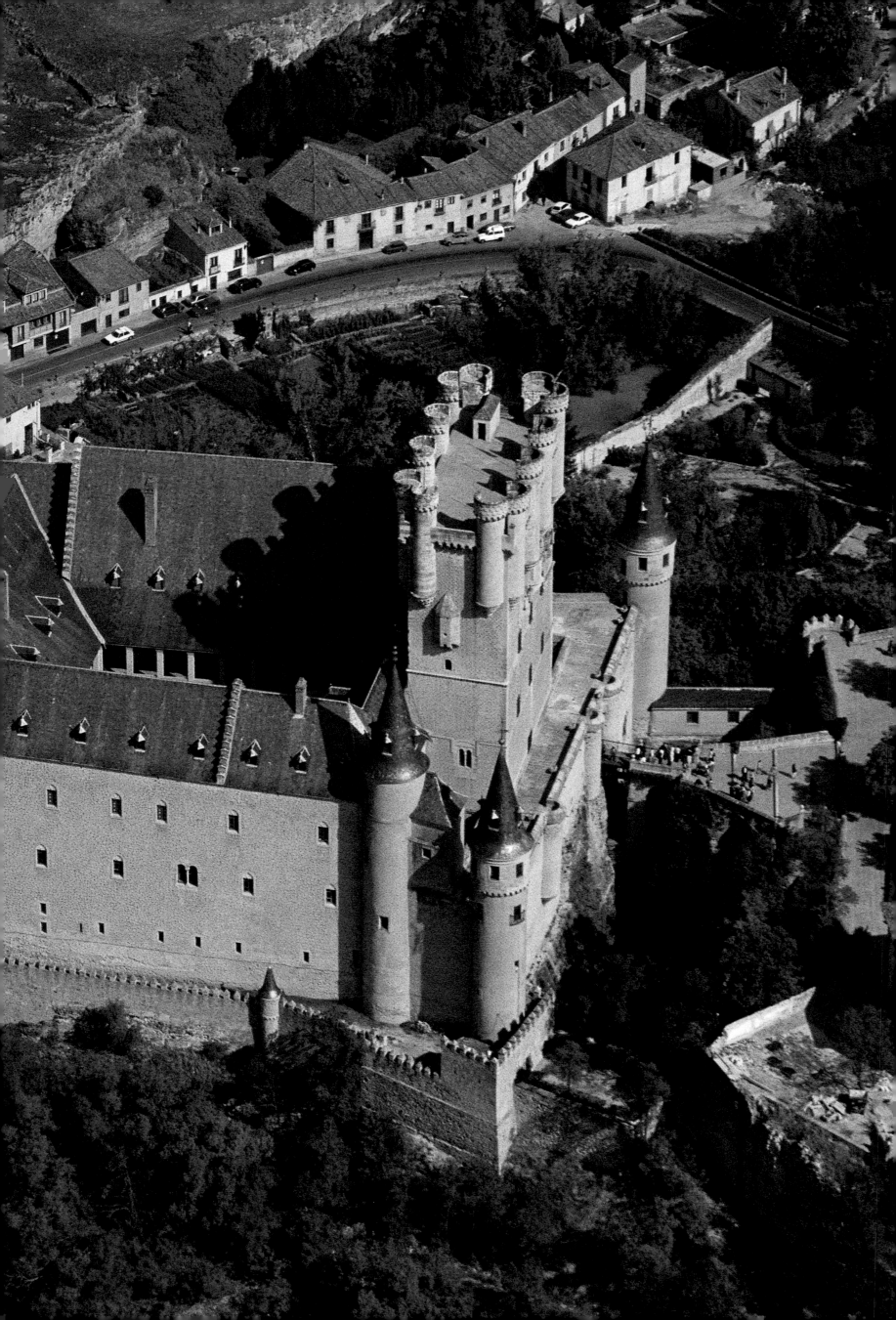

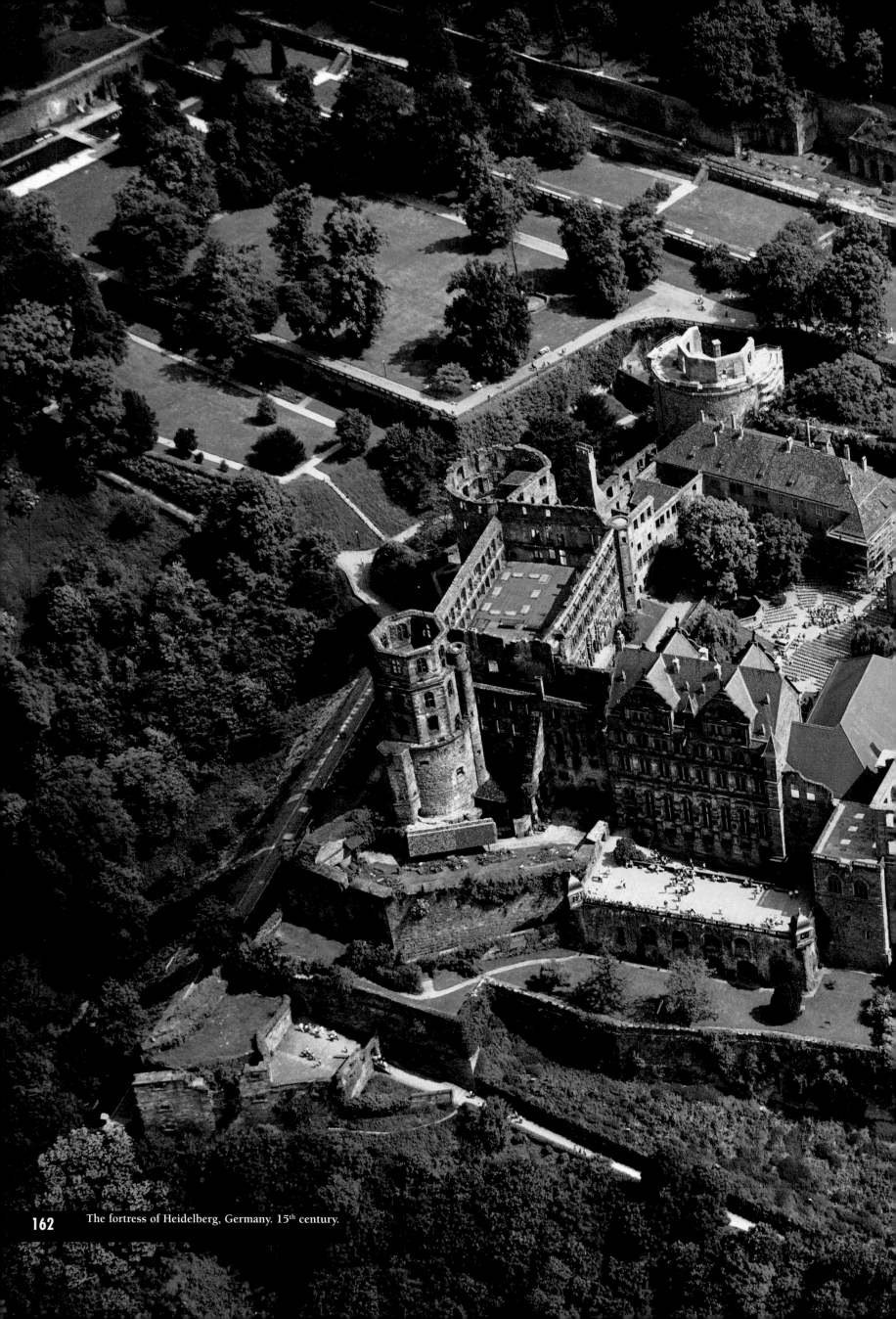

The fortress of Heidelberg, Germany. 15th century.

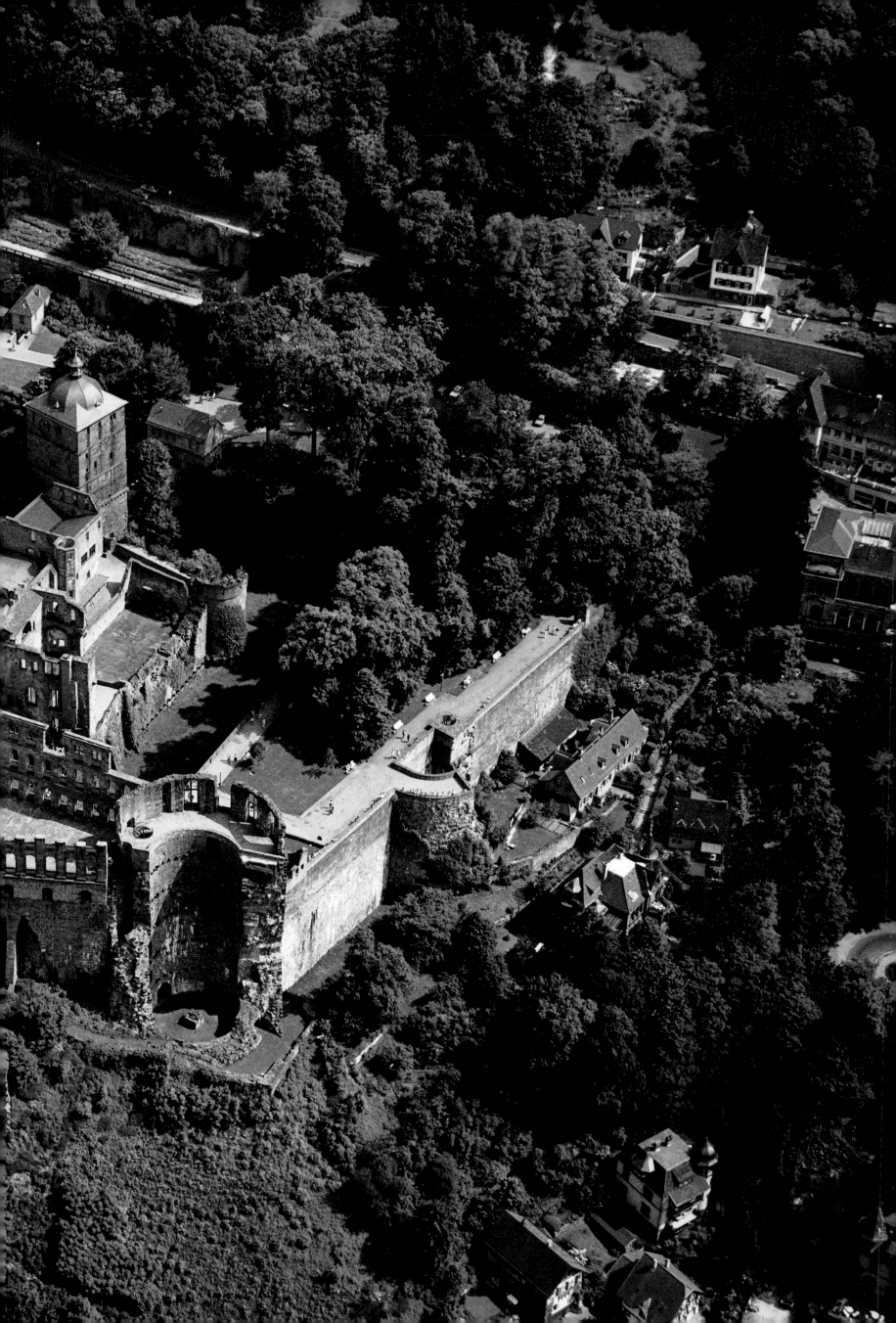

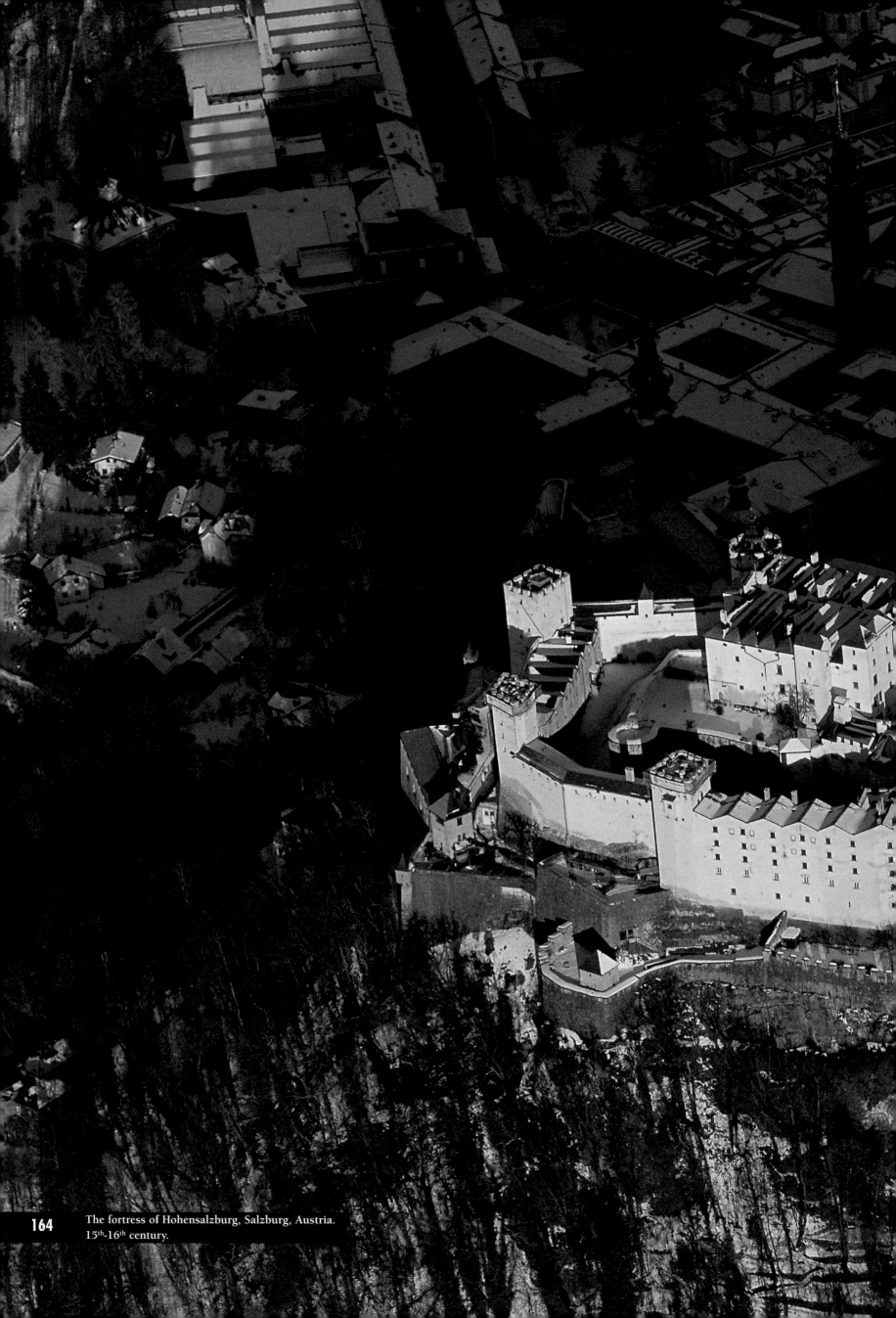

The fortress of Hohensalzburg, Salzburg, Austria.
15th-16th century.

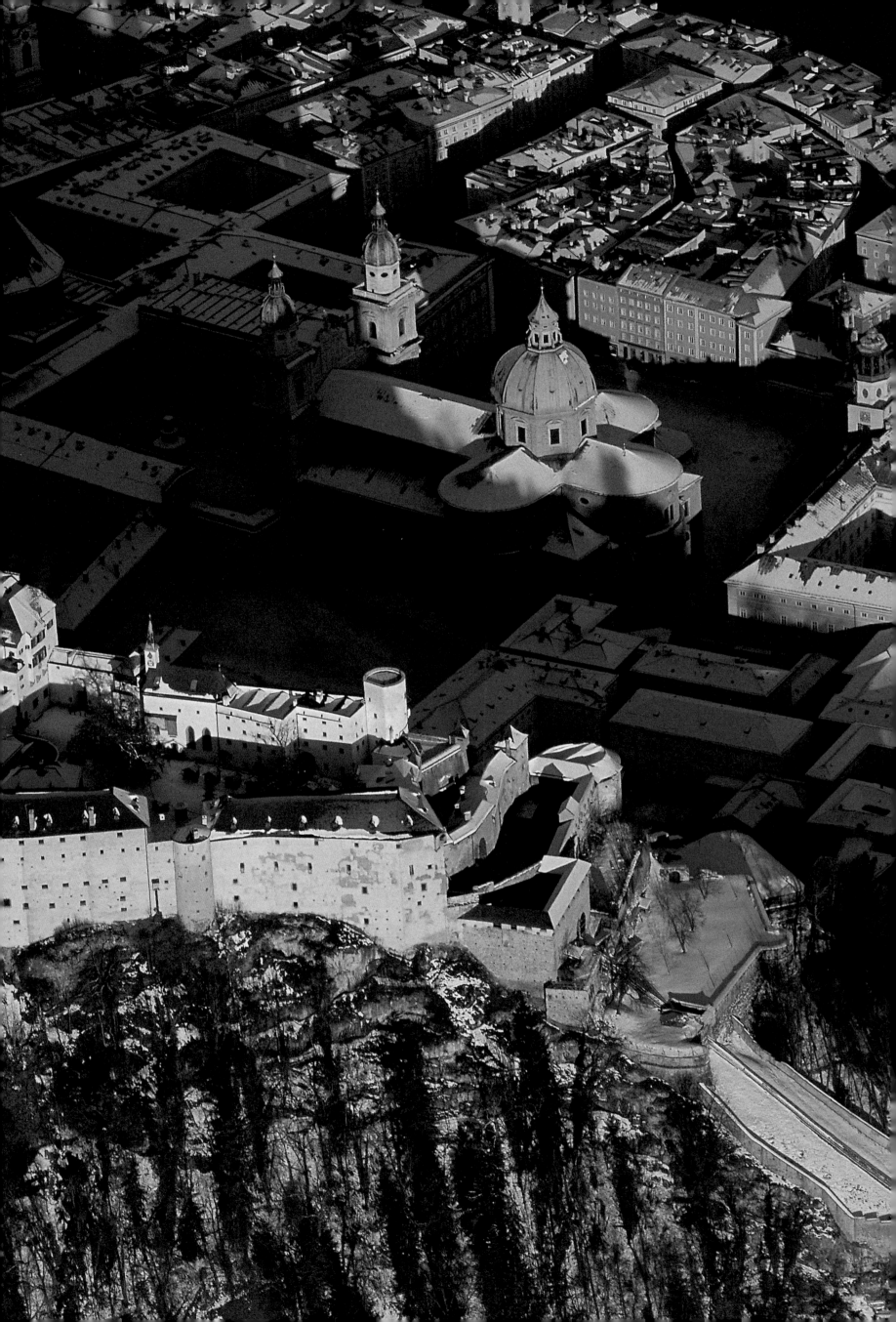

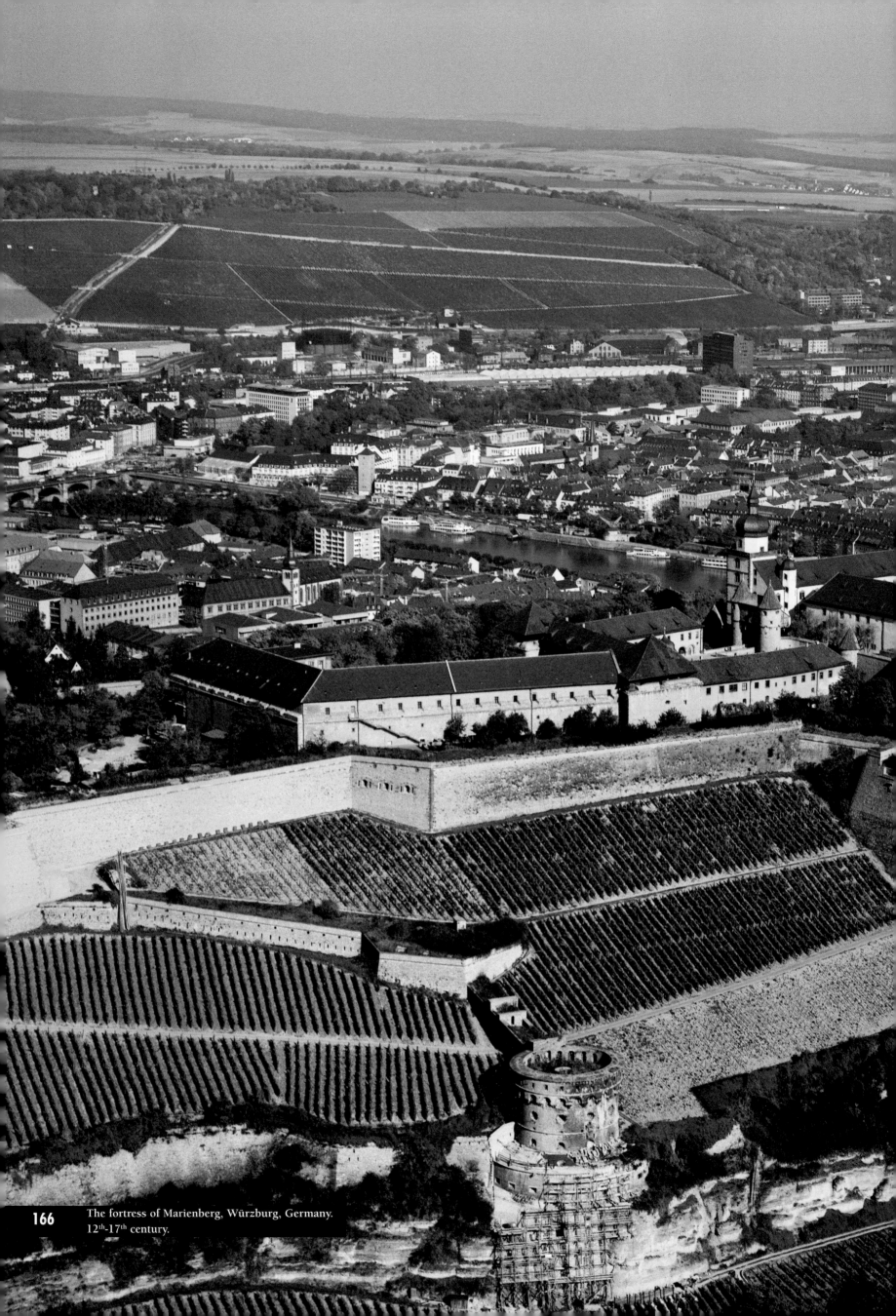

The fortress of Marienberg, Würzburg, Germany.
12th–17th century.

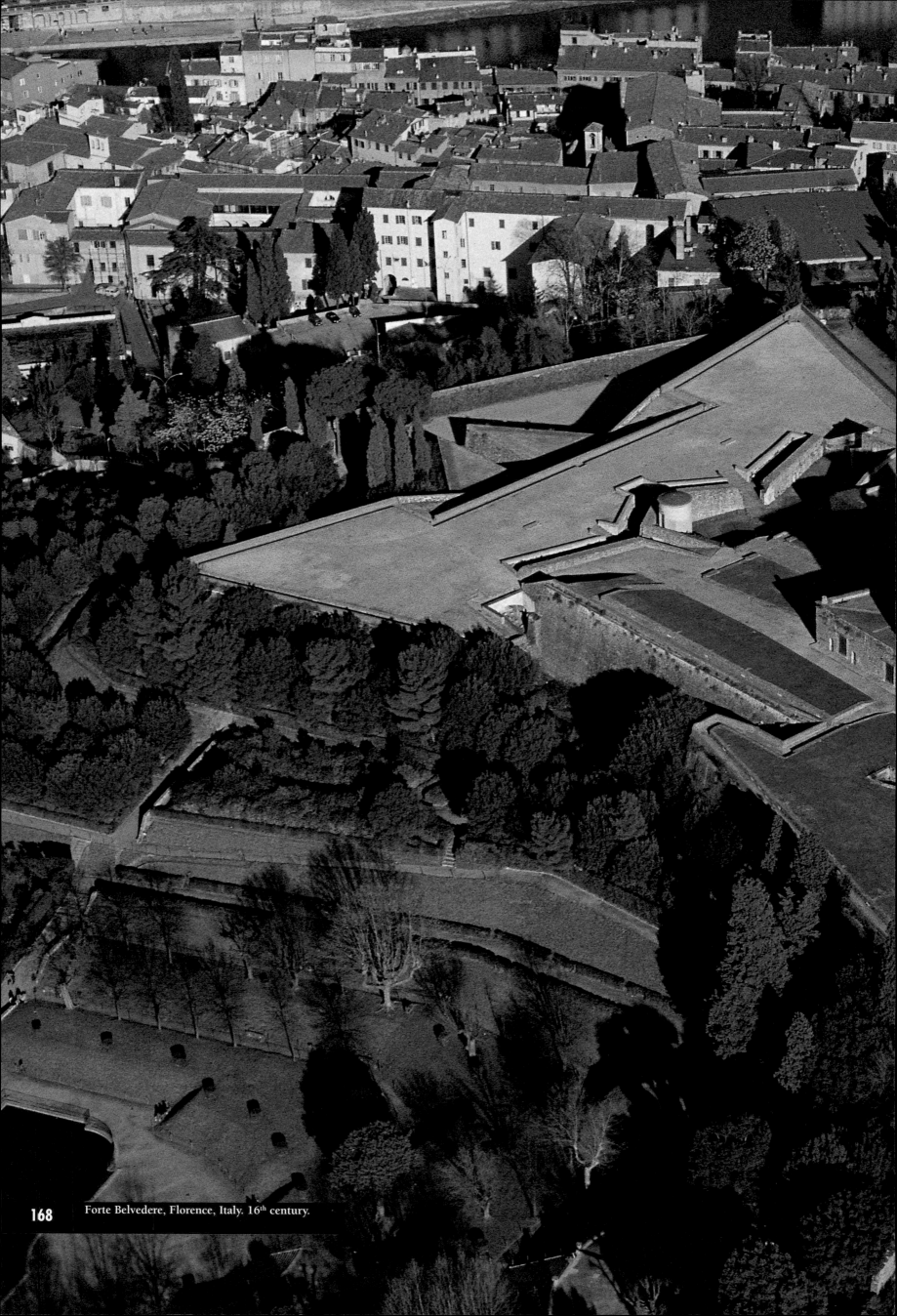

Forte Belvedere, Florence, Italy. 16th century.

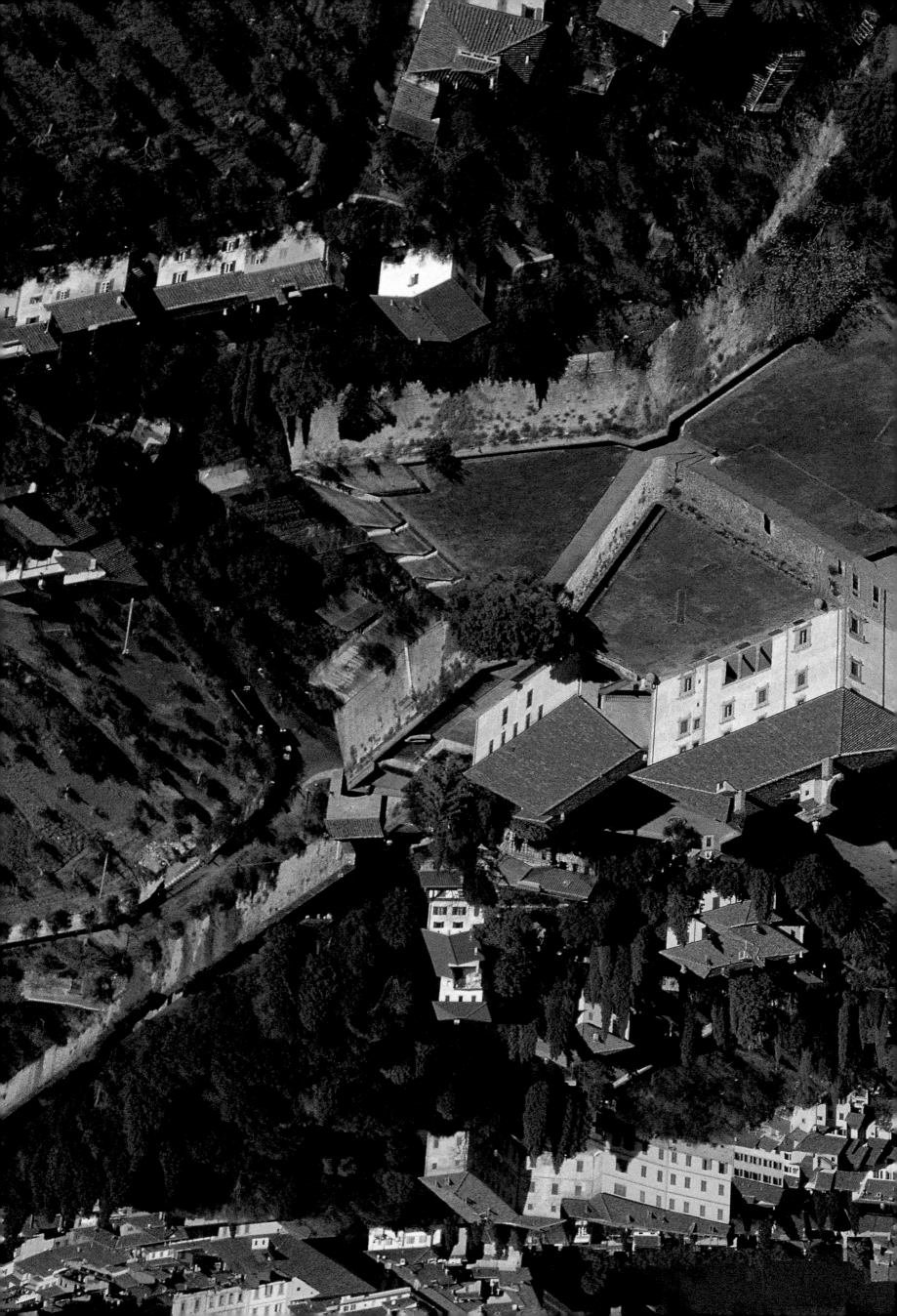

In the city

The House of Anjou was responsible for the construction of some of the largest urban castles, including the Château de Tarascon and the famous Castel Nuovo, or Maschio Angioino, in Naples, built at the end of the thirteenth century during the reign of Charles I of Anjou and rebuilt in the fifteenth century at the time of Alfonso of Aragon. Both of these castles are located at the edge of a conurbation, one on the banks of the Rhône and the other on the Gulf of Naples; both have imposing cylindrical towers at each corner.

The Castello Sforzesco in Milan was also originally sited on the edge of a conurbation, although today it is in the middle of town. The present building is the outcome of restoration work carried out in the early twentieth century; during this rebuilding the military buildings erected in the eighteenth and nineteenth centuries, when the castle was a garrison, were removed. This revealed the original fifteenth century plan with its three courtyards, designed in 1450 under Francesco Sforza, lord of Milan, on the site of an earlier building (1300), erected when the Viscontis were in power in Milan. The Castello di San Giorgio in Mantua is also now fully integrated into the town; this was the original part of the grandiose ducal palace of the Gonzaga family (see p. 142).

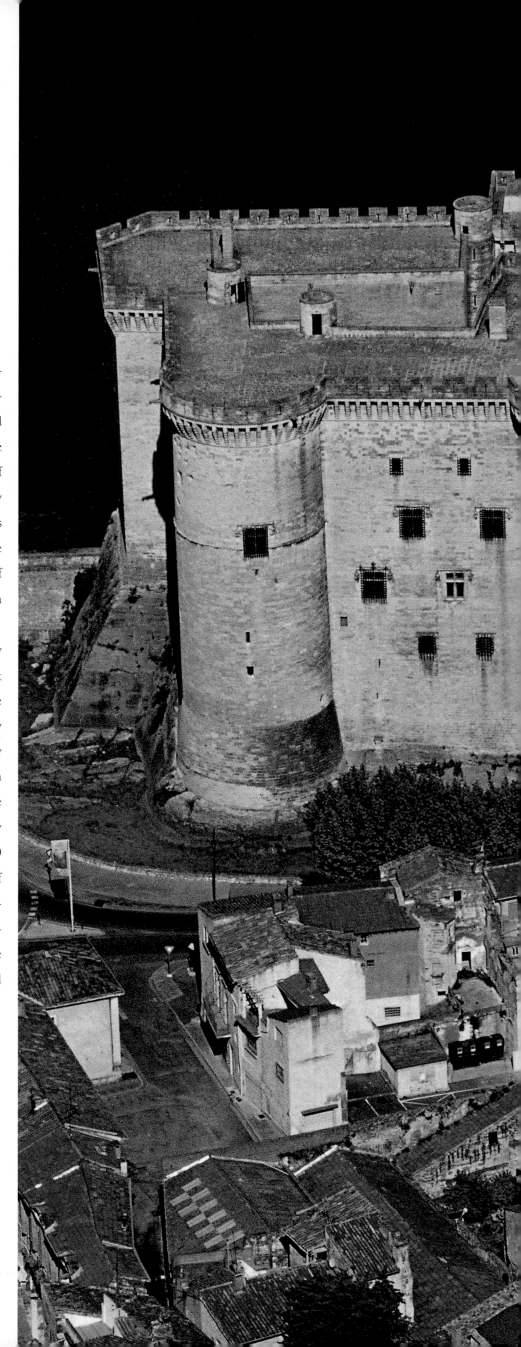

Château du Roi René, Tarascon, France.
15th century.

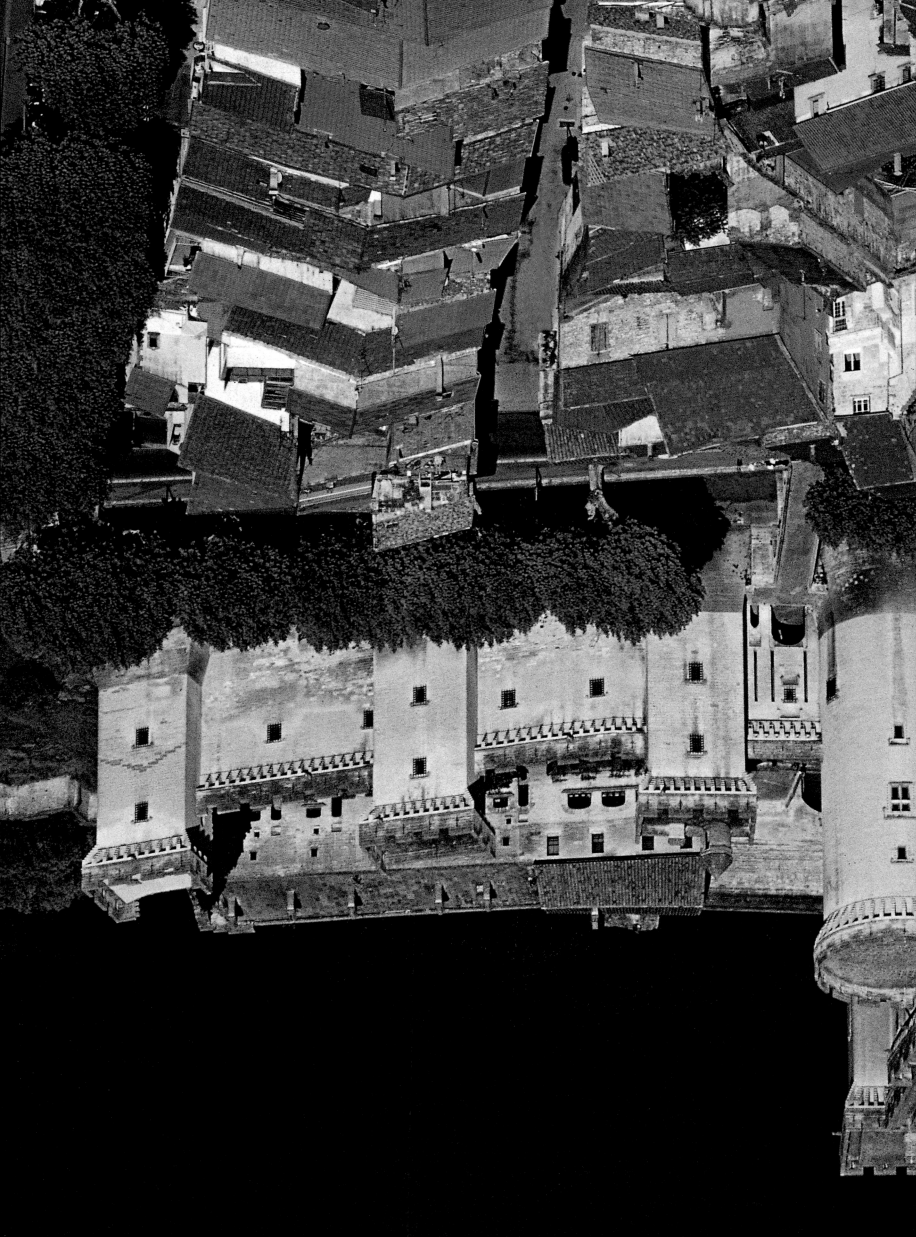

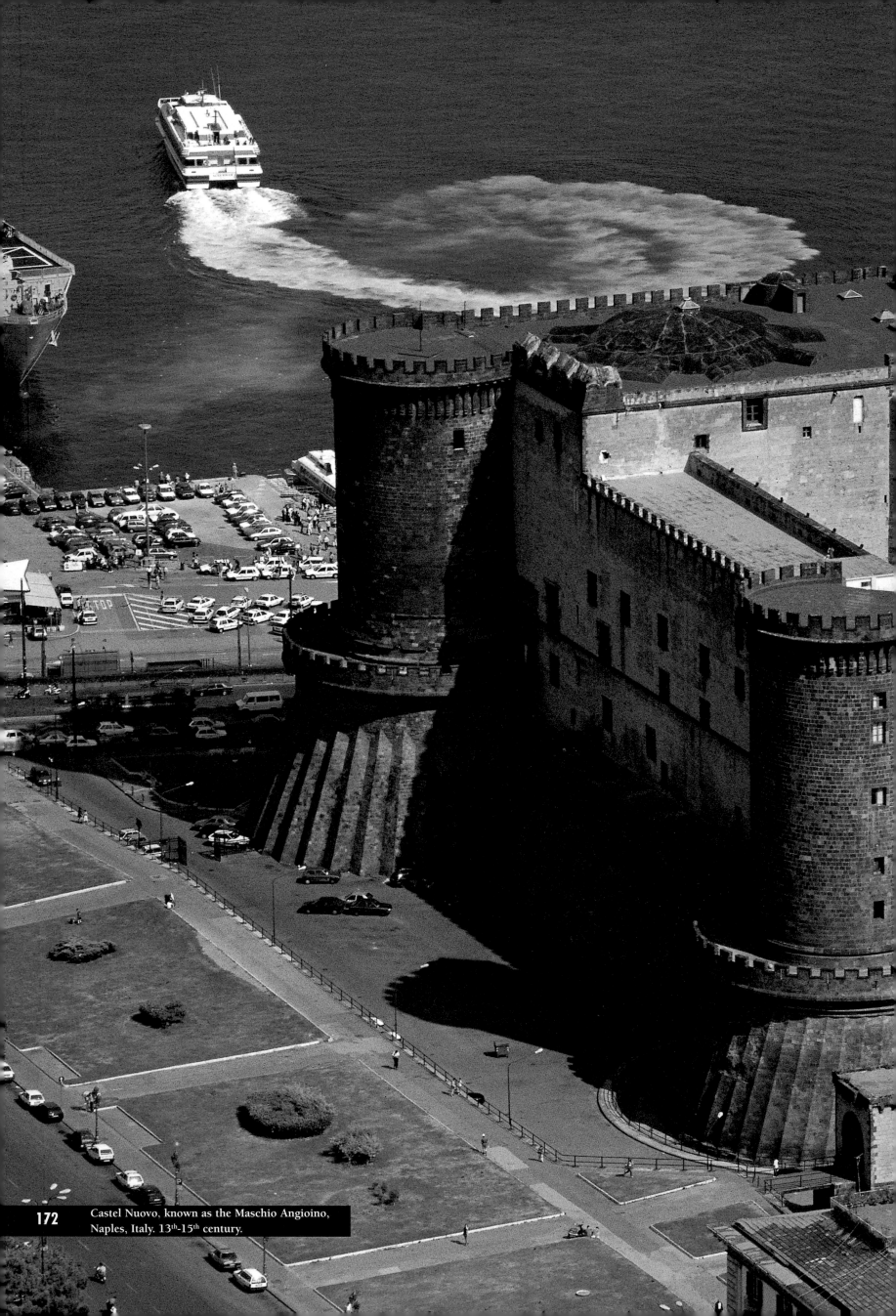

Castel Nuovo, known as the Maschio Angioino,
Naples, Italy. 13th-15th century.

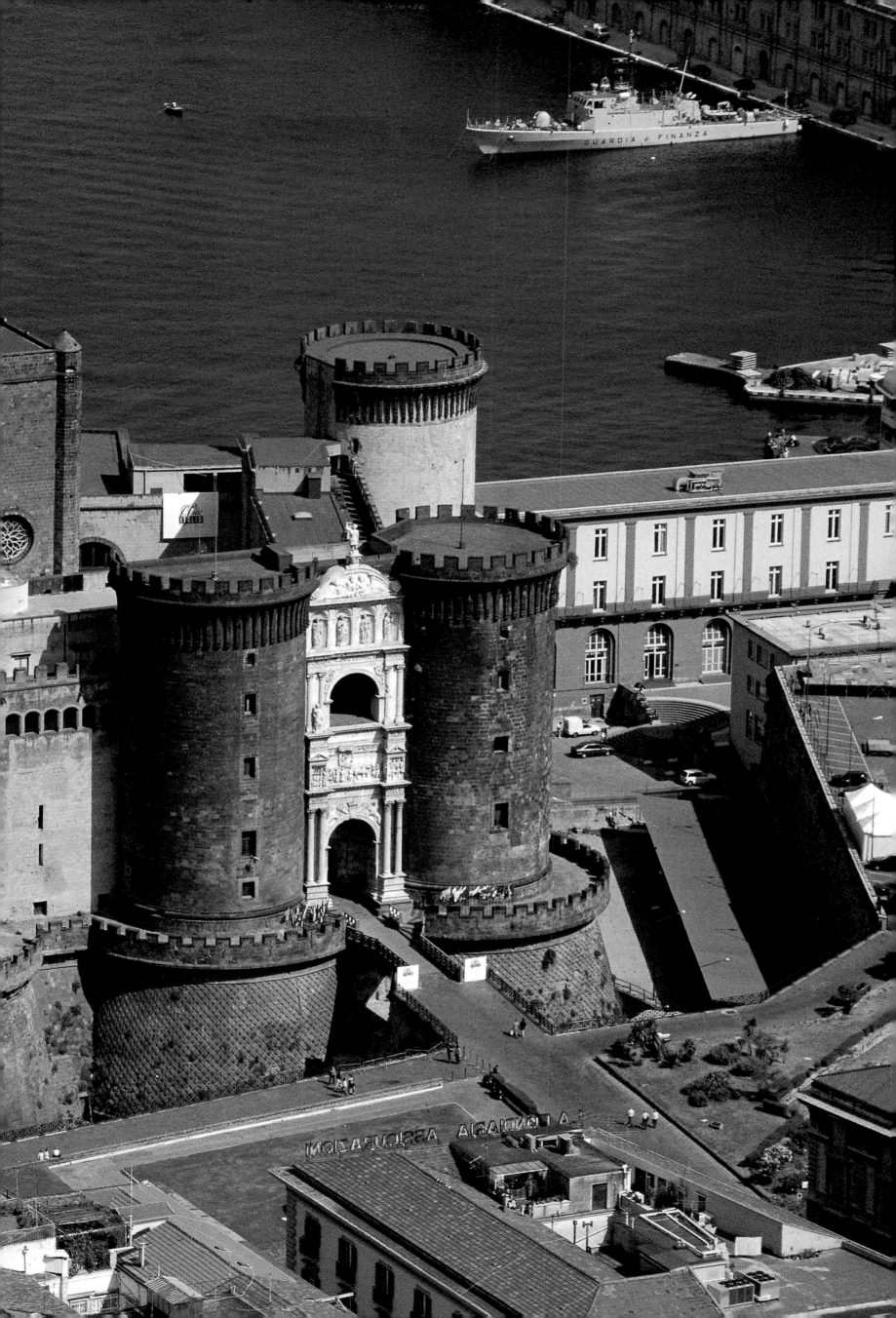

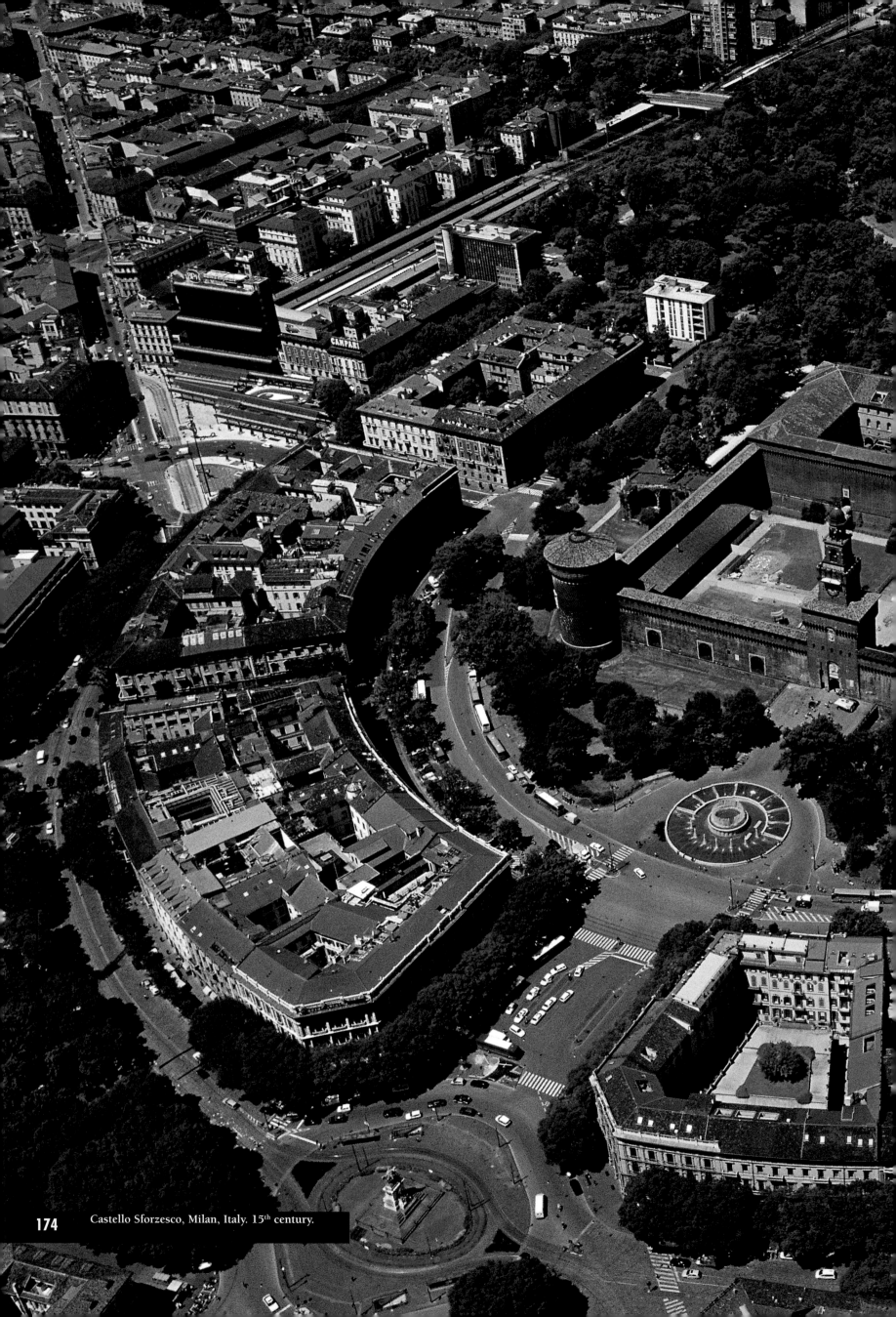

Castello Sforzesco, Milan, Italy. 15th century.

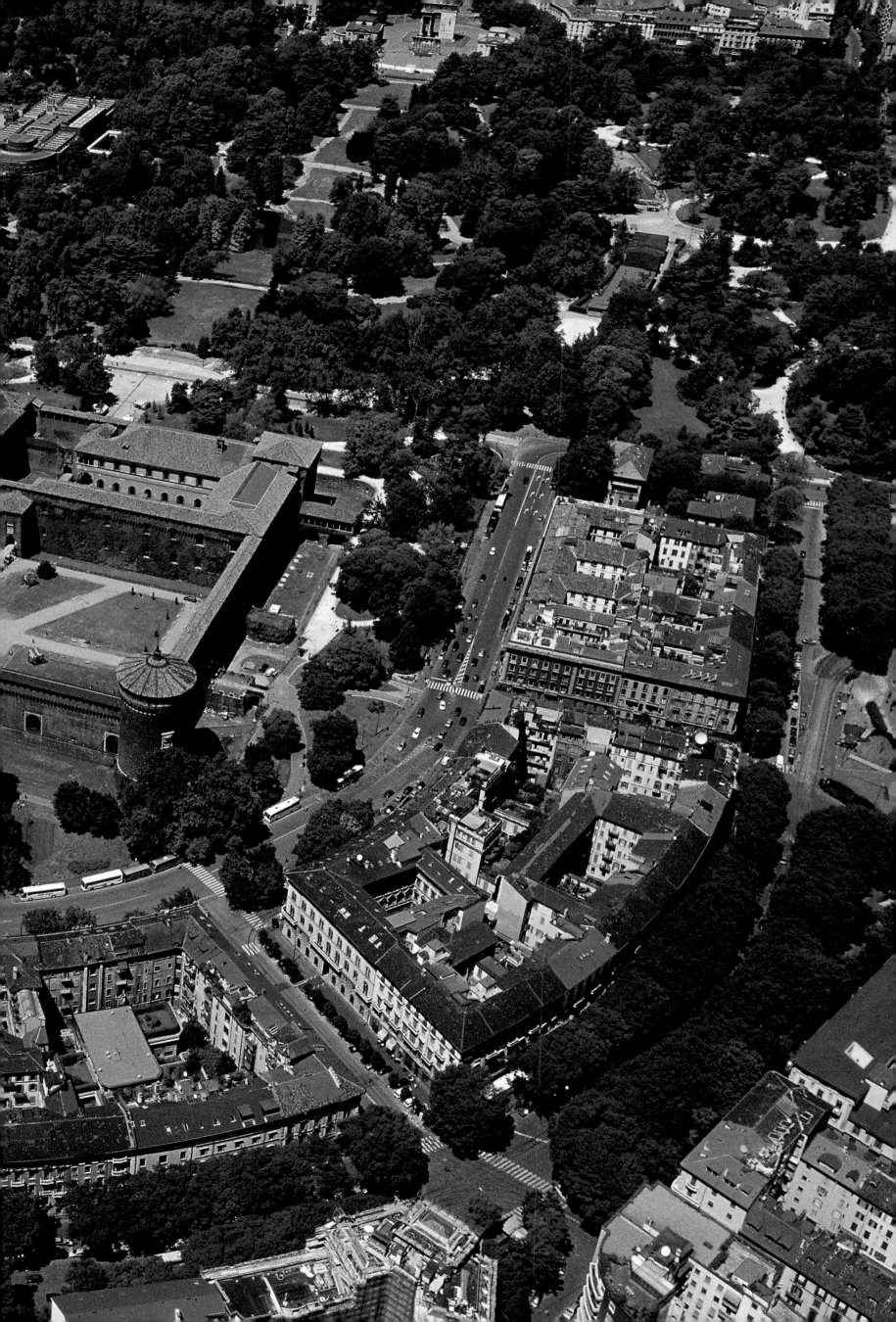

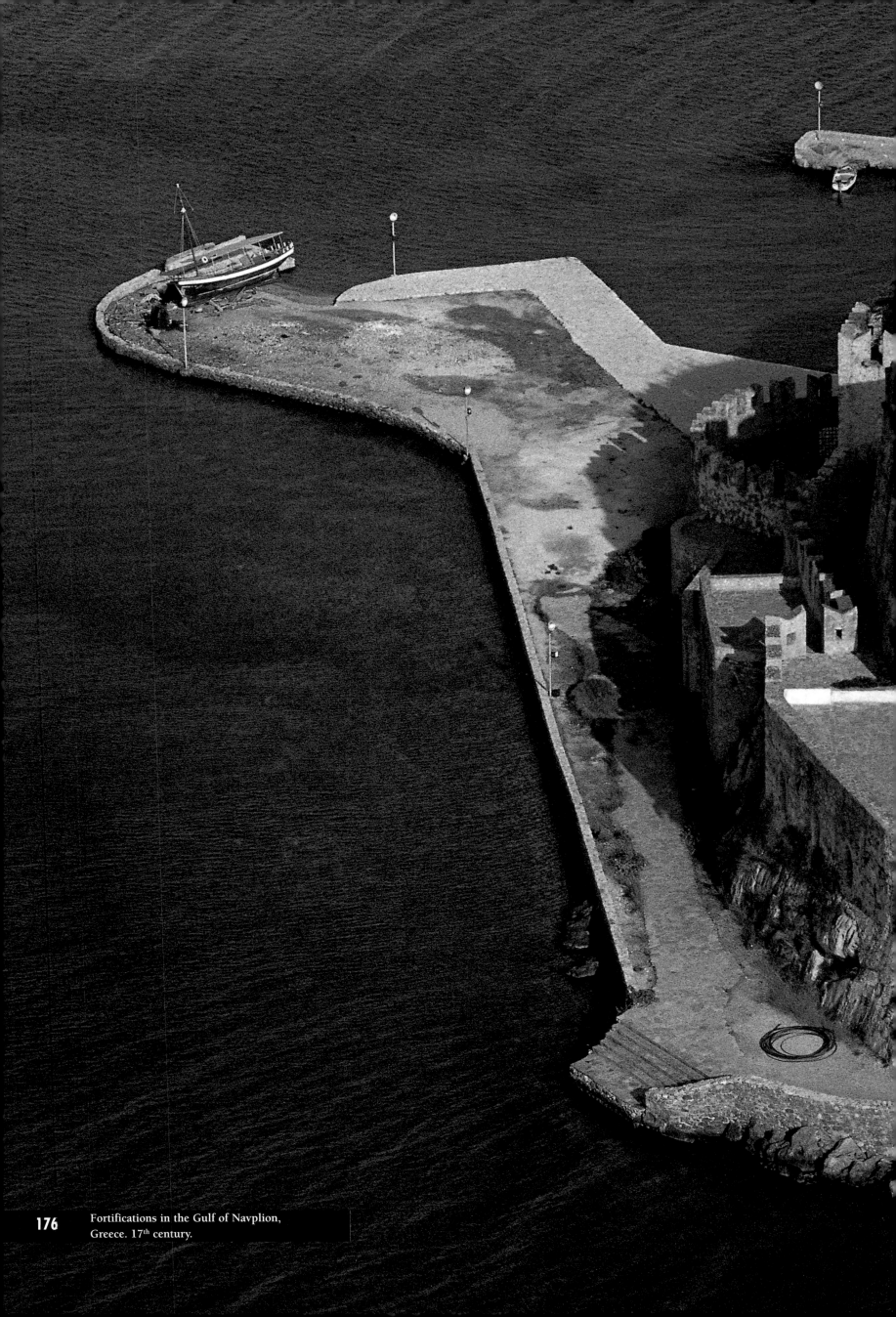

Fortifications in the Gulf of Navplion,
Greece. 17th century.

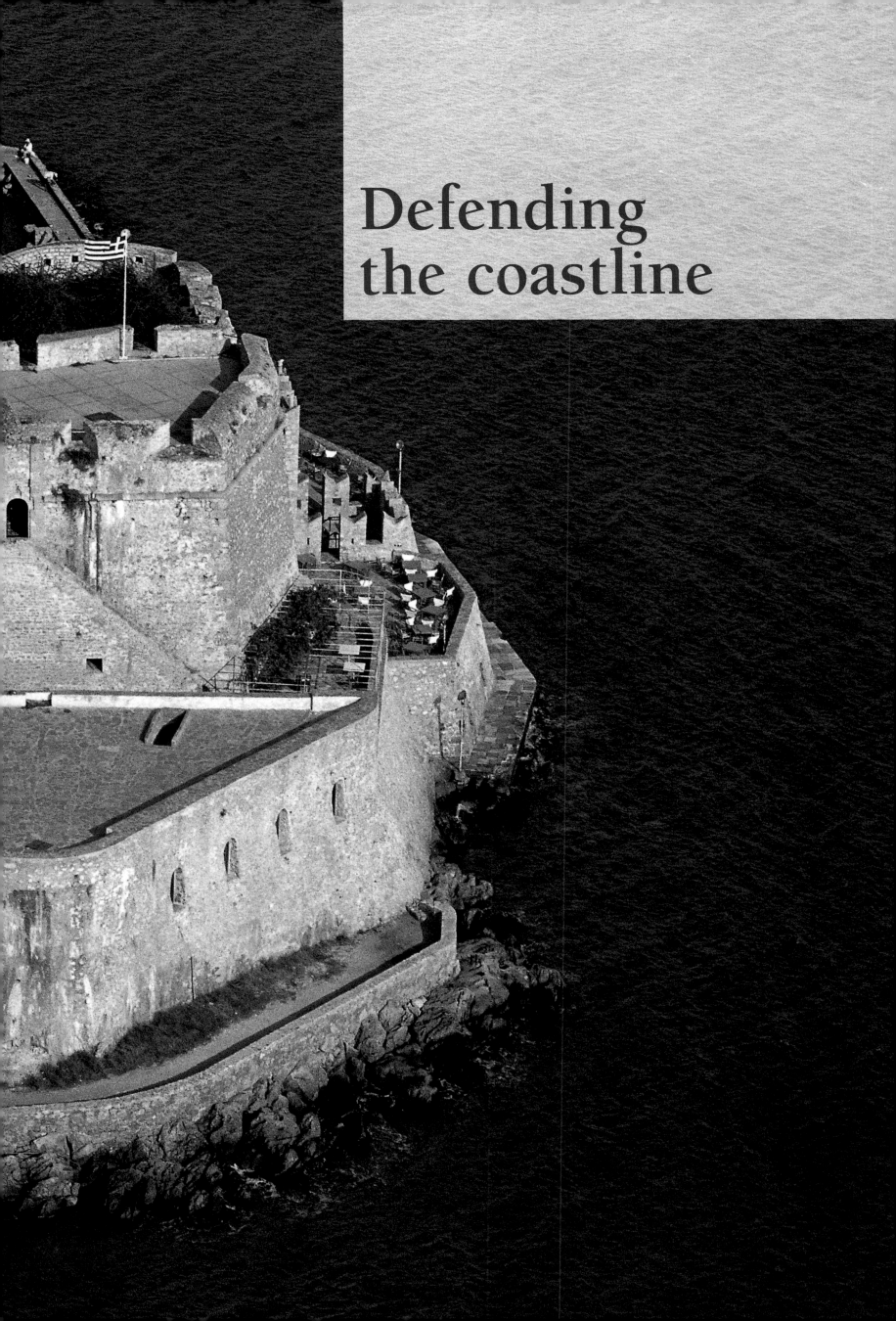

Defending the coastline

Systems of coastal defence

In the early Middle Ages, when the cultural unity of the Mediterranean was split into three distinct territories between the Byzantine Empire (the Aegean, the southern Adriatic and the Black Sea), the Arab caliphates (the Eastern Mediterranean, North Africa, Sicily and the Iberian Peninsula) and the barbarian kingdoms (France and Central and Northern Italy), an important change came over the nature of Mediterranean navigation. Alongside the traditional mercantile activity a new threat developed. Piracy, and corsairs were also used as a political tool by the Islamic caliphates for making territorial conquests and exercising military pressure. Protection of the coastline, and defence of the approaches to commercial and military ports became an increasing preoccupation and caused the building of innumerable defensive structures, tailored for different types of attack. In barbarian Europe, during the last centuries of the first millennium, the main type of defensive building was the lookout tower, a simple and very widespread structure whose aim was to sound the alarm when corsair ships were espied, so that adequate defence of the populace and their possessions could be arranged – or the populace could be evacuated. As time passed, these towers were also the first line of defence against invasion from the sea. The tower could be surrounded by a fortified wall and protected on the seaward side by crenellations and arrow slits, as can be seen in Piombino (Livorno). On the border between Spain and Portugal the coastal fortress of La Guardia perches on a great Renaissance bastion. Another type of coastal defence is the genuine castle constructed on an islet near the coast, to which it might be joined by an embankment and a pontoon. One interesting example is the Aragonese castle of Isola di Capo Rizzuto, now partly washed away. In later centuries, after the initial phase when the buildings had the sole of function of defending the coast and the population, buildings became more confused in style and more complex: the watchtower which could provide a first line of defence became a structure which also offered protection to the buildings around the port; naval activity was important to the local economy, in both military and mercantile terms. Complex systems were incorporated which were designed to protect the port and its equipment, its warehouses and ships rather than the local populace. This is exemplified by the Torre di Belem in Portugal, built in about 1500 on the estuary of the Tagus; the tower was situated downstream to protect the port of Lisbon. It has the appearance of a castle and is an example of a mature version of the Manueline style, a strange marriage between late Gothic art and the Moorish influence.

Castello Aragonese, Isola di Capo Rizzuto, Italy. 13th-16th century.

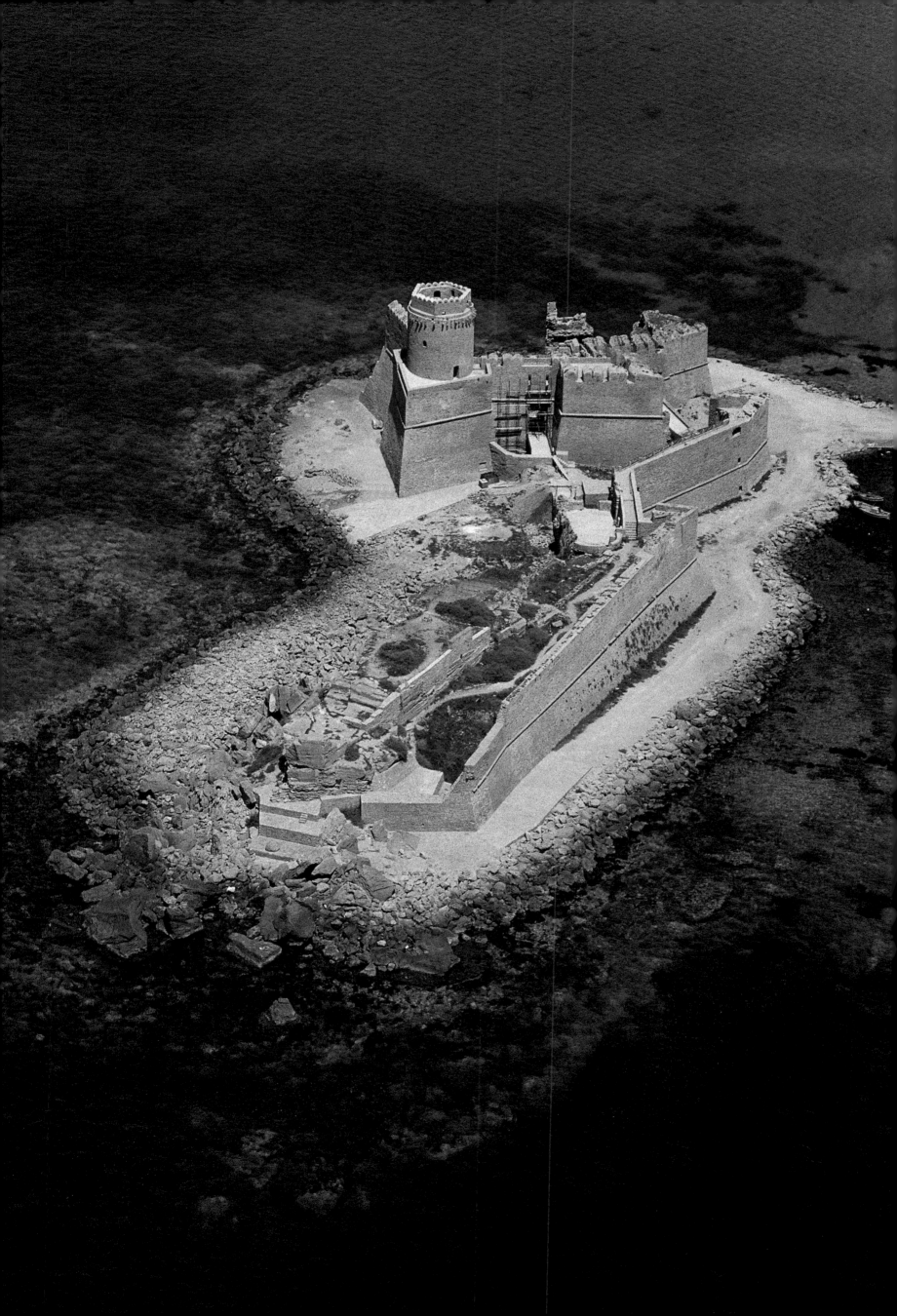

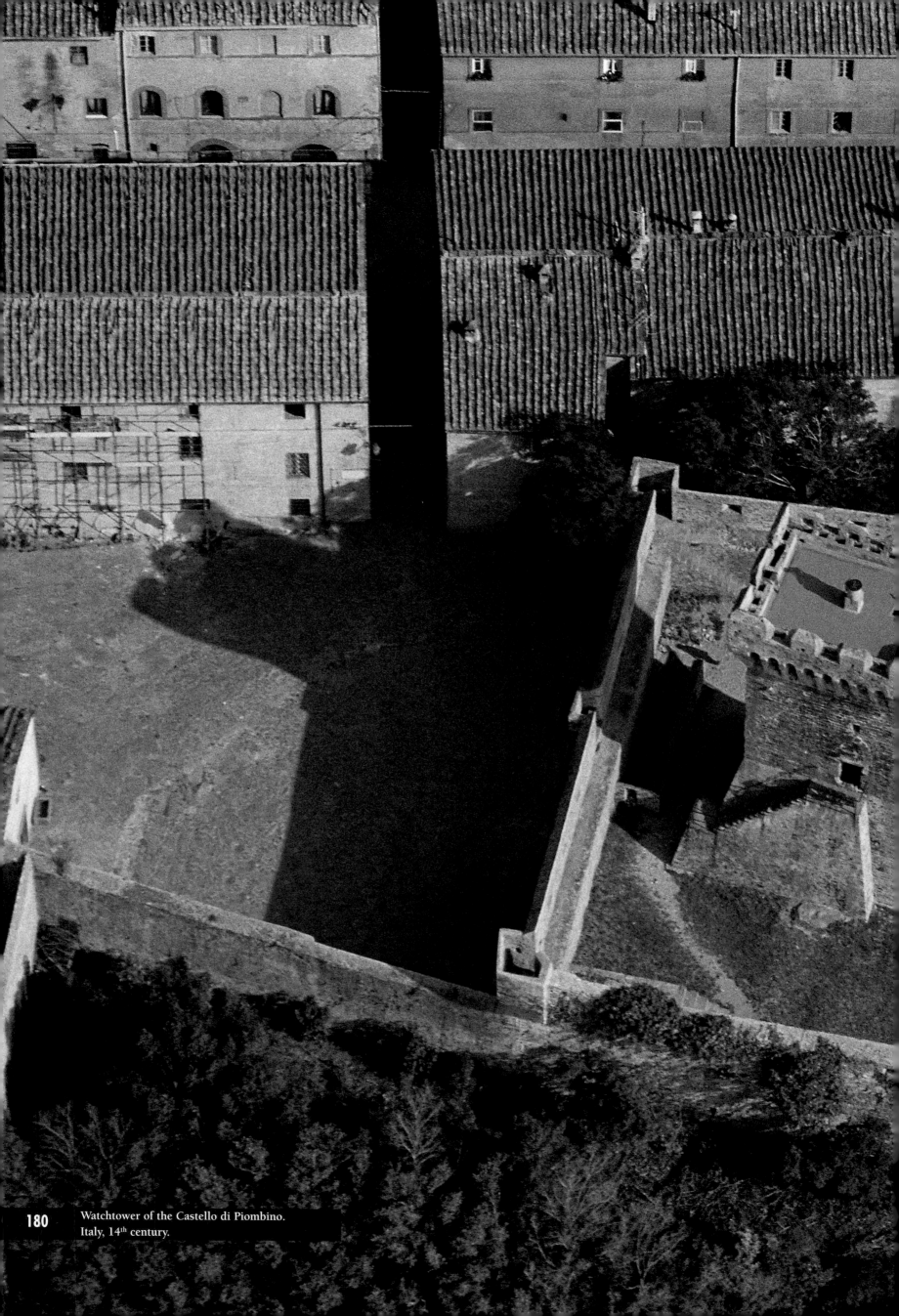

Watchtower of the Castello di Piombino.
Italy, 14th century.

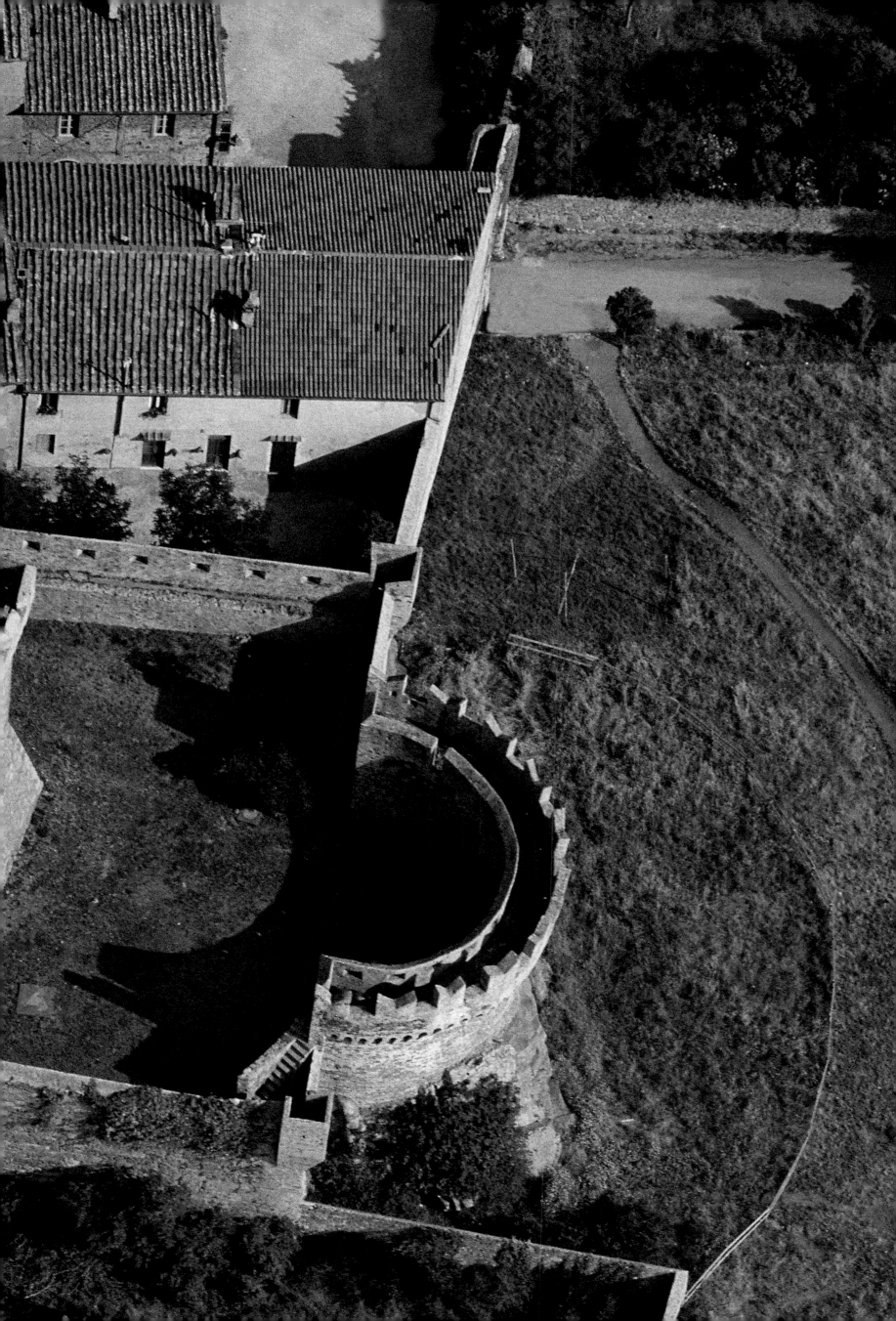

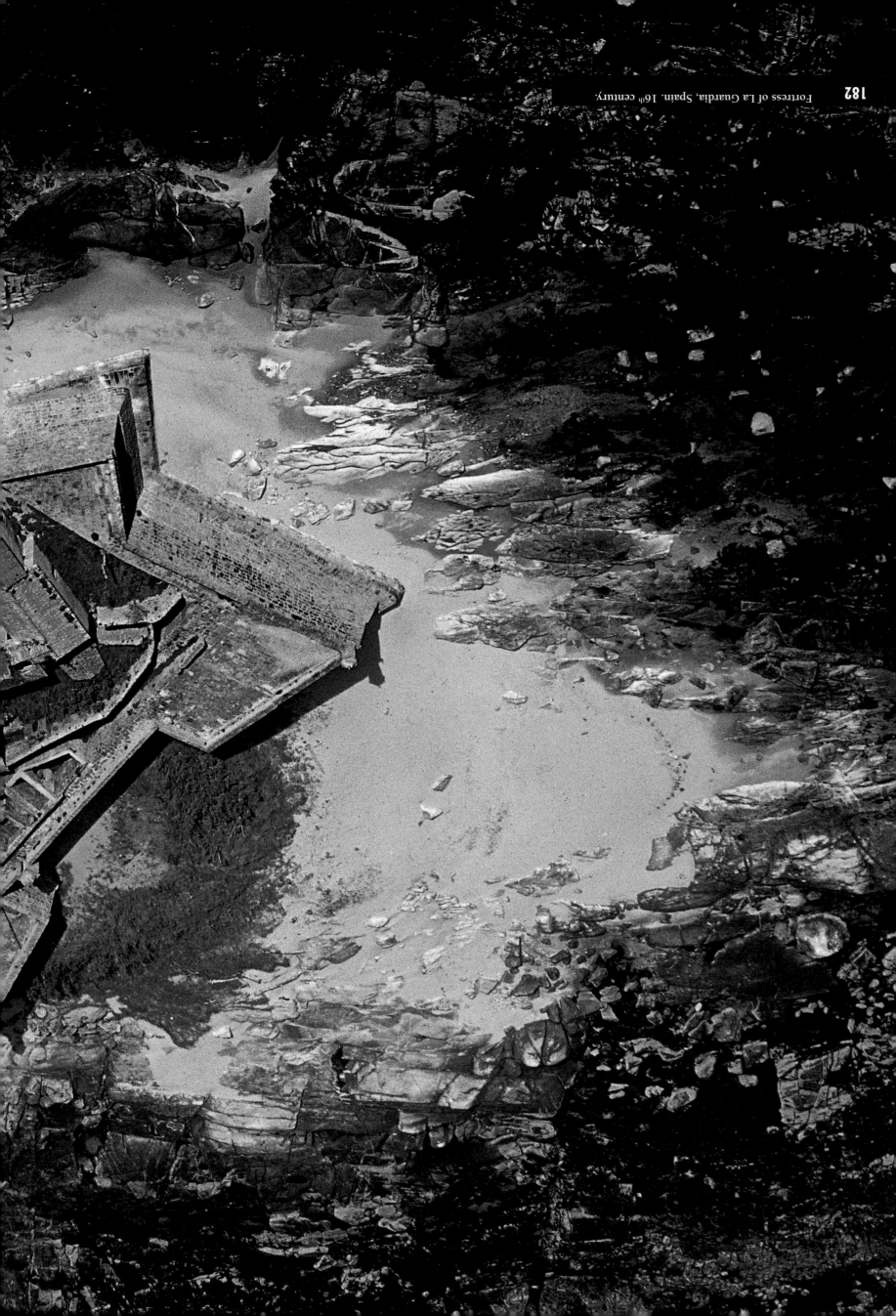

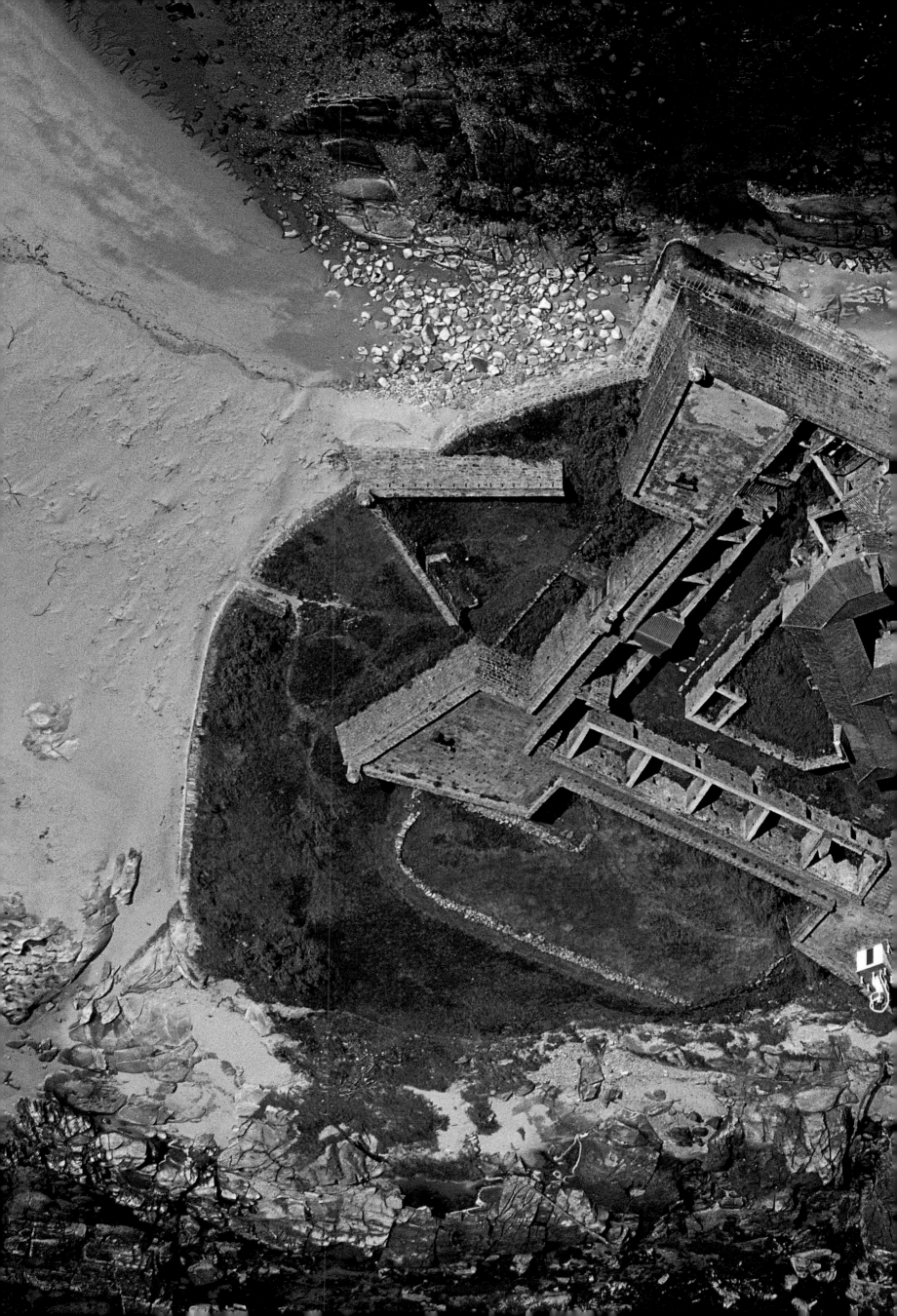

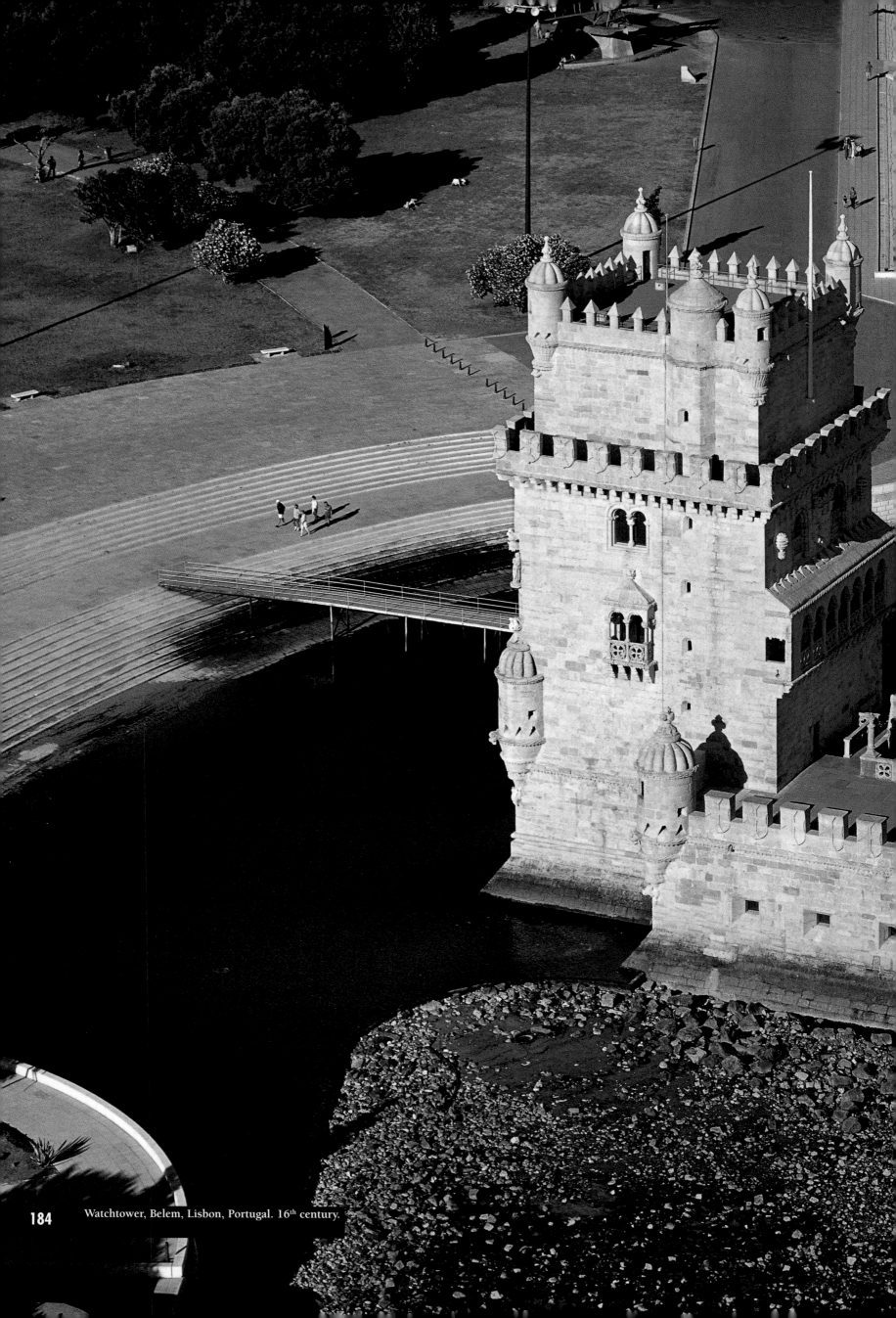

Watchtower, Belem, Lisbon, Portugal. 16th century.

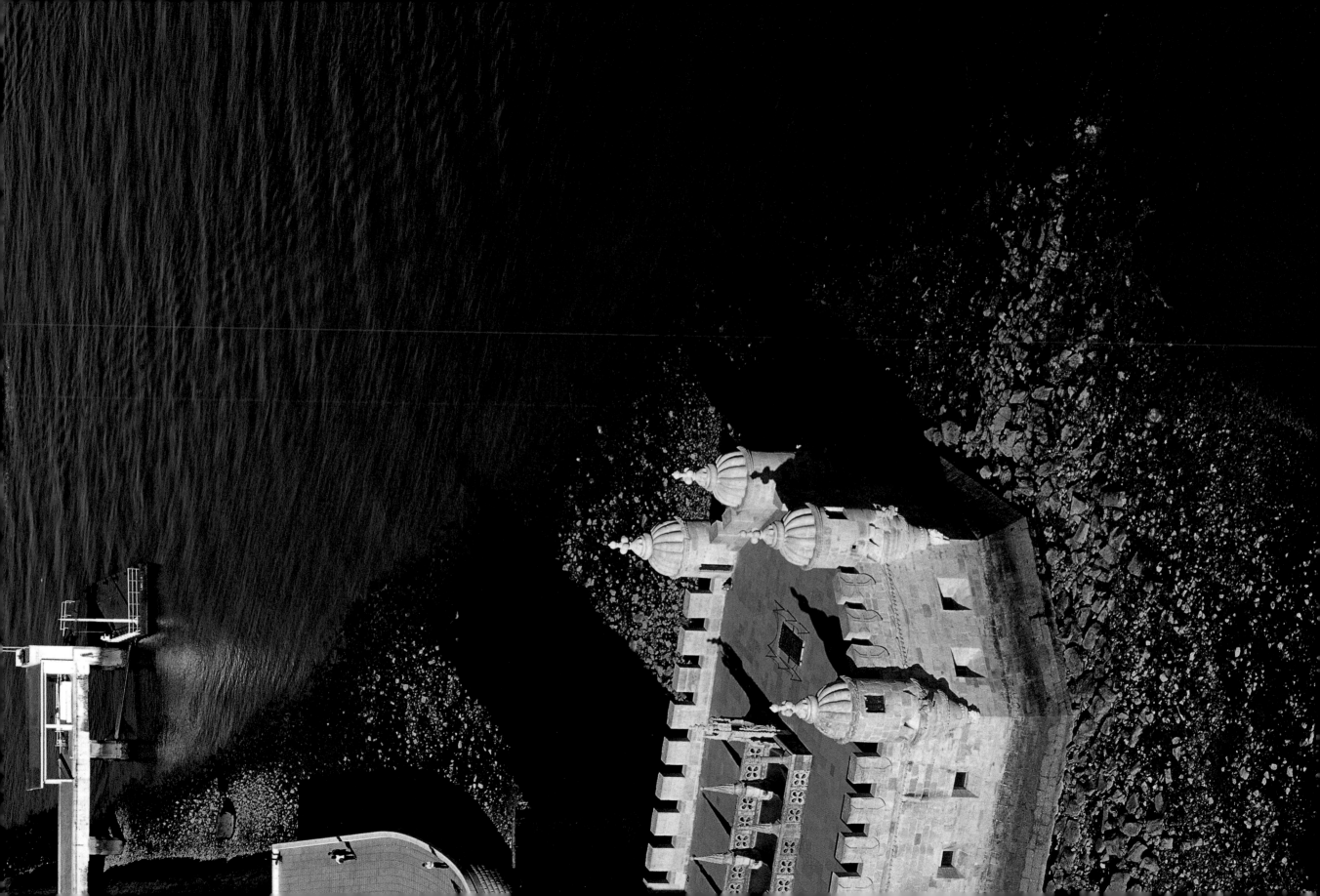

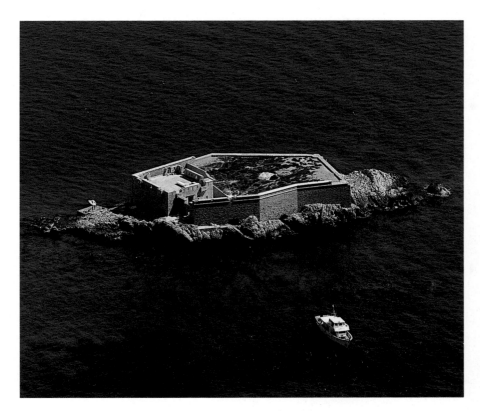

Fortifications on an island outside the port of Marseille.

Ports and harbours

A complete example of integrated defences can be seen in the port of Marseille, where two advanced positions are located on two small islands just outside the harbour, plus two fortresses at the entrance to the harbour. One of these, the Fort St-Jean, has a massive keep. These structures helped ensure the security of ships entering and leaving the port. The keep, called the Tour du Roi René, was built in the fifteenth century to stand over the entrance to the canal which constituted the old port. Of the two fortifications on the islands opposite the coastline, the most notorious is the Château d'If, a massive castellated tower surrounded by walls along the circumference of the island; it was used for years as a prison. This is the tower described by Alexandre Dumas in his famous novel, *The Count of Montecristo* (1844-45).

The fortress of La Rochelle is also connected with Dumas (*The Three Musketeers*), and the less familiar fortress of Antibes offers an imposing spectacle with its fifteenth-century bastions and glacis with lawns. Also worth remembering is Elizabeth Castle, which dominates the entrance to the port of Jersey; the castle presents a romantic cluster of buildings built on a small island, attached to land by a dyke. Another large system of harbour defences can be found in Valletta, on the island of Malta; the cluster of buildings was rearranged several times over the centuries to adapt to new types of weaponry. The oldest part dates back to the Crusades, to the Knights of the Sovreign Military Order of Malta, a religious order which was set up in the Holy Land, transferred first to Rhodes and then to Malta as the Turkish army and navy gradually encroached on the Eastern Mediterranean. The current appearance of the fortress is the outcome of centuries of reconstruction and repairs.

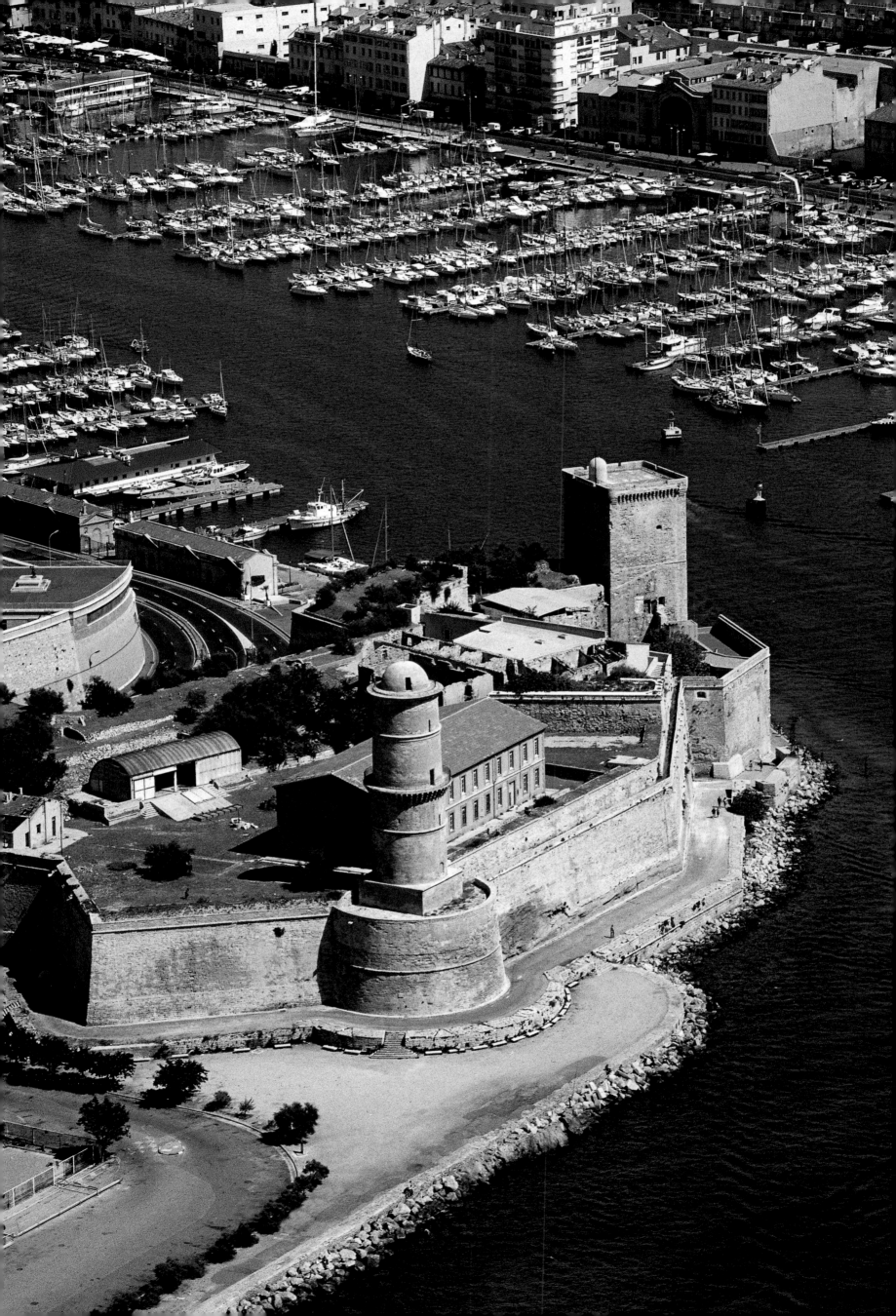

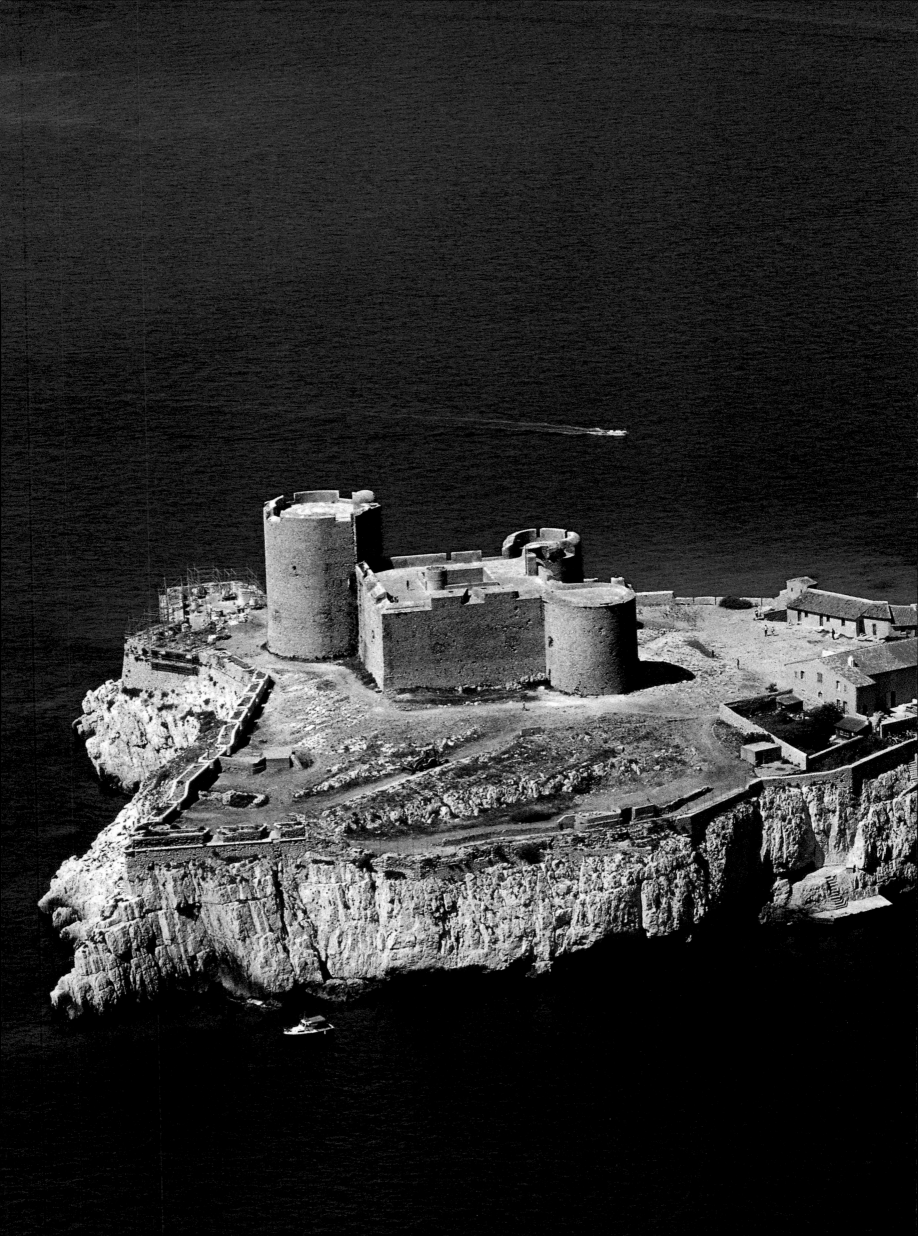

Château d'If, Marseille, France. 16th century.

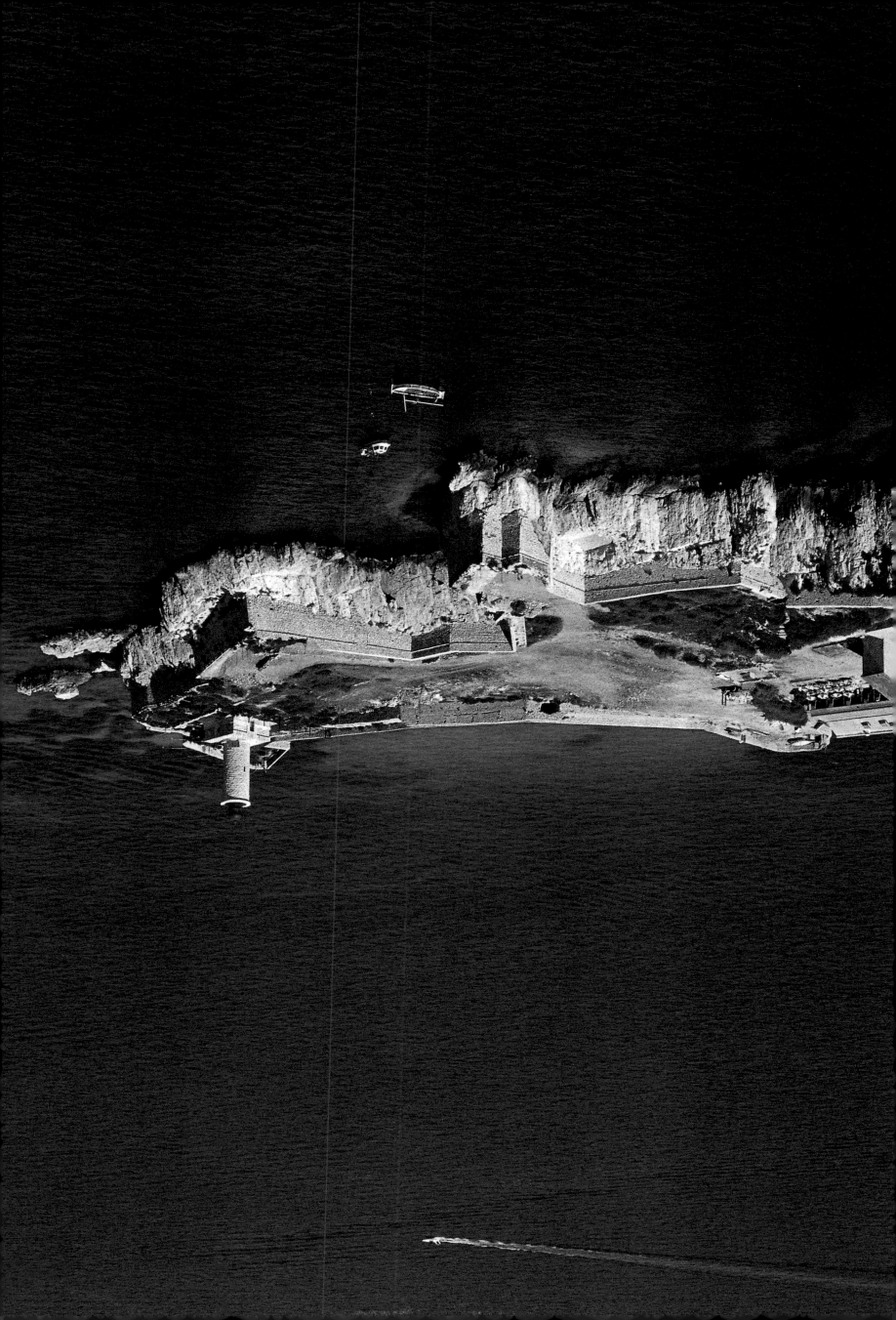

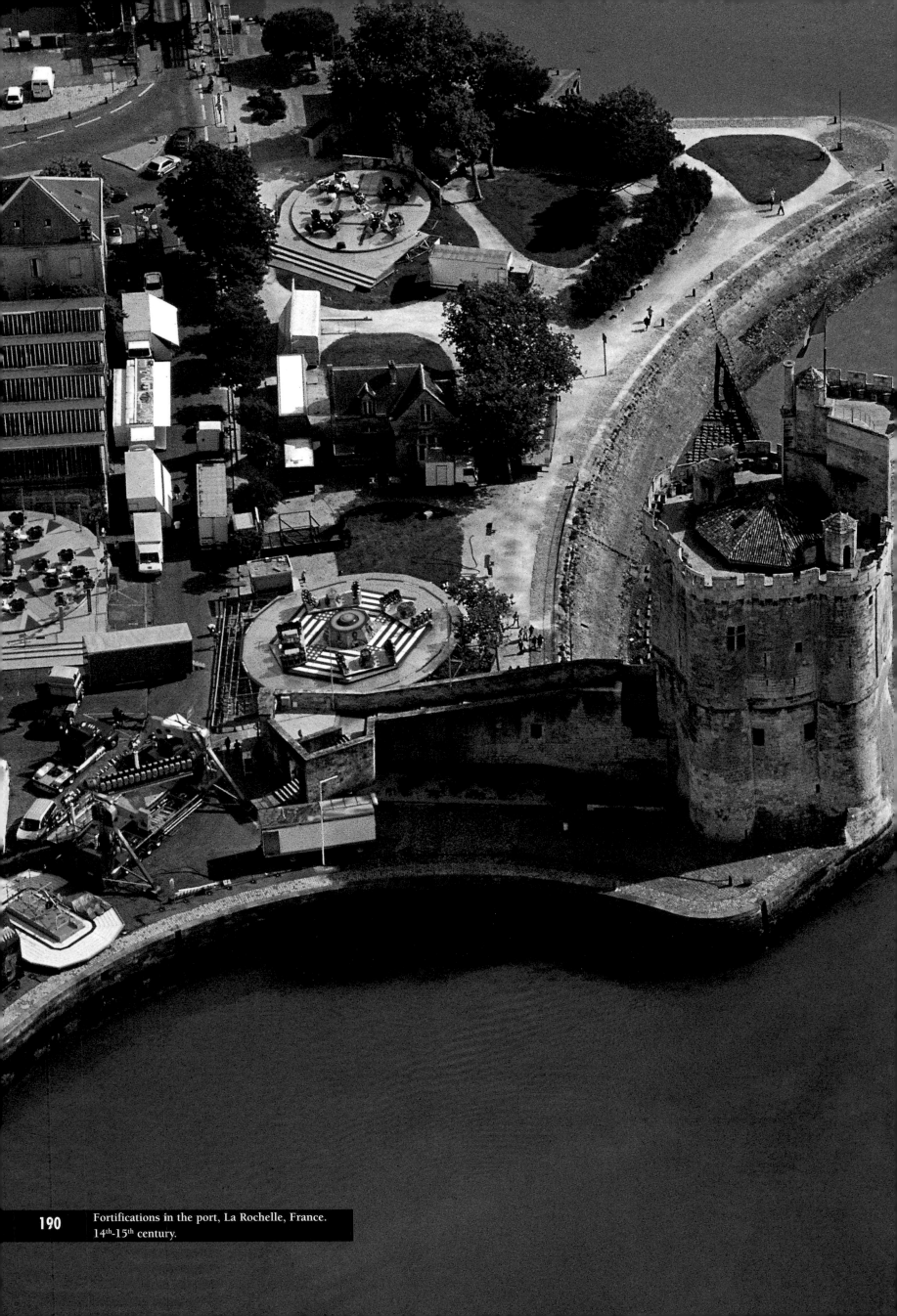

190 Fortifications in the port, La Rochelle, France.
14th-15th century.

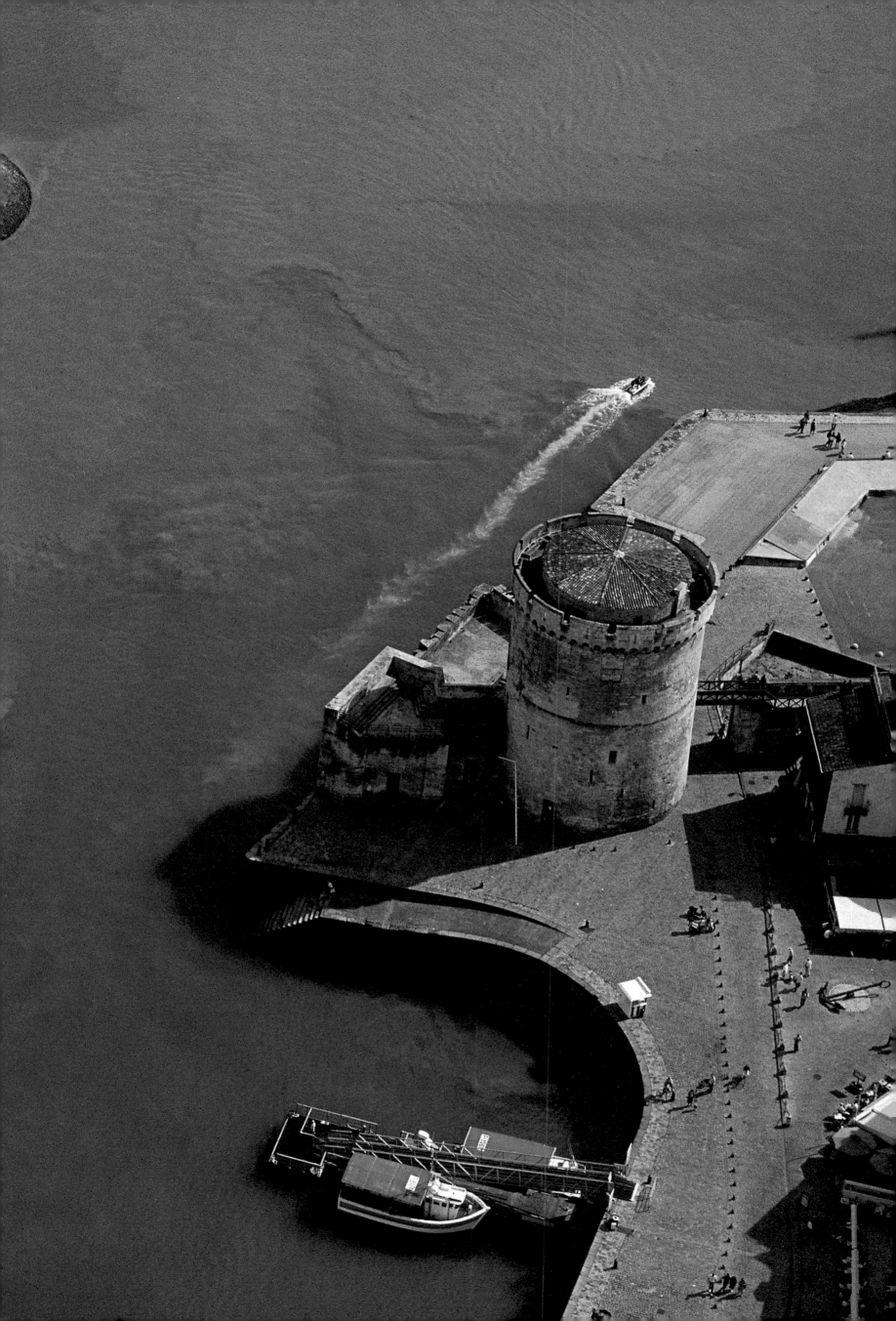

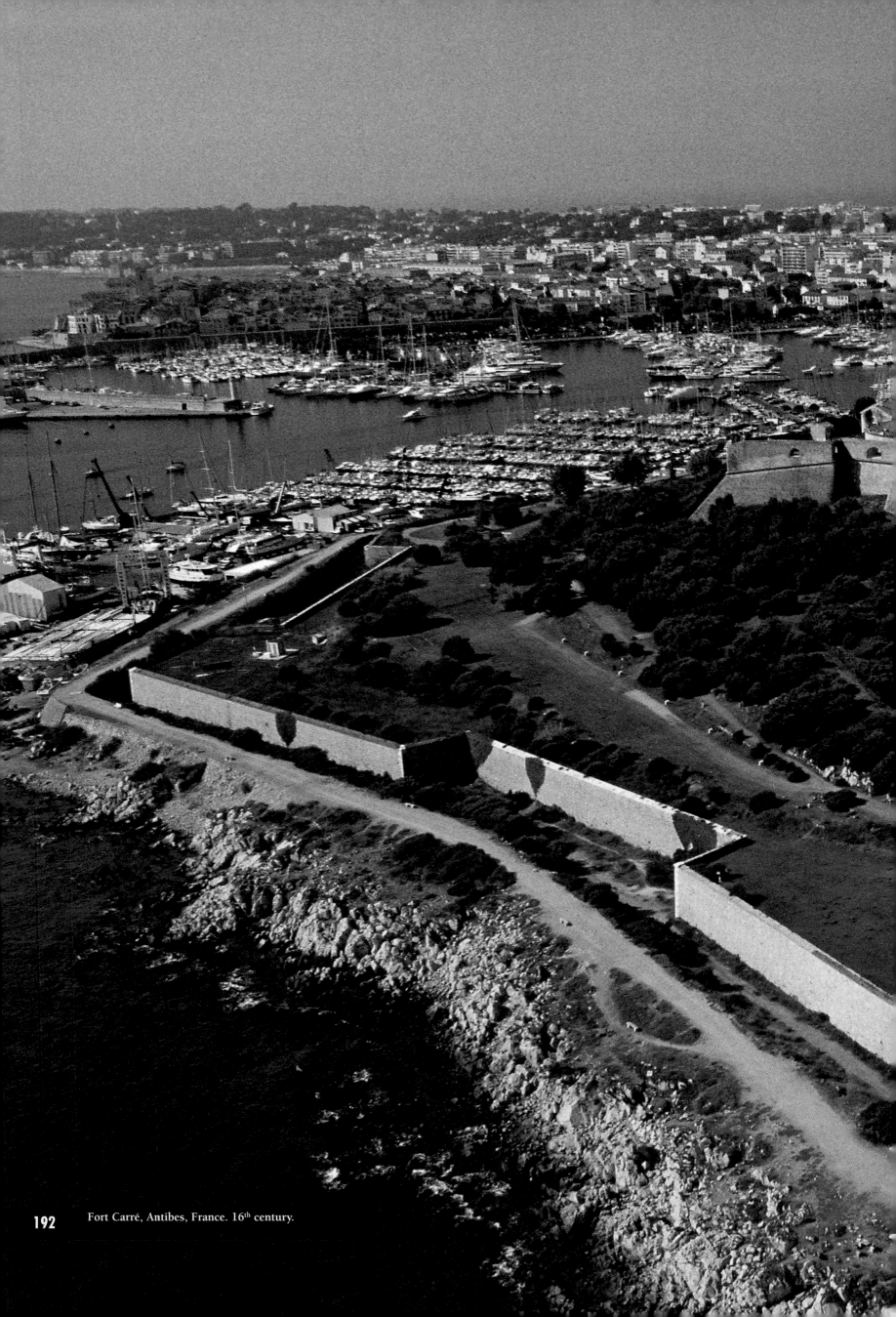

Fort Carré, Antibes, France. 16th century.

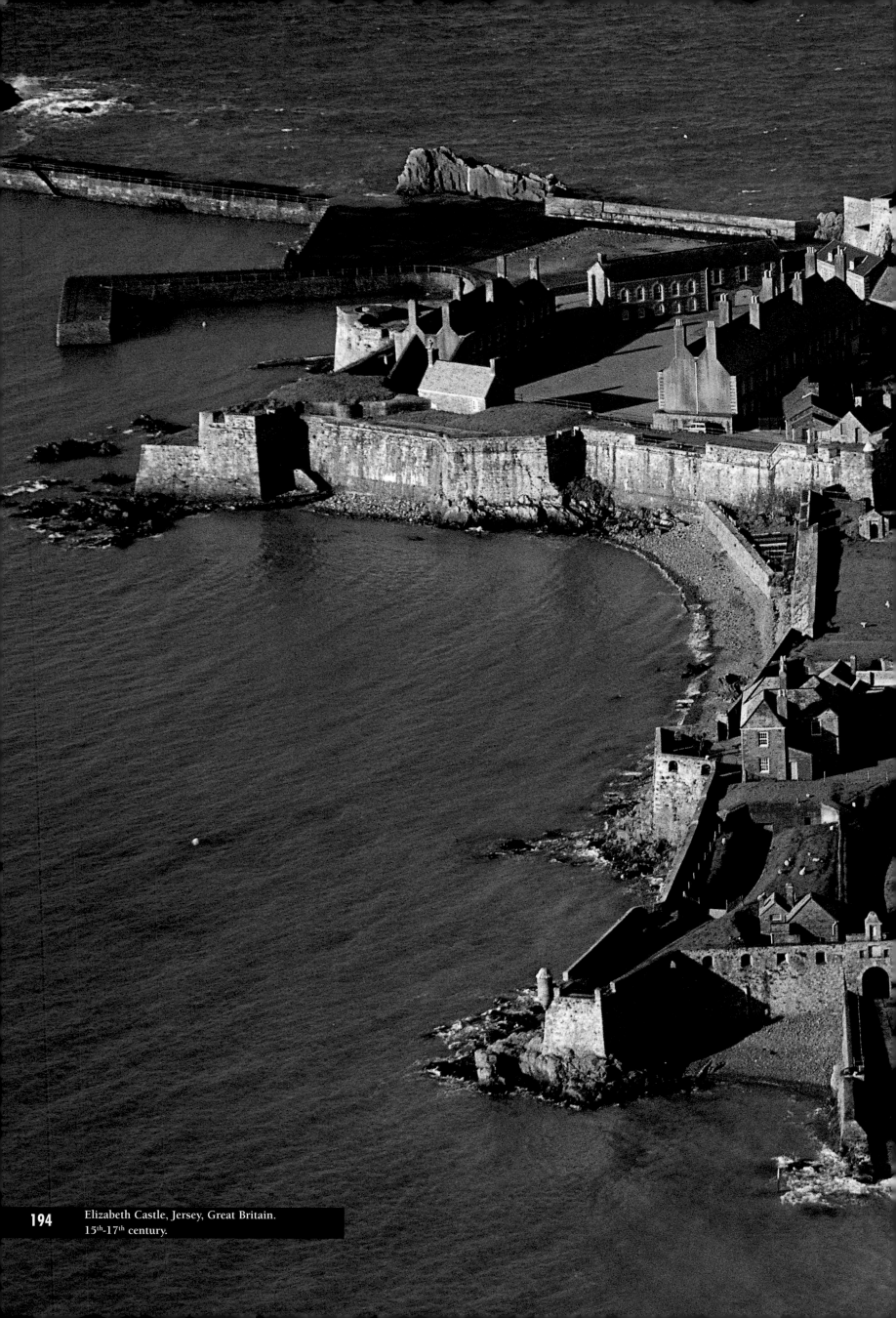

Elizabeth Castle, Jersey, Great Britain.
15th-17th century.

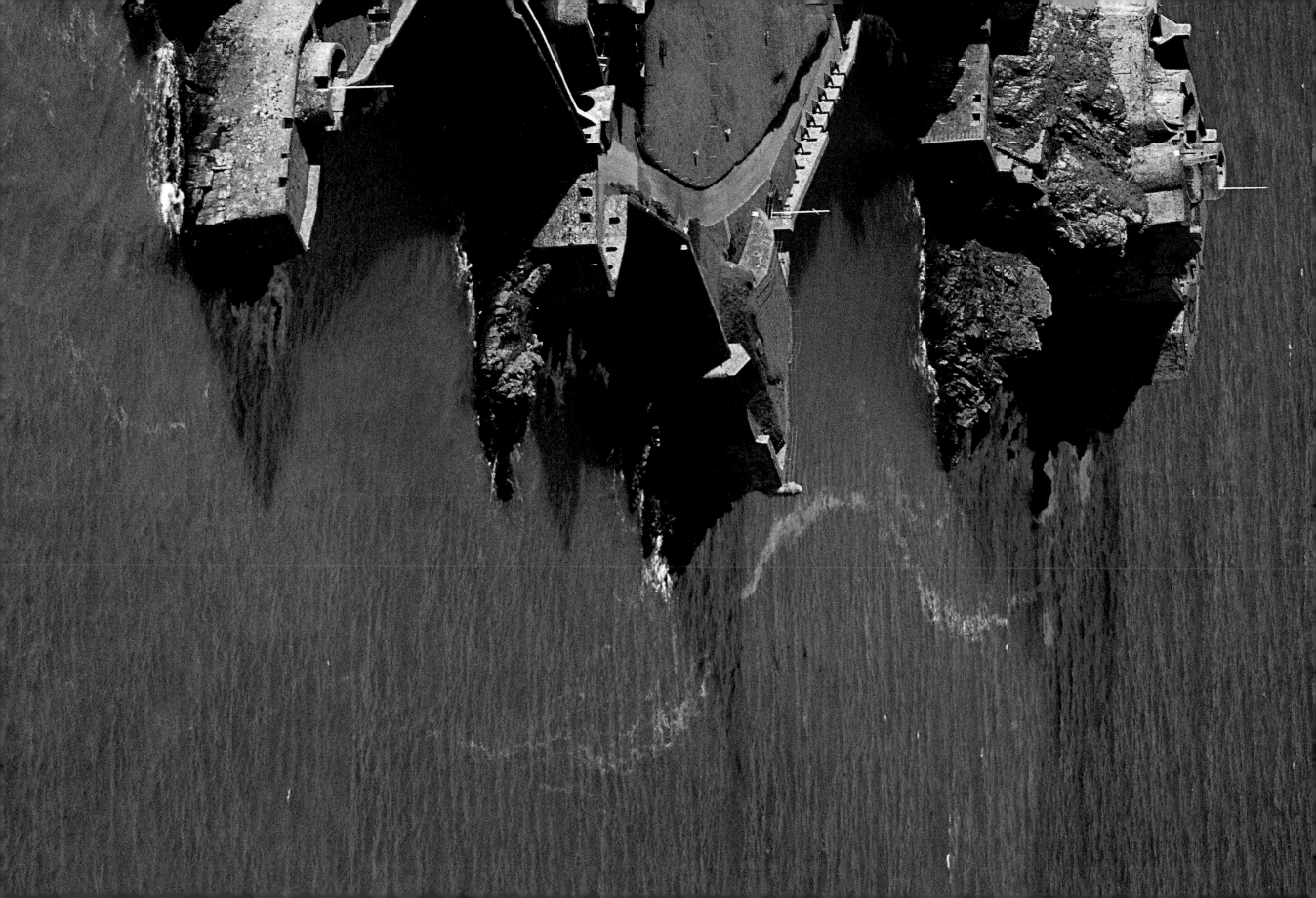

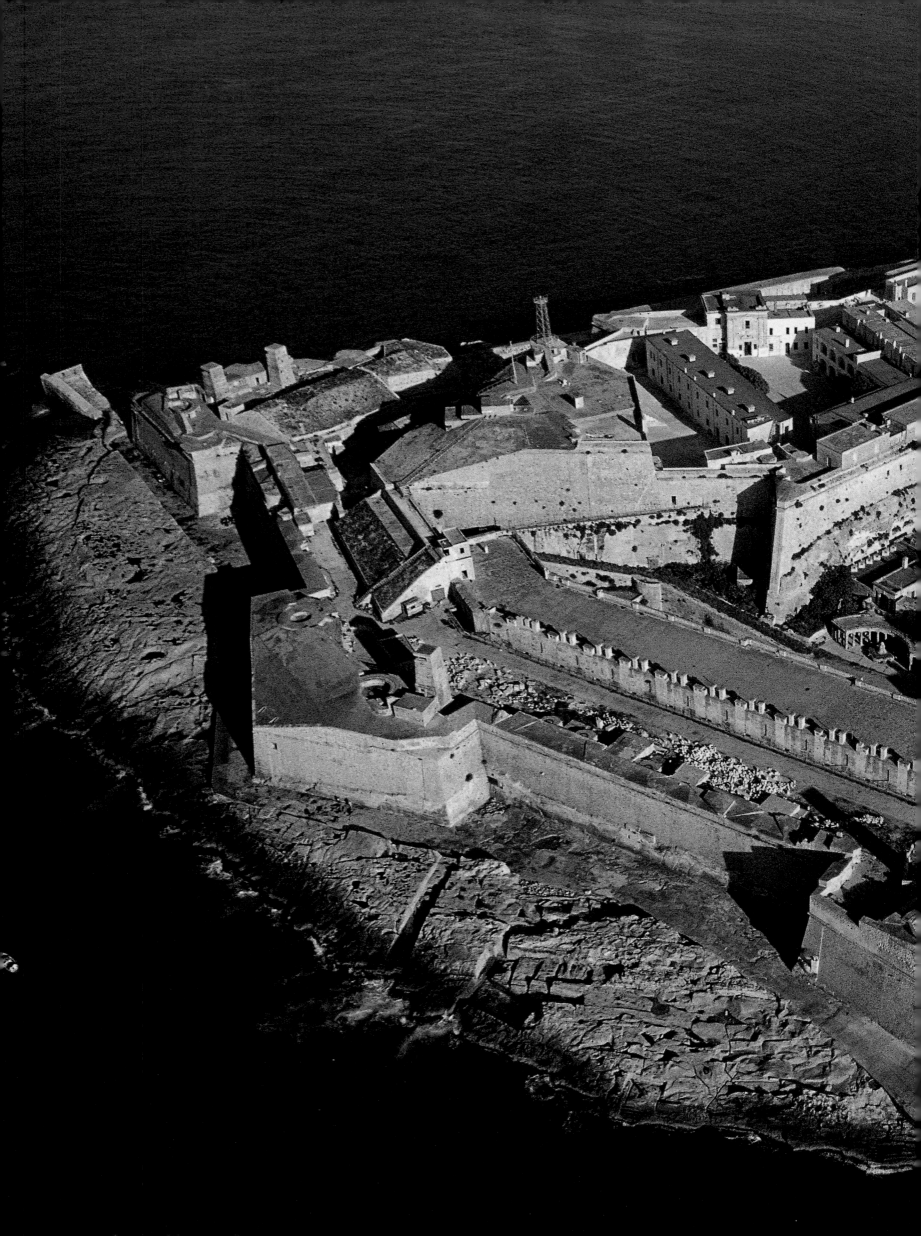

Fortifications of the port, Valletta, Malta.
16th-19th century.

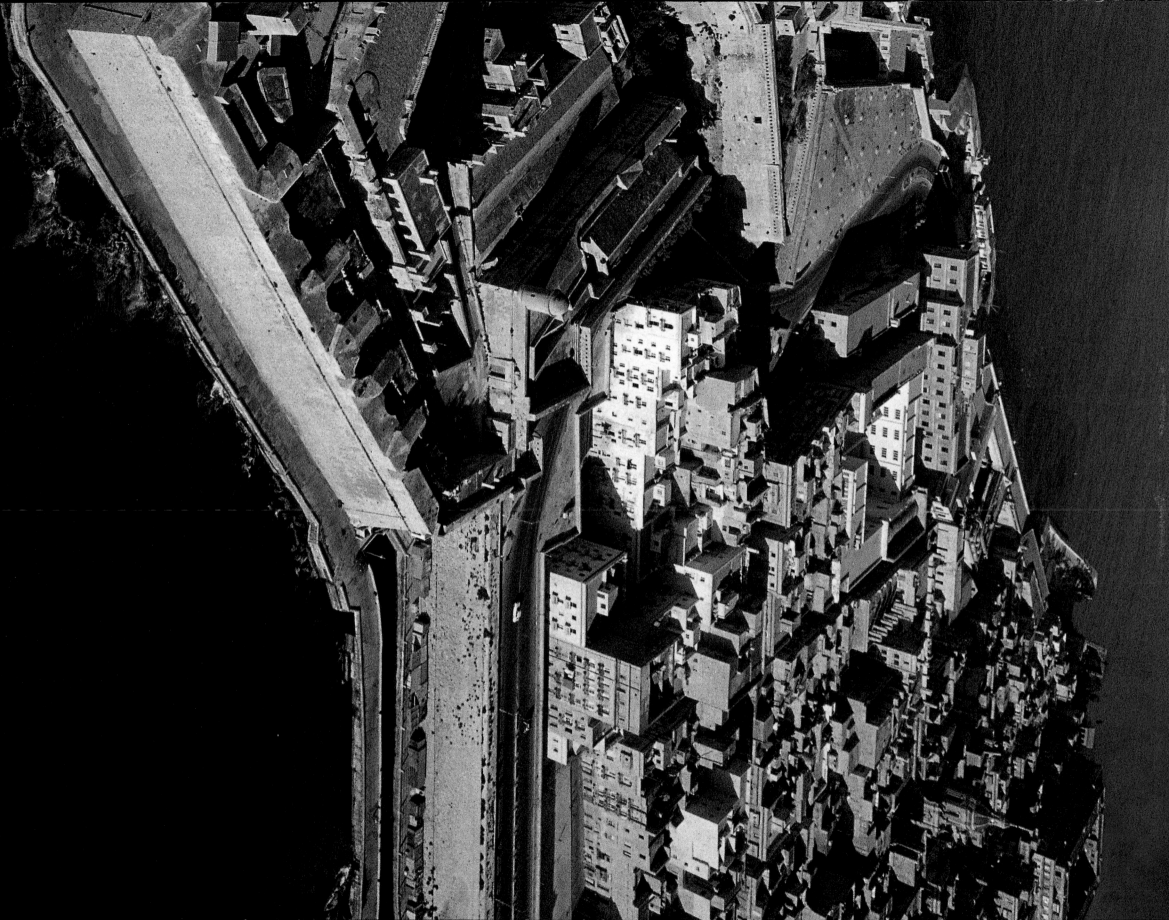

Great coastal fortresses

The history of Great Britain is studded with epic coastal battles, from the Roman invasion to the Second World War. It was after the Norman invasion in the eleventh century, however, that it was realised that the situation warranted the building of fortified buildings which would make England, already a naval power, inaccessible to attack by other European powers.

The complicated question of subservience which linked the English crown to the King of France, through English possessions on French territory, ended at the beginning of the fifteenth century after the Hundred Years' War, when these possessions were lost and the ties of vassalage dissolved. The politics and power of England were therefore forged in this ambiguous and curiously antagonistic relationship with the countries on the other side of the Channel, particularly with France. Because of this, the importance of the fleet and activity in British ports, and the necessity to defend the entire coastline in order to protect the country from invasion from overseas led to the construction of large coastal forts from the Middle Ages onwards.

One of the most imposing of these is Dover Castle, which dates back to before the Norman invasion; it was begun by King Harold and completed in the twelfth and thirteenth centuries by Henry II and Henry III. Its present appearance is the result of the completion of the external defences during the Napoleonic period. It consists of a turreted central tower, encircled by a double wall with fortified gateways and imposing keeps.

Caernarvon Castle, at the mouth of the river Seiont in Wales, is another very imposing building. It was built between the thirteenth and fourteenth centuries. Its present condition owes a lot to recent restoration. However, it is true to the original plan. Coastal castles can be found in other countries, and particularly in the Eastern Mediterranean, but nowhere is as well supplied as the South of England, where the monumental castle is an expression of both strength and power.

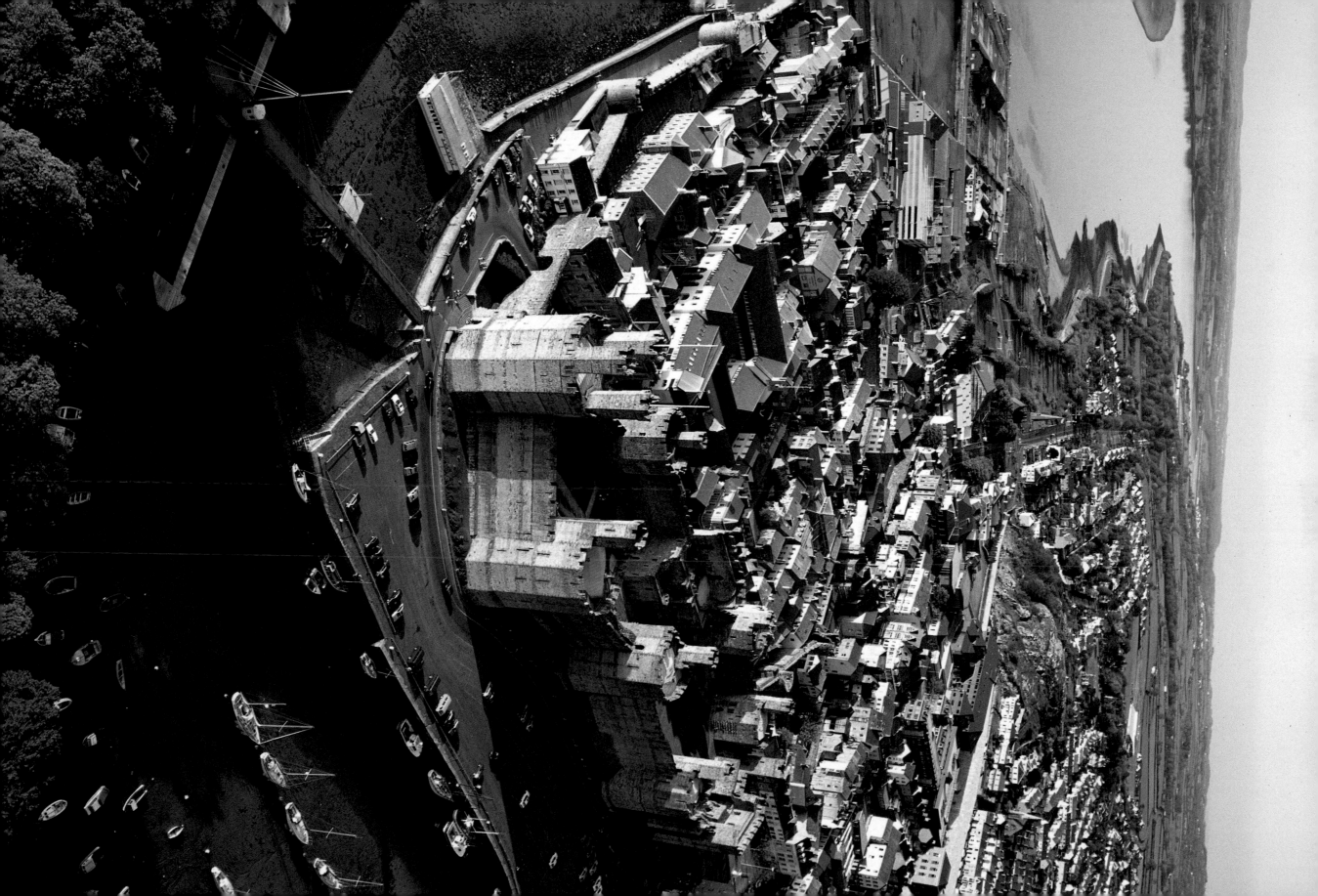

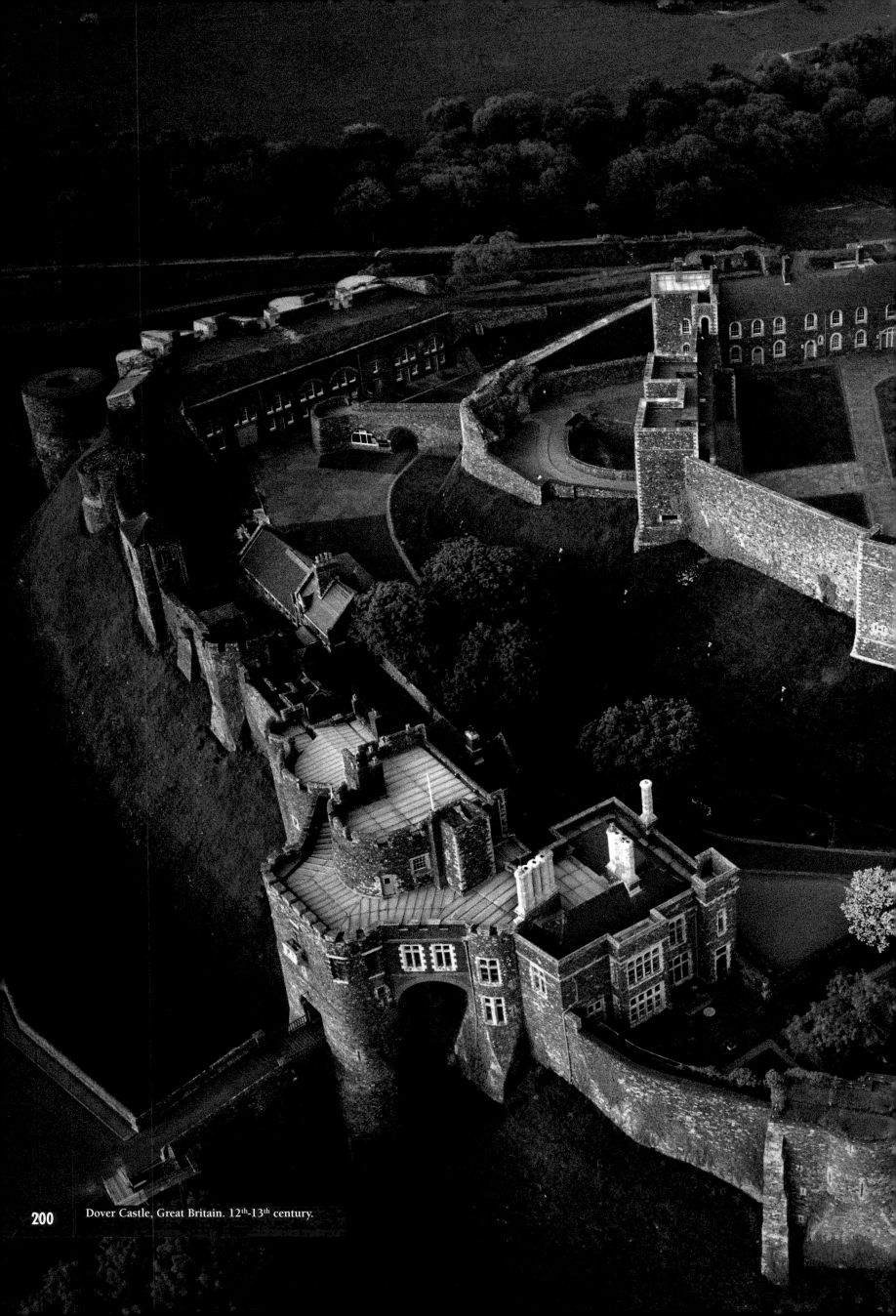

Dover Castle, Great Britain. 12th-13th century.

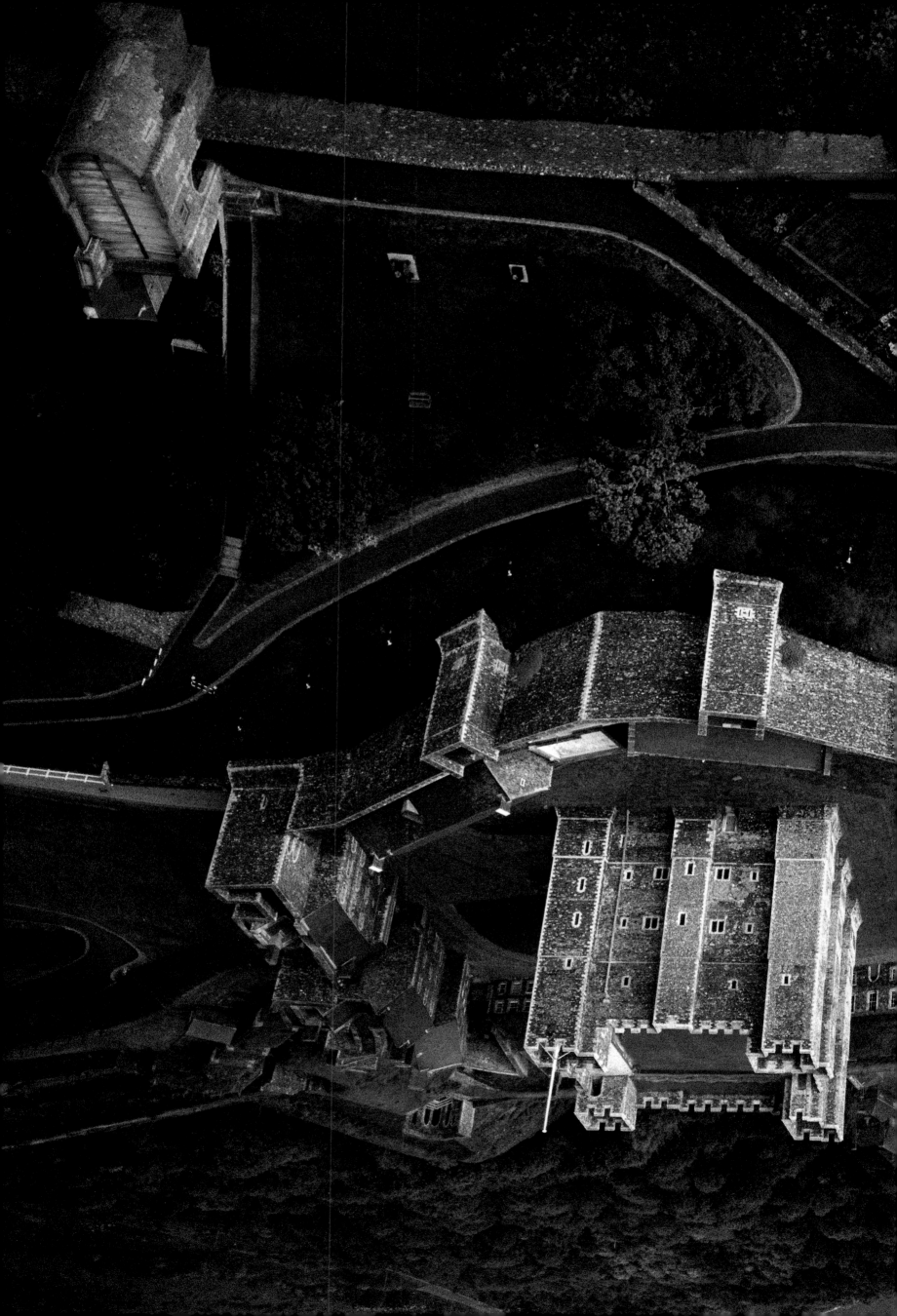

The security of coastal villages

There are innumerable villages along the densely populated Mediterranean coastline and they are not always well situated from the point of view of security and attacks from the sea. In the past, their existence was constantly threatened by pirates, invading armies and enemy action, and so they often contain defensive buildings of various kinds.

Not all of the defences are the same: they may be fortifications erected by the inhabitants, or built by some other authority, far or near, which recognised the strategic importance of the site. In general there is a group of buildings which serves a variety of functions, not always defensive; they may also be related to social aspects of the life of the village. A fine example of this type is the Templar castle in Collioure, which also houses the parish church. Above Collioure a small fort contains a typical lookout tower. When coastal defences such as these are more compact it usually means that they are also the residence of the local landowner or of some delegated authority, appointed to govern as well as to look after defence. This is the case with the castle-fortress of Benedict XIII in Peniscola (Spain), owned by the Avignon papacy. When the fortification is part of a more complex defensive operation it is usually identifiable by its isolation and by the presence of walls with bastions around the central nucleus of the fortress itself, as in Saint-Tropez. In Saint-Malo, in Brittany on the French coast, the massive Tour Solidor is built on a large rock and attached to the coast by a short bridge.

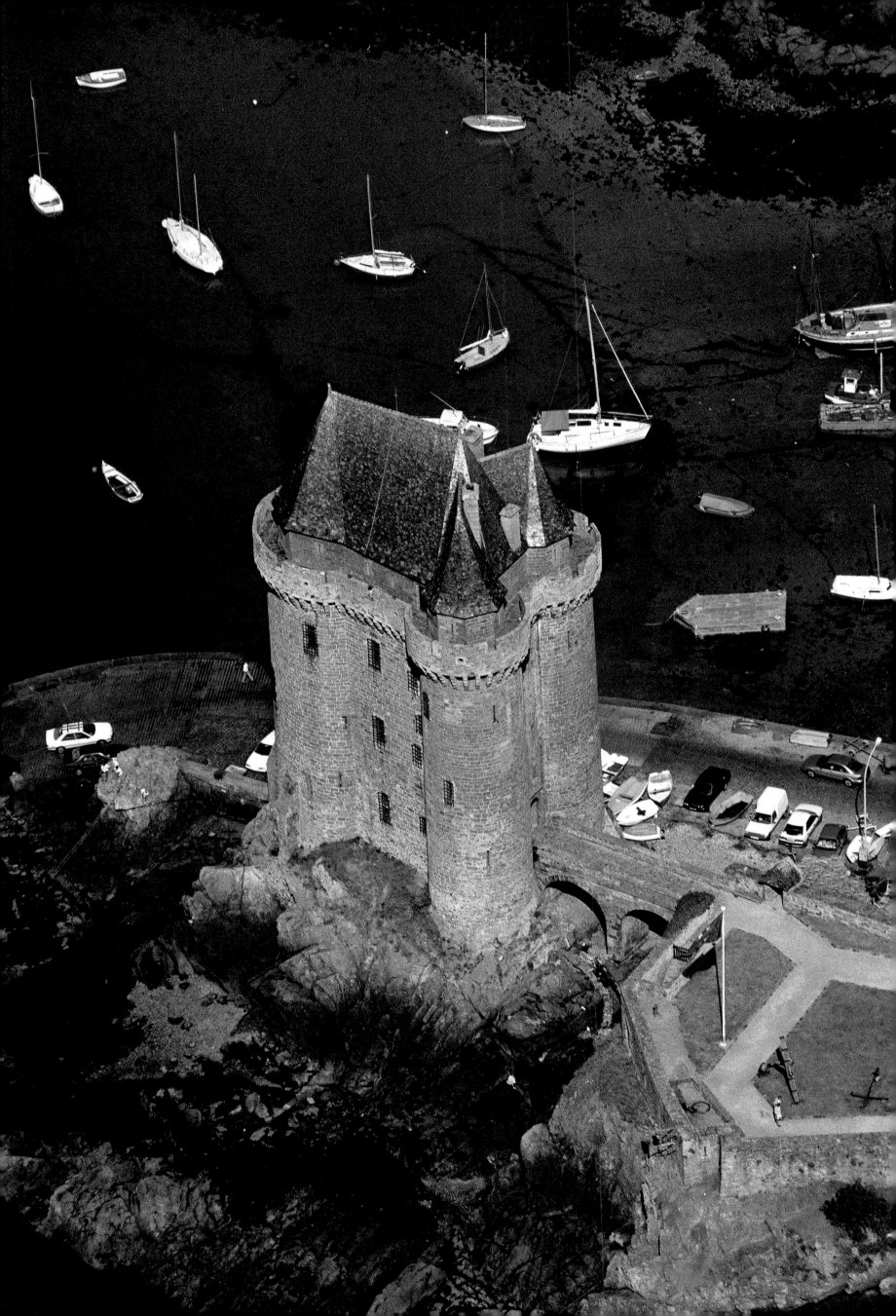

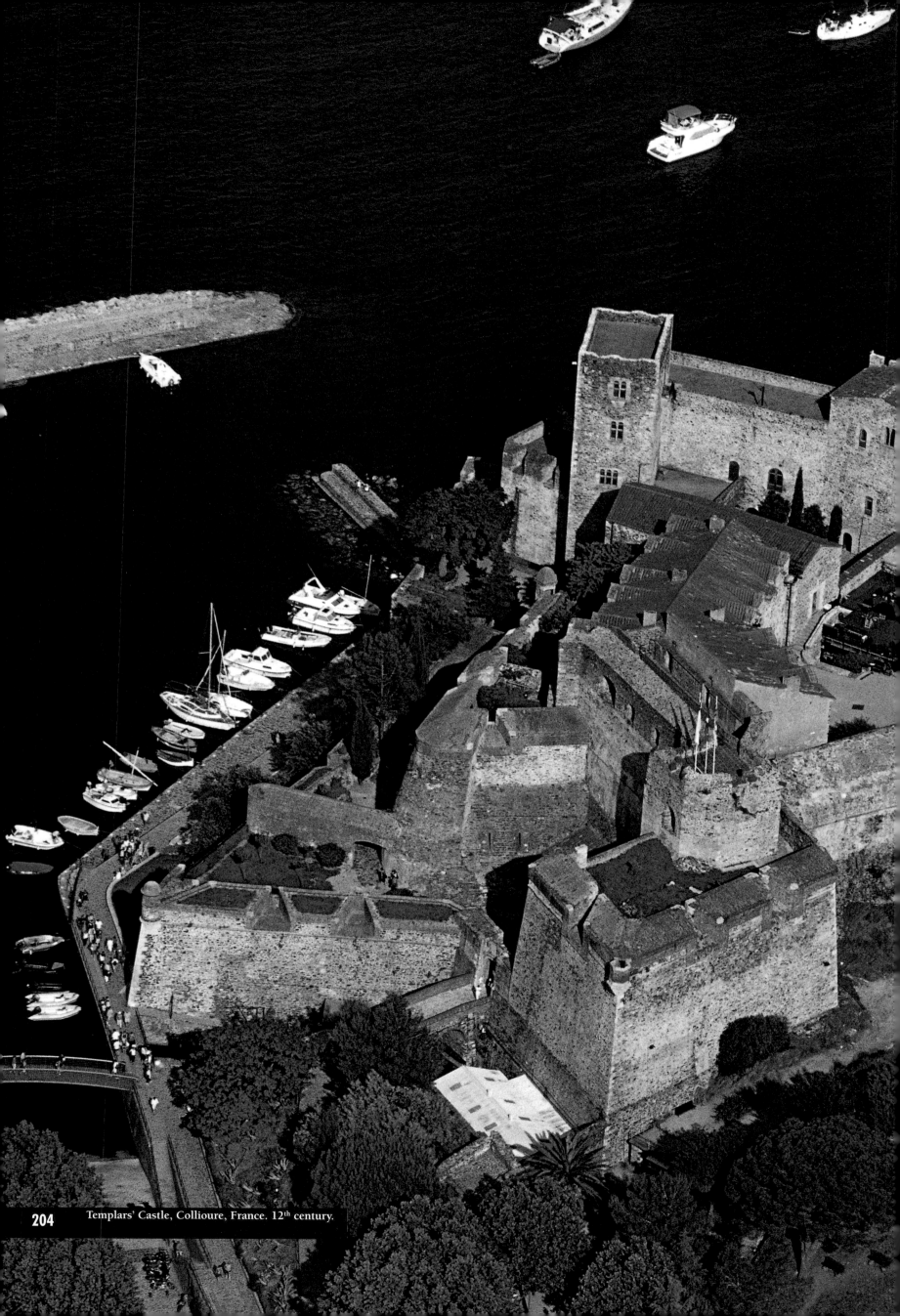

Templars' Castle, Collioure, France. 12th century.

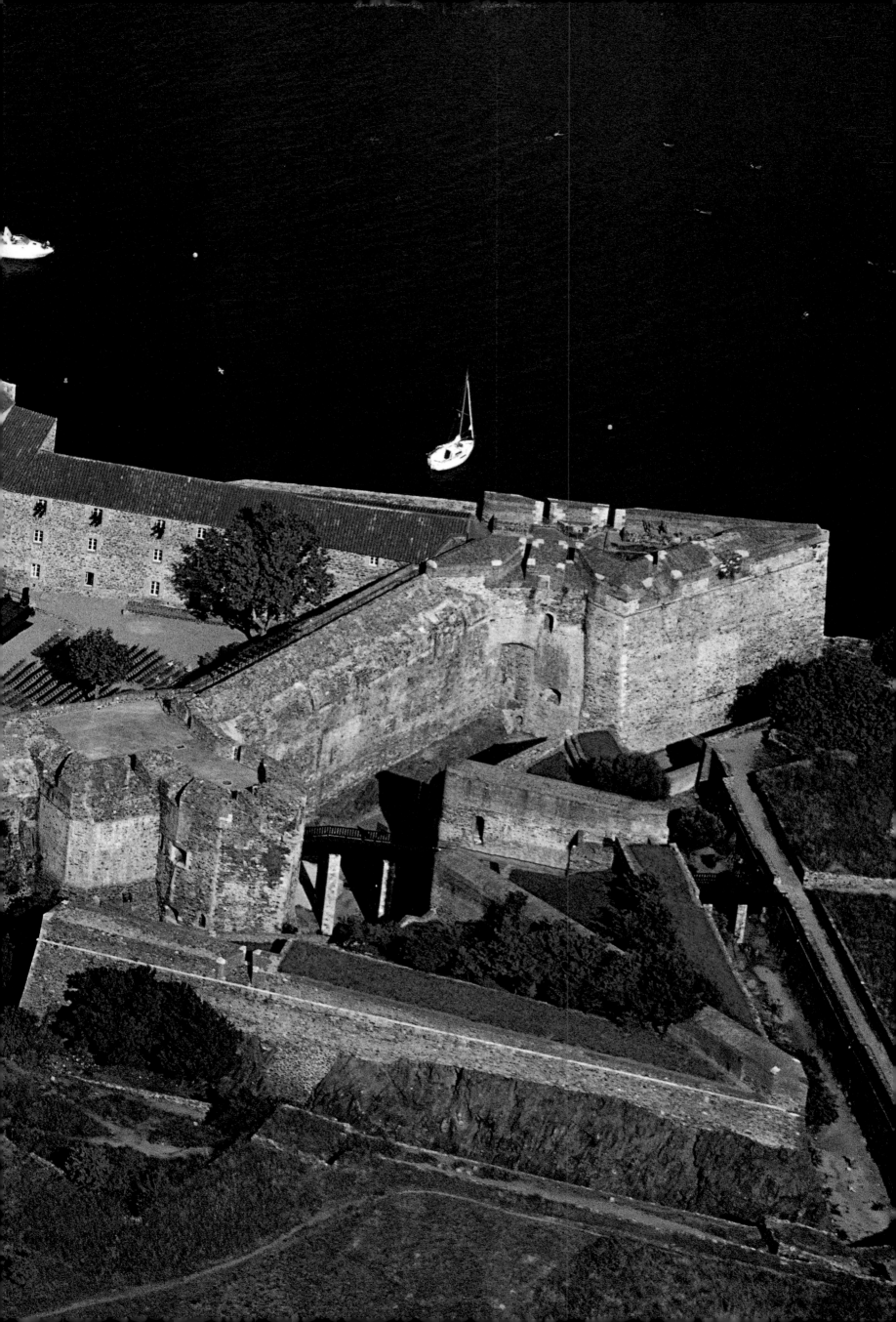

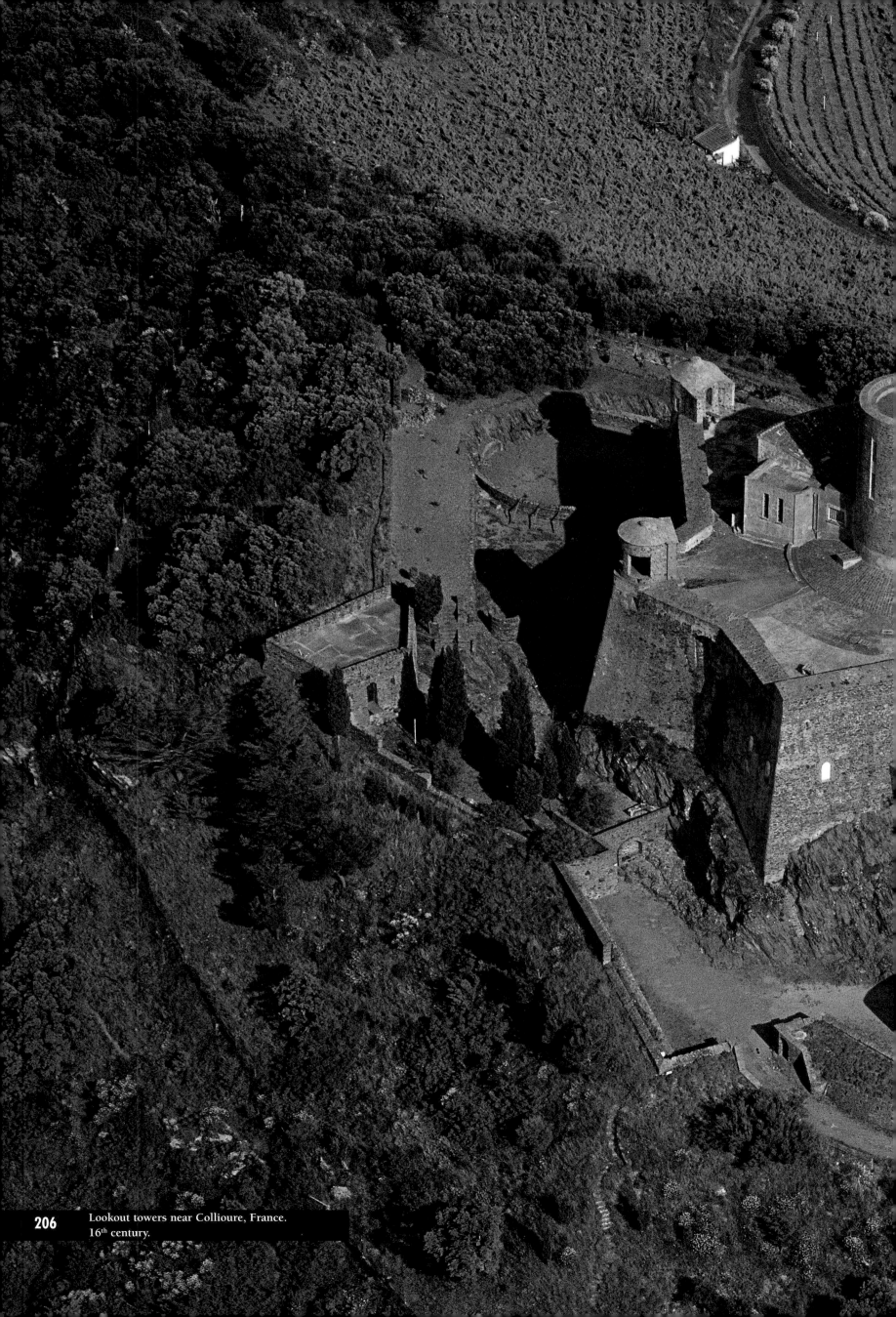

Lookout towers near Collioure, France.
16th century.

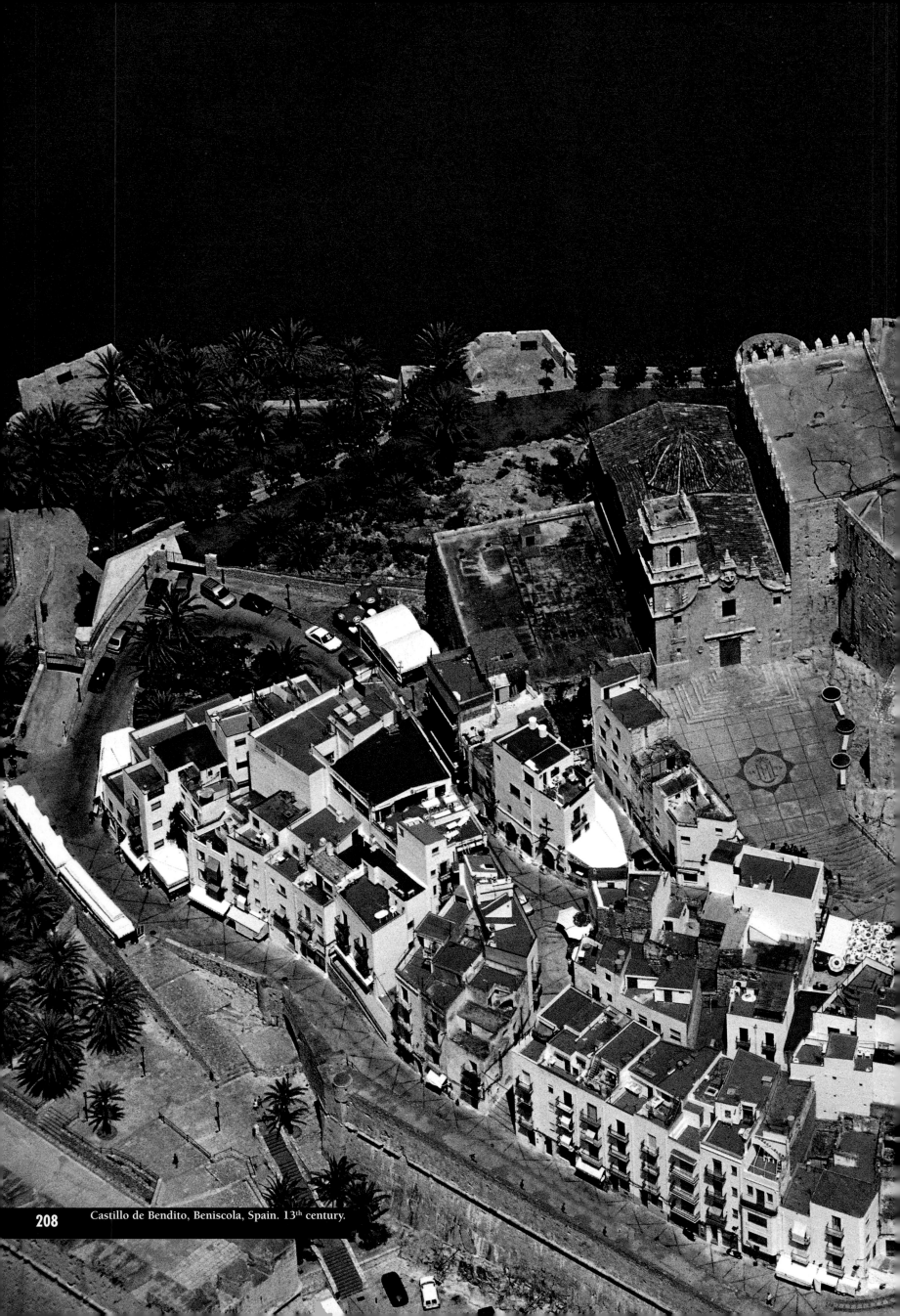

Castillo de Bendito, Beniscola, Spain. 13th century.

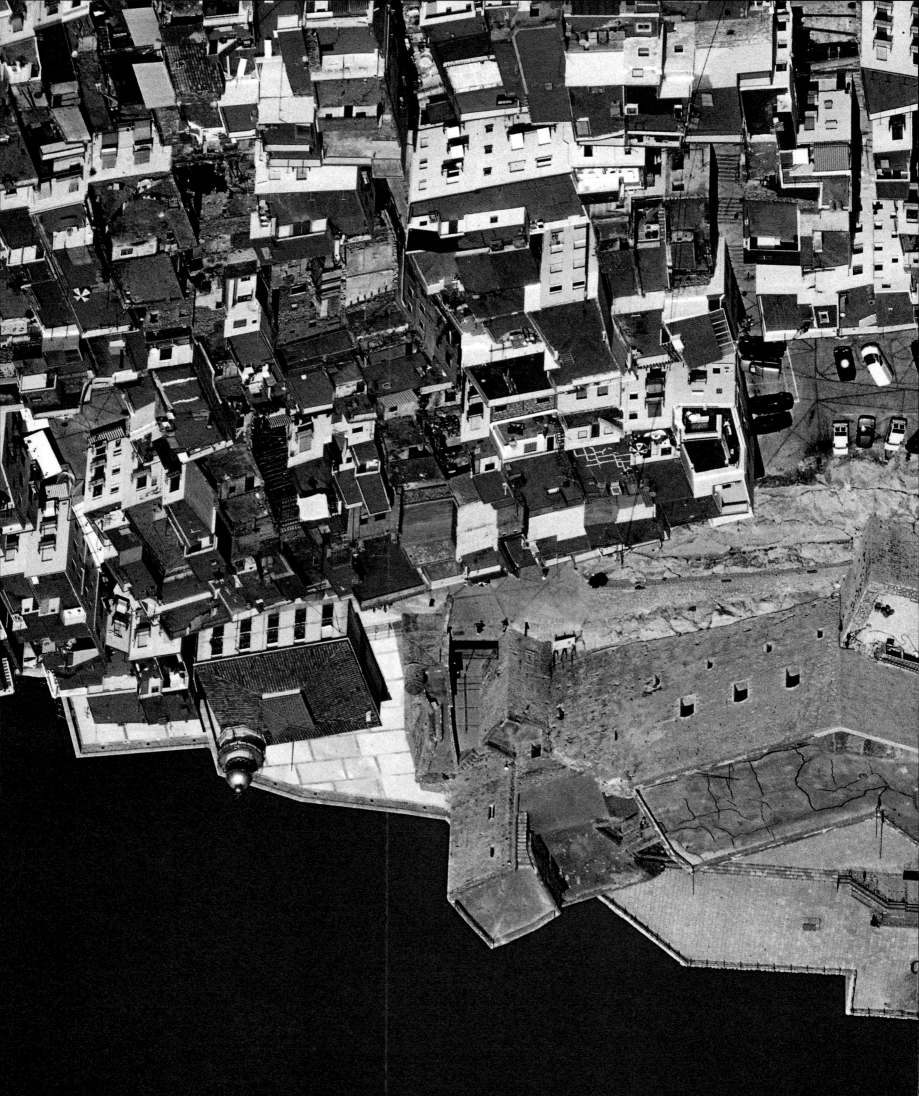

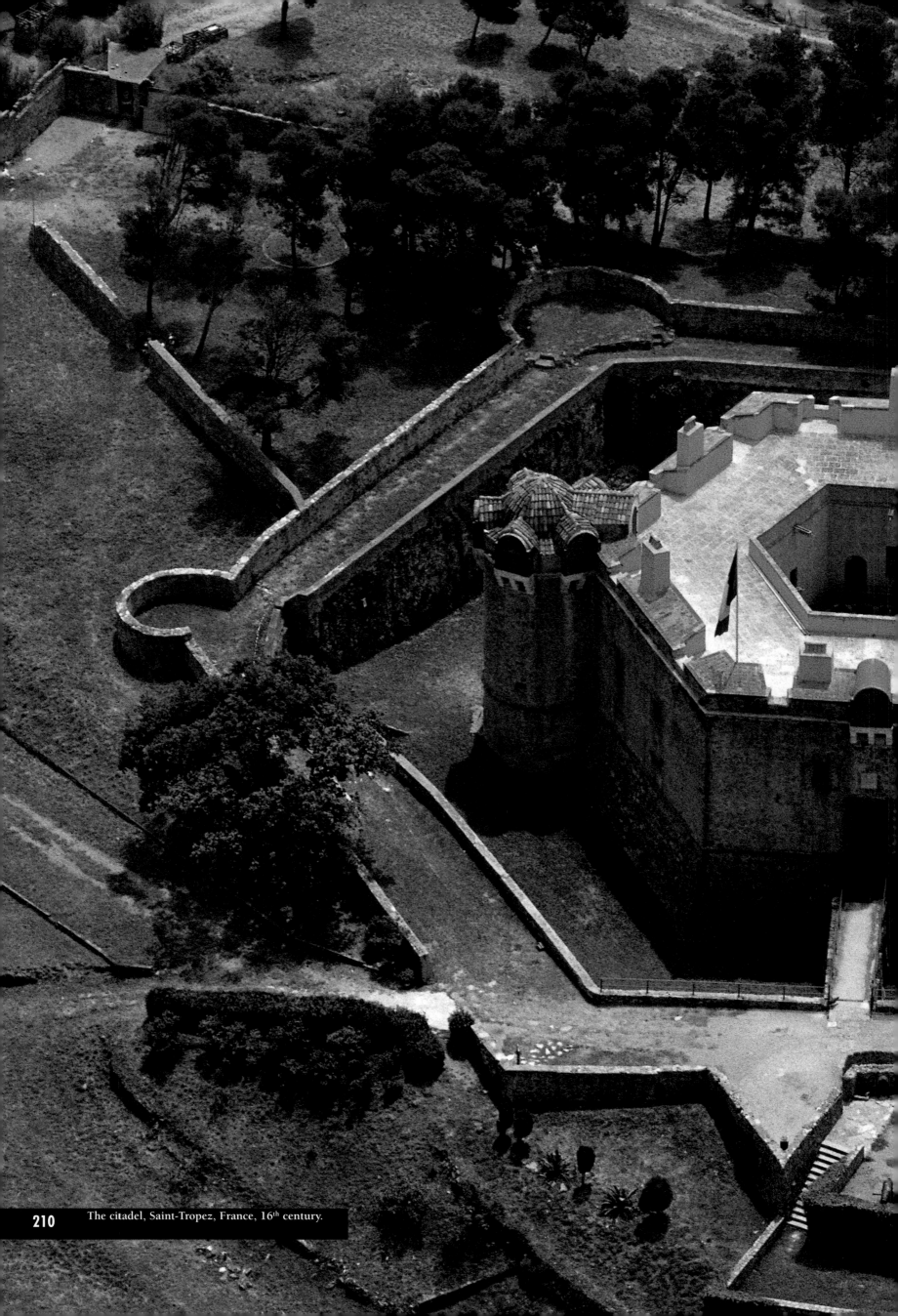

The citadel, Saint-Tropez, France, 16th century.

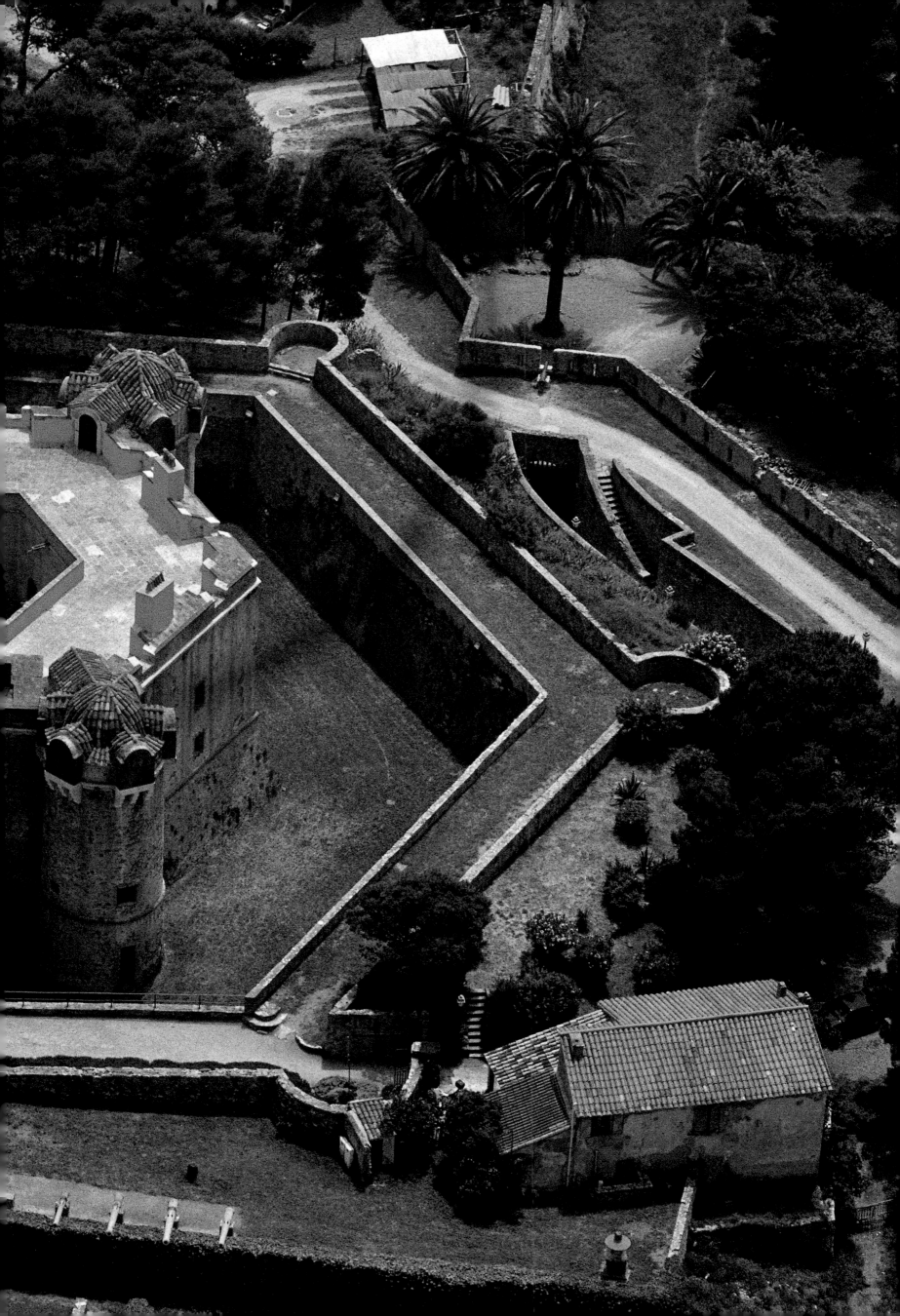

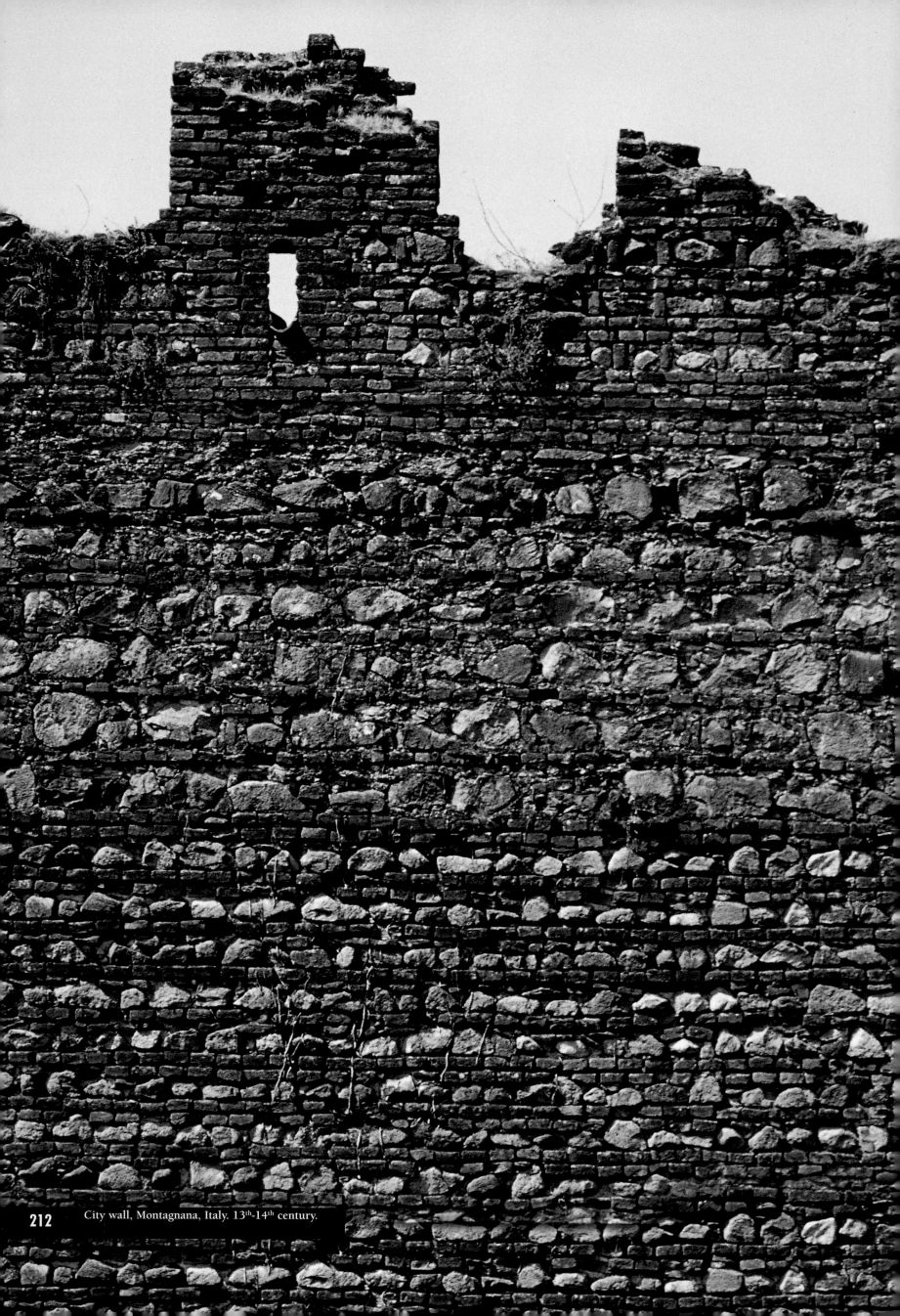

City wall, Montagnana, Italy. 13th-14th century.

Fortified enclosures

Villages

Defending a city by means of a wall is one of the oldest forms of fortification, and some interesting examples can be found in the ancient Mediterranean world. These include the walls of Roman cities, with their monumental gateways and towers; although these may be the most conspicuous examples, they are not the oldest, as the ruins of the cities of Mesopotamia demonstrate and, in Italy, of Etruscan cities. During the Middle Ages, the fortified enclosure was often intended to protect the houses and vegetable gardens of small villages and towns from predatory animals and robbery. The often asked question of whether the wall was built to protect the village, or whether the houses grew up within the walls of a castle enclosure, is otiose. Both hypotheses are valid, and there is plenty of evidence for both.

If we stay for a moment with the small settlements, which have remained the least changed and are the oldest, we can divide them into three different types: the first is the village surrounded by walls: archaeology has demonstrated that there were villages in England in the eighth century which already had a wooden picket fence around them for example Hereford. An exceptional example of this type is the village of Monteriggioni, in Tuscany, with its turreted wall around the houses and gardens of the inhabitants. Its origin was not spontaneous, however: it was built by the Sienese in the thirteenth century as a bulwark against the aggressive expansion of the rulers of Florence, and probably owes to this fact its organised, solid structure – otherwise improbable for such a tiny community.

The second type is the enclosed castle, with its central keep and walls with defensive towers and fortified gateways. The difference here lies in the development within the walls of a genuine small town, which sometimes sprang up to serve the local feudal landlord, often appearing only after the defensive buildings were finished. The space between the walls is filled with houses, churches, workshops and other buildings needed by the community: a good example of this is the village of Evoramonte in Portugal.

The third type derives from the castle with double surrounding wall, when the upper level is kept for defence and for the residence of the noble owner, and the lower level houses the villages, as in Marvao, also in Portugal. The village developed in the same random way as the preceding one.

The fortress of Königstein in Germany belongs to the same historical type but enjoyed a more aristocratic destiny. Within the imposing seventeenth-century walls there are a number of older buildings which were used for a variety of purposes: as palaces, barracks, places of worship and administrative offices, as if it were a genuine citadel.

The Fort Saint-André in Villeneuve-lès-Avignon was built by Philippe le Bel between the end of the thirteenth and beginning of the fourteenth centuries as a symbol of royal power, to oppose the authority of the papacy.

Fortified village, Monteriggioni, Italy. 13th century.

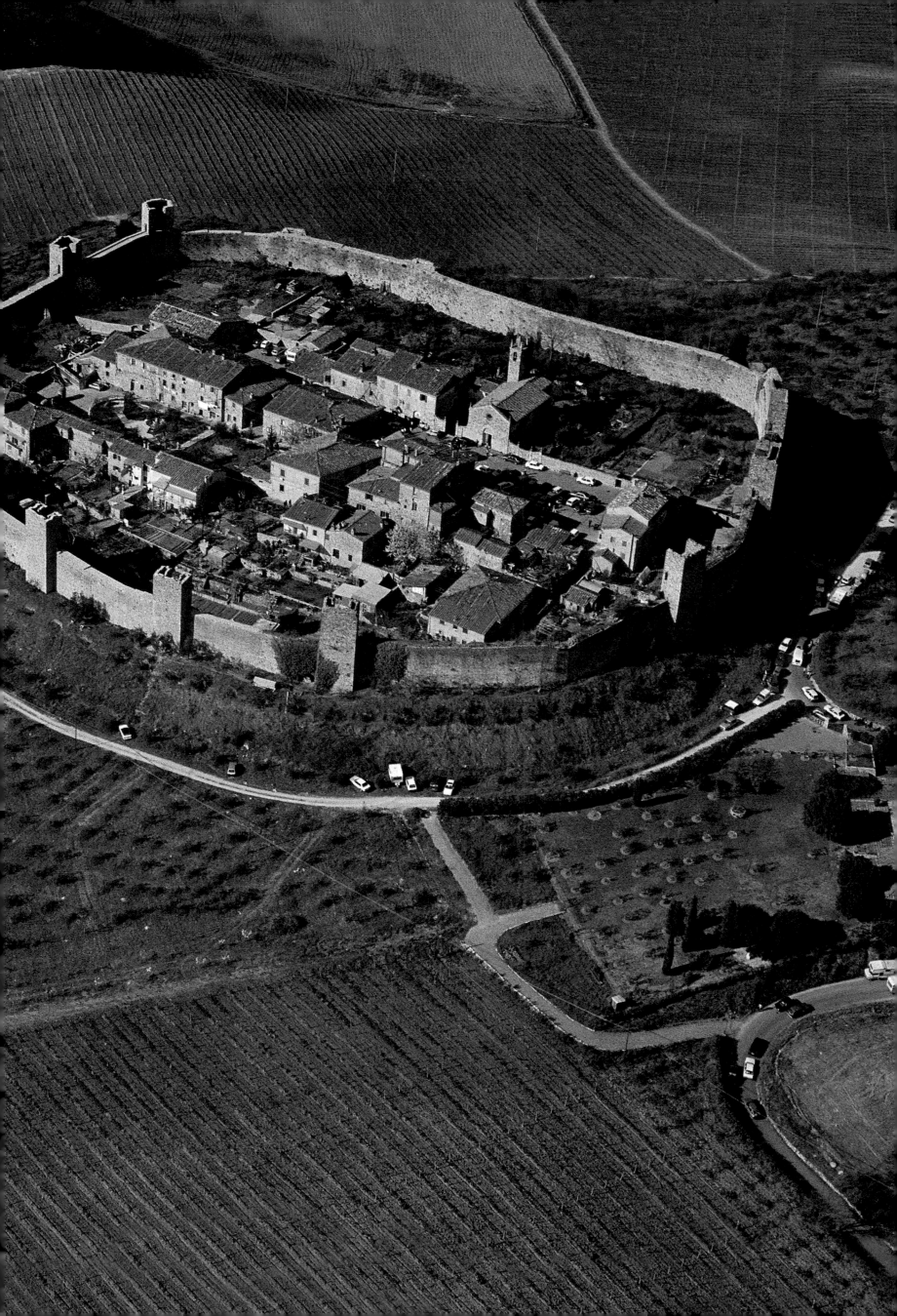

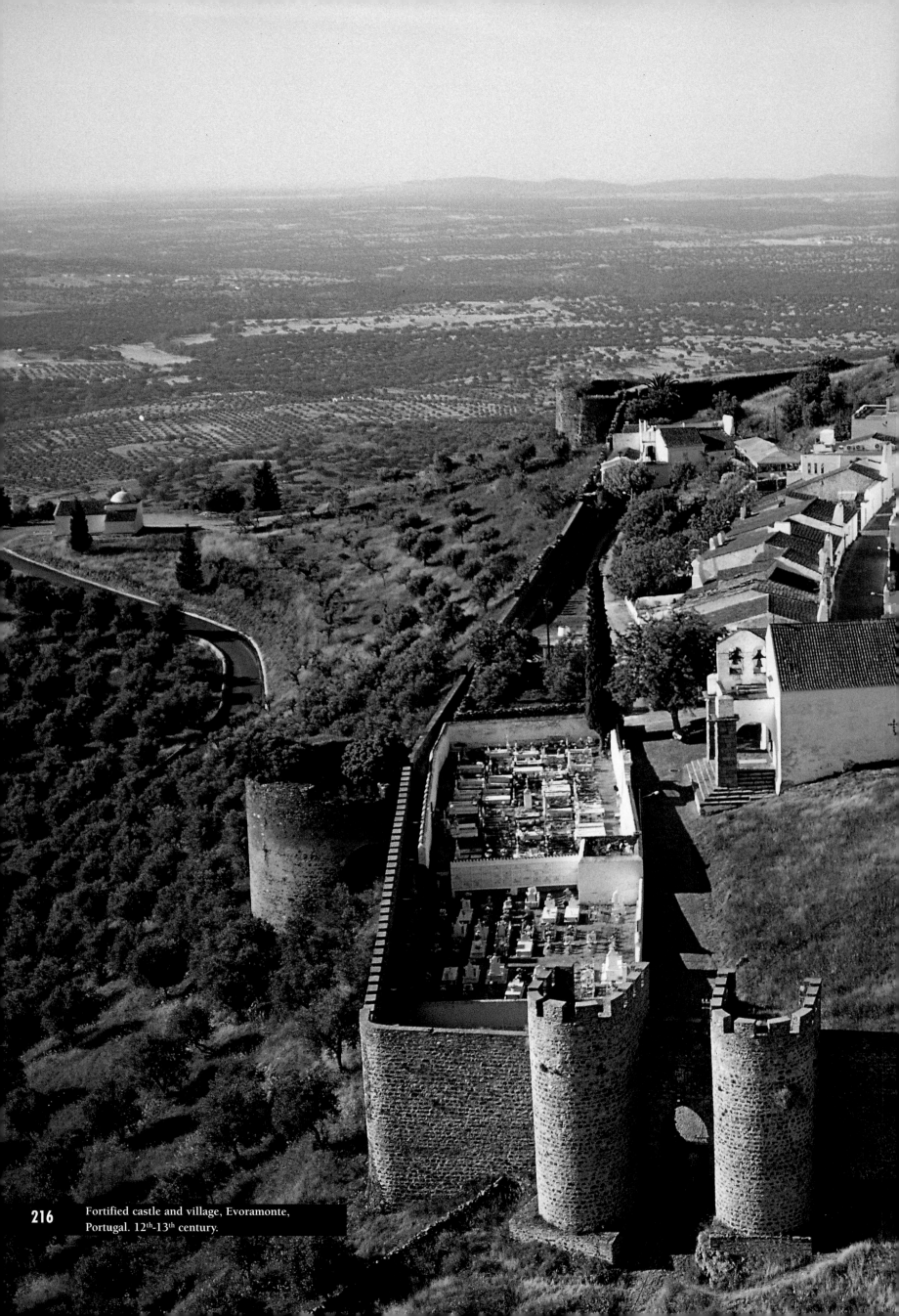

Fortified castle and village, Evoramonte,
Portugal. 12th-13th century.

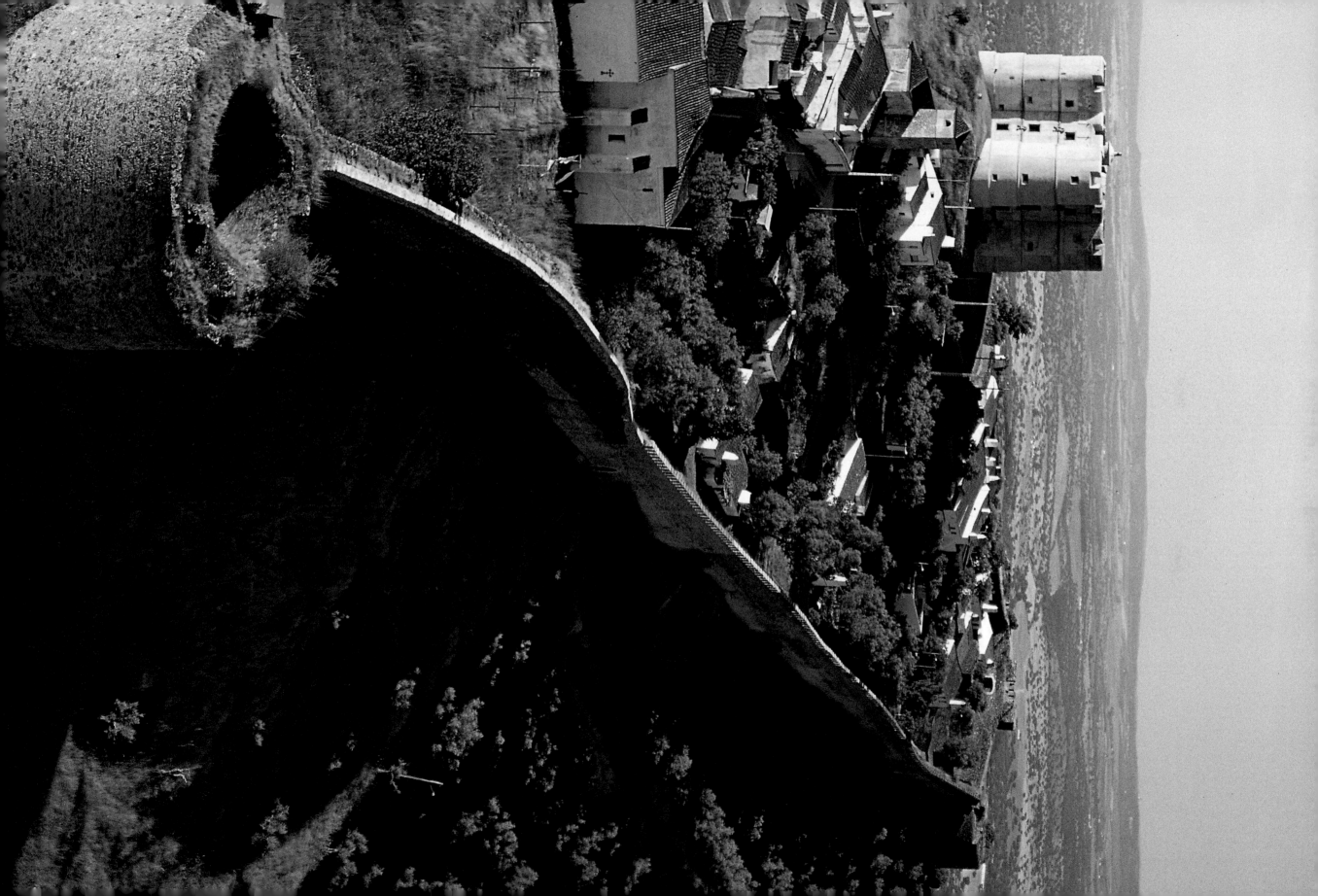

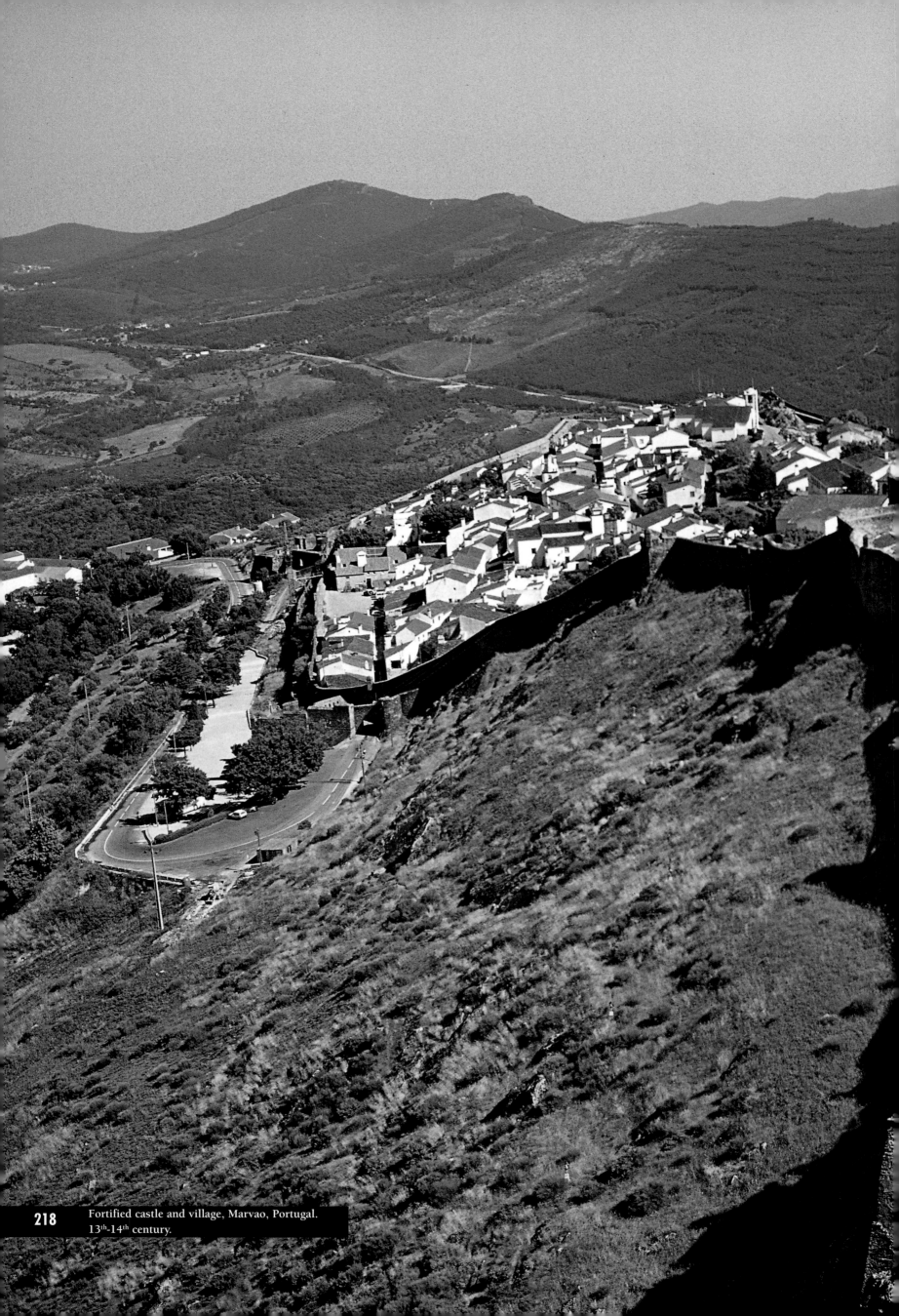

Fortified castle and village, Marvao, Portugal.
13th-14th century.

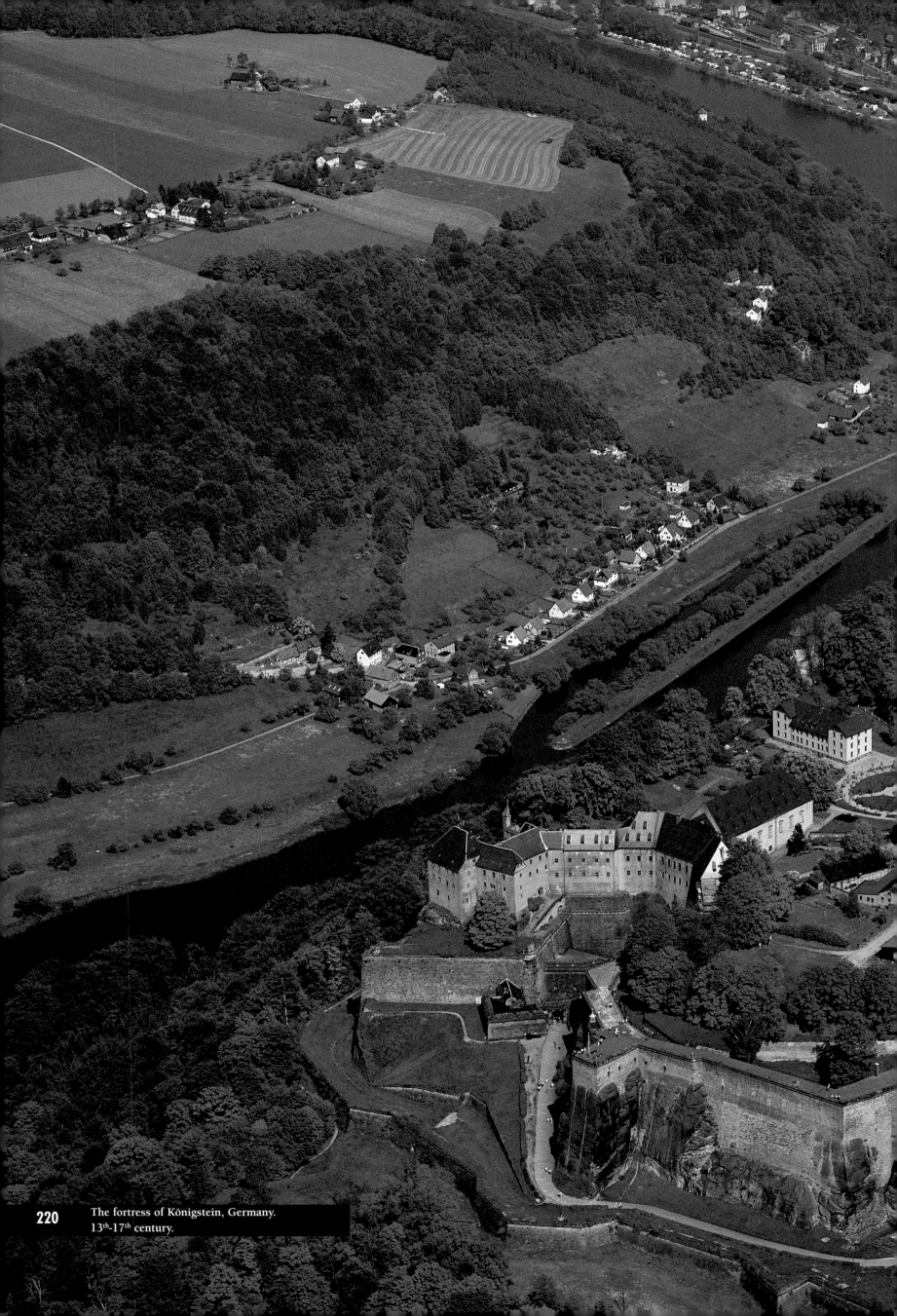

The fortress of Königstein, Germany.
13th-17th century.

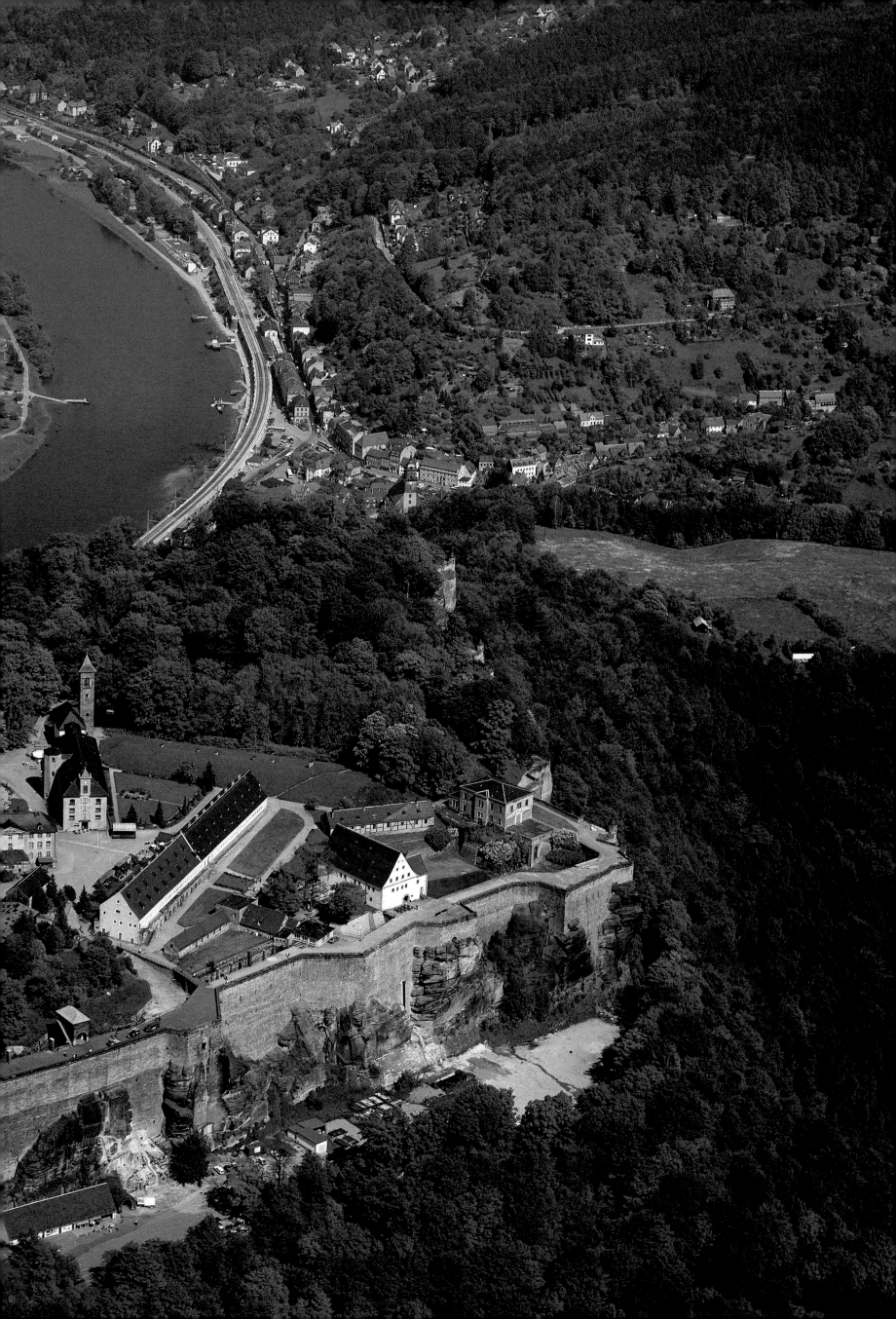

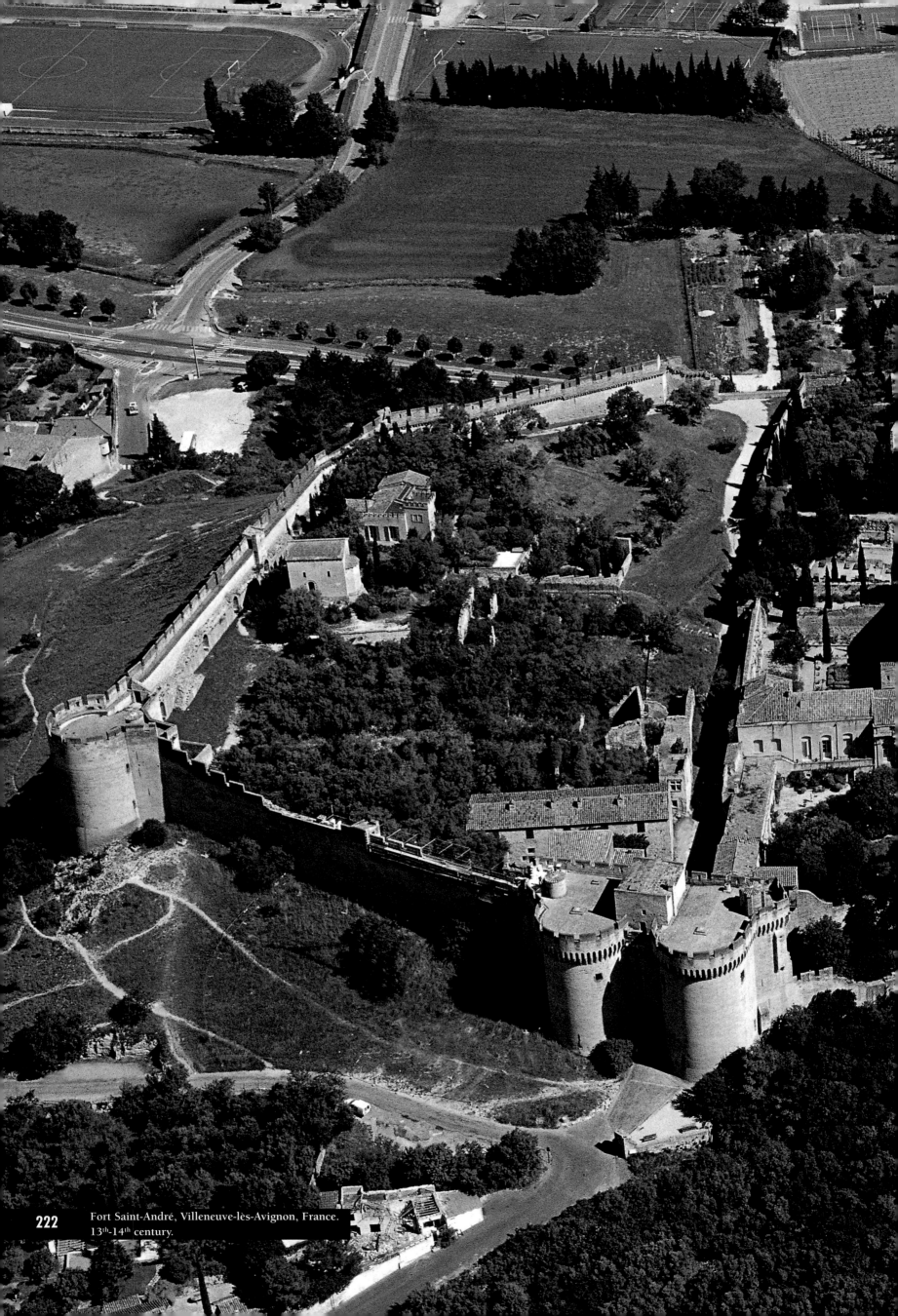

Fort Saint-André, Villeneuve-lès-Avignon, France.
13th-14th century.

Citadels

The urban citadel represents a particular type of enclosure. Usually located in an elevated position, the walls enclose buildings intended for a variety of purposes: military, religious, administrative, residential, and also places of worship. The citadel may be the original ancient nucleus of a fortified village which has become a city, or it may be the outcome of expansion and additions to the original castle. The castle at Collioure (see p. 204) bears the characteristic features of this kind of citadel.

Another fine example of this type of castle is the citadel of Calvi, in Corsica: it was built by the Genoese in the fourteenth and fifteenth centuries and possesses a series of imposing bastions.

Edinburgh Castle, in Scotland, is the result of the juxtaposition of a succession of buildings; today it constitutes a real acropolis built on a rugged spur with three sheer sides. The site was already inhabited in the Iron Age, and was fortified at the end of the tenth century. Within the walls can be found the governor's palace, various barracks, a hospital, a small Romanesque church dedicated to Queen Margaret, mother of King David I of Scotland, and large numbers of other buildings. These are now mainly museums, and many are relatively recent, but the whole complex is fascinating.

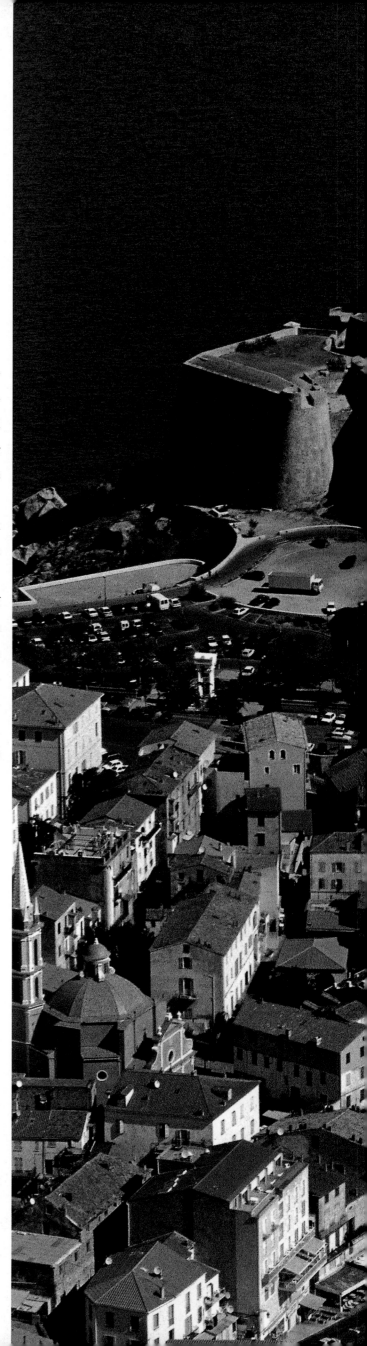

The Citadel, Calvi, France. 14th-16th century.

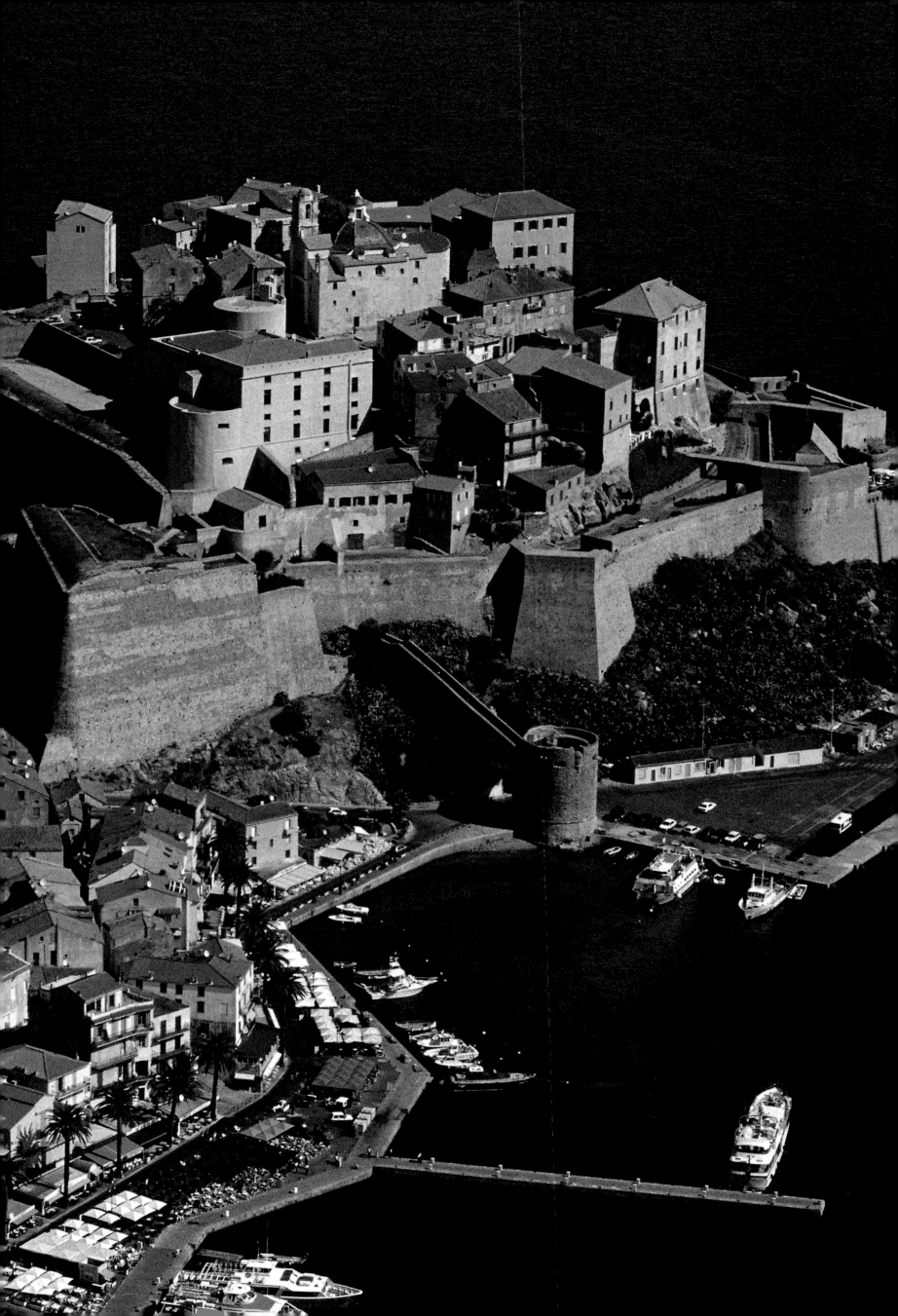

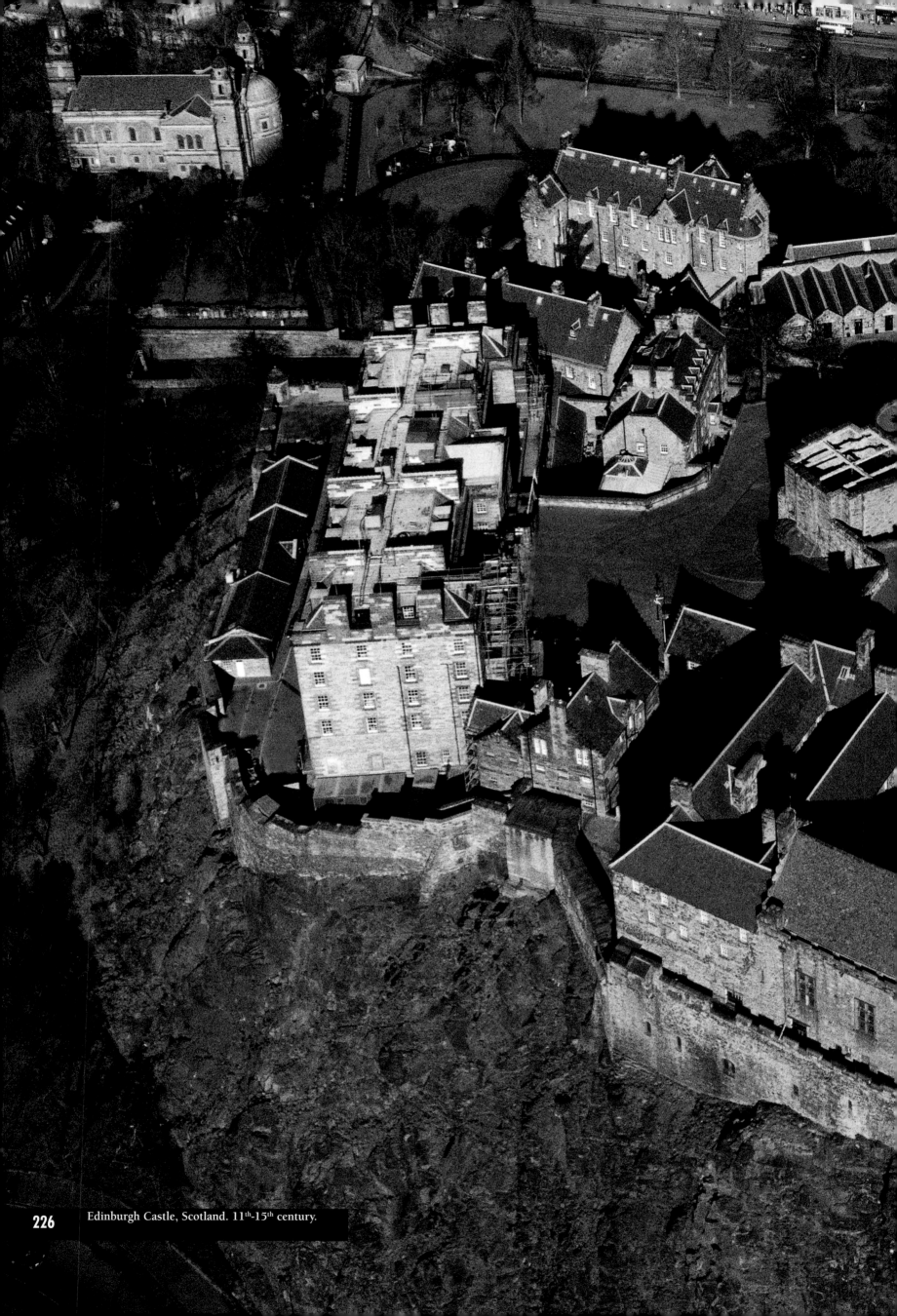

Edinburgh Castle, Scotland. 11th-15th century.

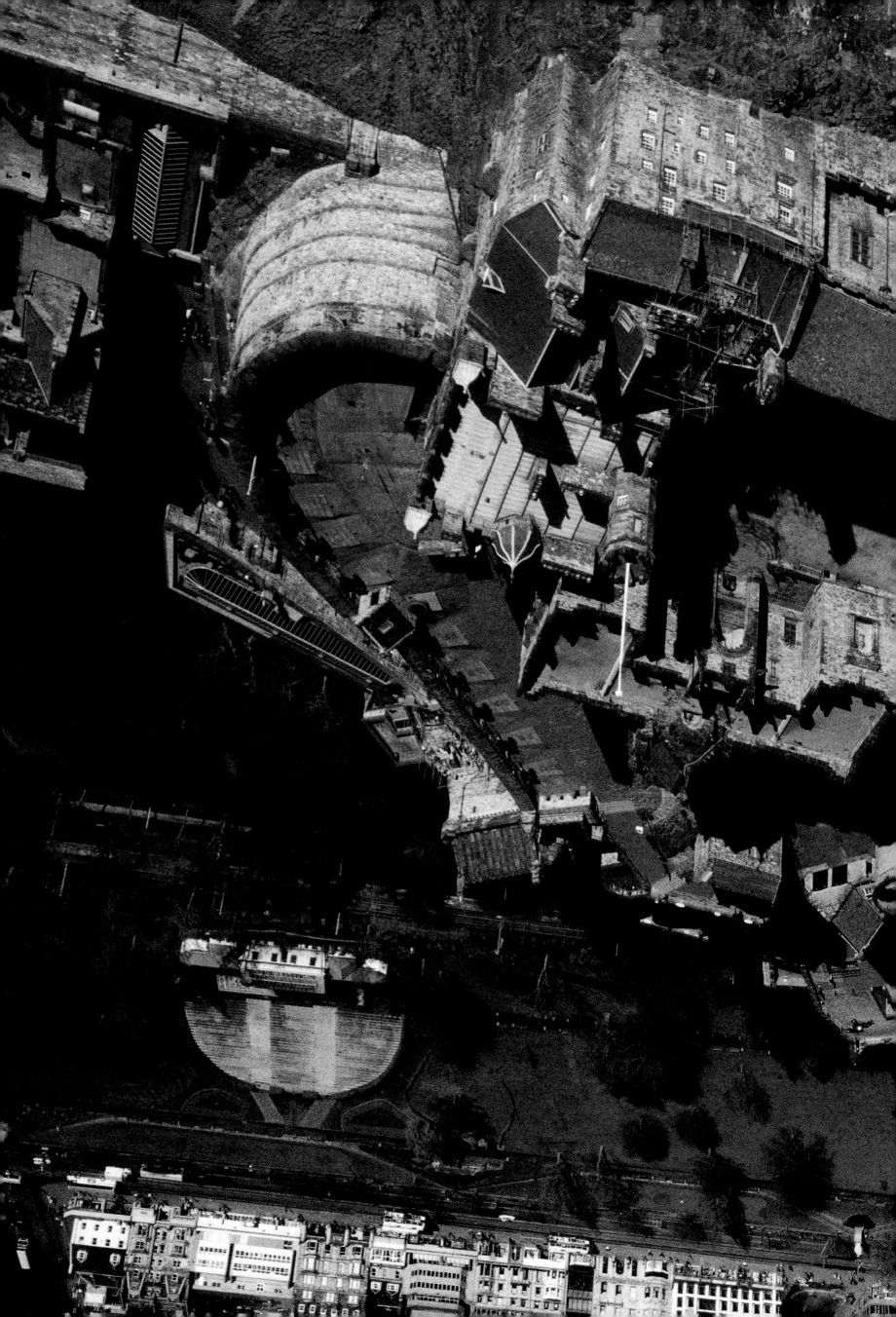

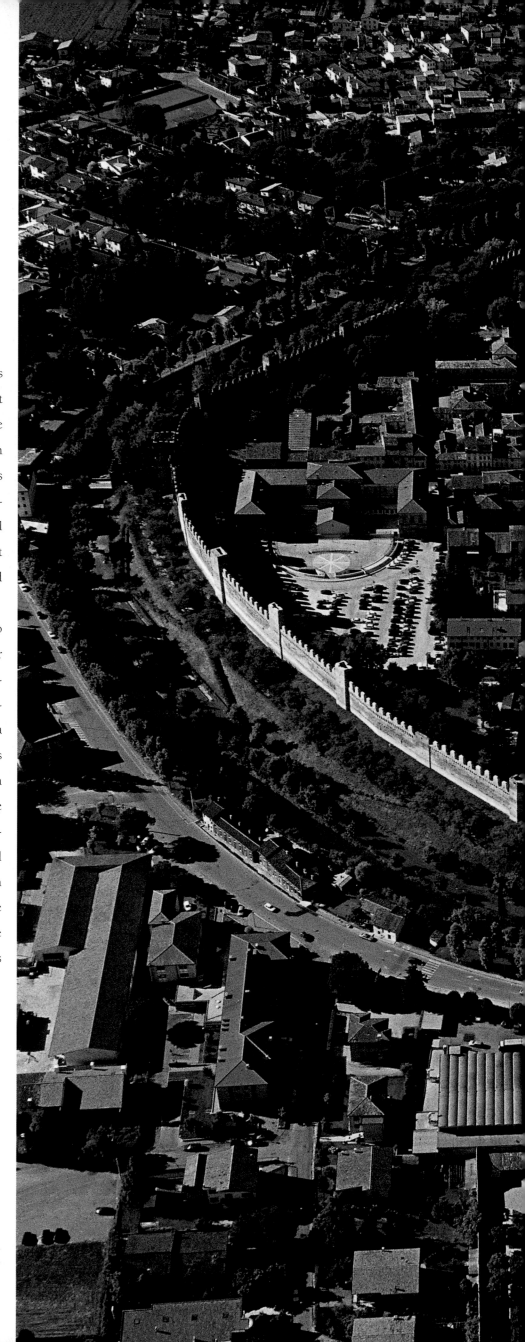

Walled cities

The main difference between a village and a town is essentially one of size, even though it is quite difficult to settle on an exact stage at which one becomes the other. Another criterion for the distinction is based on institutional characteristics and the inhabited area's relationship with the surrounding countryside: a village may have no magistrature and no institutional duties, depending for these on a higher authority. But a city is identified by the presence of political and administrative institutions.

Another way of identifying this distinction is to study the form of any fortifications, analysing their relationship to the residential fabric and the road system. Usually in a town, with independent administration, things seem more organised and correspond to a plan, which the surrounding wall completes. There is no other way of explaining the difference between Monteriggioni (see p. 214) and Cittadella, two of the best examples in Italy of municipalities. In Monteriggioni, although the wall is planned, the residential buildings inside the wall inhabit the space in an almost random fashion. In Cittadella the roads are designed to co-ordinate with the gateways and the orderly disposition of the buildings and open spaces confers an undeniably "city" feeling.

City walls, Cittadella, Italy. 13th-14th century.

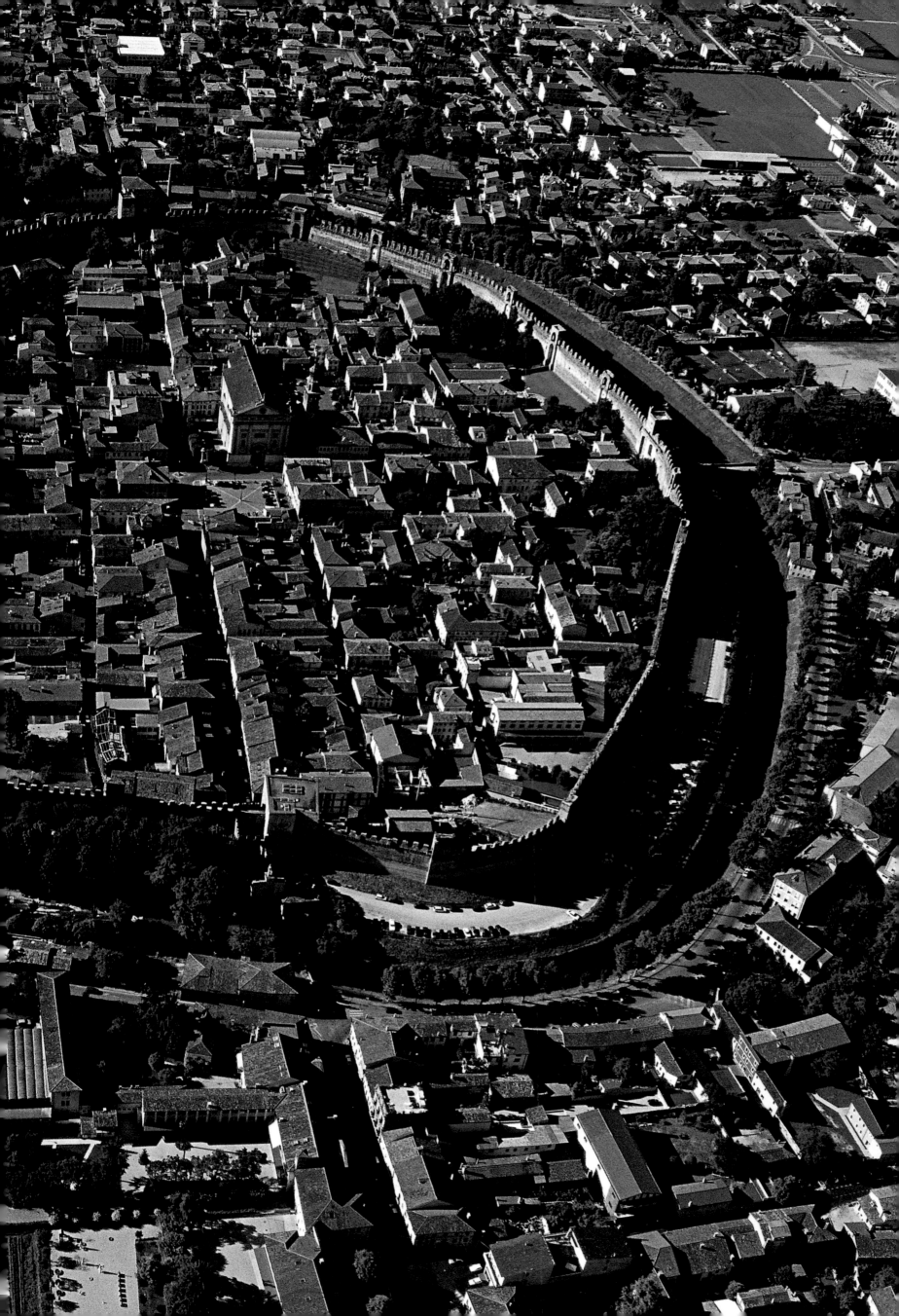

In the thirteenth century a magnificent curtain wall was erected around the city of Carcassonne, enlarging and restoring the internal defences of the ancient Visigoth wall.

At Aigues-Mortes, in the Camargue, the quadrilateral plan of the wall, with its twenty towers, ten gateways and lookout tower which also functioned as a lighthouse, are proof that we owe the design to a single authority: Louis IX of France wanted to use the city as the point of departure for his Crusade, and commissioned Nicola Cominelli and Guglielmo Boccanegra from Genoa to design and build the city and the port. At that time, the thirteenth century, the city was much closer to the sea than it is today, because of the progressive silting up of the mouth of the Rhône. Large turreted walls enclosing cities are particularly numerous in the South of France and in Spain – for example, Avila.

When artillery was introduced, the curtain wall had to be replaced by a system of bastions, usually laid out in a star shape to protect the entrance doors, which were located in the angles between the points. At Palmanova, near Udine, this system was designed and built to a single plan: the city and the fortifications were planned together, in the sixteenth century. The symmetrical town has nine sides and a hexagonal open space in the centre. It was built by the Venetians in 1593, and is a clear illustration of the new defensive techniques made necessary by technological developments in artillery: the three gateways could be protected against assault by cannon fire, and guns at the point of each star could keep enemy fire at bay.

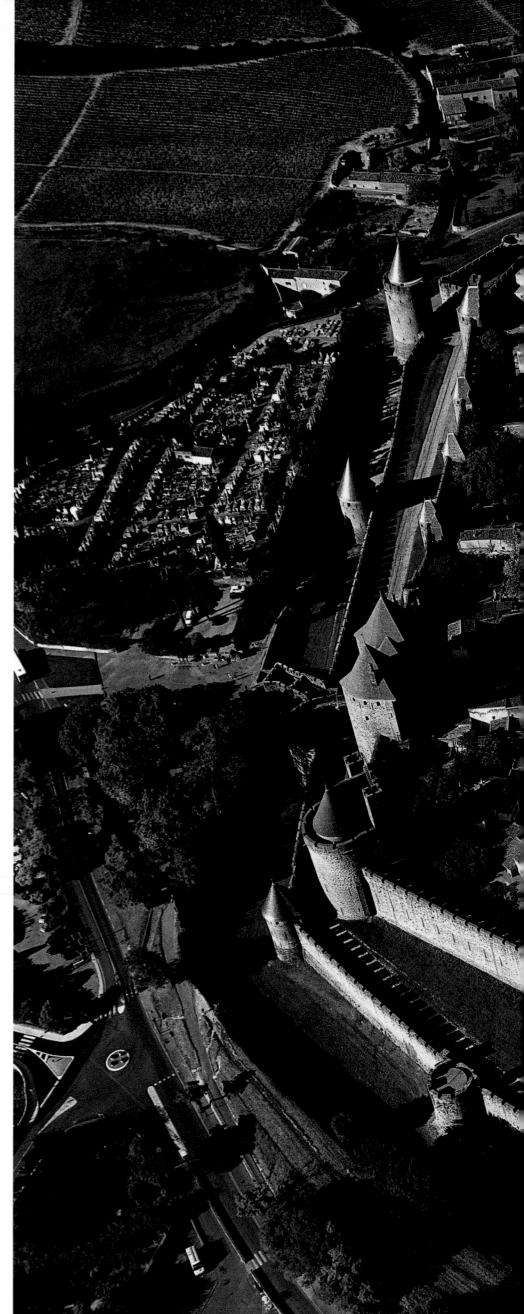

The fortifications of Carcassonne, France.
13th century.

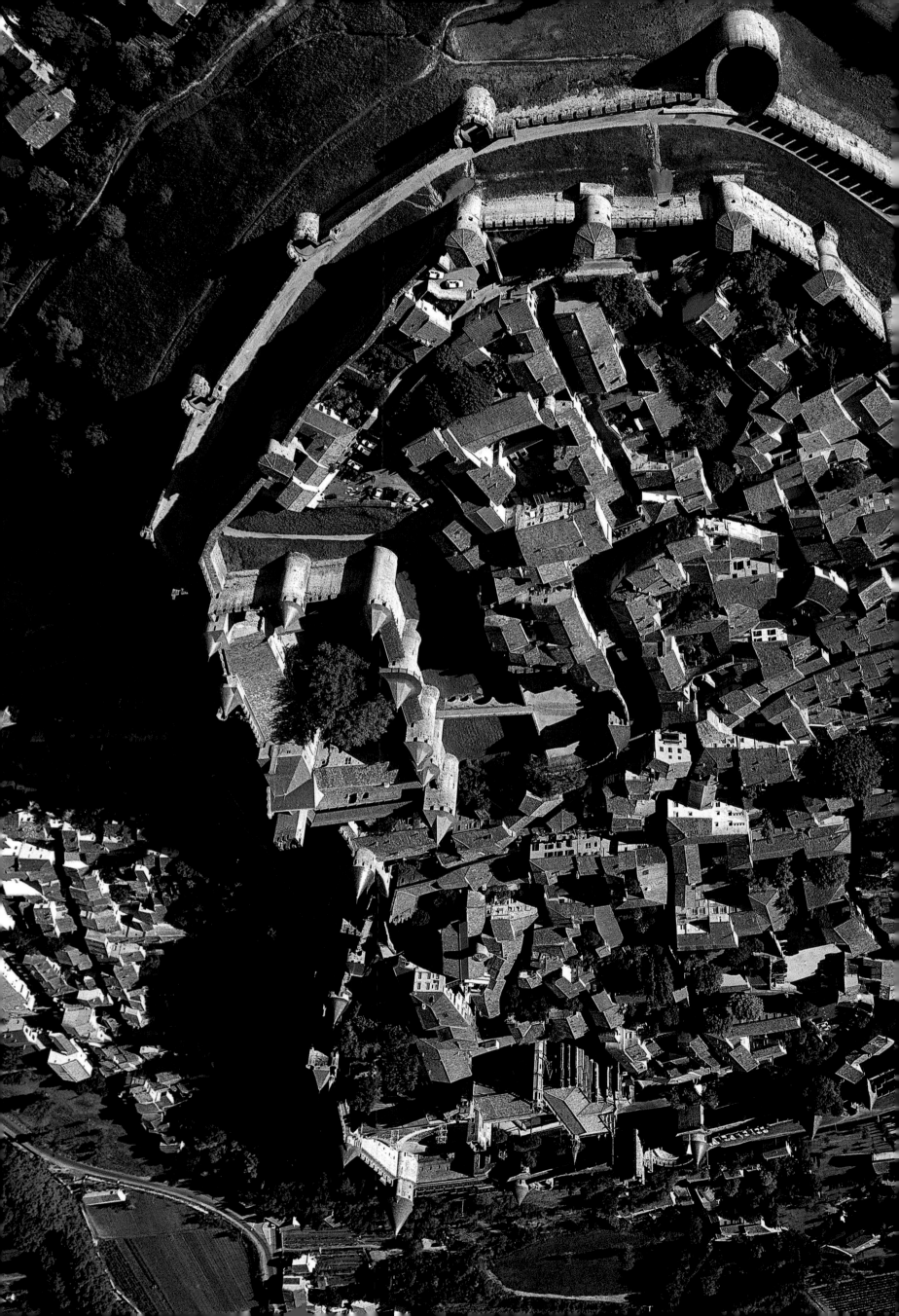

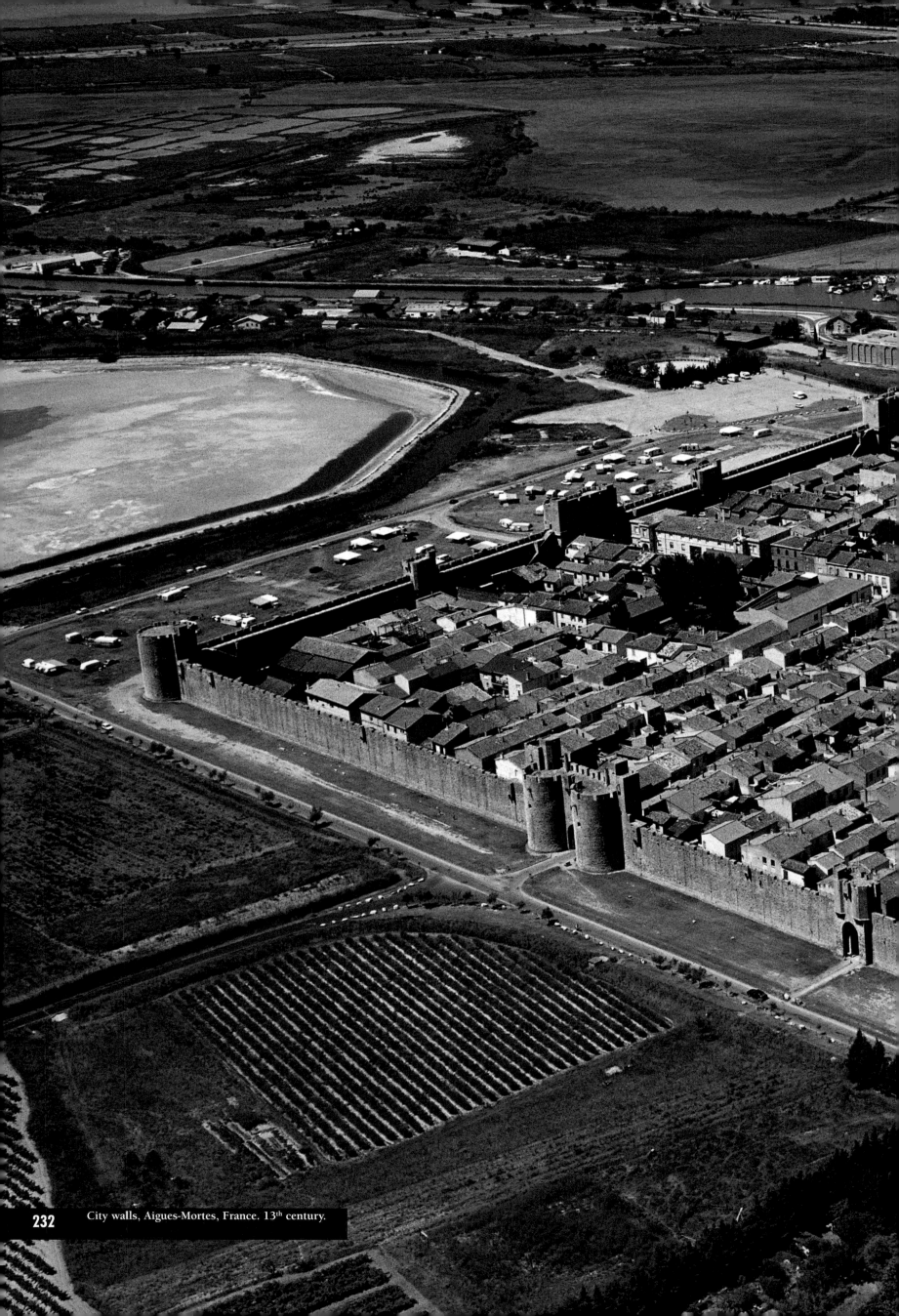

City walls, Aigues-Mortes, France. 13th century.

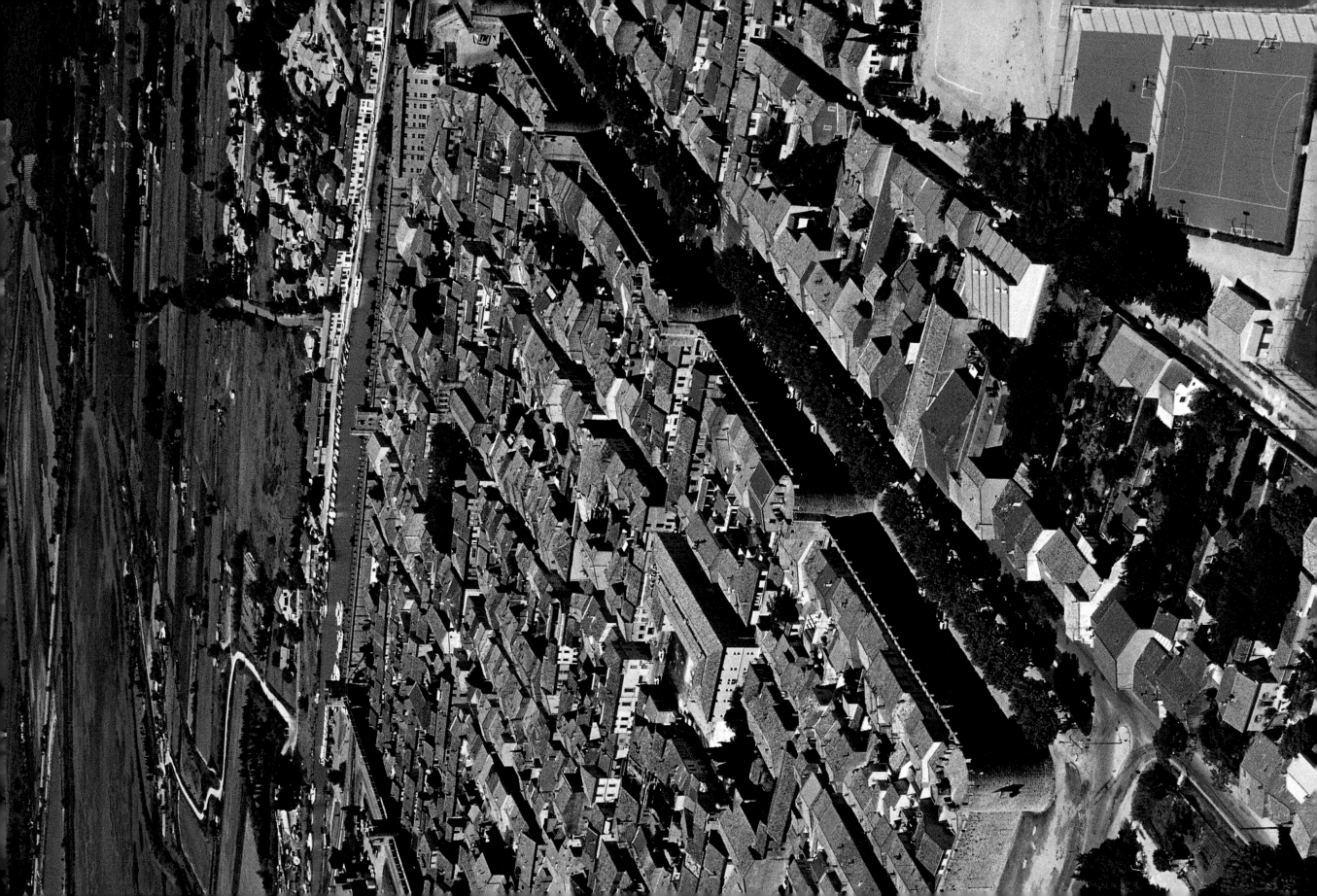

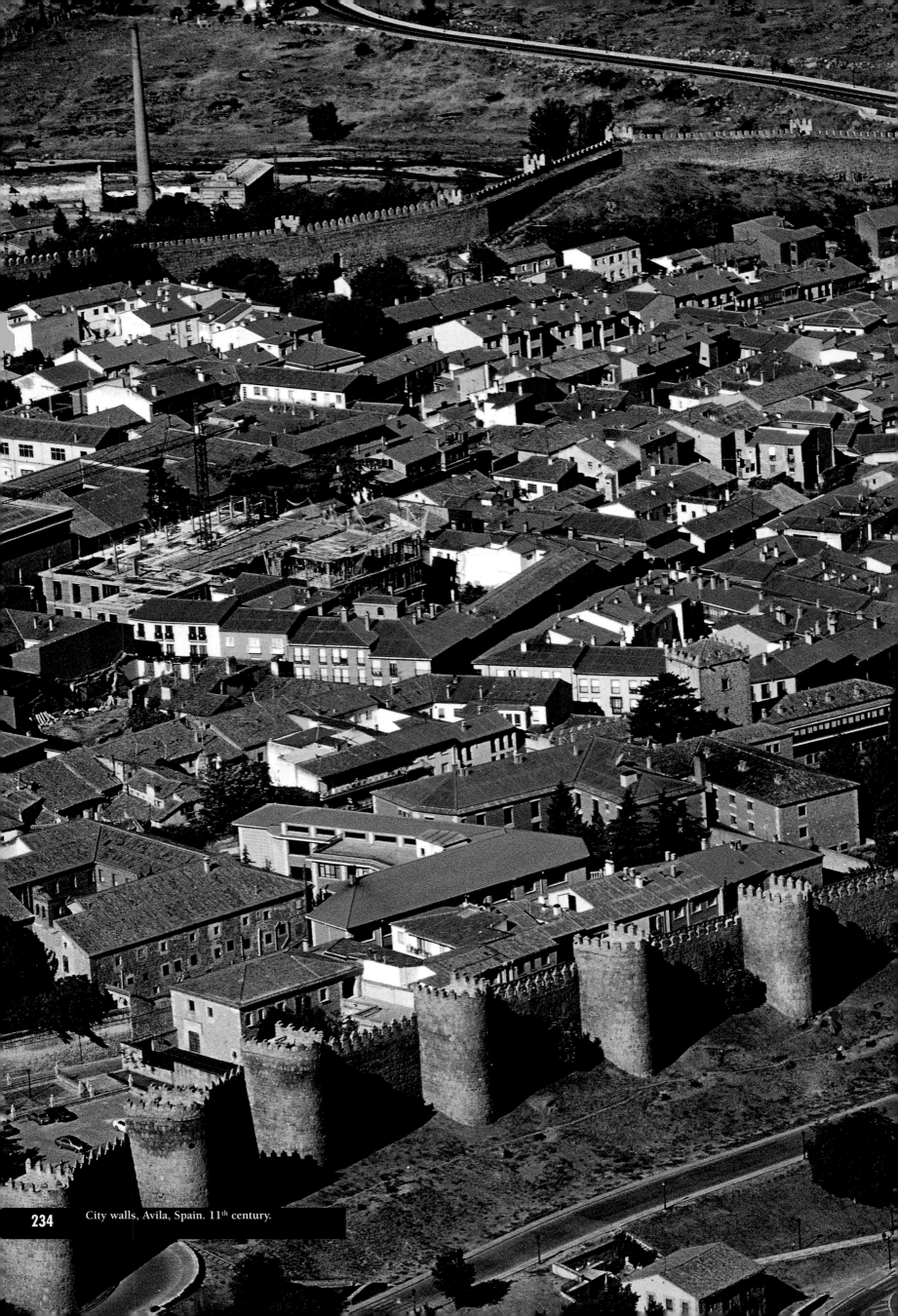

City walls, Avila, Spain. 11th century.

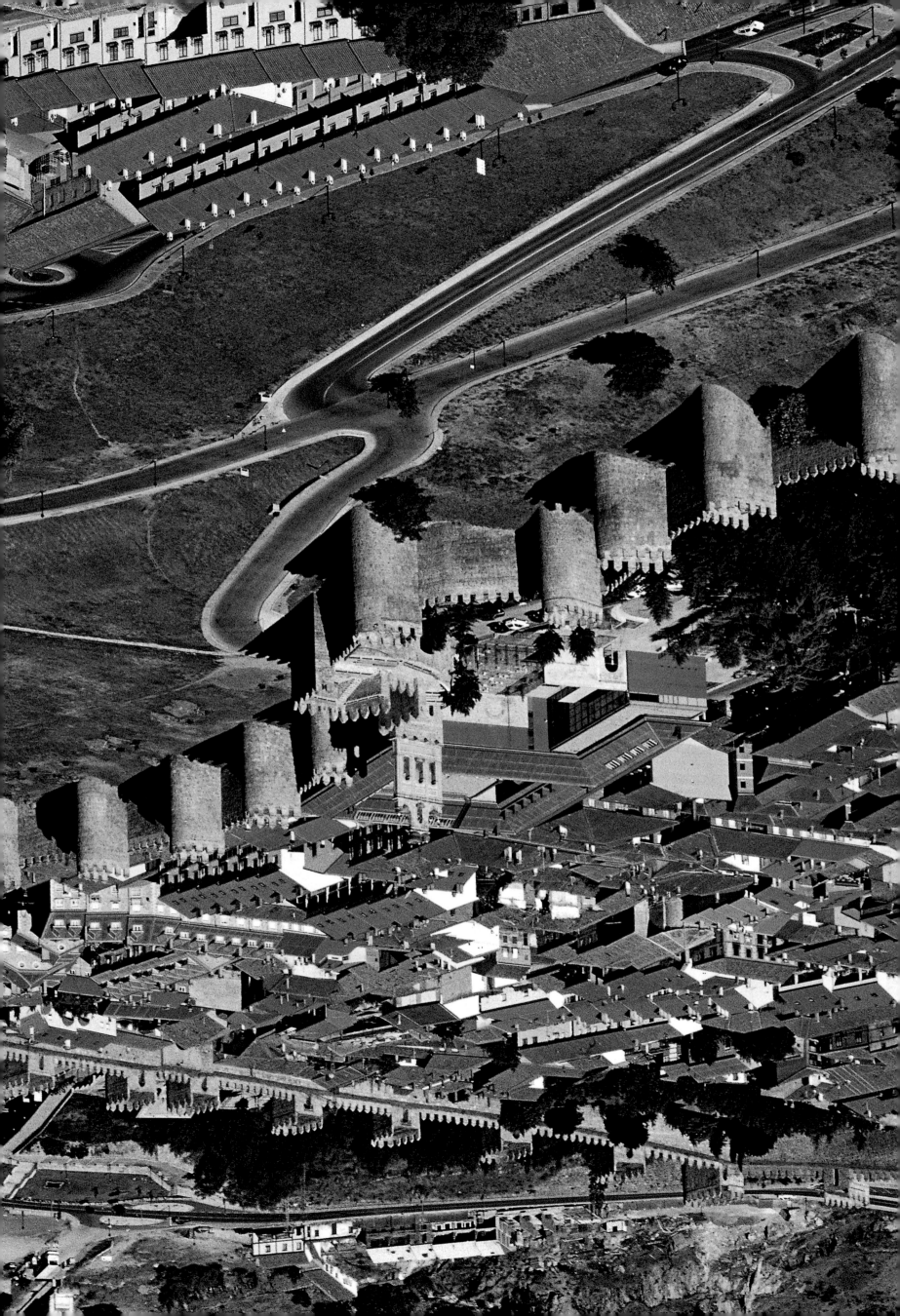

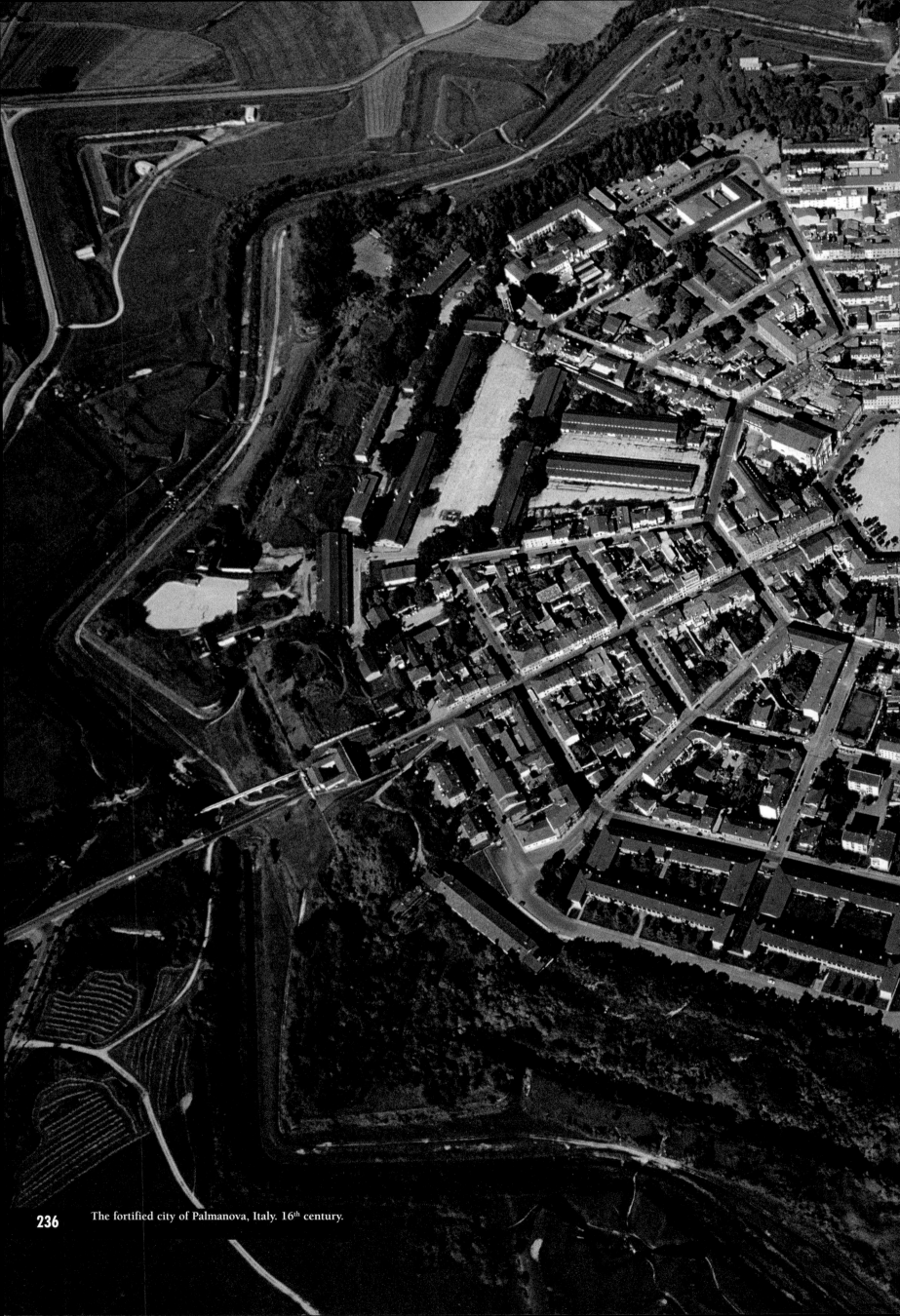

The fortified city of Palmanova, Italy. 16th century.

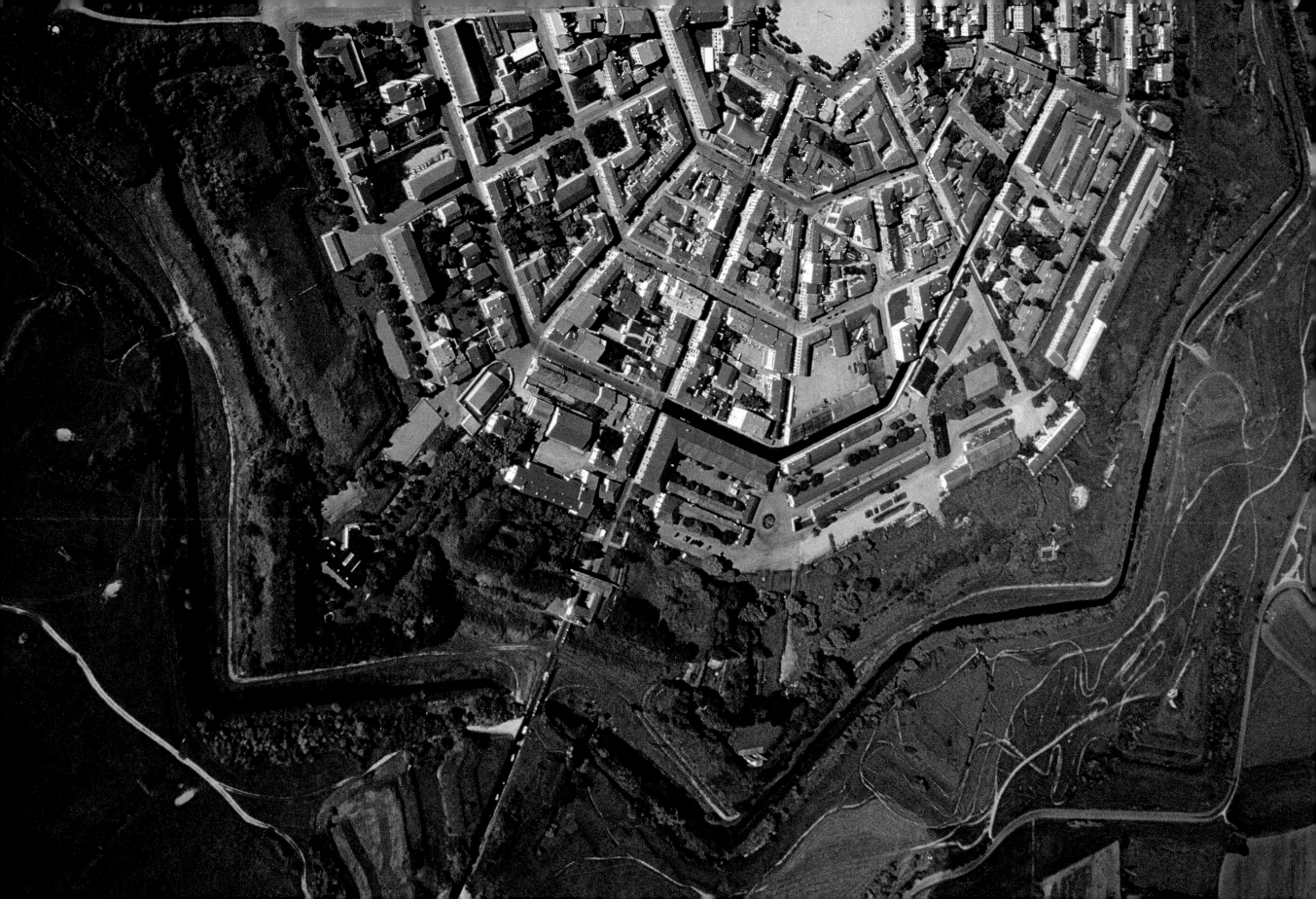

Ruins of Anadolu Kavagi, Turkey. 13th century.

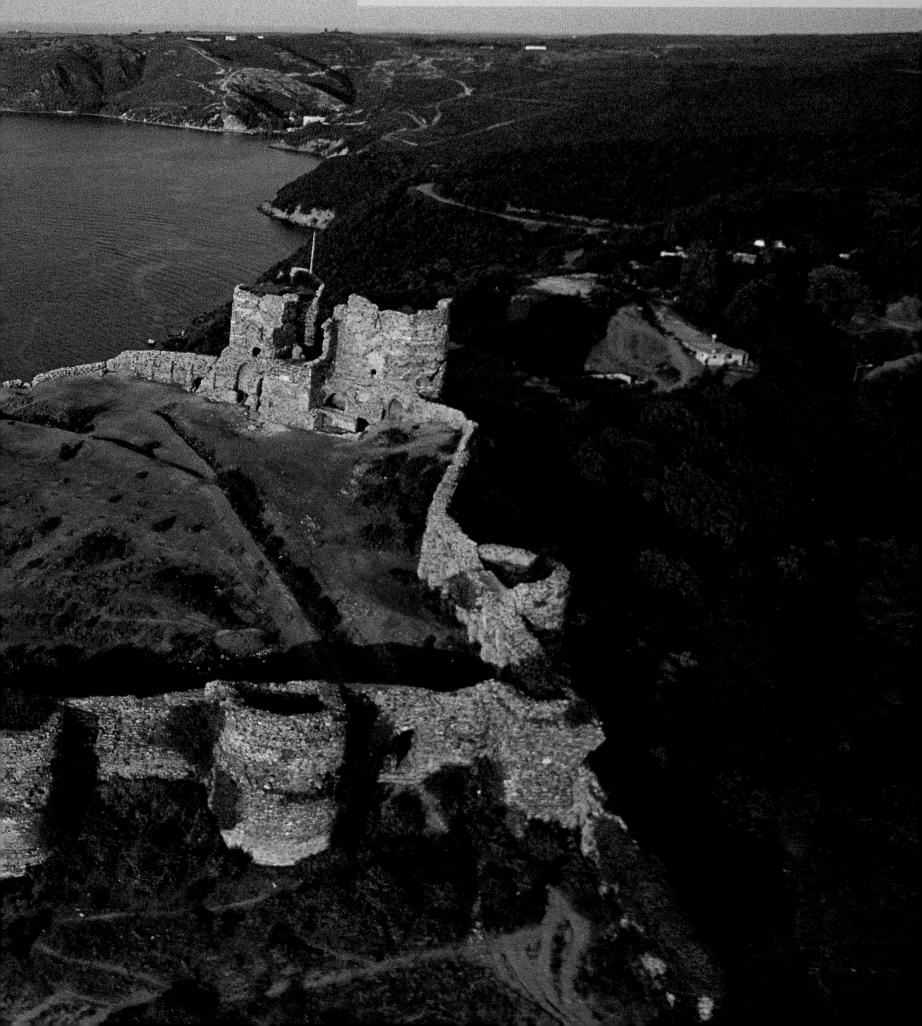

Castles
in Greece
and Turkey

Some history

As we said in the introduction, the castle, or rather the fortification, is to be found wherever man has undertaken his trek from a savage state towards primitive existence on the road to civilisation. Social inequalities generated by the division of labour, and the diversity of lifestyles derived from different levels of development and wealth have always been the cause of war, as has the need (or greed) for access to raw materials.

It is not the forms that castle architecture may have taken in remote places that interests us here, but the forms as they were connected to the influence of mediaeval European culture, or were dictated by opposition to it. The confrontation between Europe and the East in the late Middle Ages was above all the confrontation between the Christian and the Muslim worlds: this may be seen in terms of religion, but in reality it was the confrontation between a civilisation which was heir to ancient forms of social organisation, and a new, thrusting vision of the world, also born in the Middle East but taking on new and original forms within the European context. In the centuries that interest us here – the eleventh to the sixteenth – relations with the Orient were characterised mainly by the mercantile activities of the marine republics, above all Pisa and Venice, and by Europe's expansionist ideas: these found expression in the reconquest of Spain, the Norman expansion and, above all, in the Crusades.

After centuries of subjection, Europe now laid claim to direct control of the Eastern Mediterranean. This could not be achieved without bloodshed: first they encountered strenuous resistance from the Arabs, then they had to deal with the advance of the Turks, the new lords of the Eastern seas. Subsequently the Turks managed to overrun almost the entire Balkan Peninsula and even to lay siege to the city of Vienna.

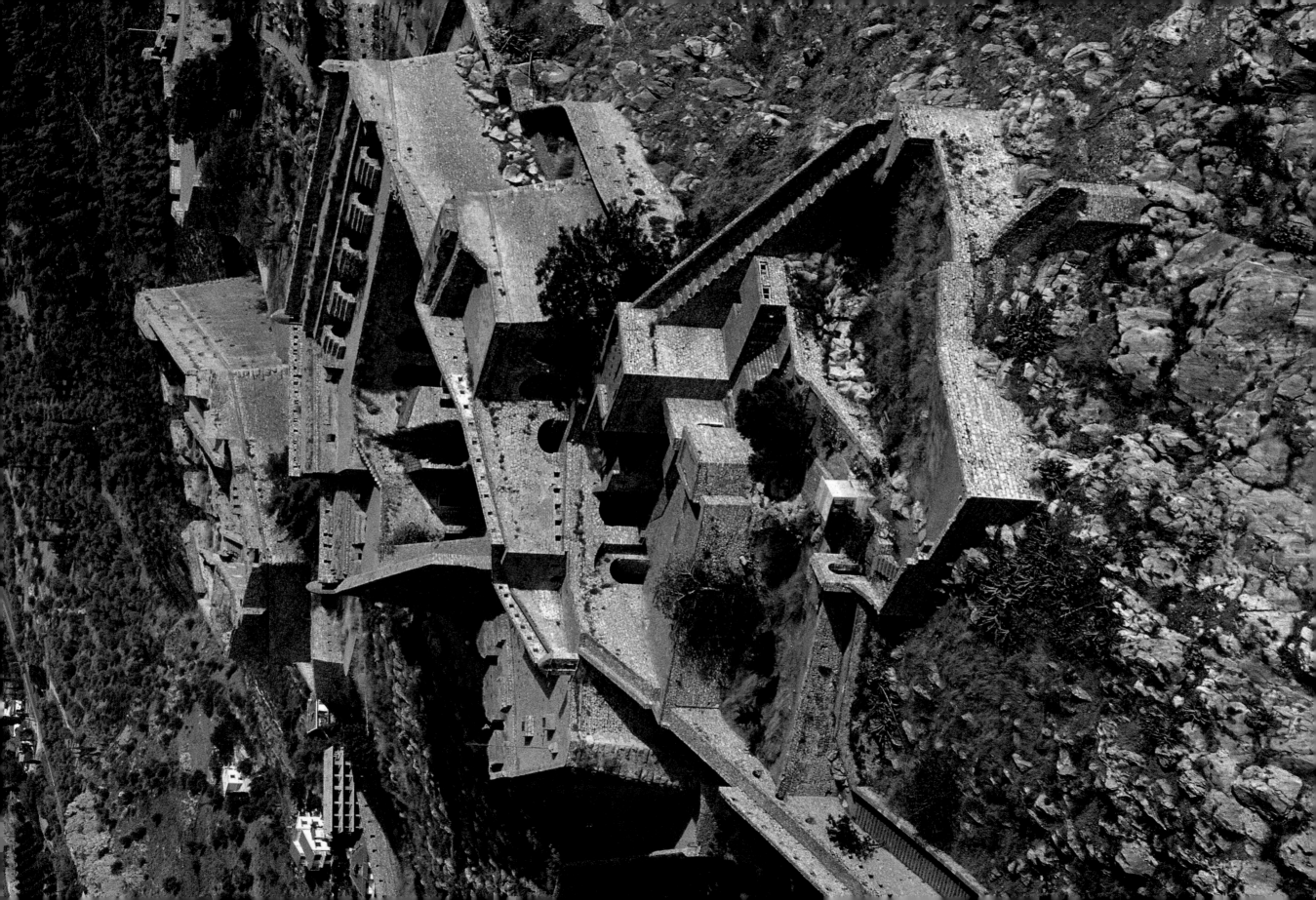

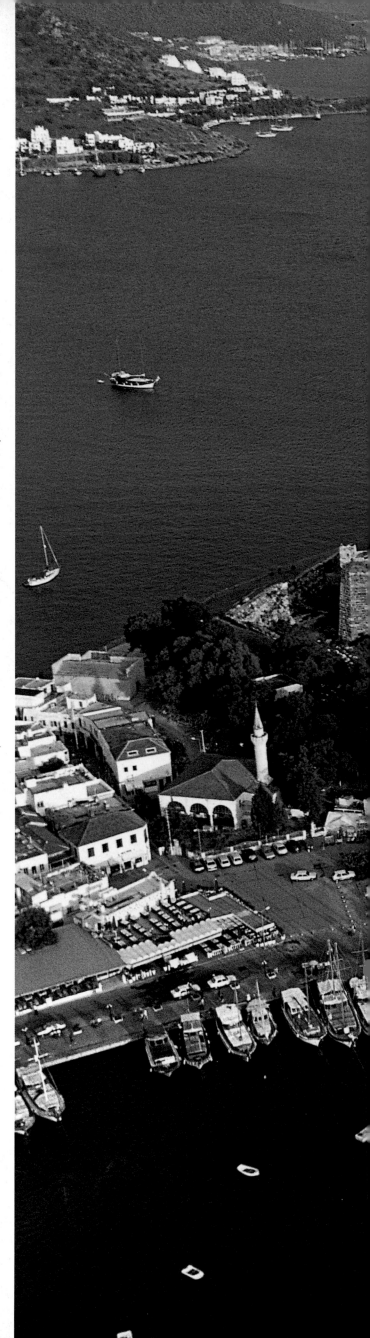

Christian castles in the Aegean

For centuries, a system of Venetian castles maintained control over sea routes and harbours, protecting their commercial interests. These castles sprang up on the coast of the Aegean, in Greece and Turkey, often on the site of a former acropolis, as in Navplion, where the Venetian fortress of Palamidi is built on the vestiges of an early mediaeval castle. European construction methods were used, adapted to the nature of the site and to defence requirements, including the possible hostility of the local people.

The Crusades played a decisive role: in Bodrum (ancient Halicarnassus), on the southern coast of Anatolia, the crusaders built the castle of St Peter by dismantling the monumental tomb of King Mausolus, dating from 355BC, and considered one of the seven wonders of the ancient world. The stone blocks were reused like ordinary building materials in the construction of the new walls and bastions; sometimes they were adorned with traces of earlier carved decorations. Evidently at that time reliefs carved by Scopas and Leochares made no impression on the builders.

The castle of Leros has different origins. It was erected in the Byzantine period on an island in the Dodecanese, but it owes its present form to the Knights of Rhodes, the longest-lived and the largest of the religious-military orders founded during the Crusades. The castle of Argos is also linked to the presence of crusaders. It fell into the hands of the French in the thirteenth century, then to the Venetians, and was enlarged by the Turks in the fifteenth century.

St Peter's Castle, Bodrum, Turkey. 15th century.

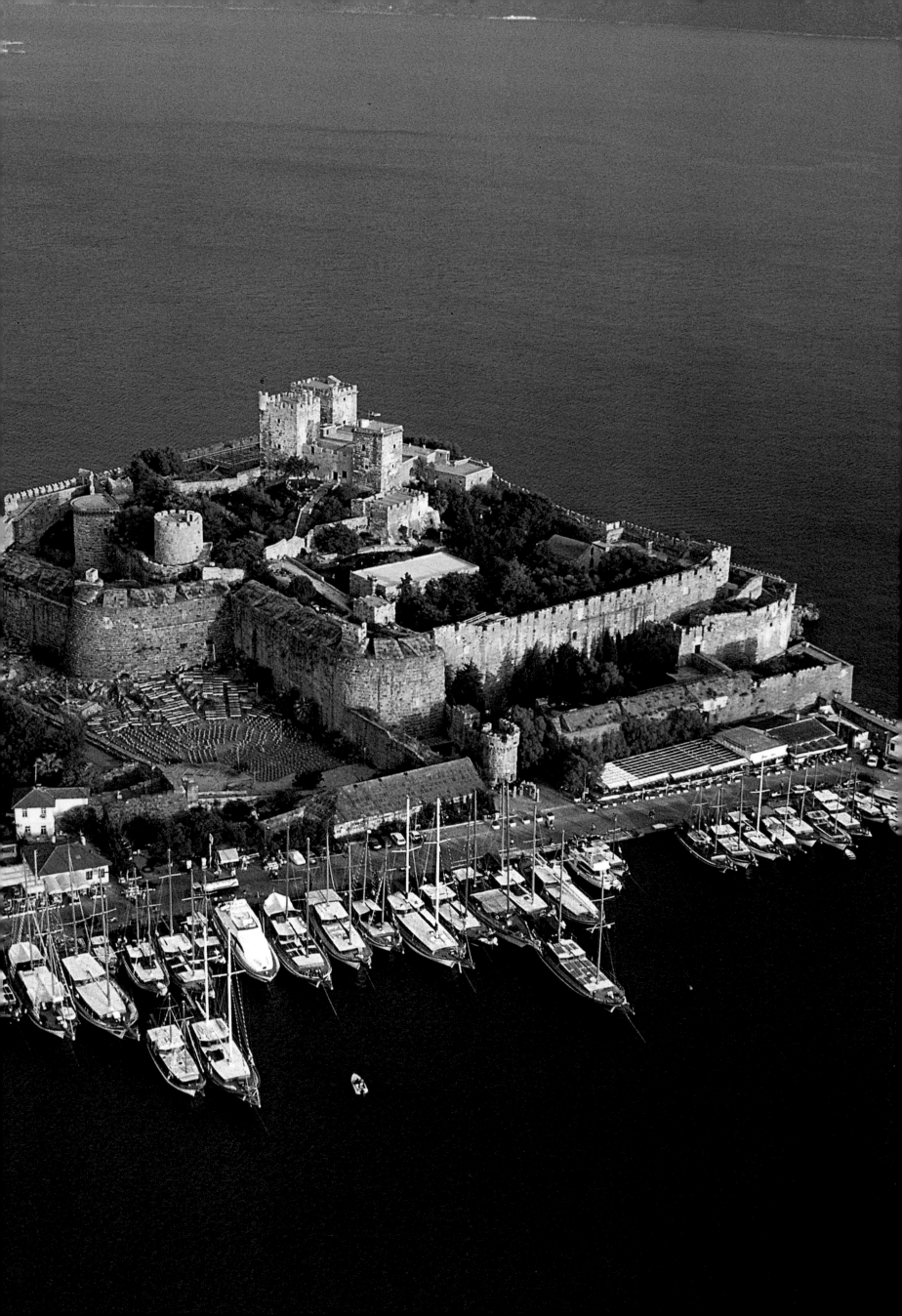

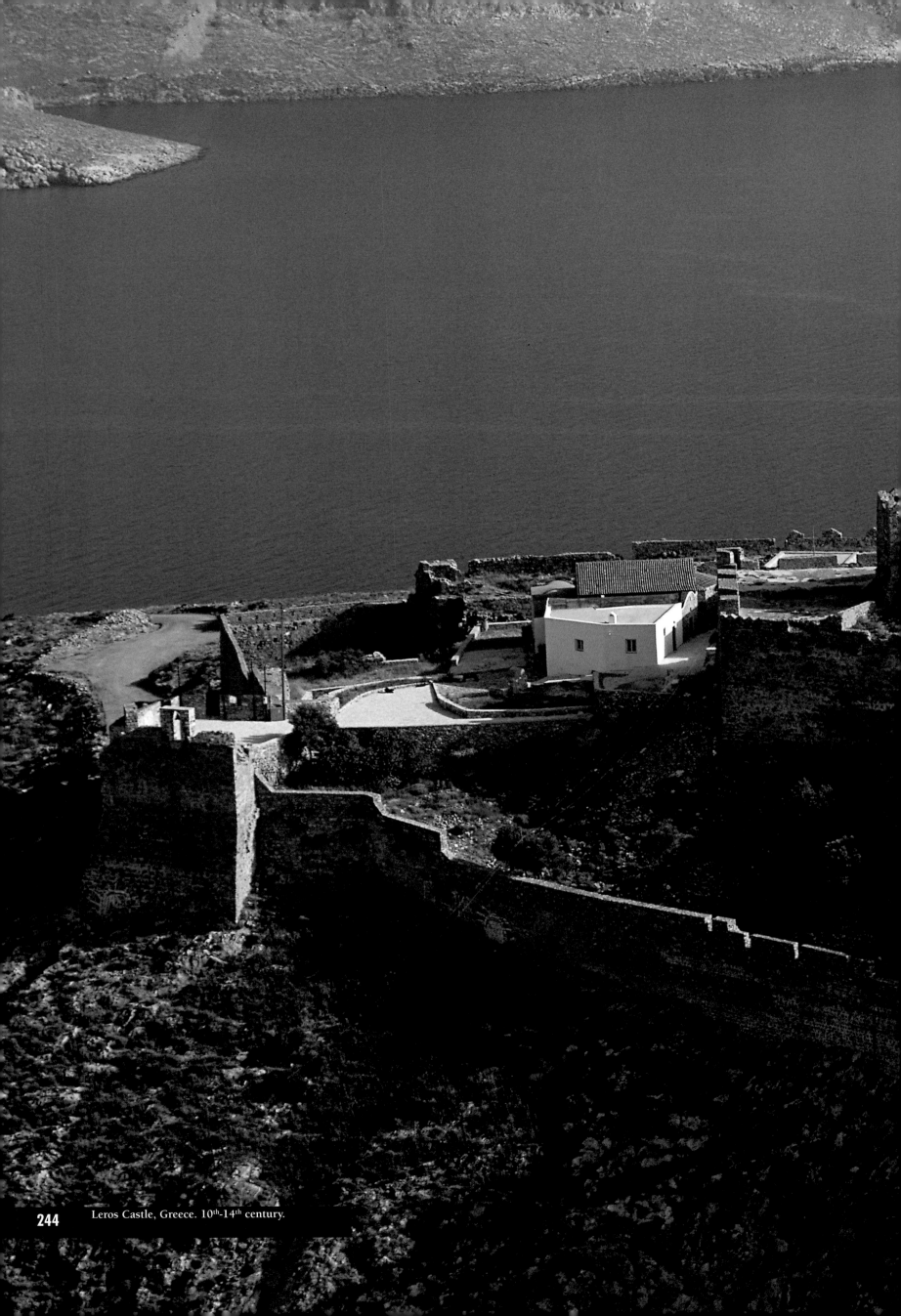

Leros Castle, Greece. 10th-14th century.

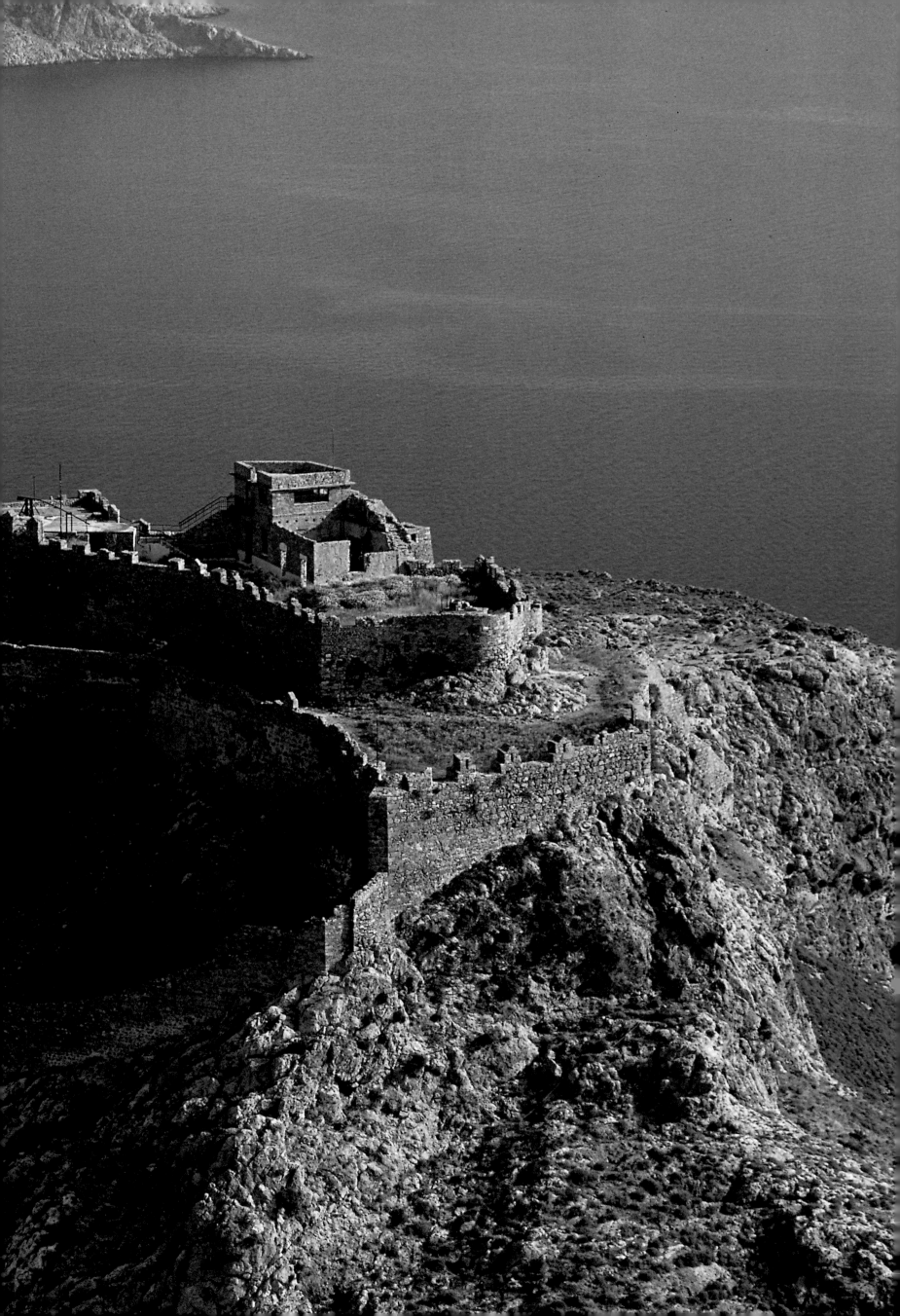

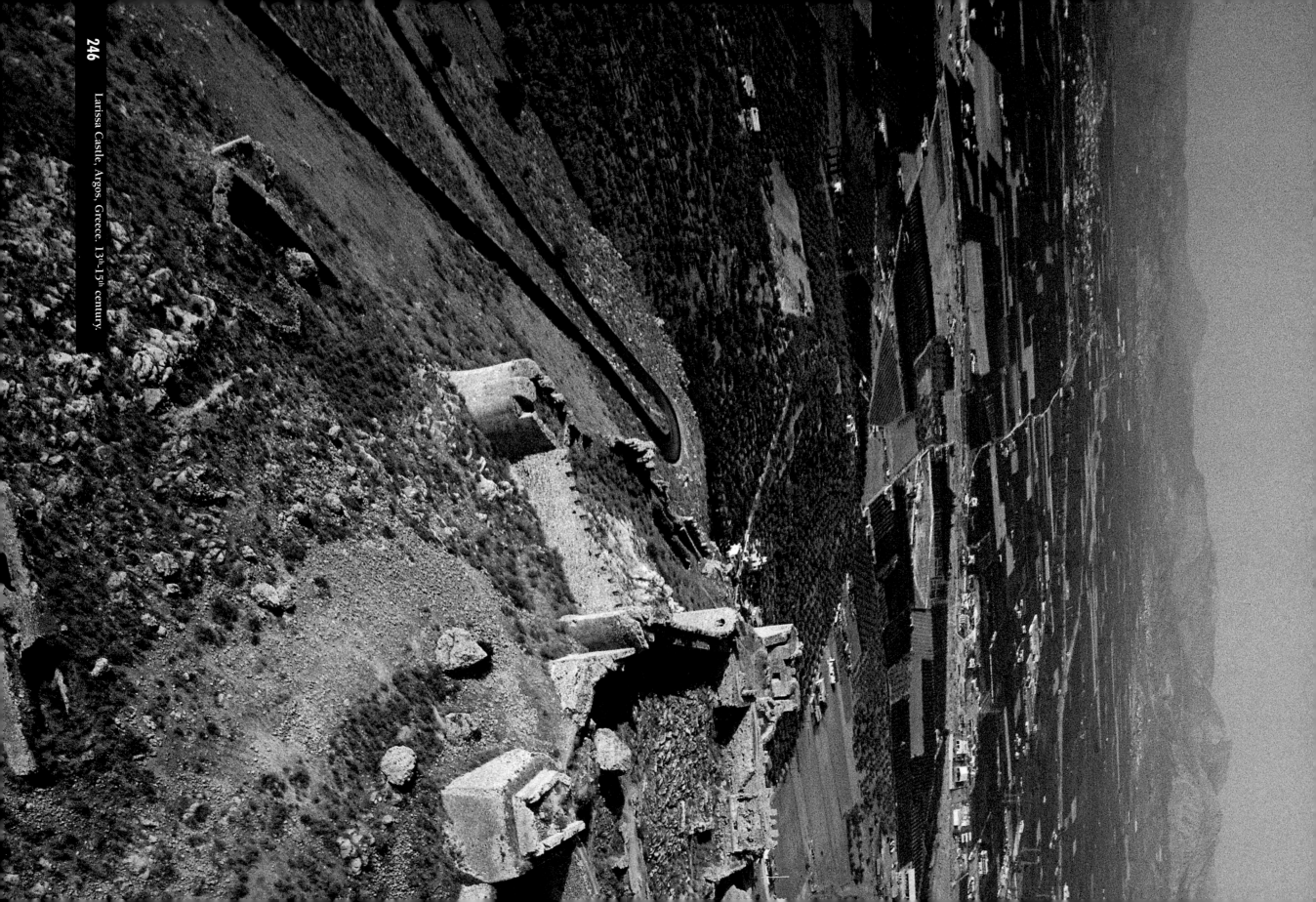

Larissa Castle, Argos, Greece. 13th–15th century.

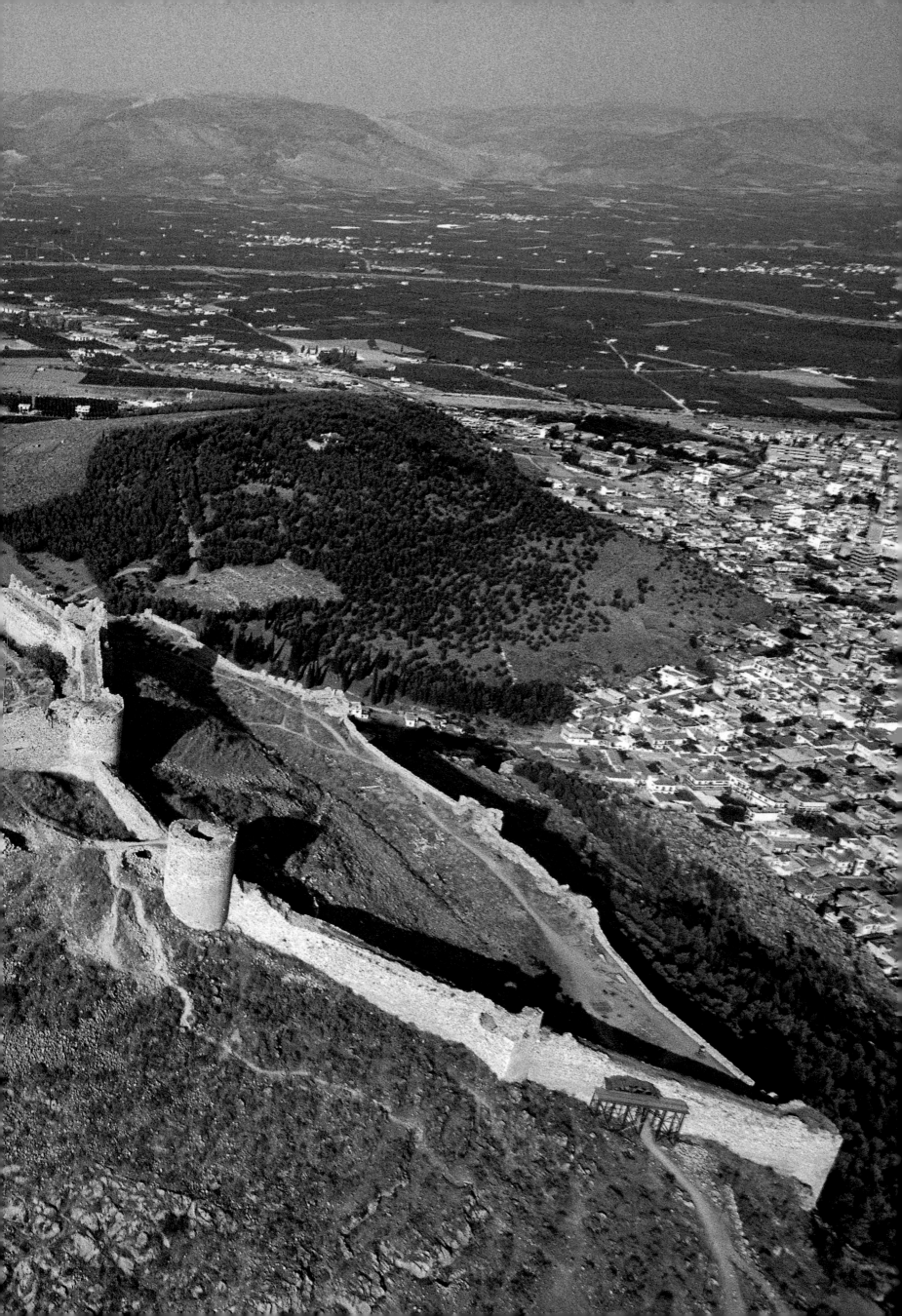

Turkish castles in the Aegean

The presence of the Turks in the Aegean from the fifteenth century had all the characteristics of a military occupation; consequently the architecture it produced is massive, compact and closed, conceding nothing to the more elegant aspects of life.

Their castles go from severe, square, heavy blocks, a rough parallelogram surrounded by a rectangular curtain wall with cylindrical towers at the corners (as in the fortress in Çanakkale), to the fantastically shaped fortress in Eceabat, dictated nevertheless by defensive requirements: a tall, trilobate wall with no windows or arrow slits, with a crenellated walkway along the top; within the wall stands a triangular tower with slightly convex sides, also massive and with few openings. The outer wall with its battlements and turrets looks useless and insignificant by comparison.

The Turks built their own, exclusively military fortresses on the shores of the Peloponnese as well. In Pilos in the sixteenth century they erected the so-called Neocastro (new castle) in a dominant position: a low hexagonal bastioned building, surrounded by a long, crenellated curtain wall.

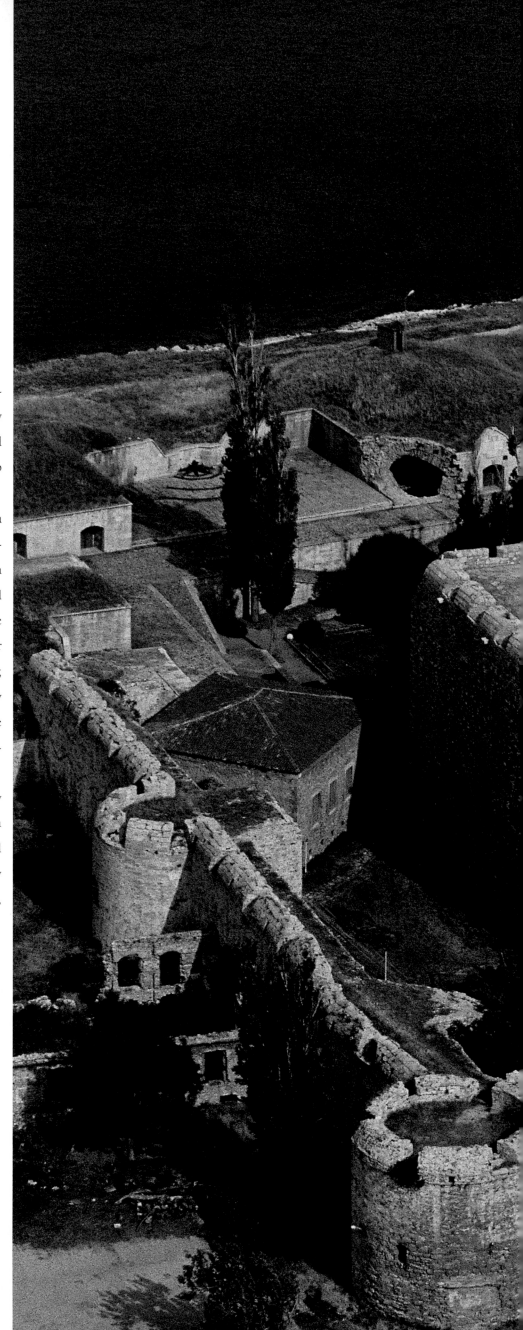

Cimenlik fortress, Çanakkale, Turkey. 15th century.

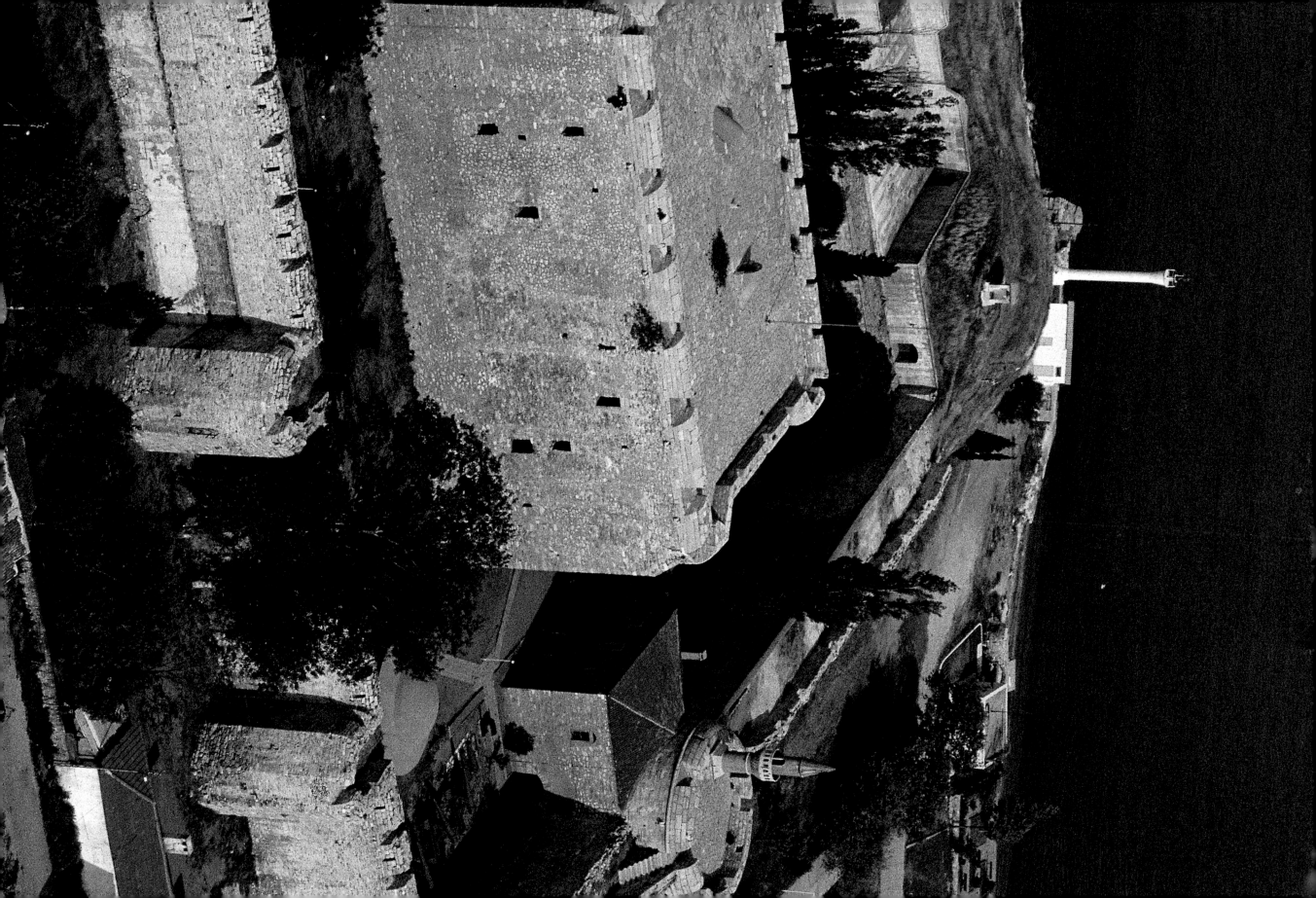

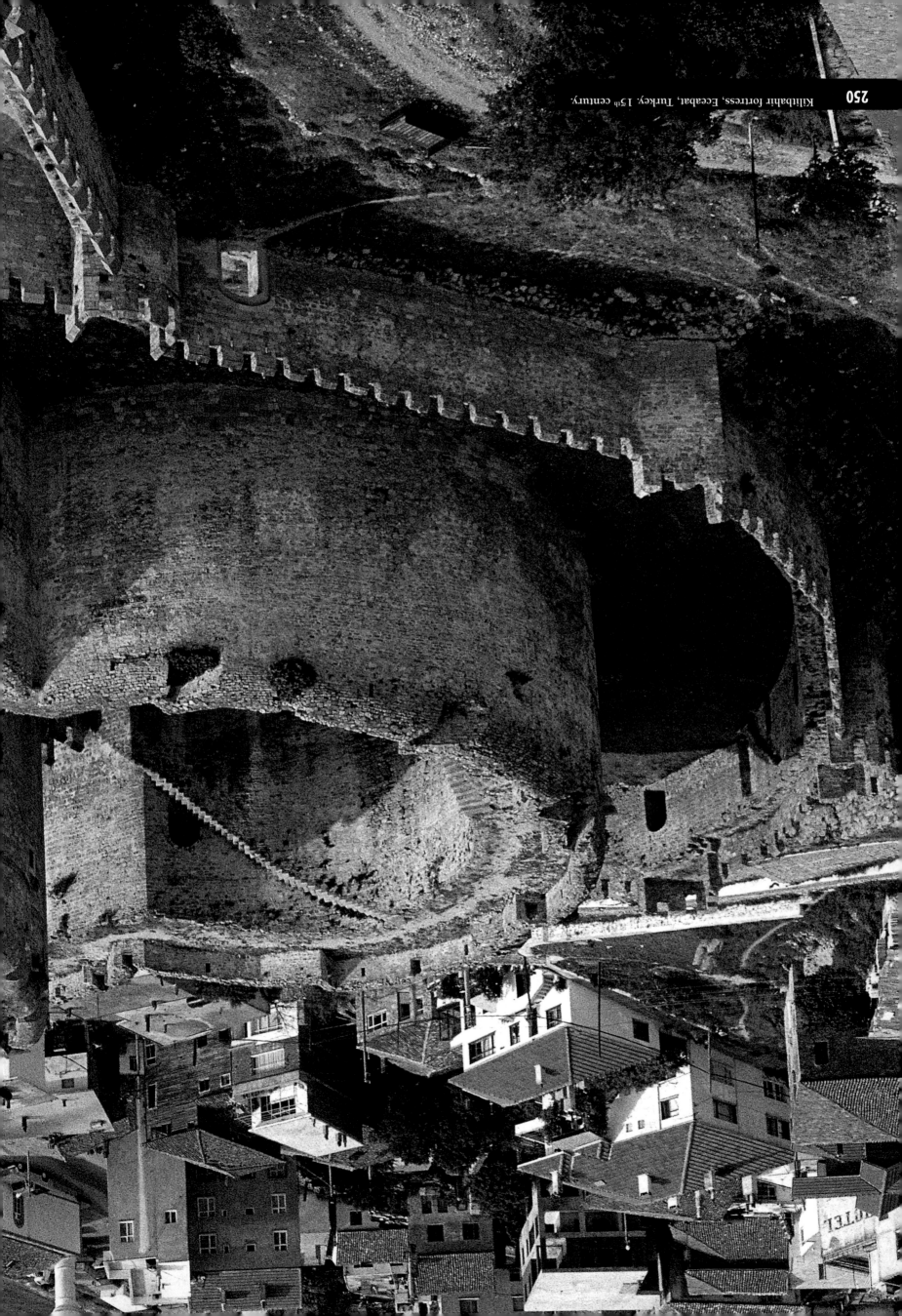

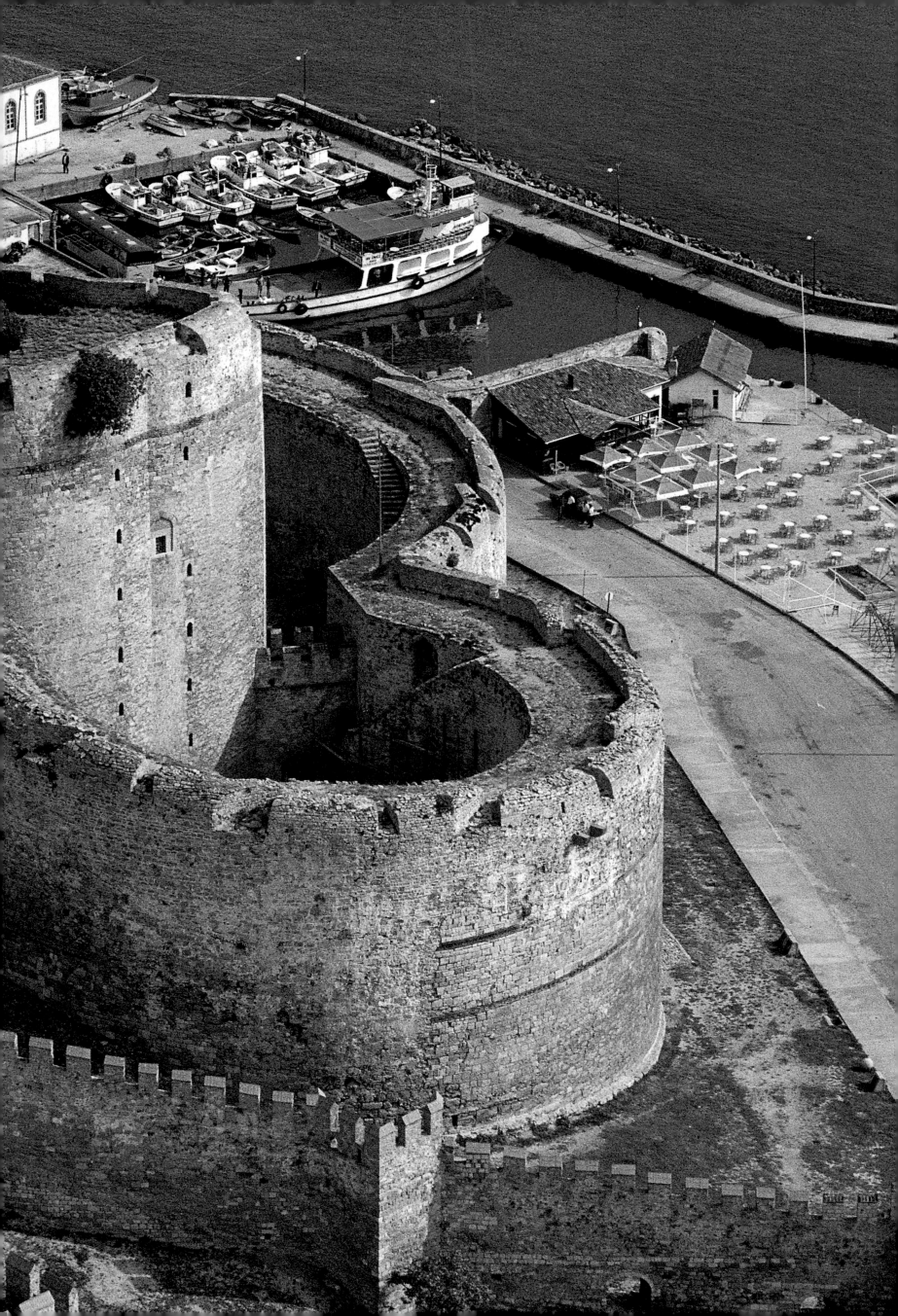

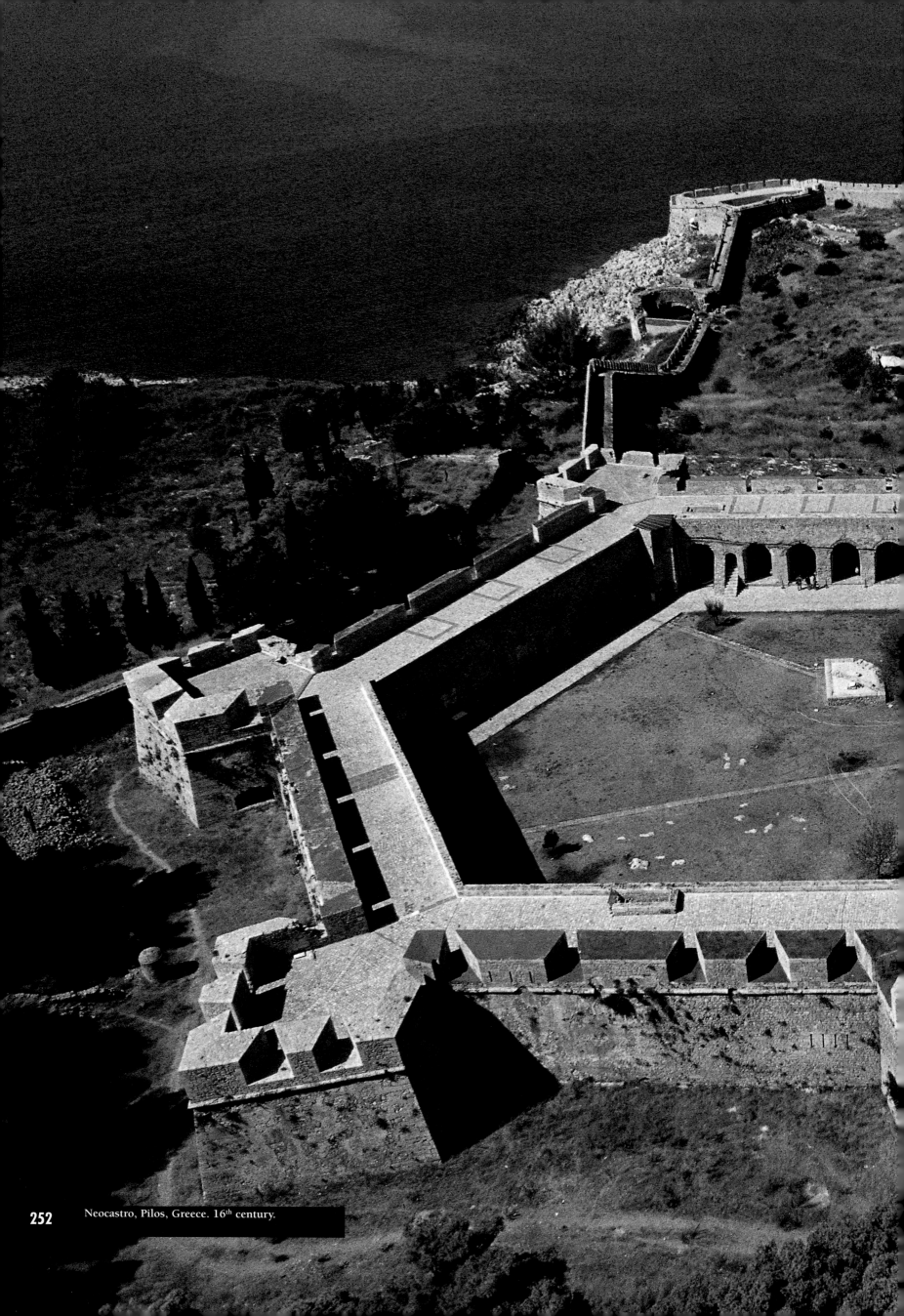

Neocastro, Pilos, Greece. 16th century.

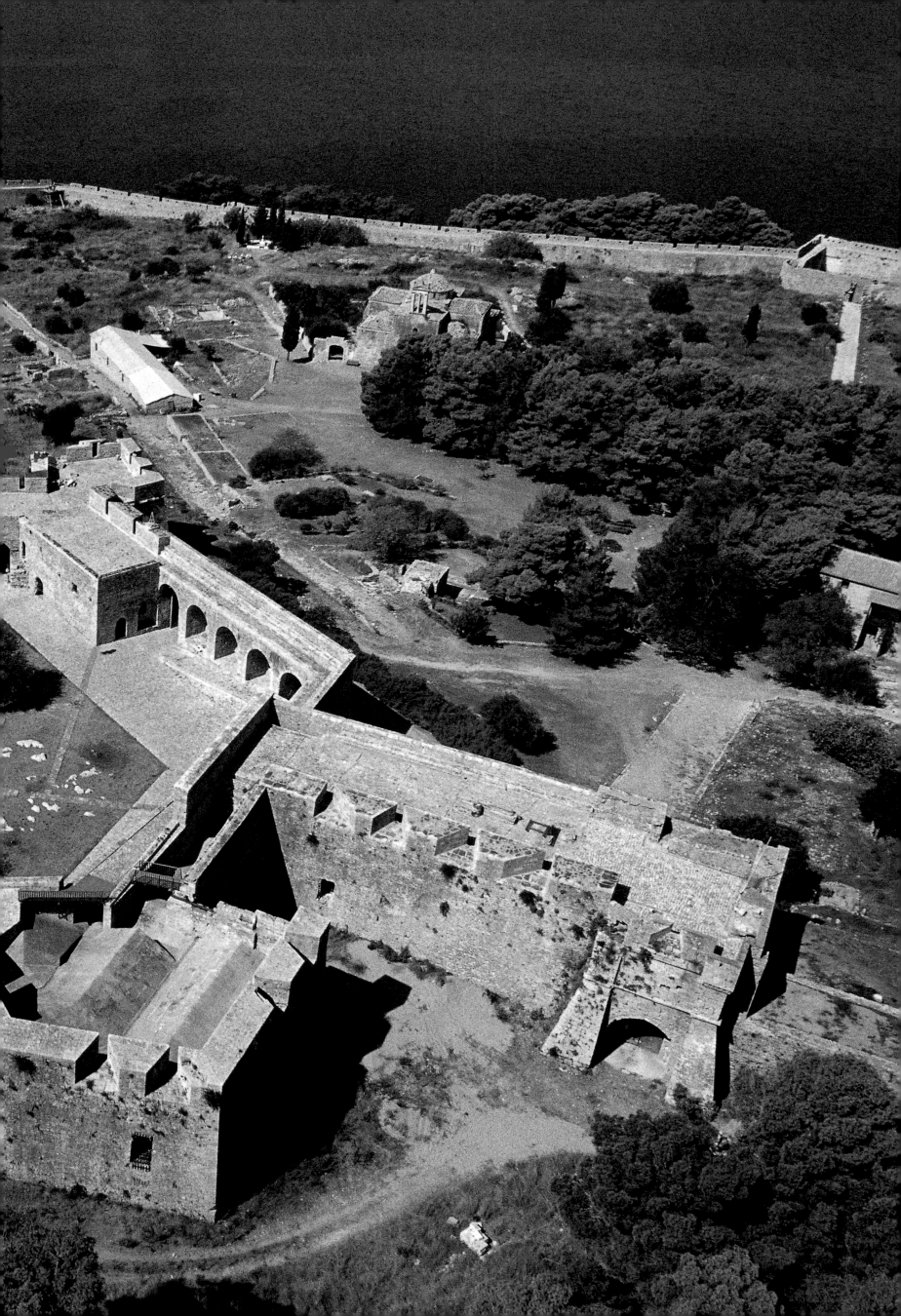

Index

Text: Giampiero Gianazza

Photographs: Mauricio Abreu: 34-35, 216-217, 218-219.

Yann Arthus-Bertrand (Imagebank): 16-17, 26-27, 42-43, 124-125, 136-137, 138-139, 164-165, 238-239, 242-243, 244-245.

Bertram-Luftbild München-Haar: 119, 120-121, 130-131, 132-133, 158-159, 162-163, 166-167, 220-221.

Davide Camisasca: 36. Jason Hawkes: 30-31, 103, 104-105, 106-107, 109, 110-111, 112-113, 114-115, 117, 199, 200-201, 226-227.

Paolo Lazzarin: 212-213. Daniel Philippe: 122-123, 128-129, 140-141.

Basilio Rodella: 38-39, 45, 60-61. Isy Schwart: 100-101.

Hans Wolf: 126-127.

Guido Alberto Rossi: all other photographs